Medieval Wall Paintings

in English & Welsh Churches

Roger Rosewell

First published 2008
The Boydell Press, Woodbridge
Reprinted 2016

ISBN 978-1-84383-368-0

The Boydell Press is an imprint of Boydell & Brewer Ltd
PO Box 9, Woodbridge, Suffolk IP12 3DF, UK
and of Boydell & Brewer Inc.
668 Mt Hope Avenue, Rochester, NY 14620, USA
website: www.boydellandbrewer.com

A CiP catalogue record for this book is available
from the British Library

Original design and typesetting 2007 by
Heritage Marketing and Publications Ltd

This publication is printed on acid-free paper

Printed in Wales by Gomer Press Limited

Dedication

To my parents, and my children, Harriet & Christopher

Contents

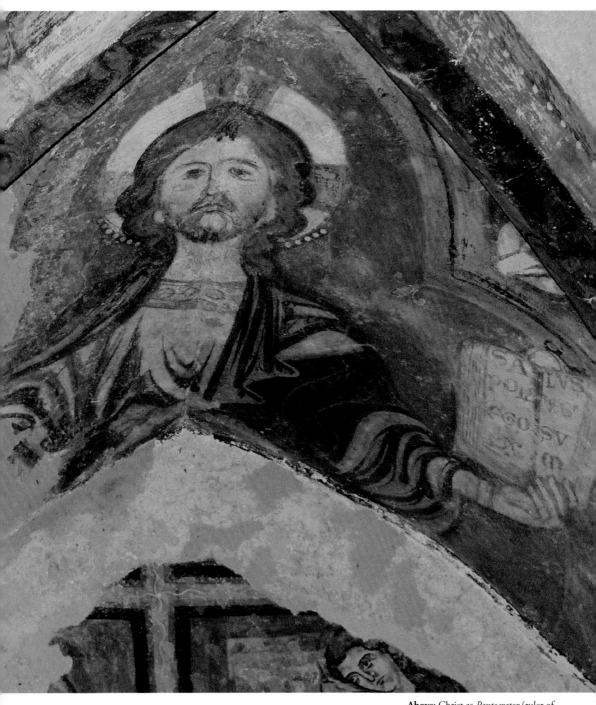

Above: Christ as *Pantocrator* (ruler of all things): The Holy Sepulchre Chapel, Winchester Cathedral, *c.* 1220.

Preface

This book could never have been written without the help of many people. Everlasting thanks are due to the innumerable rectors and vicars, churchwardens and key holders who left the comfort of their homes to open churches for me and who responded kindly to my sometimes arcane questions and requests. Despite endless reports of its imminent demise, on the evidence I saw at first hand, the friendliness and innate decency of the Church of England remains as strong as ever.

Gratitude and admiration is also extended to those art historians and conservators who have devoted their working lives to explaining and discovering wall paintings. In particular I could not have attempted to write this book without the outstanding scholarship of David Park and Helen Howard of the Courtauld Institute's Department for Wall Painting Conservation.

Thanks are also due to the staff at the Bodleian Library, Oxford University; Witney Library in Oxfordshire; County Record Offices in Norfolk, Northamptonshire and Bedfordshire; and architects at Ely and Wells. I am also grateful to the Revd. Tony Parkinson for sharing his knowledge of Welsh wall paintings. Special thanks are owed to Christopher Barrett, Mrs Mollie Beaulach, Susie Blackett, Richard Bryant, Stuart Cakebread, Charles Carus, Brian Clark, Dr John Clegg, David and Shirley Clifton, Mrs Helen Crawford, Claudia Copithorne, Phil Draper, Peter and Ticky Fullerton, Derek and Jeanne Glenton, the late Joanna Greenfield, Christopher Guy, Ian Hanson, John Hardacre, Alexander Kent, Gerallt Nash, Brenda Pask, Dr Kevin Rogers, Joseph Spooner, Lyn Stilgoe, Thomas Galbraith, Alan Thomas, Pat Tufnell, Richard and Susan Wheeler, Anne Willoughby, Alan Wright and many others who insisted on remaining unmentioned. I am also appreciative of the support of my publishers, especially Matthew Champion.

Photographs are an essential part of this book. Many have proved difficult to take in dimly lit churches and in often awkward locations. The contribution of c b newham has been outstanding. His achievements at Ewelme in revealing paintings never properly seen since they were made in around 1475 deserve the highest praise. (figs 212: 213: 214: 215)

My final thanks go to Dr Athene Reiss whose enthusiasm inspired my interest in wall paintings and from whom I learned so much.

Naturally all mistakes are mine and mine alone.

Introduction

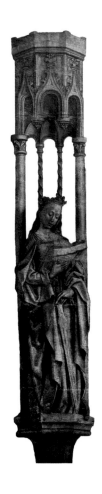

Not far from the roaring chicanes of Silverstone race track lies the tiny Northamptonshire village of Slapton. From a narrow lane, its parish church, St Botolph's, looks like hundreds of others in the English countryside. Built in the thirteenth century, it stands on a slight rise with a sprawling manor farm for a neighbour, and views that stretch from grassy paddocks to the edge of modern housing.

But opening its ancient door is like entering no other. (1) On a far wall, a bearded giant carries a child across a river swirling with fish, while either side of a stone arcade a hanging man dangles from a tree and an angel gestures towards a young woman. Look further and more paintings appear: a huge white horse, a wall of walking skeletons, a haloed figure in a friar's habit linked by black rays to the crucified Christ. (2) It is a world of wonderment and the miraculous, a world that once entranced and embraced generations of Christian worshippers and which still has the power to astonish and delight today.

Slapton is one of the best places in England to see how a medieval church would have looked before Tudor monarchs outlawed its images, banned its paintings and imposed a more austere, less sensual, form of national religion.

Sadly, it is also one of the few. Of around ten thousand medieval churches, fewer than ten per cent retain significant remains of their original painting schemes. For every extant wall painting, innumerable others have been destroyed. Even where paintings cling to survival they often appear as spectral outlines of their former selves.

Yet when impressive examples of original schemes can be seen, they are evocative reminders of how these rich and vivid displays transformed the interior of every church, with intoxicating colours and stirring art.

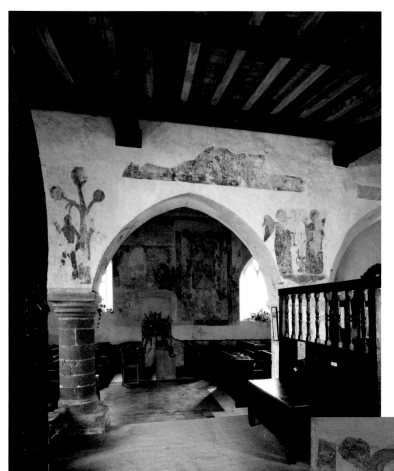

Figure 1 'The Painted Church': Slapton, St Botolph.

Opposite: The head of St Christopher carrying the Christ child. Detail taken from St Christopher, Slapton, St Botolph.

Below: St Christopher. Detail from Slapton, St Botolph.

At their best, they include masterpieces by some of the leading European artists of their day, while at the other extreme, even the most awkwardly rustic can still provide tangible encounters with medieval life and people.

Whatever its condition almost every painting demands a long-jump of imagination. Just as the original artist had an 'idea' about how his scheme would look before he picked up his brushes, so too we must make a similar effort to 'see' what he intended, as fresh and rich as the day he made them. We have to visualize complete schemes and salvos of coppery greens, ocean blues, and bold reds blazing across walls lit by flickering candles and tapestries of coloured glass.

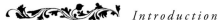

Wall paintings were a unique art, complementing, and yet distinctly separate from, other religious imagery in churches. Unlike carvings or stained glass windows that could be perfected in workshops, their *support* was the structure itself and meant that they had to be made on-site in the church and nowhere else. They were also monumental, often larger than life-size images for public audiences, hugely different in scale, composition, and purpose from private devotional aids such as books and domestic-sized carvings of saints. The artist's 'canvas' was stone and plaster: hard and uneven, sometimes awkward to paint or difficult to see in dimly lit buildings. Everything he did was shaped and framed by the supporting architecture. As churches were altered, extended, and sometimes demolished and rebuilt, so too the 'canvases' on which these artists worked were destroyed, modified and rearranged. New windows and walls lopped off painted arms and legs, while lowered roof lines decapitated heads and sheared the feathers of flying angels. At Checkendon in Oxfordshire, for example, a painting of the Twelve Apostles adoring Christ became a painting of nine and a half after fifteenth-century builders punched a hole in the wall of the apse to insert a new window. (3)

Notwithstanding their dissimilarity from other religious art, wall paintings were also an integral part of church interiors, enhancing devotional imagery and inspiring faith and commitment in their own right. Today, when many can only be seen as patches amidst otherwise plain and sparsely decorated walls, they can appear without meaning or context. But five hundred years ago, when windows shone with colour, polished silver chalices gleamed on altars, and polychromed statues wore velvet cloaks and gold rings, wall paintings provided a enclosed artistic setting for the church's sacred rituals and public ceremonies.

Figure 2 St Francis receiving the Stigmata: Slapton St Boltolph, fifteenth century.

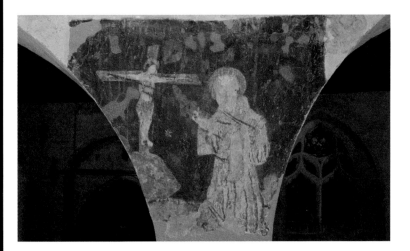

At their simplest, such paintings were ornamental: often simulations of regularly cut masonry blocks stencilled with petalled roses or sprigs of flowers. Elsewhere elaborate scrolls, trails of leafy foliage, imitation textiles and looping contrasts of colour enchanted the eye. Perhaps inevitably it was figurative paintings, like those which still survive at Slapton, which had the greatest impact with medieval audiences. The angel and the woman on the south wall of the nave arcade depict *The Annunciation*, the moment when God sent his angel, St Gabriel, to tell a young Virgin that she had been chosen to bear his only son. To the west on the same arcade, the hanging man is the treacherous Judas Iscariot who betrayed Christ for thirty pieces of silver and then committed suicide in shame. Other paintings revered saints whose intercessory powers and closeness to God played such an important role in late medieval belief. The white horse is the charger ridden by St George as he battled a monstrous dragon. The man in the friar's habit is St Francis of Assisi receiving the stigmata, the scars of Christ's wounds, on his own body. The bearded giant carrying the infant Christ across a river is St Christopher, whose burly image was credited with talismanic powers and protected anyone who saw it from an evil death that day.

The paintings at Slapton, and elsewhere, contributed different layers of meaning for different audiences. They added a visual sheen to a church, defining and honouring it as the House of God. They confirmed the Christian faith of those who saw them and which bound communities together in life and after death. As celebrations of Christian lives and ritual, the paintings provided inspiration for faith and personal devotion. By reminding audiences of the certainty of death and the equally inevitable verdict that would separate the saved from the damned, they contributed to the greatest purpose of all – redemption and salvation through belief in the death and resurrection of Jesus Christ.

However, despite their universality, and like other religious imagery in late medieval England, wall paintings were suspected by Protestant reformers of fomenting suspicion and idolatry. When the sixteenth-century Reformation swept traditional religion aside, wall paintings were among the first casualties. Three hundred years later, during the Victorian restoration of many churches, some of these paintings were discovered behind up to thirty

Opposite:
Figure 3 An inserted window cuts into a painting of the Twelve Apostles with St Paul shown under a canopy: Checkendon, St Peter and St Paul, mid-thirteenth century.

Below: A mermaid admires her reflection in a mirror. Detail from St Christopher, Slapton, St Botolph.

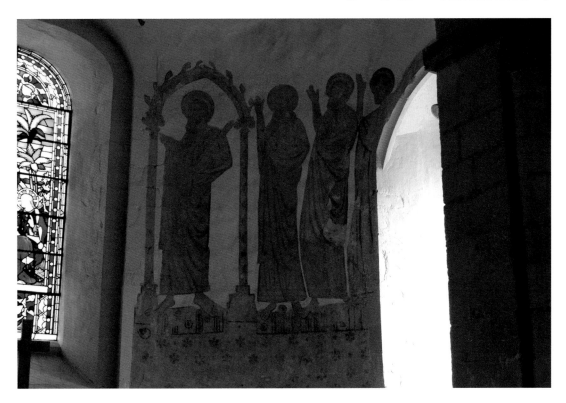

coats of whitewash and centuries of grime. Fortunately those at St Botolph's were saved. Too often, others were not.

This book is an introduction to the best of those paintings that have survived these vicissitudes of destruction and decay. It seeks to answer the most commonly asked questions:

- When were the paintings made?

- What do they show?

- Who made them?

- How were they made?

- Why were they made?

- Why did the Church stop making them?

- Where can I see some more?

It includes an extensive Gazetteer, listing over five hundred places where most of the important paintings in England and Wales can be seen, and a comprehensive Guide to the subjects depicted. The book focuses on paintings which can be seen by public audiences, not those to which access is normally restricted.

For centuries, generations of Christian worshippers drew hope from the visions of courage and redemption that glowed from the walls of their churches and which transported them from the drudgery of daily survival into the company of angels and knights, popes and saints, and the Divine made real.

For such audiences, these paintings were not just art. They were indivisible from the art of life itself.

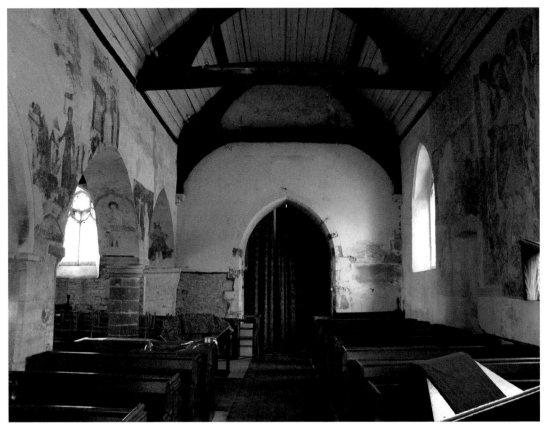

Figure 4 The nave looking west: Slapton, St Botolph.

A History of Wall Paintings

Most of the medieval wall paintings that can be seen in churches today were made between 1,000 and 500 years ago. But the tradition itself is much older, beginning around two centuries after Christ's death when the walls of Roman catacombs (underground burial galleries) and chapels began to be painted with an album of Christian imagery. These included decorative schemes delineating walls and ceilings and framing 'pictures', as well as figure subjects from both the Old and New Testaments.

Figure 5 The earliest known Christian wall painting in England, recovered from Lullingstone Villa, Kent, fourth century.

Initially Christ was shown only symbolically rather than directly – for example, as an anonymous good shepherd tending his flock – but towards the end of the fourth century, around the same time that Christianity was adopted as the official religion of the Roman Empire in AD 380, explicit portraits began to appear. By the fifth century, these had been joined by extensive picture cycles drawn from the first book of the Bible, the Book of Genesis, and Gospel stories of His life.

The enormous changes in the status and appeal of Christianity during this period probably inspired the earliest Christian wall paintings so far discovered in England. Now displayed in the British Museum, they were recovered from the ruins of a fourth-century first-floor 'house church' in a Roman villa near Lullingstone in Kent and include garlands of flowers and fruit enclosing the CHI-RHO monogram, the first letters of Christ's name in Greek.(5)

Anglo-Saxon

Surviving examples of Anglo-Saxon wall paintings, despite manuscript references to churches and monasteries being decorated with images on panels, are exceptionally rare. One of the best is a fragment painted around AD 900 discovered in Winchester in 1966. It shows the face of a man and some pelta patterning (a row of linked shields) which probably decorated a monastic building in Alfred the Great's Wessex capital. (6)

Figure 6 Anglo-Saxon fragment of a face and pelta patterning, *c.* AD 900: Winchester City Museum.

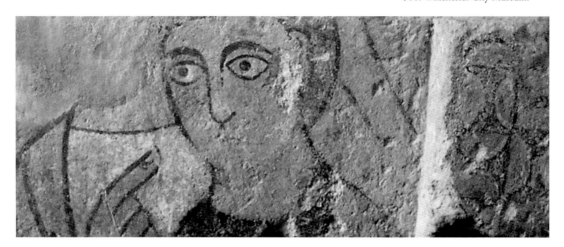

Why so few? When the Western Roman Empire collapsed, so did the Imperial occupation of Britain. It was not until Pope Gregory the Great sent St Augustine on a mission to convert the English to Christianity in AD 596 that any revival of the art began in earnest. Even so, any efforts were despoiled in later centuries by Viking raids which devastated churches across much of the country. Only a small number of late Anglo-Saxon buildings now survive: those which were not ransacked by the Danes were often demolished or rebuilt by the Normans and succeeding generations.

But at Deerhurst in Gloucestershire and Nether Wallop in Hampshire original walls of both churches *do* survive despite later modifications. And it is on these walls that the earliest remaining wall paintings can still be seen where they were made in the tenth century or at its cusp.

At Deerhurst, the painting is extremely faded. It shows a standing figure with a disc of light around his head (a nimbus) painted on a stone panel high up on the east wall of the church. It is possible that the image was part of the decoration of a now lost first-floor chapel. (7)

At Nether Wallop, however, the painting is clear and unforgettable. Made around AD 1000, it shows two angels, one either side of an enlarged chancel arch, censing a now destroyed painting of *Christ in*

Figure 7 The tenth-century painted figure, Deerhurst, St Mary. Recorded and drawn: Richard Bryant 2006.

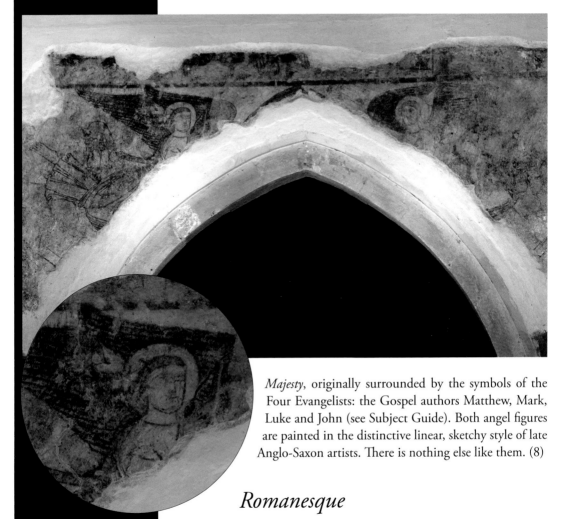

Majesty, originally surrounded by the symbols of the Four Evangelists: the Gospel authors Matthew, Mark, Luke and John (see Subject Guide). Both angel figures are painted in the distinctive linear, sketchy style of late Anglo-Saxon artists. There is nothing else like them. (8)

Romanesque

The next painting to have survived was made around the third quarter of the eleventh century, when invasion and conquest were transforming England into a very different country. Revealed in the 1990s during the repair of a semi-derelict, ivy-strewn church in Norfolk, the paintings at Houghton-on-the-Hill, near South Pickenham, are the most extensive scheme of early paintings to have survived. On the north wall, God is shown making Eve from Adam's rib, almost certainly part of an originally larger scheme which would have shown the couple's subsequent *Temptation* and *Expulsion from the Garden of Eden*. On the east wall of the nave a large painting of the Last Judgement reflects the consequences of their sin. At its centre, an image of the 'Throne of Mercy' Trinity (the name given to a representation of God the Father holding the cross on which his crucified son hangs, as a dove representing the Holy Spirit wings its way to Heaven) sits within a triple mandorla. Flanking portraits of adoring saints and traces of the Damned being driven into Hell complete the

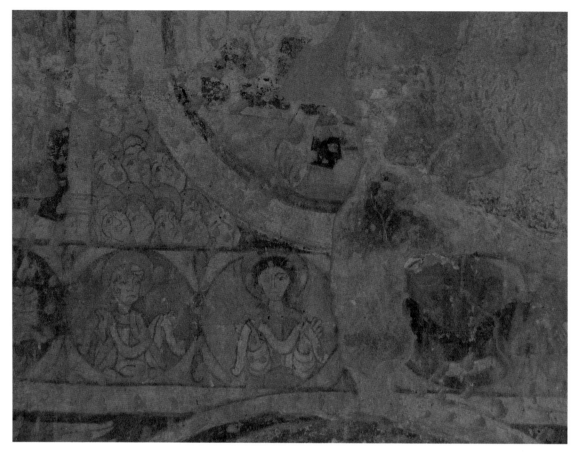

Figure 9 The Trinity with saints looking up to God with Christ and Apostles confronted by Satan (on the right) below: Houghton-on-the-Hill, St Mary, *c.* 1080.

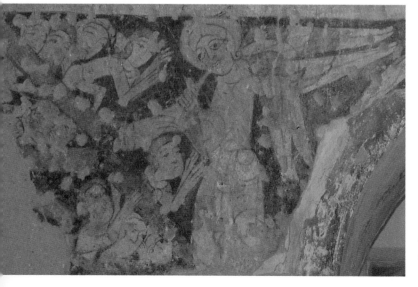

Figure 10 The Last Trump: An angel summons the dead to judgement: Houghton-on-the-Hill, St Mary, *c.* 1080.

scene. Below the main painting is a band of roundels showing Christ and Apostles holding scrolls as Satan and his demons glare at them from the south side of the arch. (9) On the north side, below this tier, souls emerge from their graves as an angel blows the last trump summoning them for Judgement. (10) Despite some affinities with Anglo-Saxon traditions, the stylistic characteristics of the paintings are indicative of eleventh-century Norman, or Romanesque, art.

Based on ancient Roman models of monumental architecture, sculpture and painting styles, Romanesque art reigned supreme across Western Europe for almost two hundred years. Just as its buildings were static and imposing, so too were the wall paintings it spawned. Instead of the Anglo-Saxon preference for lightness, Romanesque imagery exuded presence and mass, with modelled figures heavier and less linear than before.

The finest surviving Anglo-Norman paintings from this early era were made around 1100 and belong to the 'Lewes Group' of five churches in Sussex, so-called after an early-twentieth-century assumption that they were made by a 'school of painters' associated with the powerful Cluniac Priory of St Pancras at Lewes. Although these links have never been established for all five of the group, the paintings themselves are certainly the product of the same band of travelling artists.

Figure 11 A Romanesque 'Strong-Man' holding up the Chancel arch: Coombes Church, *c*. 1100.

The first three named of this group, Hardham, Clayton and Coombes, have the most extensive remains. Of the others, Plumpton possesses several important paintings on the north wall while Westmeston's were destroyed shortly after their discovery in 1862. Although the colours have faded, it is still possible to see a strong impression of the original schemes at Hardham and Clayton.

Structurally, the churches are small and elementary, just a nave and a chancel. They were built when books were scarce, few priests could read Latin and universities did not exist. Yet their walls shimmer with ideas and stories drawn from many sources, including France, the German Ottonian Empire, and the eastern wing of the Christian Church based in Constantinople, Byzantium. Nor is this the only surprise. Rhyming hexameters in white Lombardic capitals stride the upper walls at Hardham, while at Coombes the chancel arch seems to be held up by a grimacing 'Atlas'-type strongman, comparable to those seen in some French churches of the same period. (11) At Clayton the entire scheme

Below:
Figure 12 Christ in Majesty above the chancel arch: Clayton, St John the Baptist, *c.* 1100.

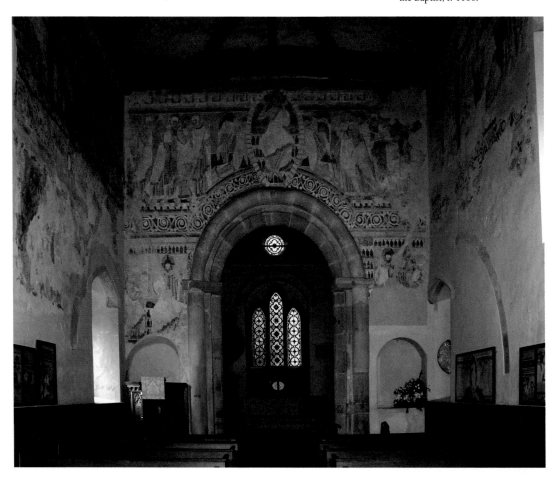

Right:
Figure 13 St Paul and the Viper with trompe l'oeil effects: St Anselm's Chapel, Canterbury Cathedral, mid- twelfth century.

Opposite:
Figure 14 Apostle's head, part of a border: Henham, St Mary, twelfth century.

Below:
Figure 15 St Cuthbert: the Galilee Chapel, Durham Cathedral, twelfth century.

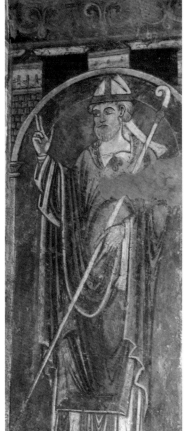

illustrates different aspects of a single theme. All have an organized coherence in which ideas of sin and salvation predominate.

Although the same triumphalist image of Christ adored by angels that was painted at Nether Wallop persists over the chancel arch at Clayton, the style of the Anglo-Norman 'Lewes' version is markedly different from a century earlier. Figures are elongated and have large hands and small heads. There is no attempt to depict incidental details like trees or buildings in proportionate scale. Traits already seen at Houghton-on-the-Hill become more pronounced. At Clayton, jaws jut and hair seems bunched as if under a hairnet. Unlike Nether Wallop, where the angels' wings flutter against a white background, the whole of the Hardham scheme locks the figures into an infinity of colour with stylised towers and striking borders separating individual scenes.

The Romanesque style seen in these churches reached its peak in the twelfth century, when gesture and shapes prevailed. Figurative painting reflected the relative importance of those who were shown, with Christ often portrayed larger than subsidiary figures such as apostles and saints. His image projected the authority of a Ruler, a Majesty, an Emperor. (12) Drapery was arranged in a succession of mannered triangles and circles: nested V-folds which allowed hems to form lively patterns, followed by 'damp-fold' where robes were shown clinging to ovoid-shaped bodies as if they were wet.

Figure 17 Masonry pattern: West Chiltington, St Mary, twelfth century.

(13) Byzantine influences proliferated. Images were not 'realistic' but expressive of character and purpose, with Christ and the apostles typically shown with eyes open wide and intensely staring pupils. (14) Paintings in the apse at Kempley (Glos), made around 1130–1140, are among the most important of the twelfth century. (16: 238)

Other significant paintings from this period can also be seen at Witley (Surrey); Wingerworth (Derbys); Copford (Essex); St Gabriel's Chapel in Canterbury Cathedral (Kent), and at Durham Cathedral (Co. Durham), where a painting of the local saint, St Cuthbert, eulogizes Romanesque dignity and hieratic authority. (15)

Patterning was also bold and lustrous. Walls, arches, window splays and columns were often decorated with a profusion of colourful abstract motifs.

The most popular of these designs was the painting of imitative regularly cut blocks of ashlar, known as masonry pattern. Usually drawn in red, it was formed of single- or double-lined oblongs with the latter, particularly, resembling pointed stonework: this was a conceit well understood by painters, as illustrated by instructions from Henry III to the Constable of the Tower of London in 1247 ordering his Queen's

Opposite:
Figure 16 The apse: Kempley, St Mary, *c.* 1130-40.

chamber to be 'whitewashed and pointed'. (17) In Cistercian monasteries which shunned excessive decoration, like Fountains Abbey (Yorks), the pattern was achieved in white, rather than red, paint and supplemented by other simple designs such as fish scale ornament. Refined variations of these feigned masonry patterns included fictive niches, piers and capitals, vault bosses, and voussoirs (wedge-shaped stones forming an arch), sometimes highlighted in bands of alternating colour.

Other embellishments abounded. Apart from the continued use of Winchester-type pelta patterning, as at East Shefford (Berks), new motifs included: two-toned ribands often bent to create zig zags; lozenges; chevrons; wavy lines; double-axe patterning; dog-tooth borders; spiralling scrolls; surging acanthus foliage; Greek keys; and vertical bands or stripes. Bolder concepts also appeared: enclosing images in roundels, as at Henham (Essex), or under arcades, as at Stowell (Glos), and, at Canterbury Cathedral, the virtuoso use of *trompe l'oeil* techniques on adjacent stonework to 'frame' a painting of St Paul and the Viper in St Anselm's Chapel. (13) Imitation drapery was another feature: sometimes as full-length curtains, as at Corhampton (Hants), more often as fictive draperies at dado height below figurative paintings, as at Hardham.

Figure 18 Architectural framing, Christ carrying the Cross: West Chiltington, St Mary, thirteenth century.

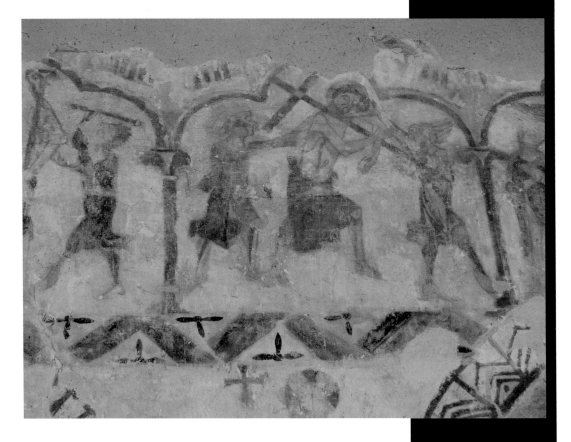

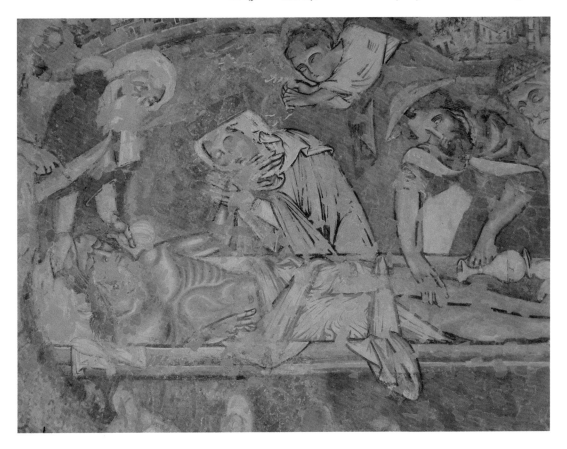

Figure 19 The Entombment: The Holy Sepulchre Chapel, Winchester Cathedral, *c.* 1170-80.

The Thirteenth Century

The transition from late Romanesque to the Gothic style of architecture around 1200 had far-reaching and cumulative effects on the evolution of wall paintings. Romanesque churches enjoyed large areas of wall space with deep window splays and massive columns that provided a perfect setting for powerful monumental imagery and coherent works of art which traversed walls and vaults. But the new architectural style embraced an aesthetic which celebrated height and light. Narrow rounded windows gradually gave way to lancets, soaring thirty feet high in some cathedrals, which told narratives in glass rather than on walls. Contiguous walls were disrupted as windows were inserted or enlarged. As the new style gathered momentum, artists were imbued with a similar flair. Paintings became more curvaceous, less stiff, and often incorporated contemporary architectural features to frame and separate scenes, as at West Chiltington (West Sussex), where a cycle depicting Christ's Passion, or Death, was portrayed within a series of three-lobed arches resting on slender shafts with capitals. (18) More importantly, these new images began to convey genuine humanity, definable qualities of compassion and suffering, best summed up in images of Christ himself. Instead of the upright Majesty

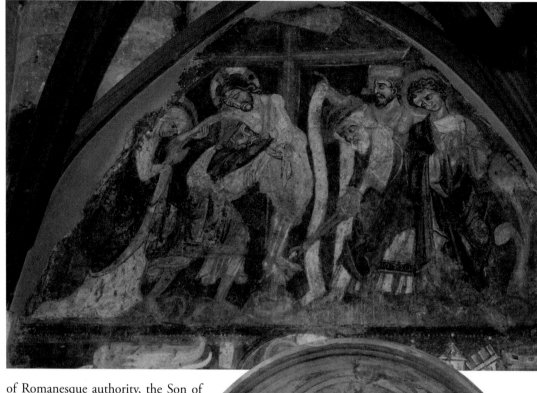

of Romanesque authority, the Son of God was invariably shown as a half-naked man dying on the cross, his arms stretched upwards and pulled taut by the straining weight of his drooping body, his head slumped forward, his feet splayed to escape the pain of nails hammered through his flesh and sinews.

The impact of these changing styles can be seen in extraordinary close proximity in the Holy Sepulchre Chapel at Winchester Cathedral (Hants), where two paintings of the same subjects, *The Deposition* and *The Entombment* of Christ, the first made around 1170–80, the other overpainted on it around 1220, now face each other on opposite walls after a twentieth-century restorer discovered the scenes and carefully removed and repositioned the later painting. (19: 20)

Figure 21 The Virgin and Child: The Bishop's Palace, Chichester *c.* 1250.

Opposite:
Figure 20 The Deposition: The Holy Sepulchre Chapel, Winchester Cathedral, *c.* 1220.

Whereas the earlier scheme retains the heavy facial modelling of late Romanesque paintings, the figures in the later painting are lighter and far more emotionally expressive. Thirty years later at Chichester (West Sussex), a painting of the Virgin and Child in the Bishop's Palace Chapel shares its melting tenderness with the viewer. (21) Towards the end of the century paintings in royal circles embraced French styles of elegance and delicacy which gave figures astonishing grace and movement. Exaggerated backward 'S' curves and figures draped in broad swathes of cloth ('the Broad Style', with convoluting folds and meandering hemlines) were among the innovations. Good examples of the latter can be seen in the *c.* 1270 paintings of St Christopher and the *Incredulity of St Thomas* in the south transept of Westminster Abbey.

Changes in style were matched by changes in materials, techniques and new frontiers in painted illusion. At Winchester Cathedral, the vault of the Chapel of the Guardian Angels was transformed by roundels framing portraits of angels seen against a blue sky as if its stone roof was perforated with holes. (22) New glazes gave paintings translucency while the use of applied wooden, metallic and, sometimes, glass reliefs, as well as expensive materials like gold leaf, endowed schemes with depth and complex reflective surfaces.

Figure 22 The vaults of the Guardian Angels' Chapel: Winchester Cathedral, *c.* 1230.

Painted heraldry also began to appear, with early examples in the Lady Chapel at Worcester Cathedral (Worcs), and at Silchester (Hants), where the arms of the local Bluett family bellow their patronage from the east wall of the chancel. (23)

Patterns and framing devices continued to evolve. Masonry designs were embellished with the addition of five or six petalled rosettes in the centre of each 'stone'. Sometimes sprigs of flowers appeared from the vertical lines. Both versions of the pattern were known as 'stones and roses'. The Queen's bedchamber in the Tower of London, mentioned previously, was so adorned, another of Henry III's commands to his Constable being that the 'pointings be painted with flowers'. Good examples of these refinements survive at Aston (Herefordshire) and Martley (Worcs), where artists also painted the pattern in receding size in window splays, deepening the sense of perspective. (24)

The decoration of roundels and drapery effects also became more sophisticated, as at Romsey Abbey (Hants). (25)

Architecture and art were not all that was changing. Europe was becoming more prosperous as forests were cleared for farming and towns began to expand. Trade and travel were also increasing. So were the spiritual and pastoral ambitions of the Church. An international summit of Bishops at the Pope's Lateran Palace which met in Rome

Figure 23 Asserting patronage, the Bluett arms: Silchester, St Mary, thirteenth century.

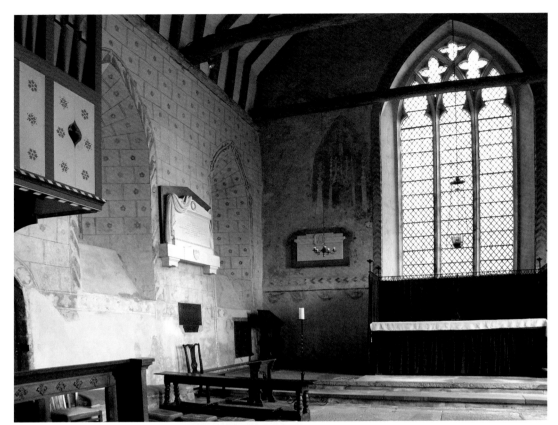

Figure 24 Masonry patterning and east wall decoration of different dates, including fictive image niche and fictive drapery: the chancel, Martley, St Peter.

Figure 25 Drapery below roundels depicting The Miracles of St Nicholas: Romsey Abbey, mid-thirteenth century.

in 1215 (the Fourth Lateran Council) consolidated developing trends and formalized the relationship between the established Church and the laity: the Twenty-First Decree instructing that, at least once a year, every lay person should confess their sins to the parish priest and receive absolution and communion. The implications were immense. Priests had to know what to teach: parishioners had to learn what they were taught. The Council of Oxford in 1222 embraced these decrees in England and over the next century they were promulgated energetically, creating a new emphasis on spiritual devotion and commensurate visual imagery. Among the most long-lasting and influential programmes was that drawn up by Archbishop Pecham's provincial Council of Lambeth in 1281, the *Ignorantia Sacerdotum*, which ordered priests to expound the principal themes of the Church to their parishioners at least four times a year. New orders of friars, travelling preachers like the Franciscans, provided vital extra manpower to this task, bringing what Robert Grosseteste, the Bishop of Lincoln, 1235–1253, and himself a member of the order, called 'a bright light of teaching and preaching'. Episcopal regulations demarcating responsibility for the upkeep of churches – the laity, the nave; the clergy, the chancel – provided another impetus for wider lay patronage and devotion. The publication of compendiums of saints' lives built on earlier traditions and encouraged devotion to popular holy exemplars.

Figure 26 Three female saints, St Margaret, St Katherine, St Mary Magdalene: Little Wenham, All Saints, early fourteenth century.

Numerous wall paintings depict these changes. Decorative schemes above and behind altars, either as reredoses (devotional displays) or as fictive panel paintings, retables, reflected the provision of more 'Masses' when consecrated bread and wine was transubstantiated into Christ's body and blood, the Eucharist. While paintings of saints had appeared at Hardham and other Romanesque churches such as Wareham (Dorset), and Godalming (Surrey), they now grew rapidly in number and variety. At the same time the prominence given to some other concepts receded, such as the representation of two women in the apse at Fritton (Norfolk), representing *Ecclesia*, holding the triumphant church and the Jewish *Synagoga*, blindfolded and incapable of seeing the truth of the gospels and the message of salvation they reveal.

Images of the Passion of Christ also multiplied, as did paintings devoted to the Virgin Mary, whose cult became pervasive towards the end of the thirteenth century.

Figure 27 A Chapter House bay: Westminster Abbey, late fourteenth century.

Most importantly, the coherence of earlier schemes began to falter and disintegrate. Less wall space, competition from glass painters, repairs and alterations to buildings, and changing devotional and artistic preferences by patrons and audiences alike combined to produce more episodic painting schemes. One consequence was the greater use of cartoon-strip-like narratives which portrayed the lives of Christ and popular saints in successions of small rapid frames. In a similar vein, other images were conflated or reduced to a salient scene which encapsulated larger and more complex ideas.

The Fourteenth Century

Although the century was blighted by famine, plague and revolt, wall paintings continued to evolve. In the first quarter of the century, styles prevalent in court circles spread to the provinces. The mannered elegance of the French inspired backward 'S' style can be seen to good effect in the paintings of three female saints on the east wall of the chancel at Little Wenham in Suffolk. (26)

Later paintings saw French artificial mannerisms displaced by fashionable Italian influences and the increasing use of lavish techniques. By the close of the century a blending of traditions from Paris, Italy, Germany and Bohemia saw the emergence of a 'International Gothic Style'. Paintings became more naturalistic and detailed. The modelling of hair and faces was noticeably refined. Figures were set in architectural space. The Chapter House scheme at Westminster Abbey (London) is a superb example of this style. (27)

Ornamentation and subjects also changed. Masonry patterning was used less often. New decorative devices emerged with the petalled rosettes formerly used in 'stones and roses' schemes appearing in their own right as powdered diapers against brilliant white backgrounds. Examples can be seen scattered around figures, as at Chalgrove (Oxon), where they separate subjects, or at Pickworth, (Lincs), where they complement an entire scheme along the north arcade. (28)

The first known textural inscriptions in vernacular English also appeared, at Wensley (Yorks). Subject paintings of Adam and Eve were chosen less often, while others, rebuking transgressions and stressing the observance of Christian pieties, made their debuts. Wall paintings admonishing the disruption of church services by what exasperated

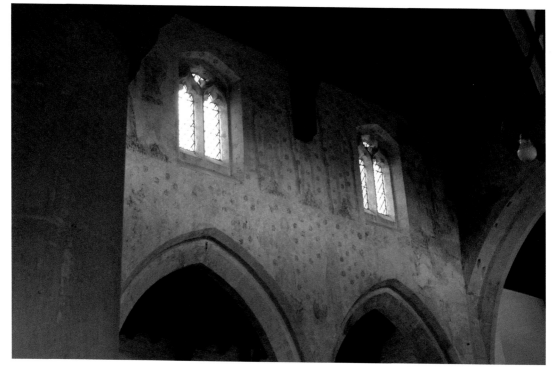

Figure 28 Decorative background patterning: Pickworth, St Andrew, late fourteenth century.

Figure 29 St George slays the dragon: Troston, St Mary, *c.* 1400.

preachers called people chattering and 'jangling' were pictorialised from around 1300 and were followed by wall paintings contrasting the Seven Deadly Sins and the Seven Works of Mercy a few years later. Towards the close of the century, other new themes, such as strictures to observe the Sabbath – The Sunday Christ – and literal interpretations of the sin of blasphemy, also appeared in paint.

The most visible impact of changing imagery was how reminders of Death, Judgement and the Afterlife were portrayed. Whereas Romanesque schemes had often showed a regal *Christ in Majesty* above the chancel arch or in the apse, now The Doom –paintings throbbing with the inevitability of Death and Judgement– dominated the eastern end of the church as the faithful looked up from prayer. Although such imagery had prowled the walls of Houghton-on-the-Hill and Clayton, this new emphasis was stark and formatted: Hope and Salvation or Hell and Damnation. Complementary themes, such as paintings of the Three Living and the Three Dead, and separate scenes of St Michael weighing souls in a pan hung from a balance, drove the point home.

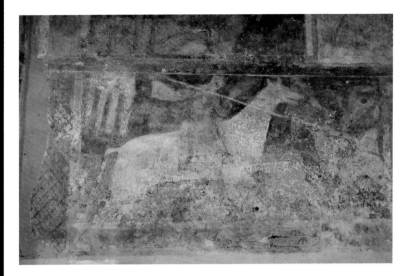

Figure 30 St George routs the infidels: Hardham, St Botolph, *c.* **1100.**

The Fifteenth Century

As England recovered from the economic and social upheavals of the previous century the newly wealthy flaunted their piety by building grander churches and ornate personal chantry chapels where masses would be said to minimise their sufferings in purgatory, a sort of ante-room to Heaven where minor sinners were 'purged' of their imperfections before entering the celestial city. The scale of such rebuilding provided new 'canvases' for artists to paint. In the 150 years prior to the Reformation up to two-thirds of England's parish churches were substantially rebuilt or significantly altered, many in the new Perpendicular style of architecture which revelled in additional light and larger windows.

Figure 31 St Christopher with Christ Child, windmill and hermit: Llanynys, St Saeran, *c.* 1420.

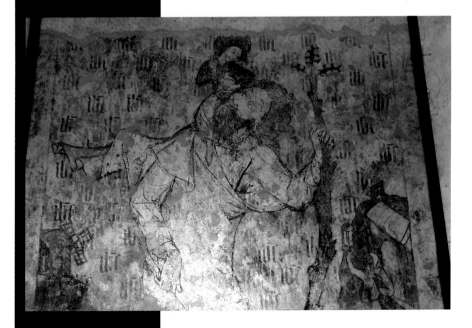

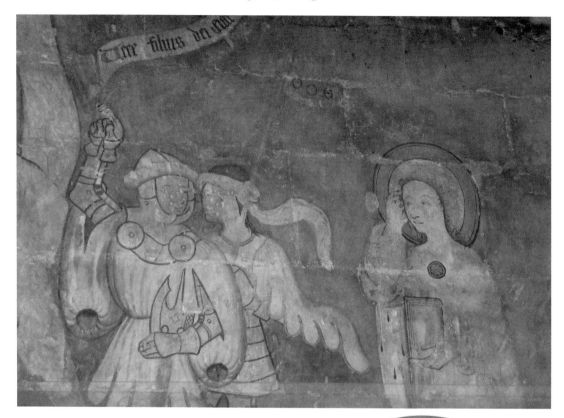

Paintings of this period are more difficult to define by style alone. They often seem insular and more assertive, with the delicate modelling of the previous century supplanted by brighter colours and brash effect. In some examples, the borders to paintings resembled actual picture frames, as at Willingham (Cambs). Whereas paintings of St Christopher in the early 1300s showed a simple standing saint, fifteenth-century representations burst with muscular energy and descriptive details. Often the saint wades through waters congested with fish and crustaceans as a preening mermaid admires her reflection in a mirror, as at Oaksey (Wilts). (236) Sometimes a hermit holding a lantern, a fisherman with his bait basket and picturesque background scenery including windmills and church steeples complete the scene. (31) St George was another favourite, wearing the red cross of a valiant *miles Christianus,* a knight of Christ, as he overcomes a fire-breathing dragon symbolising evil. (29) The finest example of this scene can be seen at St Gregory's church, Norwich, where it was painted on the west wall around 1500. (238)

Figure 33 The Magi: Heydon, St Peter and St Paul, fourteenth century.

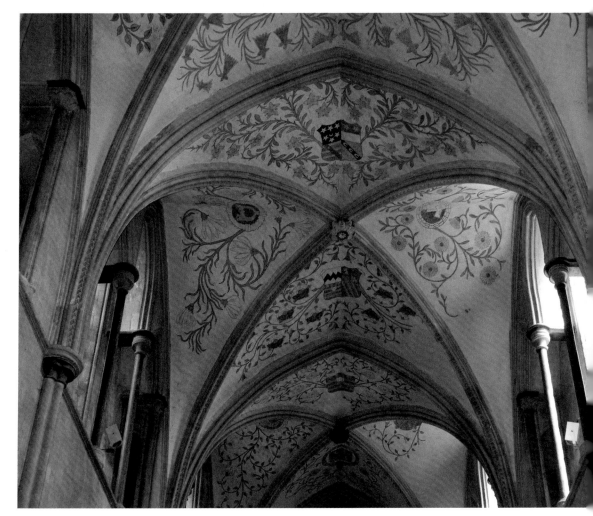

Opposite top:
Figure 32 Soldiers at the foot of the Cross with one holding a banner depicting the Langley arms: St Anne's Charterhouse, Coventry, 1417.

Above:
Figure 34 Heraldic decoration: Boxgrove Priory, St Mary and St Blaise, sixteenth century.

Changes in style were accompanied by subtle shifts in subject choice as images associated with new liturgical devotions or drawn from newly printed books also began to appear.

Armour, costume, heraldry, and other incidental detailing within paintings, such as architecture, musical instruments and domestic metalware, can often provide useful clues to dating paintings as styles changed between the early Romanesque and the late Gothic. Combined with other evidence, such as the life spans of donors, such details can also help to correct stylistic mismatching: the making of new paintings in older styles.

At Hardham, a *c.*1100 painting of St George charging infidels at the battle of Antioch shows the fighters carrying kite-like shields similar to those worn by the Norman cavalry less than fifty years earlier as they crushed the English army at Hastings. (30) Three hundred years later, however, at St Anne's Charterhouse, Coventry (Warks), a painting of The

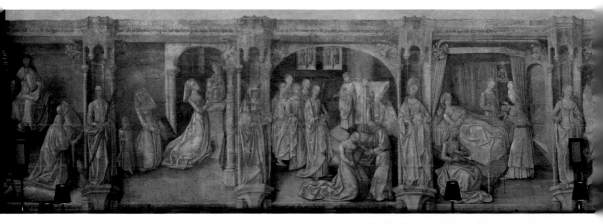

Crucifixion made around 1417 shows Roman soldiers clad in plate armour of the kind worn at the battle of Agincourt two years earlier. (32)

Similar evidence can be gleaned from costumes. At Heydon (Norfolk), for example, the Three Kings, in a painting of *The Adoration of the Magi*, wear doublets, hose and shoes fashionable in the court of Richard II (reigned 1377–1399). (33) Styles of women's attire can be just as helpful, as at Denham (Bucks), where a kneeling woman in a painting of The Doom wears a headdress of *c.* 1460. Images of St Christopher also frizzle with contemporary detail. His leggings, the fastenings of his cloak, the hats he wears, can all help to date a painting. At Pickworth a painting of a three-legged, two-handled bulbous-shaped cauldron is similar to those made around *c.* 1380.

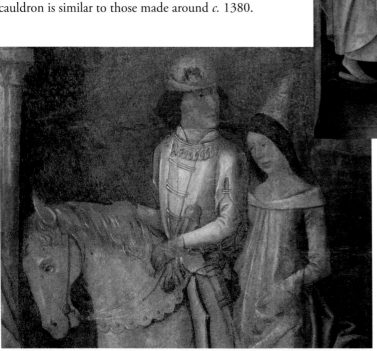

Details from the grissaille paintings from Eton College Chapel. Note the highlights of colour on these largely monochrome images.

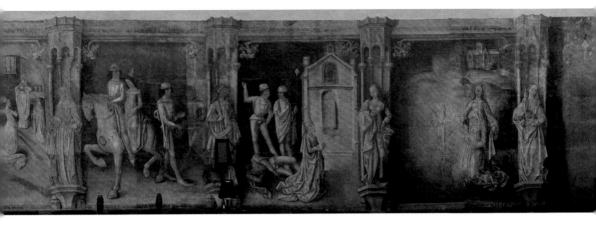

Top:
Figure 35 Grisaille paintings of The Miracles of the Virgin: Eton College Chapel, late fifteenth century.

The End of the Middle Ages

Style and technique define a final group of paintings that appear in the late fifteenth and early sixteenth century and which signify the beginning of an artistic transition from the Middle Ages to the Renaissance. At Eton College Chapel (Bucks), a scheme made in several stages between 1479 and 1487 lauding some of the best-known *Miracles of The Virgin* used grisaille painting in shades of grey or monochrome combined with illusionistic effects such as shadowing and receding perspectives to imbue the paintings with remarkable three-dimensional spatial depth. Instead of 'seeing' paintings, viewers are almost invited to 'step inside' them. (35)

Wall painting in the years immediately prior to the Reformation largely continued to follow the same painting styles and to depict the same subjects as those developed in the late fifteenth

century. Sixteenth-century grisaille images of female saints appear in window splays at Cassington (Oxon), and many of the more flamboyant St Christopher paintings were also made in this period.

The career of Lambert Barnard sums up these final decades. A talented artist, equally able to paint on plaster and wood, Barnard, perhaps an Anglicized Fleming, was employed at Chichester Cathedral for possibly forty years, beginning in the 1520s and continuing until at least 1561. One of his commissions was to decorate the vaults of the Lady Chapel for Bishop Robert Sherborne (served 1508–1536). Parts of this scheme still survive and show a strong stylistic affinity with Renaissance preferences on the continent. Like related paintings in the south aisle of the nave, they include a delicate pattern of flowers, fruit and acanthus foliage radiating from a circle which itself encloses a boss with the pomegranate of Katherine of Aragon, Henry VIII's Queen from 1509 until the divorce of 1533. Another, similar, scheme painted by Barnard around the same time can still be seen largely intact at nearby Boxgrove Priory, also in West Sussex. (34) Records of Barnard's later work in the Cathedral survive only in various payment books but we can read them like a story. In 1543 he repaired a painted cloth of the Crucifixion that hung over the high altar; in 1556, during the short-lived Counter-Reformation of Mary I, he painted the carved figures on a re-erected Rood; in 1561, under Elizabeth I, he was paid 8s 4d to paint the Ten Commandments on a cloth to hang behind the altar.

In less than his lifetime, sumptuous colour had been replaced by black letter texts espousing the Bible in words, not images. Church walls had changed forever.

The Subjects

**The Resurection: Chalgrove St
Mary, early fourteenth century.**

As patterns of architecture, artistic style and lay devotion changed during the Middle Ages, the subjects shown in wall paintings also evolved. Often more complex than the range of subjects was the repertoire within them and the way in which different images might be chosen, portrayed, arranged and seen.

Paintings could be used in different ways for different audiences and for similar, yet different, purposes. Images might be separated, amalgamated, shuffled, paired or juxtaposed. Painting schemes could be large or small, appear as cartoon-like strips or in tiers, and sometimes be conflated, with more than one scene squeezed into the same picture. Occasionally only a single image was painted symbolising an entire subject. A few paintings went further and combined different subjects in a single scheme to convey an overarching comprehensive image or visual idea. Subjects were often painted in specific locations, as with paintings of St Christopher opposite doors where he could be seen easily, scenes of *The Last Supper* in monastic refectories and Resurrection imagery above tombs. Altars might be surrounded by decorative effects such as rich textiles and fictive spiral columns to enhance their devotional importance.

While most subjects were rooted in traditional texts and centuries-old apocryphal stories, others, like the late medieval image of *St Anne* preparing her daughter for the Annunciation by teaching her to read (*The Education of the Virgin*) seem to have been invented around 1300 without any literary precedents. In other instances textual sources can only be guessed at. Paintings of the Seven Deadly Sins, for example, appear in at least eight different formats.

Moreover, some subjects were more common in the twelfth century than in the fifteenth and others were over-painted as different priorities took precedence. When the north wall at Little Horwood (Bucks) was rebuilt in the late fourteenth century, possibly after a fire, two earlier images showing the Miracle of St Nicholas reviving three boys who had been pickled in a brine tub during a famine and a separate scene of The Martyrdom of St Thomas Becket were replaced with a new scheme warning against the perils of sin. (36) Medieval audiences were never averse to replacing old schemes with newer preferences.

Inevitable variations between the architecture, size and evolution of buildings also meant that churches might show all or some of the same subjects in different ways and to varied effect. The patronage of paintings, and the wealth and ambitions of the people who paid for them, also changed significantly during these five hundred years, as did the audiences for whom they were made. Anglo-Saxon England was as remote from Tudor times as Henry and his wives are from the twenty-first century.

Within a shared canon of belief and artistic imagery, there was never a uniform 'one size fits all' model of how a painted church from the earliest to the last should look, with a central controlling hand insisting on the

Figure 36 A palimpsest of St Nicholas and The Three Boys, and The Martyrdom of St Thomas Becket, below a late-fourteenth-century scheme of The Seven Deadly Sins surrounding a naked man: Little Horwood, St Nicholas.

same identical 'brand image' everywhere. Even when the 'Lewes Group' of artists worked in five neighbouring Sussex churches, around 1100, every scheme they painted was unique. The style was similar, often the same themes predominated – indeed, parts of the same stories might be shown – but how subjects were sequenced and artistically presented was not identical.

Most wall painting subjects made between AD 1000 and 1540 fall into one of nine categories, although they can be defined as fewer if moralising allegories, sometimes called 'Warnings', are grouped in a single entity known as 'Moralities'. These include paintings of Death and The Last Judgement, Pieties and Transgressions. This chapter describes the main subjects, while Chapter 5 explains how these paintings were used in the medieval Church for both public and private purposes. Elsewhere, the Subject Guide and the Gazetteer describe some of the individual scenes in greater depth and lists where examples can be seen in five hundred buildings.

The nine subject categories can be classified as:

- Scenes from the Old Testament
- Devotional Images of Christ
- The Life of Christ and Scenes from The Holy Infancy and The Passion (His Death)
- The Life, Death and Miracles of The Virgin Mary
- The Saints and their Lives
- Death and The Last Judgement
- Pieties: Good versus Evil
- Transgressions
- Christian Allegories and Symbols

As innumerable wall paintings were destroyed both before and after the Reformation it is possible that some subjects were shown more often or in other ways than can be seen today. However, comparisons with other medieval arts, such as sculpture, glass and manuscript painting, suggest that these broad categories encompass all of the main subjects which appeared, even when some scenes cannot be identified precisely.

SCENES FROM THE OLD TESTAMENT

Despite its importance to Christian history, very few scenes from the Old Testament seem to have been painted on church walls. For example, none of the famous stories, such as the miraculous parting of the Red Sea

to allow the fleeing Israelites to escape the pursuing Egyptian army, have been found. Even seminal moments in Christian history, such as when Moses received the Ten Commandments from God in a burning bush, do not seem to have been painted extensively on walls.

Nor did these omissions change between 1100 and 1500, despite events like David's slaying of the Philistine giant, Goliath, being routinely illustrated in late-medieval private devotional manuscripts known as Books of Hours. Much the same seems to have true elsewhere in northern Europe.

There are no contemporary explanations for these omissions and discrepancies. Certainly some 'Books' of the Old Testament may have been hard to pictorialise and the contents of others are notoriously obscure. But the fact that a much wider repertoire of Old Testament stories was shown in other media from at least the twelfth century is proof enough that it was not beyond the imagination of inventive artists to depict scenes in recognisable and striking ways. The most likely explanation for the omissions is that neither the Old Testament's generalised history of the Jewish people, nor the science of interpreting its stories as predicting the Life of Christ as described in The New Testament, were regarded as core messages to mass audiences of medieval Christians or particularly relevant to the sacred rituals that defined the church. For succeeding generations religious duties and public rituals were more important than knowledge or texts. Traditions, iconographical conventions and the best way to use monumental architectural canvases may have also played a part in shaping these apparent demarcations. By these criteria, and the prevailing emphasis on sin and salvation, a few stories from the Old Testament, such as *The Creation, The Temptation* and the *Fall of Adam and Eve* were relevant, but most were not.

Those scenes which did occur can be grouped as:

- The Creation
- The Fall of Mankind
- Cain & Abel

The Creation, Temptation and Fall of Mankind

The story of Adam and Eve was one of the few complete Old Testament stories to be portrayed. The subject may also have been more common in the early church than it appears today, with many such paintings being destroyed as churches were rebuilt and the subject was abandoned or superseded in subsequent redecoration schemes. Very few examples now survive.

Figure 37 The Temptation of Adam and Eve: Hardham, St Botolph, *c.* 1100.

Wall paintings of *The Creation and Fall* showed incidents from the first book of the Old Testament, the Book of Genesis, beginning with God's creation of the first human, Adam, and the provision of a beautiful garden called Eden for him to live in where he would want for nothing; see, for example *The Creation*, Chalfont St Giles, (Bucks). Later, sensing that Adam was lonely, God gave him a companion, waiting until he was asleep and then making the first woman, Eve, from Adam's rib: *The Making of Eve*, Houghton-on-the-Hill.

But Adam and Eve were not only given Paradise, they also possessed free will. When Satan took the shape of a serpent and beguiled Eve to eat a fruit from the forbidden Tree of the Knowledge of Good and Evil and share it with Adam, they defied God's commandment not to do so and succumbed to *The Temptation* as at Hardham. (37) Their disobedience brought sin into the world. Nothing would be the same again.

The origin of Satan was never properly defined in the Bible, although for the medieval church his presence was, in modern parlance, a clear

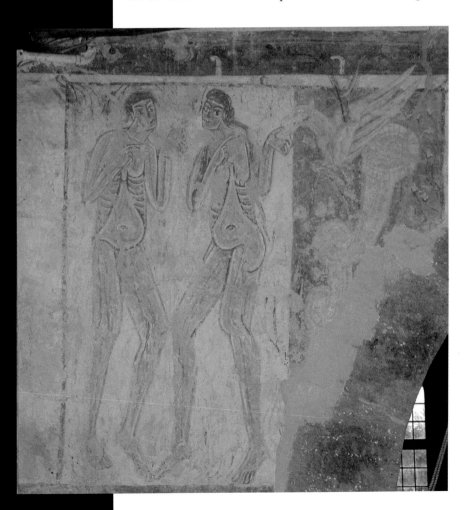

and present danger. According to theologians, in addition to the human world there was also a parallel invisible spirit world bustling with angels and devils. Before God made Adam, some of these spirits, led by their ringleader Lucifer, had rebelled against God, their pride preventing them from serving him. After a ferocious battle in heaven the loyalist angels, led by the Archangel, St Michael, routed the rebels and cast them out, whereupon the defeated angels became devils and Lucifer, Satan, the enemy of both God and humans. At Clayton, a wall painting shows the anti-Christ dethroned.

After God's discovery of Adam and Eve's disobedience, they too were driven from Paradise by St Michael as depicted in *The Expulsion* at Easby (Yorks). Forced to fend for themselves, Adam learned how to dig and to grow food, and Eve how to spin and to make clothes, *The Labours of Adam & Eve*, Broughton (Cambs). Nor was this the end of their punishment. When their sons, Cain and Abel, gave sacrifices to God and Cain's was rejected, jealousy drove him to kill his younger brother, Abel, shattering his skull with the jaw bone of an ass, as depicted in *The Murder of Abel*, Capel (Kent). (38) Convicted of this terrible crime by God, as shown in *The Conviction of Cain* at Kelmscott (Oxon), Cain was banished to the east of Eden, where he formed a new tribe and was eventually murdered himself.

Figure 38 Cain murders Abel with the jaw bone of an ass: Capel, St Thomas of Canterbury, early thirteenth century.

And still the misery caused by *The Temptation and Fall* of Man reverberated. As 'men began to multiply' God was so appalled by their mounting wickedness that he decided to 'destroy [every] man whom I have created' by drowning the world. But fortunately there was one who found grace in his eyes, a man called Noah whom he told to build a boat, an ark, for himself and his family and 'two of every sort of animal'. After the rain fell for forty days and forty nights, they were the only survivors of the Great Flood, or Deluge, and as the waters receded, God promised never again to 'smite every thing living' and announced that a (rain)bow would be the symbol of his covenant. Mankind had been given a second chance.

The only painting of the Great Flood and *Noah and his Ark* now surviving can be found at Houghton-on-the-Hill. It is very fragmentary and shows only the upper part of the ark. Other paintings, as at Shenley in Buckinghamshire, were destroyed in the nineteenth century. Another example could be found within some

thirteenth-century wall paintings at Worcester Cathedral Chapter House, now also lost. Here it was included in an important scheme of typological themes, the study of the Old Testament (type) as a code for understanding the truth of the New (anti-type).

The Truth of The New Testament: Types and Anti-Types

Simple versions of typology, pairing themes and incidents from the two Testaments and using the miracles and prophesies recounted in the Old as precursors for the Life of Christ as told in the Gospels of the New, were among the earliest Christian wall paintings. By the third century artists working in Rome had illustrated scenes from the story of Jonah and the Whale – how Jonah fell into the sea, how he was swallowed by a whale, and how, after three days, he emerged from its belly unscathed – as a prefiguration of Christ's own death, entombment for three days and subsequent resurrection. Later medieval theologians greatly extended the number and interpretations of such parallels. A treatise known as *Pictor in Carmine,* written by an anonymous author around 1200, contained examples of 510 types and 138 anti-types for use by artists.

Figure 39 The Chapter House, with traces of painted drapery and angels in the bays and remains of a Tree of Jesse curling around the central pillar: Worcester Cathedral, thirteenth century

None of the famous typological paintings at Peterborough Cathedral (Cambs), and Worcester Cathedral Priory, which were based on such parallels now survive, although the shadowy remains of a *Tree of Jesse* (the family tree of Christ's human ancestry linking him to figures in the Old Testament), which spirals around the central pier in Worcester's Chapter House, almost certainly belonged to this latter scheme. (39) Paintings of angels holding books above the bays where the monks sat in this circular room may have provided a further embellishment to a cosmos of painted thought which seemed to spin without beginning or end. Faint traces of this scheme can be seen in the north-west quadrant.

Attempts to reconstruct the Worcester scheme from manuscripts in the Cathedral library suggest that the vaults were painted with ten typological subjects, each illustrated by groups of five medallions and textural inscriptions declaiming the appropriate virtues and commandments ascribed to them. Thus assembled around the Virtue 'Obedience' and the Commandment 'Do Not Kill' were paintings which paired Christ's Crucifixion with the Old Testament story of God's commandment to Abraham to kill his son, Isaac, which he was about to obey until restrained by an angel. Such paintings also provided meditative layers of contrast between and within images, which could be explored by monastic scholars. The story of God and Christ, Abraham and Isaac were not just parallels about fathers, sons and death. Christ died, Isaac did not; Christ understood his sacrifice, Isaac did not; while God's command to Abraham that he kill his only son as a test of obedience was sought, it was never exacted; the command of God that he sacrifice his own son, Jesus, was unwaveringly obeyed by God.

Such schemes, even of a simple kind, appear rarely in parish churches, although a now lost painting of the story of Abraham and Isaac, previously visible in the 'Lewes Group' church at Plumpton, (East Sussex), may have been paired with an anti-type (New Testament) scene when it was made.

Prophets

Again, although prophets feature prominently in the Old Testament, their primary importance in the medieval Church was as witnesses to the truth of the New. And, like the treatment of other Old Testament stories, representations of them appeared far less frequently in wall paintings than in other media, such as glass or painted chancel screens. A now lost painting at Friskney (Lincs) included Prophets and Moses, while a Victorian reconstruction of a thirteenth-century scheme of Prophets holding scrolls can be seen in the Presbytery of Salisbury Cathedral (Wilts).

The Tree of Jesse

A final group of paintings which combined Old and New Testament texts to prove the Truth of the New used genealogical imagery to directly straddle both. Known as *The Tree of Jesse,* it traced the human ancestry of Christ and fulfilled the prediction of the Old Testament prophet, Isaiah, that 'the Messiah' (or anointed one) would be a descendent of Jesse, the father of King David. Whether in paint or other media, such as sculpture, the scene shows a literal family tree springing from the recumbent figure of Jesse and branching upwards past various Prophets and royal ancestors, including King David playing his harp, before culminating in the progenic figures of the Virgin Mary and Christ at the apex, as at Weston Longville (Norfolk). (40)

Figure 40 The Tree of Jesse: Weston Longville, All Saints, late fourteenth century.

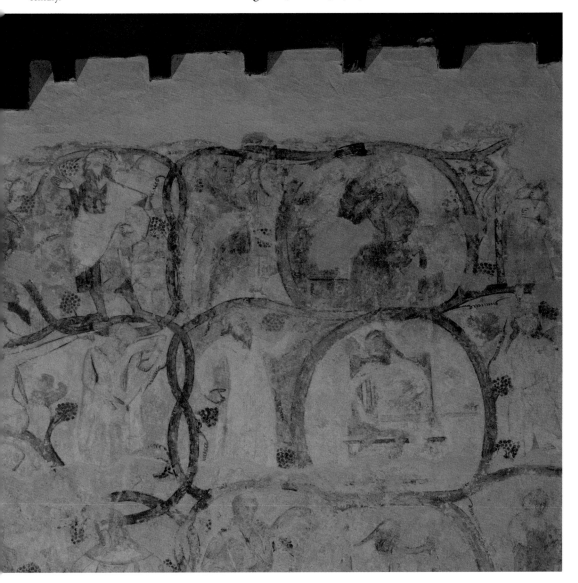

THE NEW TESTAMENT

If wall paintings of subjects from the Old Testament were rare, images drawn from the Gospels of the New filled every church.

Images of Christ

As described in Chapter 1, images of Christ changed dramatically during the lifetime of the western medieval Church.

Anglo-Saxon and Romanesque images portrayed him either as supreme on the Cross, or as an imperial ruler of the universe, similar in demeanour and pose to the earthly emperors who were ritually anointed and crowned in God's name. Such wall paintings often showed Christ sitting on a throne surrounded and adored by choruses of the heavenly host, angels and apostles: *Christ in Majesty*. When his death was alluded to it was often as the sacrificial Lamb of God (*Agnus Dei*), as at Hardham. (41) Such paintings were located on the east chancel wall, or above the chancel arch on the east wall of the nave, where their monumental serenity and glory transcended the congregation below.

Later images of Christ were very different. His suffering and death on the cross was seen as representing his humanity and his divinity, his

Figure 41 *Agnus Dei*, The Lamb of God, above the chancel arch: Hardham, St Botolph, *c.* 1100.

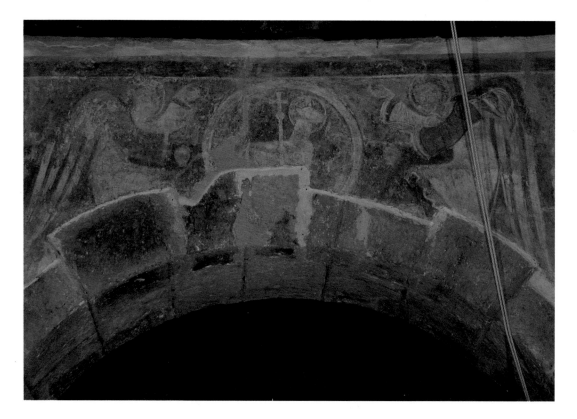

sacrifice for mankind and the expunging of sin. Images of his dying or dead body, symbolising Redemption and the Resurrection, became prolific. A single church would have numerous such images in wood and stone carvings, on glass and painted panelled altarpieces, even engraved on silver chalices used during services.

Wall paintings of the Crucified Christ were equally ubiquitous, appearing above chancel arches, behind altars, on tombs and in conjunction with rituals and ceremonies, particularly the Mass. Some also complemented other devotional images. Images of the Resurrected Christ as a demi-figure displaying his wounds, *The Man of Sorrows* or *The Man of Pity*, also appeared.

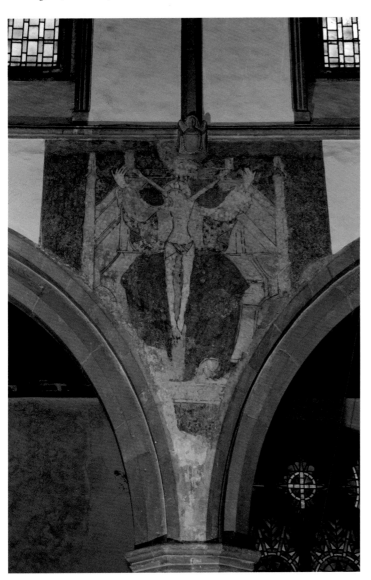

Figure 42 The Trinity: Framlingham, St Michael, *c.* 1400.

A few paintings showed Christ within the Trinity, an image showing God the Father, large and sitting, holding the crucified Christ in his lap, with the dove of the Holy Spirit hovering between them, as at Framlingham (Suffolk). (42)

By far the most extensive wall paintings of Christ asserted the truth of His life and the salvation of mankind He offered.

- The Holy Infancy
- The Passion

Both stories were usually shown in tiers or strips containing between three and fifteen scenes, although longer examples are known. They appeared from at least the twelfth century, usually on nave walls and arcades. Scenes are typically read west to east on the north wall and east to west on the south wall. Again, paintings in tiers usually proceed left to right across each row, normally starting at the top. Inevitably there are a few exceptions,

such as at Chalgrove, where the scenes appear to dart between tiers, and at Coombes, where the story of The Holy Infancy begins west to east on the south wall and continues west to east on the north. Some cycles incorporate episodes from both The Holy Infancy and The Passion of Christ. At Brook (Kent), extensive remains of an original fifty-six-scene cycle combining both stories still survive. (43: 234)

Some churches had single scenes which could act as salient images or proxies for a whole tale. Apart from any other applications, individual paintings of the *Adoration of the Magi* representing the Holy Infancy may have performed this role as at Chalfont St Giles.

Except for some possible scenes of the Wedding at Cana where Christ turned water into wine (His first miracle), there are no surviving scenes or cycles of Christ's miracles and ministry such as The Feeding of the Five Thousand. Surveys in the nineteenth century found only nine recorded examples. Paintings of the Miracle of Christ healing Jairus's daughter, at Copford (Essex), or raising Lazarus from the dead, as at Winchester Cathedral, appear as part of Passion/Resurrection sequences rather than as illustrations of his wider miracles. Again, apart from a few paintings of the moral of *Dives and Lazarus*, the story of a rich and selfish man who goes to Hell and a pauper who goes to Heaven at Ulcombe (Kent), there are no paintings of Christ's more well-known parables such as the story

Figure 43 The Infancy and Passion of Christ: Brook, St Mary, mid-thirteenth century.

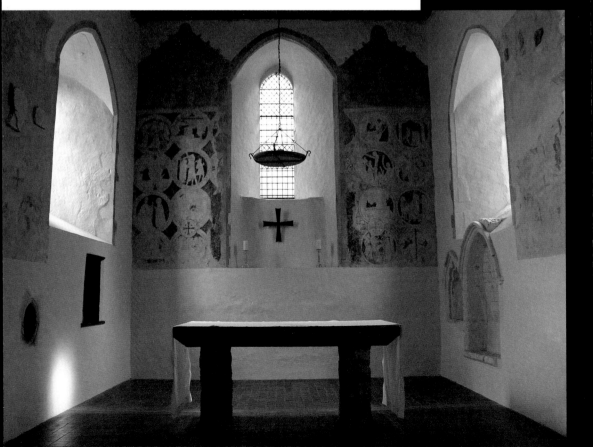

of the Prodigal Son or the Good Samaritan, notwithstanding that both were told in contemporary glazing schemes.

Because wall paintings showing the life cycles of Christ can vary in the incidents they show, and are sometimes difficult to decipher when damaged, the following descriptions of Christ's Holy Infancy and Passion provide an overall narrative context for the most commonly seen paintings.

The Holy Infancy

According to the Gospels, God sent his angel (from the Greek *angelos* or messenger) St Gabriel to tell a young virgin, Mary, that she would bear Him a son (*The Annunciation*). This scene is usually shown as a standing or kneeling angel with an inscribed scroll facing the young Mary holding a book as at St Thomas, Salisbury (Wilts). (44) Sometimes a pot of lilies is included. Images of the Annunciation could also appear separately from narrative sequences, such as on opposite facing window splays.

Figure 44 The Annunciation with background patterning, including a pot of lilies: Salisbury, St Thomas, late fifteenth century.

Subsequently Mary visited her cousin, Elizabeth, who embraced her and said "Blessed art thou among women, and blessed is the fruit of thy womb," as depicted in *The Visitation*, Willingham (Cambs). (45)

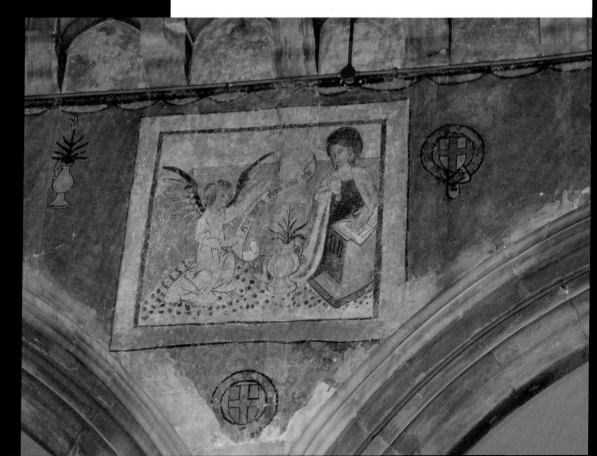

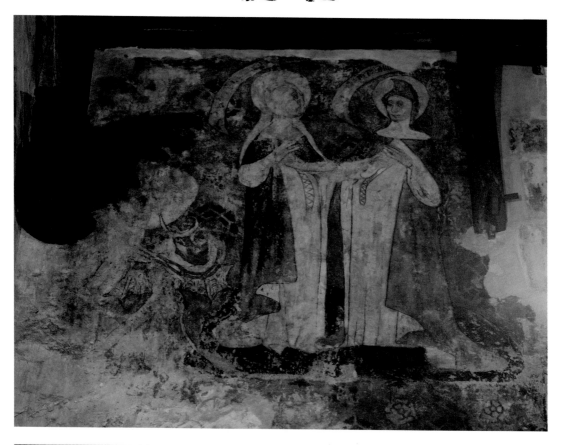

Figure 45 The Visitation: Willingham, St Mary and All Saints, fifteenth century.

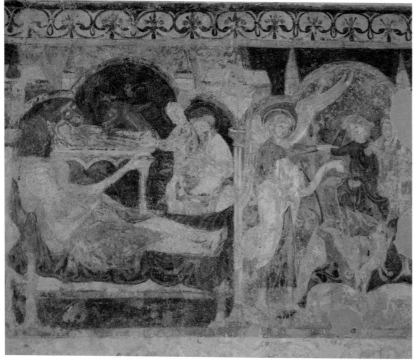

Figure 46 The Nativity: Ashampstead, St Clement, thirteenth century.

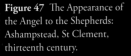

Figure 47 The Appearance of the Angel to the Shepherds: Ashampstead, St Clement, thirteenth century.

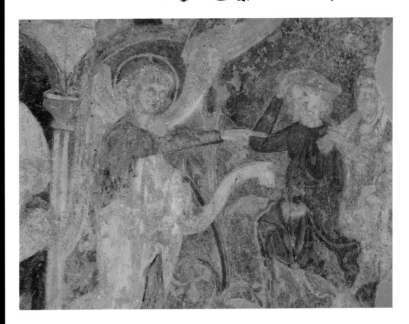

Shortly before she was due to give birth Mary and her espoused husband, Joseph, went to the town of Bethlehem where her son was born in a manger, a scene usually depicted as Mary holding the infant Christ, while adoring animals look on (*The Nativity*), as at Ashampstead (Berks). (46)

After the birth of the Messiah an angel appeared to some nearby shepherds and told them of the miraculous event; see *The Appearance of the Angel to the Shepherds* at Ashampstead. (47) From the east, Three Kings or Wise Men (The Magi) followed a star which led them to Bethlehem, where they could worship the holy child. When Herod the Great learned of their quest he was afraid of the infant 'that is born king of the Jews'.

Finding the Christ child, the Magi gave Him gifts (*The Adoration of the Magi*). This scene shows the eldest of the three, Jasper, kneeling before the Virgin and Child offering a gift of gold while Balthazar and Melchior, the younger of the kings, stand behind him bearing myrrh and frankincense, Pinvin (Worcs). (48) They were the first gentiles (non-Jews) to worship Christ. The event is celebrated in the Christian calendar as Epiphany, when Christ became manifest to mankind. From the second century onwards this scene also became one of the most enduring wall paintings in the Church, especially as it also had symbolic associations with the Magi worshipping at the 'altar' of Christ.

Before the Kings departed, an angel appeared to them urging them not to return to Herod's palace: *The Magi's Dream*, Wissington (Suffolk). (49) Joseph was also warned in a dream to take Mary and the infant and to flee the country before Herod found and murdered the baby Jesus: *Joseph's Dream*, Newington (Kent). As Herod's troops began killing every

male child below the age of two in the hope that Jesus would be among the victims (*The Massacre of the Innocents*) the Holy Family made their desperate escape (*The Flight into Egypt*). This scene shows Mary riding an ass and cradling the Christ child while Joseph walks ahead holding the reins, as depicted at Croughton (Northants). (50)

Figure 48 The Adoration of The Magi (lower left), with fifteenth-century overpainting of St Roche: Pinvin, St Nicholas, *c.* 1300.

Some longer cycles resume the story after Herod's death, when the angel reappeared to Joseph in another dream and told him that it was safe to return to Israel. As at Brook, they might follow the gospel of St Luke and pair the earlier story of Jesus' *Presentation in the Temple* as a newly born child with the episode where, as a twelve-year old, He wandered into the Temple and debated religious ideas with assorted authors and scribes (*The Dispute with the Doctors*) – the first example of His teachings. Other

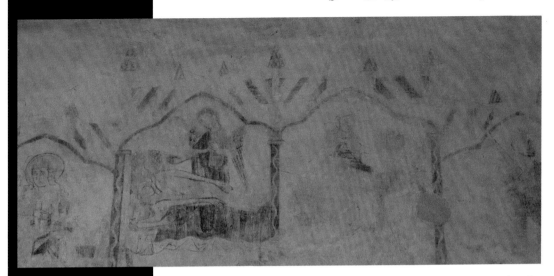

Figure 49 The Dream of the Magi: Wissington, St Mary, thirteenth century.

paintings might show His baptism in the river Jordan by St John the Baptist, the son of Mary's cousin, Elizabeth (*The Baptism of Christ*), the beginning of His public ministry as the Son of God, as at Black Bourton (Oxon). (51) At Brook, Christ is shown resisting *The Temptations of Satan* as he fasts in the wilderness following His baptism.

In addition to the Gospel stories of Christ's infancy and early manhood, there were also unauthorised versions which supplemented the official Biblical account and enjoyed such popularity that they eventually became accepted conventions within the church and incorporated into its artistic iconography. Perhaps the most enduring of these tales is the story that He was adored by a donkey and an ox in the manger where He was born.

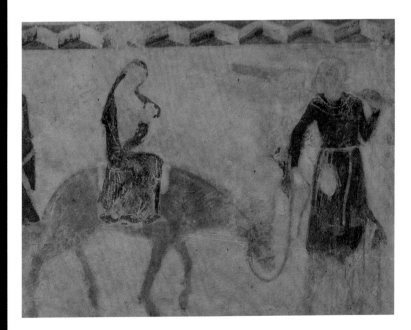

Figure 50 The Flight into Egypt: Croughton, All Saints, early fourteenth century.

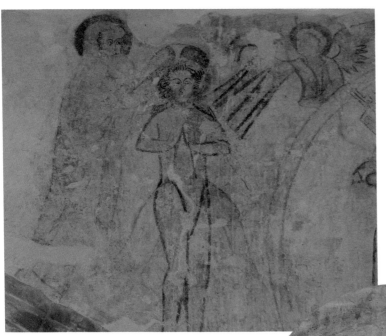

Figure 51 The Baptism of Christ: Black Bourton, St Mary, thirteenth century.

Apocryphal gospels such as the *Protevangelium of James* included the first example of the infant Christ's powers, as when His arrival in the pagan city of Sotinen during *The Flight into Egypt* caused idolatrous statues to fall from their pedestals: *The Fall of the Idols*, Brook. (52) The author of other apocryphal gospels, *The Gospel of Thomas* and the *pseudo Matthew*, also enthralled medieval audiences with various tales of the young Jesus's miracle-

Above:
Figure 52 The Fall of the Idols: Brook, St Mary, mid-thirteenth century.
Left:
Figure 53 The Christ Child with St Mary: Shorthampton, All Saints, fifteenth century.







working powers, such as when He gave life to some model birds that He had fashioned from clay, or played with lion cubs while the older lions wagged their tails. At Shorthampton (Oxon), the infant Christ is shown with another child, possibly His cousin, St John the Baptist. (53)

The Passion of Christ

As with Holy Infancy cycles, Passion cycles are painted on nave walls running west to east on the north side and east to west on the south. They can range from four scenes, as at Capel, to twelve at Croughton and fifteen at South Newington (Oxon). Although most sequences are similar, sometimes common scenes are omitted while rarer episodes are included. At Peakirk (Cambs), for example, the *Entry into Jerusalem* is missing whereas the *Mocking of Christ* is included. Some schemes appear above the chancel arch, as at Ashby St Ledger and Burton Dasset (both in Northants), which in this case seem to be drawn from similar workshop models. On other occasions versions of the story might be found in the chancel or in a chantry chapel, making generalized classifications about location difficult.

As with the Holy Infancy, the most common scenes shown in these narratives are highlighted in italics. Whatever the date or length of a cycle, Christ is always recognisable by His halo and the Roman-type robes He wears. His torturers are portrayed as wicked and ugly, with bulging eyes and jagged teeth. Soldiers wear armour contemporary with the painting itself.

Figure 54 The Entry into Jerusalem: Fairstead, St Mary, thirteenth century.

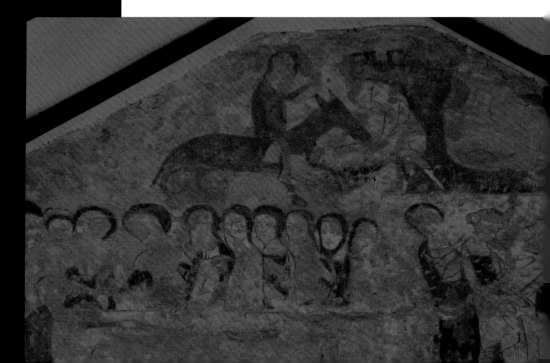

Most cycles begin with Jesus' arrival in the Judean capital on Palm Sunday (*The Entry into Jerusalem*), where He is shown riding a donkey while onlookers lay out carpets or watch from battlements, as at Fairstead (Essex). (54) The next scenes are usually *The Washing of Feet* and *The Last Supper*, when Jesus broke bread and told His disciples, 'This my body, which is given for you. Do this in commemoration of me', and then gave them wine, exclaiming, 'This is the chalice, the new testament in my blood, which shall be shed for you'. For Christians this particular painting was full of Eucharistic symbolism, the ritual of the Mass when 'bread', normally a wafer, and wine were blessed and miraculously transformed into the 'host' or presence of the resurrected Christ. Paintings of this scene show a long table, laid with plates and cutlery. Christ sits centre stage with St John the Evangelist resting his head against Him. The other disciples are seated on either side. Judas is often included as a figure in the foreground, apart from the other disciples, and with a money bag hanging from his belt. At Halling (Kent) the disciples are tonsured. (55)

After the meal, the narrative continues with Christ going to the Mount of Olives and into the garden of Gethsemane, where He wrestled with the duality of his life, the human horrors He knew He was about to endure with the divinity which gave Him strength (*The Agony (or struggle) in the Garden*). Soon the treacherous disciple, Judas, who had betrayed Him for thirty pieces of silver, rushed forward and kissed Him, identifying Him to the High Priest's soldiers who were waiting to arrest Him, (*The Betrayal*), as depicted at West Chiltington (West Sussex). (56) Some paintings include the disciple St Peter trying to protect Jesus from

Figure 55 The Last Supper: Halling, St John the Baptist, thirteenth century.

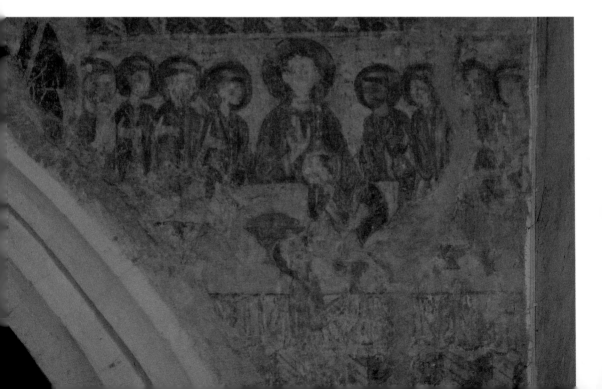

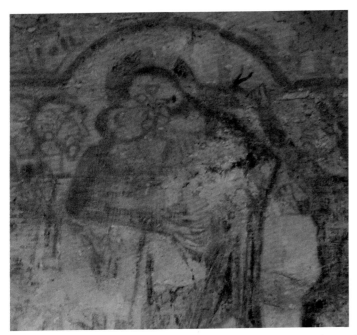

Figure 56 The Betrayal: West Chiltington, St Mary, thirteenth century.

His would-be captors, wielding his sword to cut off the right ear of the Priest's servant, Malchus, who writhes on the ground until he is healed by Jesus, as shown at Flamstead (Herts). Thereafter the soldiers who had seized Christ took Him to the Jewish High Priest who sentenced Him to death (*Christ before Caiaphas*). A variation of this scene might be *Christ before Herod Antipas*, the son of Herod the Great. Overcome with remorse at what he had done, at least one cycle shows Judas hanging himself from a tree: *The Suicide of Judas*, Gussage St Andrew (Dorset). Christ was then handed over to the Roman governor of Judea, who reluctantly acquiesced with the Priest's demands for the prisoner's execution (*Christ Before Pilate*). Led away for crucifixion, Jesus was stripped and brutally scourged (*The Flagellation*). This scene shows Christ with his hands bound and tied to a column as soldiers swing their whips, as depicted at West Chiltington. (57) According to *The Gospel of St Matthew* he was then spat at, *Crowned with Thorns* and *Mocked*. At St Teilo, Cardiff, St Fagans (Wales, Vale of Glamorgan), spittle dribbles down His face. (58)

Subsequent scenes might show *Christ Carrying the Cross* to Golgotha, often accompanied by a man with a hammer, before he is *Nailed to the Cross* and *Crucified* alongside two thieves, as at Brook and Turvey (Beds). (59: 60) Some of these images show a Roman centurion stabbing Him in the side with a spear, as at Peakirk. (61) More often, the paintings continue with a scene of His body being taken down from the cross (*The Deposition*), as shown at Bengeo (Herts), (62) Thereafter He is buried in a tomb owned by a wealthy follower, Joseph of Arimathaea (*The Entombment*, Winchester Cathedral). (19) In a few instances Joseph is shown pleading with Pilate for Christ's body, as at Duxford (Cambs). Sometimes the *Three Marys at the Tomb* are shown watching over His sepulchre, as at Kempley. (63)

Between his burial and the third day, when God undid His son's death, a number of wall painting cycles illustrate Christ releasing Adam and Eve and other naked souls from the gaping Mouth of Hell (*The Harrowing of Hell*), an image visualised and inherited from a second or third century apocryphal text, *The Gospel of Nicodemus*: Pickering (Yorks). (64) This scene is often followed by Christ's emergence from the tomb,

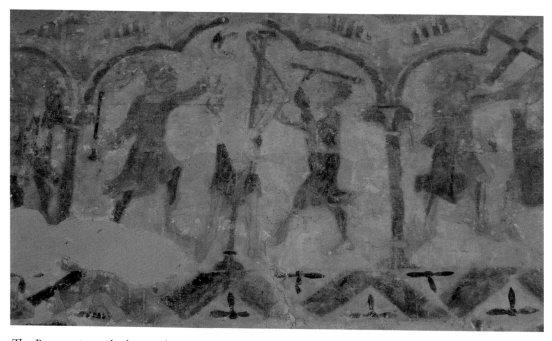

The Resurrection, which can show Him stepping over sleeping soldiers while holding the Vexillum, the flag of the Resurrection. An alternative portrayal might be *The Angel at the Tomb*, who told the Marys that the sepulchre was empty because Christ had risen. Either version, in turn, often leads to Jesus's subsequent appearance to Mary Magdalene, whom he restrains with a hand gesture telling her not to touch him (*Noli me Tangere*): Risby (Suffolk). (65)

A few paintings continue – or focus on – the next stage of the story with events from Christ's last forty days on earth, when He appeared to His disciples on *The Road to Emmaus* and told St Thomas, the apostle, to put his hand into His wounded side after he doubted the truth of the Resurrection (*The Incredulity of St Thomas*), as depicted at St Albans Abbey (Herts). (66)

Top:
Figure 57 The Flagellation: West Chiltington, St Mary, thirteenth century.

Bottom:
Figure 58 The Mocking of Christ: Cardiff, St Teilo, sixteenth century.

Right:
Figure 59 The Crucifixion: Turvey, All Saints, early fourteenth century.

Below:
Figure 60 Christ Carrying the Cross: Brook, St Mary, mid-thirteenth century.

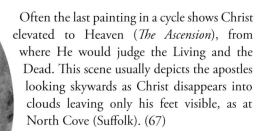

Often the last painting in a cycle shows Christ elevated to Heaven (*The Ascension*), from where He would judge the Living and the Dead. This scene usually depicts the apostles looking skywards as Christ disappears into clouds leaving only his feet visible, as at North Cove (Suffolk). (67)

A few schemes, however, may also show *Pentecost*, when the Holy Spirit descended upon the Apostles and the Christian Church began its ministry.

Right:
Figure 61 Longinus at The Crucifixion: Peakirk, St Pega, fourteenth century.

Just as there were unauthorised versions of Christ's infancy, so too there were apocryphal versions of His death which enjoyed widespread popularity in the medieval Church until they eventually became accepted doctrines and pictorial conventions.

Apart from The Harrowing of Hell scene mentioned earlier, other stories from *The Gospel of Nicodemus*, also known as *The Acts of Pilate*, named the Roman soldier at the crucifixion who stabbed Christ as Longinus. Later accounts went further and claimed that a malady of the centurion's sight had been cured after Christ's blood ran down the lance and into his eyes. Some paintings show the spear-thrusting Longinus pointing to his eye, as at Peakirk. (61)

Apart from direct images of the Passion, the suffering it portrayed could be inferred from paintings of the Instruments of the Passion, thirteen different objects and tools associated with the Crucifixion and Christ's last hours before His death. Examples such as the whip used during the flagellation or the crown of thorns are often

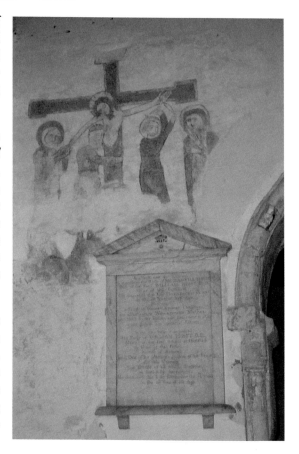

Top:
Figure 62 The Deposition: Hertford Bengeo, St Leonard, thirteenth century.

Left:
Figure 63 The Three Marys: Kempley, St Mary, *c.* 1130.

Top:
Figure 64 The Harrowing of
Hell: Pickering, St Peter and St
Paul, late fifteenth century.

Right:
Figure 65 *Noli me Tangere*:
Risby, St Giles, fourteenth
century.

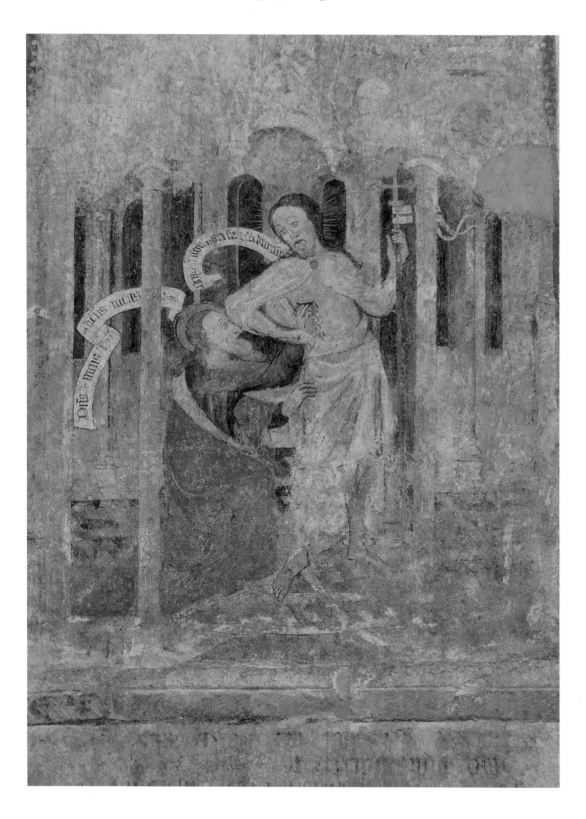

Left:
Figure 67 The Ascension of Christ: North Cove, St Boltolph, fourteenth century.

Below:
Figure 68 The Instruments of the Passion: South Newington, St Peter ad Vincula, fifteenth century.

Left:
Figure 66 The Incredulity of St Thomas: St Albans Abbey, fifteenth century.

shown being carried by angels or displayed on shields. They can appear as images in scenes such as The Last Judgement (q.v.), or in their own right, as at South Newington (Oxon). (68)

THE VIRGIN MARY

Paintings of the Virgin Mary were valued from at least the Council of Ephesus in AD 431, at which the Church formally proclaimed her as the Mother of God. When Bishop Biscop, the Abbot of the famous double monastery at Wearmouth Jarrow, in Northumbria, made the dangerous journey to Rome in AD 678, panel pictures of St Mary were among the prized treasures he brought back to England to adorn the walls of his church.

Biblical accounts of Mary's life are brief. Her Hebrew name was Miriam. Betrothed to Joseph, she was living at Nazareth when St Gabriel announced that the Holy Spirit would come upon her. Some wall paintings still retain traces of their original Latin inscriptions of St

Figure 69 The Virgin and Child: Shelfanger: All Saints, late thirteenth century.

Gabriel's salutation – '*Ava Maria gracia plena*' (Hail Mary, full of grace). Other than her appearances in The Holy Infancy story, the Gospels say very little about Mary during Jesus's childhood and early manhood. According to *The Gospel of St John*, she stood at the Cross during the Crucifixion, and the first chapters of the Biblical *Acts of the Apostles* suggest that she may also have been present during Pentecost. There is no mention of her death in the Bible.

Apocryphal gospels such as the second-century *Protevangelium of James* and the *pseudo-Matthew*, composed between AD 550 and AD 700, provided the missing details about her life that worshippers craved. Some wall paintings show stories told from these accounts. These include scenes of her miraculous birth, conceived by a kiss at the Golden Gate in Jerusalem after an angel had appeared and given her parents the child they yearned for but could not have. By the late Middle Ages the veneration of St Mary almost rivalled that of Christ. More churches were dedicated to God in her name than in that of any other saint and she was particularly adored by monastic orders, such as the Benedictines, who promoted stories of her miracles. From the thirteenth century onwards

Figure 70 The Lactating Virgin: Belchamp Walter, St Mary, fourteenth century.

Figure 71 The Pieta: Hornton, St John the Baptist, fourteenth century.

bishops insisted that her image be maintained on or beside the High Altar, early wall paintings of this type are still extant at Bramley (Hants), and Shelfanger (Norfolk). (69)

Paintings might show her holding the infant Christ (*The Virgin and Child*), as a mother suckling Jesus (*Maria lactans,* The Lactating Virgin), as at Belchamp Walter (Essex), (70) or as a grief-stricken figure cradling the dead body of her adult son (*The Pieta*), as at Hornton (Oxon). (71) Such images could dominate altars, as at Great Canfield (Essex). (72) Many churches retain painted backdrops where statues of the Virgin Mary would have been displayed in the chancel. Others have a separate Lady Chapel where wall paintings and other images of the saint appeared. Sometimes she was shown as a young girl with her mother St. Anne who is teaching her to read (*The Education of the Virgin*), as at Bradwell Abbey (Bucks). (73)

A few schemes portrayed apocryphal scenes of *The Life and Death of the Virgin* interspersed or paired with that of *The Holy Infancy* or Passion

Figure 72 The Virgin and Child: Great Canfield, St Mary, thirteenth century.

of Christ, as at Croughton. More common were apocryphal images of her Death: that overcome with grief for her son she gathered the apostles to her bedside as she lay dying, as at Sutton Bingham (Som.), and said her farewells (*The Death of the Virgin*). (74) Some showed a miracle said to have occurred during *The Funeral of the Virgin*, when a disbelieving Jewish priest mocked her cortege and attempted to push it over. After his hands became stuck to the bier and withered, he repented and converted to Christ, as depicted at Chalgrove. (75) A few take the story further and show her body being carried to heaven by angels (*The Assumption of the Virgin*): Lichfield Cathedral (Staffs). (76) At Chalgrove, she drops her girdle to the incorrigibly 'Doubting' St Thomas as she ascends skywards. Either as part of the cycle or separately, a number of paintings show her being crowned as Queen of Heaven (*The Coronation of the Virgin)*, as at Tewkesbury Abbey (Glos). (77)

Another genre of paintings illustrated miracles said to have occurred centuries after her death. Such stories were extremely popular throughout western Europe in the twelfth century and were collected assiduously by men like St Anselm (1033–1109), an Abbot of Bec in Normandy who

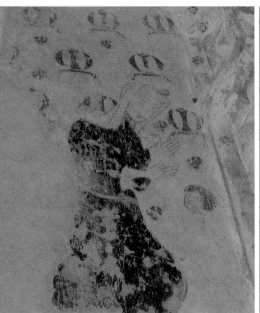

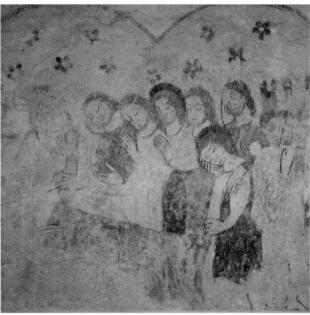

Above left:
Figure 73 The Education of the
Virgin: Bradwell Abbey, fourteenth
century.

Above right:
Figure 74 The Death of the Virgin:
Sutton Bingham, All Saints, *c.* 1300.

Above:
Figure 76 The Assumption of the Virgin: Lichfield Cathedral, fifteenth century.

became Archbishop of Canterbury in 1093, and his nephew, also called Anselm, who died as Abbot of Bury St Edmunds (Suffolk) in 1148. These stories included her rescue of Theophilus, a priest who had invoked her help after he sold his soul to Satan and from whom she wrested his bond, with the earliest known example at Risby, painted around 1210–20.

Such legends were not merely apochryphal. A large number of churches claimed to own statues of the Virgin with contemporary miracle-working powers. At Eton College, such a statue attracted pilgrims and sat in a chapel lined with wall paintings depicting *The Miracles of the Virgin*, causing the choirmaster, Robert Wylkynson, to write a nine-part *Salve Regina* in her honour integrating three-dimensional imagery, paint, text, music and voice into a choreographed harmony of devotion.

Given such beliefs it is not difficult to understand St Mary's appeal to medieval audiences. She was chosen by God to bear his son. Her obedience and chastity enabled the salvation of mankind. She gave Jesus her milk. She wept as the child she loved died on the cross. Her tears and compassion made her inseparable from the virtues of mercy and goodness. She was as other women, yet as the mother of Christ, ineffably special. Unlike other saints, whose unseen powers were linked to their physical relics, St Mary was universally accessible and exceptionally well-placed to intercede on behalf of mankind, especially after her Coronation as Queen of Heaven. As such it is hardly surprising that she was frequently shown

Left:
Figure 75 The Funeral of the Virgin: Chalgrove, St Mary, early fourteenth century.

Left:
Figure 77 The Coronation of
the Virgin: Tewkesbury Abbey,
fourteenth century

in wall paintings such The Last Judgement and The Weighing of Souls (q.v), pleading for the penitent and devout. Stencilled patterns of her initial 'M', often crowned, were also popular. According to John Mirk, a fifteenth-century Prior of Lilleshall, in Shropshire, and the author of a book on homilies known as the '*Festial*', which provided sermons in English for priests, images of the Virgin with the Christ Child '*schew all crystyn pepull how moche scho louet hor sonne, Ihesu*' (show all Christian people how much she loved her son, Jesus).

THE SAINTS

Wall paintings of saints multiplied in the twelfth and thirteenth centuries fuelled by rising religious fervour and increasing prosperity. A huge surge in church building created extra walls to paint and opportunities for new saints to join the '*The Holie Companie of Heven*' admired by wealthy patrons. The decision of the church to make the laity responsible for the upkeep of the nave, 'their part' of the church, accelerated such trends.

The circulation of manuscripts like the *pseudo-Abdias*, a sixth-century forgery purporting to be the work of the first Bishop of Babylon, was a source for most of the early stories about individual Apostles. By the thirteenth century this book had been discovered, read, copied and

Opposite top:
Figure 78 St Zita: Horley, St
Etheldreda, *c.* 1500.

Opposite bottom:
Figure 79 The Martyrdom of St
Margaret: Battle, St Mary, *c.* 1300.

circulated between monasteries across Europe for several centuries, slowly finding new and receptive audiences. Fresh stories about later saints were also added to the traditional lexicon, and spread by the publication of compendiums such as the *South English Legendary,* possibly compiled by monks at Gloucester Abbey, and the better-known *Legenda Sanctorum* or *Aurea,* often called *The Golden Legend.* Assembled by Jacobus de Voragine, the Bishop of Genoa, around 1265, this account of saints' lives became one of the best-sellers of the late Middle Ages. Evidence of its enduring appeal was William Caxton's decision to print an English translation in 1483.

Contemporary religious figures were also canonized, such as St Francis of Assisi and St Zita, a housemaid from Lucca in Italy, whose piety was acclaimed after her death in 1278. In later centuries her image was painted in several Oxfordshire churches, such as Shorthampton and Horley. (78)

Most images of saints appear as single individuals carrying attributes, often the symbols of their martyrdom, or another holy association. Sometimes their names are inscribed. The lives or miracles of a few were shown in extensive cycles, similar to those used to portray scenes from The Holy Infancy and The

Passion of Christ. These could be very detailed. Twenty-four scenes from thirty showing The Martyrdom of St Katherine of Alexandria survive at Great Burstead (Essex). At Sporle (Norfolk) a complete set of twenty-five images can be seen on the south wall. (245) The Life of St Margaret of Antioch was likewise painted in twenty-four pictures at Battle (East Sussex). (79)

The importance of saints in medieval theology cannot be understated. The Church believed that they were particularly close to God. Apart from the Virgin Mary, these included New Testament saints such as St Peter and St Paul and others who had either suffered for their faith or who had led exemplary religious lives, such as monks, evangelists and bishops. Before the papacy of Gregory IX (1227–41), local bishops were largely free to proclaim whomever they liked as saints. In Anglo-Saxon England, these included St Cuthbert, St Kenelm, St Swithin and St Edmund, King and Martyr, all of whom were later represented in wall paintings. Many Welsh churches are dedicated to local saints such as St Cybi and St Saeran, some of whom were probably depicted in now lost wall paintings. Cornwall was another region with powerful local traditions.

The Eastern wing of the Roman Church was particularly attracted to fabulous stories of saints. Some of the most popular of these accounts were exported to Western Europe before AD 1000. These included tales like that of St Katherine of Alexandria, an eastern Virgin saint, whose scholarship and miraculous rescue by angels from the tortures of a spiked wheel attracted a growing following in England after the Norman

Figure 80 St Katherine with the shattered wheel: Castor, St Kyneburga, fourteenth century.

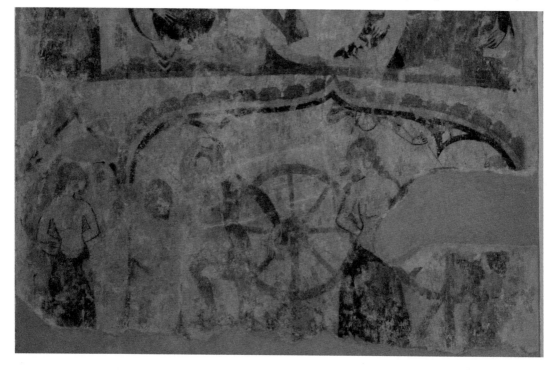

Conquest. One of the earliest wall paintings of her martyrdom can be seen at Little Missenden (Bucks), where several scenes of an original nine-part scheme of *c.* 1270 still survive. (138) Eventually the Saint's image was commonplace, as at Castor (Cambs). (80)

Although many of the stories attributed to such saints, like those of St Margaret and St George, seem to share similar plots – martyrs saved from astonishingly barbaric tortures by divine intervention and heroes able to conquer dragons or vanquish evil magicians – the public appetite was insatiable. The adoption of St James the Great as the patron saint of pilgrims and a hero of the Christian struggle to expel the Islamic invaders from Spain, the *Reconquista*, is a case in point. Legends promulgated by the *pseudo Abidas* claimed that he had battled, defeated and converted Hermogenes, a diabolical sorcerer. Other accounts said that he had evangelized Spain. When his 'tomb' was miraculously 'discovered' in the eighth century, his body was interred at Santiago de Compostela, near the north-west tip of the peninsula: for medieval western cartographers, the end of the known world. Christian knights reported the saint's appearance at various battles against the Moors, earning him the Iberian epithet, *Matamoros* or Moorslayer. In one account a prince who thought he was drowning invoked his help and emerged from a river covered in scallop shells, a story which prompted the adoption of the shell as the saint's symbol or attribute. After pilgrimages to his shrine began in the tenth century, St James was hailed as the patron saint of pilgrims, especially by

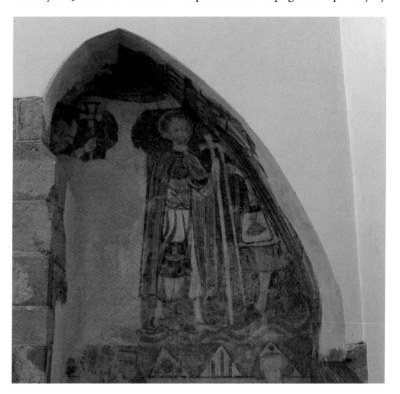

Figure 81 St James the Great: Wisborough Green, St Peter ad Vincula, thirteenth century.

those who walked the *Camino*, the long overland route across Europe to Galicia or, as was often the case in England during the Hundred Years war with France, who made the journey by sea via the port of La Coruna. Gradually paintings of the saint wearing a pilgrim's hat and a scallop badge and carrying a pilgrim's bourdon (staff) and scrip (pouch) became familiar across Europe. Wall paintings of St James in England were no exception, as seen at Wisborough Green (West Sussex). (81)

The importance of saints lay in the belief that they were intercessors who could use their special status and proximity to God to ask for mercy and favours on behalf of humans. Many churches had altars devoted to particular saints or were dedicated to one or more, such as All Saints at Chalgrave, (Beds), where at least eighteen images were painted, some life – sized.

Most saints were thought to intervene directly in earthly life, healing the sick, curing ailments, helping captives or defending those who invoked them. A number were thought to have particular powers, like Sts Sebastian and Roche, who were said to offer protection against plague. At Pinvin, an image of St Roche was painted over an earlier Life of Christ cycle. (48)

Name saints were particularly well regarded as special friends and helpers. People born on a saint's day might be christened after them, as was Henry III's daughter, Katherine, in 1253. Other people had favourite saints. William Waynflete, the long-serving Bishop of Winchester (1447–1486), named the Oxford College he founded after St Mary Magdalene. The dying often left bequests for candles to be lit below wall paintings of those saints to whom they felt close, or asked to be buried near their images and altars. Some tombs were decorated with images of the deceased person's favourite saints. Prayers were said before them.

The Christian calendar celebrated saints' days with a mixture of piety and partying, including pageants, religious dramas and festivities. At the eve of the Reformation there were over fifty *festa ferianda*, feast days dedicated to saints when all but essential work was forbidden, causing some landowners to grumble that people enjoyed far too many days off.

Many communities had local guilds or clubs which attached themselves to particular saints, such as at St John the Baptist and St Katherine. Local saints, such as St Cuthbert, enjoyed special popularity in their 'home' regions, in his case Northumbria, where episodes of his life were painted at Pittington (Co. Durham). The same was true of Hampshire's St Swithin whose miracles, including the account of how he restored a widow's broken eggs, were chronicled in the chancel at Corhampton. (82) Monasteries also promoted saints associated with their orders and decorated their refectories with paintings of those to whom they were

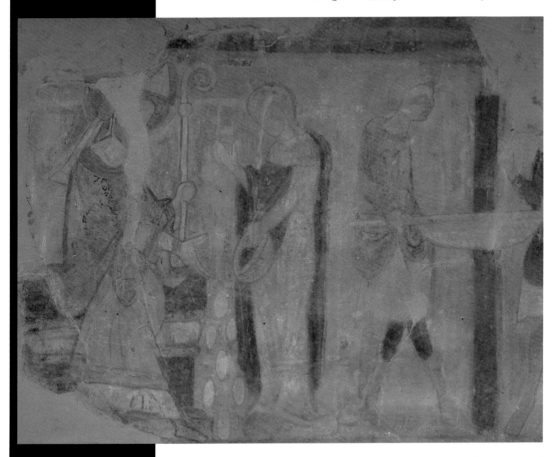

Figure 82 The Miracles of St Swithin: Corhampton Church, thirteenth century.

dedicated. By the end of the fifteenth century some churches possessed hagiographies detailing the lives of saints.

The relics – bodies and bones, clothes and other possessions – of saints also attracted pilgrimages in the belief that proximity to, or better still touching, these 'living' links would aid intercession. Almost every church, monastery, trade and occupation, city and nation had saintly patrons and heroes.

Apart from the locally or nationally venerated, some saints were cherished throughout western Christendom. These included St Christopher and St James the Great.

The earliest surviving English wall paintings of saints are those of St Martin of Tours, at Wareham (Dorset), and St George, at Hardham, both made around 1100. (30) Yet despite the number and enormous popularity of saints, only relatively few individuals were consistently painted on the walls of churches. Of the hundred and more whose lives were described by de Voragine, fewer than a dozen appear regularly in surviving wall paintings in their own right.

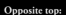

By far the most common to have survived are images of St Christopher. Usually painted opposite a door where they could be seen easily, such paintings were thought to protect anyone who saw them from dying an 'evil' or unshriven death that day – in other words, without the

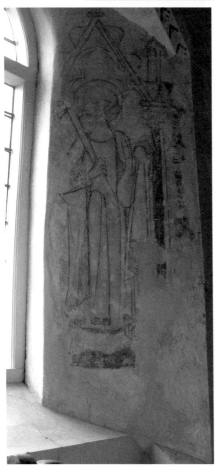

Opposite top:
Figure 86 St Nicholas, the Miracle of the Cup: Haddon Hall Chapel, early fifteenth century.

Opposite, botton left:
Figure 87 The Martyrdom of St Edmund: Stoke Dry, St Andrew, fourteenth century.

Opposite, bottom right:
Figure 88 The Martyrdom of St John the Baptist, Salome dancing: Kingston Lisle, St John the Baptist, fourteenth century.

Left:
Figure 83 The Martyrdom of St Thomas Becket: St James, Bramley, thirteenth century

Far left:
Figure 84 St Paul: Idsworth, St Hubert, fourteenth century.

Below:
Figure 85 The Martyrdom (stoning) of St Stephen: Catfield, All Saints, fourteenth century.

administration of the final sacraments. The Saint's appeal is summed up by an inscription in Norman-French previously visible at Woodeaton, (Oxon) '*Ki cest image berra ce jur de male mort ne murra*' (Who sees this image shall not die an ill-death this day). Apart from those already mentioned, others who were painted often included Sts Peter and Paul; St Stephen; St Nicholas; St Edmund; and St John the Baptist, whose birth, life and martyrdom might be shown. (84: 85: 86: 87: 88) Wall paintings of St Thomas Becket, martyred at Canterbury Cathedral in 1170 by knights loyal to Henry II, were also common. (83: 235)

DEATH AND JUDGEMENT

Wall paintings pictorialising the subjects of Death and Judgement, called the Doom, were universal in the late medieval Church and represented the words of the Gospel of St Matthew, Chapter 25:

And when the Son of man shall come in his majesty, and all the angels with him, then shall he sit upon the seat of his majesty. And all nations shall be gathered together before him, and he shall separate them one from another, as the shepherd separateth the sheep from the goats. And he shall set the sheep on his right hand, but the goats on his left. Then shall the king say to them that shall be on the right hand, Come, ye blessed of my Father, possess you the kingdom prepared for you from the foundation of the world ... Then he shall say to them also that shall be on his left hand: Depart from me, you cursed, into everlasting fire which was prepared for the devil and his angels ... And these shall go into everlasting punishment but the just, into life everlasting.

Figure 89 Purgatory: Swanbourne, St Swithin, *c.* 1500.

The church taught that everyone would face personal judgment at death and be held accountable for how they had lived their lives, good or wicked. They would be judged by their mercy and kindness to others. In the words of Geoffrey Chaucer's fourteenth-century poem *The Parson's Tale*, 'Men ought to be moved to contrition in fear of the day of doom and of the horrible pains of hell'.

Although the after-life was never explicitly described in the New Testament, medieval artists drew on numerous apocalyptic accounts to provide imagery that was simultaneously both triumphant and terrifying: scenes of everlasting bliss and relief for the saved, shocking portents of the gruesome eternity

that would befall the damned in the furnaces of Hell. Apart from an allegorical wall painting at Swanbourne (Bucks) about the fate of the soul, which shows three figures roasting in flames while textual scrolls plead for saints and friends to remember them, there are no similar representations of Purgatory. (89) Daily life in Heaven was never shown.

The earliest surviving Judgement images in an English wall painting are those described earlier on the east wall of the nave at Houghton-on-the-Hill, where an angel blasts the last trump as the dead gather to learn their destiny. (10) Slightly later instances can be seen at Hardham, where sinners shriek on the west wall as they boil in a cauldron while on the north wall at Clayton, a devil riding a horse snatches one of the damned by the hair as his mount tramples another hapless wretch beneath its hooves. Two other early examples survive at Stowell and at Chaldon (Surrey) where a painting generally known as 'The Ladder of Salvation' incorporates angels plucking the saved to safety from the grasp of devils as sinners are forced to walk across a bridge of spikes towards a medieval chamber of horrors where ferocious beasts maul the condemned. (90) In other examples, images of the Torments of Hell were depicted on the western wall of the church, where they could be contrasted with images of *Christ in Majesty* above the east wall of the nave.

Although there are a few exceptions, by the fourteenth century this earlier eclectic Judgement imagery, based on Apocalyptic visions, had evolved into an increasingly predictable two-tier scheme, usually

Figure 90 'The Ladder of Salvation': Chaldon, St Peter and St Paul, *c.* 1200.

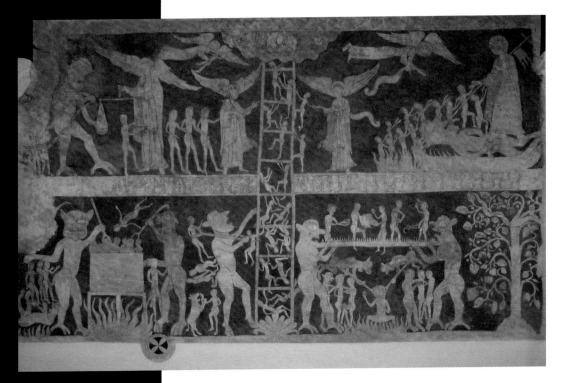

painted on the east nave wall above the chancel arch, previously the preserve of images of *Christ in Majesty*. Derived from *The Gospel of St Matthew*, it was similar to thirteenth-century imagery found in sculptured portals in French cathedrals. In this new form Christ sits on a rainbow (His covenant with mankind) displaying the wounds of the crucifixion, often flanked by apostles and, slightly lower, by the Virgin Mary on His right (left looking at the painting from the nave) and St John the Baptist wearing his coat of camel hair on the left, as at Holy Trinity, Coventry (Warks). (91) Sometimes the Virgin Mary is shown bare breasted as she pleads for mankind, as at North

Figure 91 The Doom: Coventry, Holy Trinity, mid-fifteenth century.

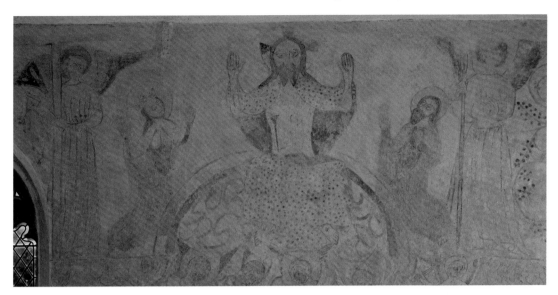

Figure 92 The Supplicating Virgin: North Cove, St Boltolph, fourteenth century.

Cove. (92) Another feature might be angels, either censing Christ or holding Instruments of the Passion.

In the lower tier, below Christ, naked souls woken by angels clamber from their graves. To Christ's right, some flock to where St Peter, holding the keys to Heaven, welcomes the saved at the Gates of the Holy City, while to His left, batches of distraught sinners are carried, dragged, prodded or ferried in a handcart pulled by demons towards the flames of a fanged Hell Mouth. The inclusion of easily recognised attributes such as head-dresses which identify the sex and status of their wearers or clues which reveal the sins of the damned, such as dishonest ale wives clutching tankards or misers being forced to swallow their hoarded gold, add a disquieting social piquancy to the paintings; as seen at Holy Trinity, Coventry. (93) Sometimes, inscriptions were included as labels describing the sins which deserved such a fate or announcing the Judgement of Christ as he separated the saved from the damned. In some instances inscriptions were painted on beams below such scenes, as at Wood Eaton: *Venite benedicte patris mea,* (the blessed come to my Father) and *Ite maledicte inignem internam* (the wicked go to eternal fire).

At Wymington (Beds), and elsewhere, these opposing scenes could appear as a virtual triptych, opening out and extending to the adjacent side walls, where images of Heaven and Hell offered contrasting fates across the nave.

In some instances, as at Denham, the paintings included a 'portrait' of the person(s) whose patronage had paid for their making.

Around two-thirds of known Last Judgement paintings are above the chancel arch, where they would have complemented the sculptured

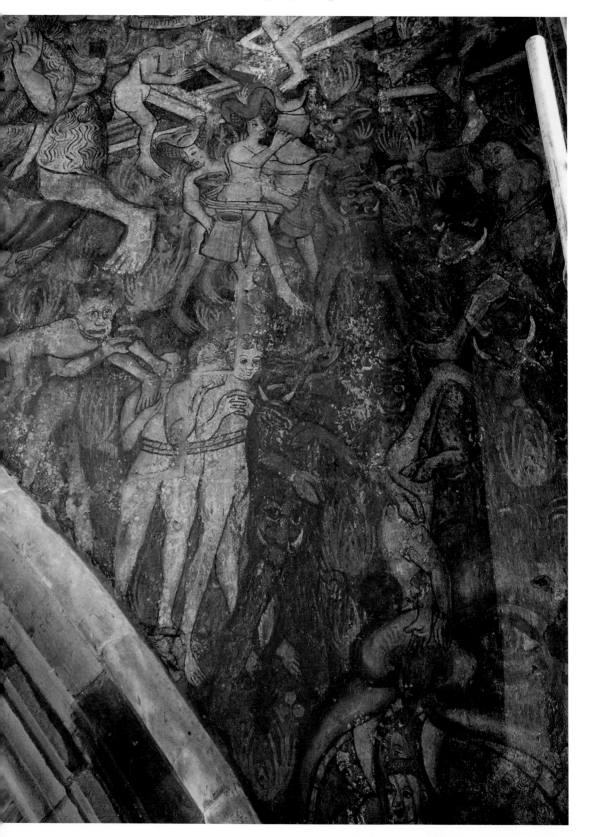

symbol of Redemption known as the Rood. Although only a few fragments of these sculptures now survive, they consisted of a wooden and painted image of the dying Christ flanked by the Virgin Mary and St John the Evangelist. All three figures were fixed above the chancel arch where they could be seen by the entire congregation.

Large and visually panoramic wall paintings of The Doom would have impressed their imagery on every worshipper. If there were no structural divisions between the nave and the chancel, or if the chancel arch was architecturally unsuitable, the painting could appear on other walls or in other media. At St Mary's, Fairford (Glos), a centrally placed tower affected how internal wall spaces were used, with The Doom appearing in glass in the west window, while the east face of the tower was reserved for the Rood sculpture supported by painted angels. Elsewhere other walls were commandeered. At West Somerton (Norfolk) the Judgement painting is on the south wall; at Oddington (Glos), it is on the north wall; at Denham (Bucks), it is above the south door; at Broughton (Bucks), above the north door; at Waltham (Essex), it is in a south chapel; and at Great Bowden (Leics), it is in a north chapel.

Apart from large-scale schemes, a few Last Judgement paintings were compressed into what are known as Abbreviated Dooms, where they could

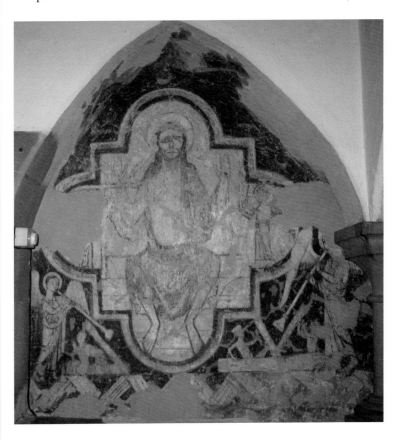

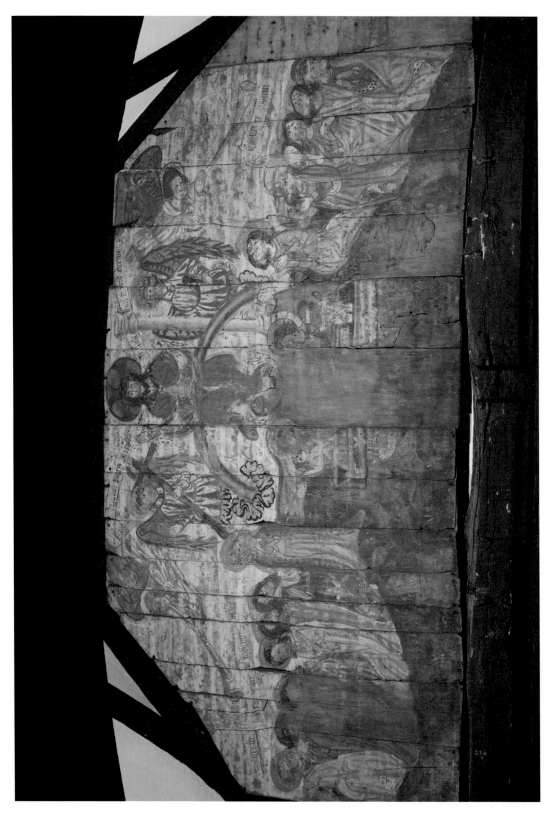

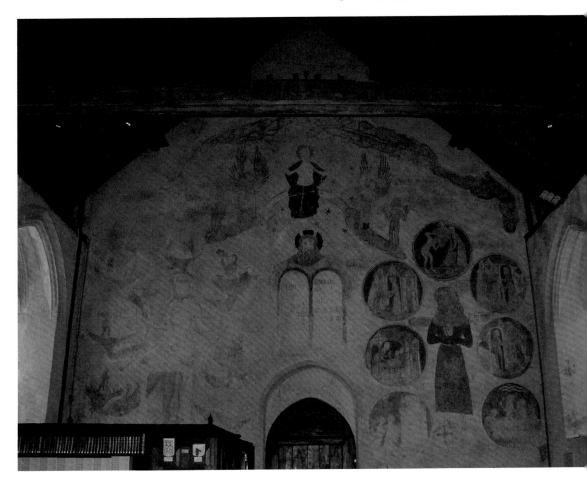

Above:
Figure 96 Abbreviated Doom surrounded by The Seven Works of Mercy and The Seven Deadly Sins: Trotton, St George, *c.* 1400.

Opposite:
Figure 95 The Doom on oak boards: Penn, Holy Trinity, *c.* 1500.

appear in smaller spaces or as part of a complex scheme conflating several themes into one. Such paintings usually incorporate a full frontal Christ showing his wounds while angels blow trumpets or hold Instruments of the Passion and the dead rise from their graves. Some of these images might be above tombs, as at East Bedfont (Greater London). (94) At Trotton (West Sussex), a unique large-scale painting on the west wall made around 1410 shows an Abbreviated Doom of Christ in Judgement sitting on a rainbow, while directly below Moses holds the tablets of God's commandments open like the pages of a book. To Christ's left, an archetypal good man is surrounded by scenes depicting the Seven Works of Mercy, while on the right the Seven Deadly Sins cluster around a naked man. Conceived as a whole the entire composition delivers an unequivocal message that links piety in life to the verdict of Judgement in death. (96)

In a few churches the Doom scene was painted on wooden boards and inserted into the space between the chancel screen and the top of the arch itself. Such panels can be seen at Dauntsey (Wiltshire); Micheldean

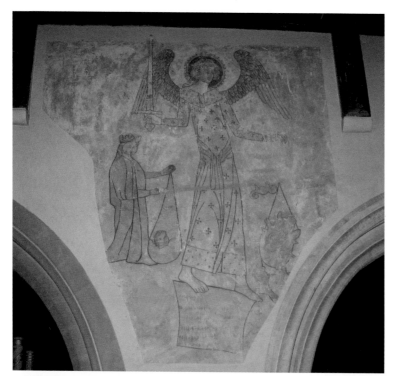

Left:
Figure 97 The Weighing of Souls: Catherington, All Saints, mid-fourteenth century.

Below:
Figure 98 The Weighing of Souls overpainted with Victorian 'restoration': South Leigh, St James.

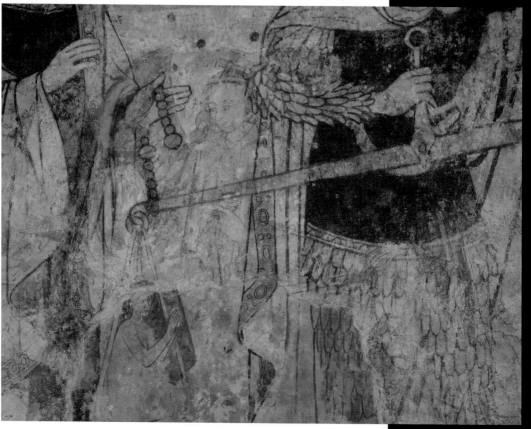

(Glos); Wenhaston (Suffolk) and Penn (Bucks). (95) A small group of different but related paintings where Christ appears holding the swords of Judgement survive at Widford (Herts), and Bishopsbourne (Kent).

The Weighing of Souls

Another frequently painted image reinforcing themes of Judgement and the afterlife showed the winged archangel, St Michael, holding a balance weighing the souls of the dead in a pan.

The earliest wall painting of this subject is at Chaldon. Similar images are known in Christian art since the second century and may have even earlier roots. Just as paintings of the Last Judgement evolved, so too did the iconographical composition and location of this accompanying subject painting. By the fourteenth century it was usually shown separately from a Doom painting, often on an adjacent wall. And whereas The Virgin Mary was absent from earlier imagery, later wall paintings of The Weighing of the Souls included her interceding on behalf of the penitent by dropping her rosary into the pan while a frustrated devil tugs vainly in the other direction, as at Catherington, (Hants). (97) A few instances portray the Virgin Mary as *Mater Misericordiae*, with souls huddling under her cloak, as at Byford (Herefordshire). At South Leigh (Oxon), an original painting of this scene can be seen below a later, and larger, Victorian over-painting made in 1872. (98)

The Three Living and The Three Dead

Figure 99 The Three Living and The Three Dead: Raunds, St Peter, *c.* 1420.

Paintings of two other subjects complemented these Judgement images, not directly but implicitly, in both cases reminding their audiences of the transience of life and that whatever earthly beauty or status someone might enjoy, Death and Judgement were inescapable irrespective of rank and privilege.

The first of these subjects, *The Three Living and The Three Dead,* had French origins and appeared in manuscripts towards the end of the thirteenth century. No directly comparable examples are known in stained glass.

The standard scene shows three kings on foot hunting in a forest, often representing the three ages of man: old, adult and young. All are finely dressed. Fashionable clothes and the trappings of wealth, such as trimmed forked beards, are sported. Sometimes one or more has a hawk on his wrist. A rare version at Charlwood (Surrey) sees the nobles mounted.

As they hunt the kings come across three walking skeletons, sometimes shown in advanced states of decay with worms oozing from their putrefying flesh. Contrasting landscapes consumate the moral. At Raunds (Northants) the living kings appear against lush greenery with a white rabbit in the foreground nibbling fresh grass. The dead meanwhile, emerge from a brown and barren terrain devoid of life and colour. At Packwood (Warks), the scene makes an unusual appearance on the east wall of the nave, either side of the chancel arch. Some paintings contain remains of inscriptions, with the earliest example in English surviving in

Figure 100 'Erthe out of erth': The Guild Chapel, Stratford-upon-Avon, late fifteenth century.

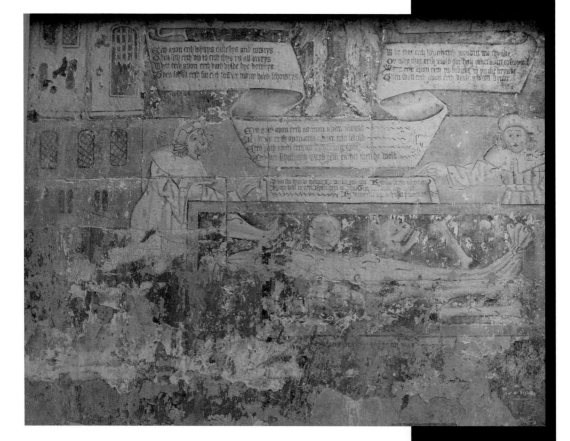

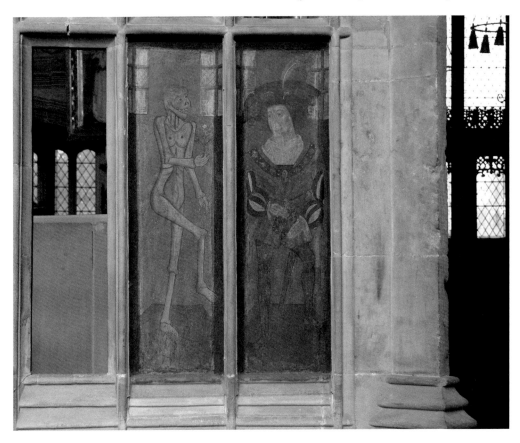

Figure 101 'Death and the Gallant': Newark-on-Trent, St Mary, sixteenth century.

a fourteenth-century scheme at Wensley (Yorks) '*[AS] WE A[RE] NOVE (Now) [THUS] SAL (Shall) THE (Thee) BE [B] WAR WYT (Beware with) ME*'. Most inscriptions echo these words:

"Who are you?" The kings inquire.

"As you are, so were we: As we are, so you will become," the walking dead reply.

At Belton (Suffolk), some now lost inscriptions provided a running commentary on the kings' tremulous reaction as the meaning of these words dawn on them, beginning with (1) 'O benedicte', followed by (2) 'O marvellous syte is that I see', and then finally, (3) 'I will fle'.

The Dance of Death

A related but rarer variation of this same theme appears in paintings known as The Dance of Death, in which 'Death', represented as a grinning skeleton, waltzes between a procession of people, male and female, young and old, rich and poor, randomly choosing those to die. Once again it reminds its audience that the only predictable outcome of life is Death and Judgement.

The most famous of these paintings in the cloisters of old St Paul's Cathedral (London) was destroyed during the Reformation. However, degraded remains of a similar scheme survive behind panelling on the north wall of the Guild Chapel in Stratford-upon-Avon (Warks). Elsewhere in this church the remains of an even rarer related scene are hidden behind panelling in the west wall. It shows a body wrapped in a shroud being eaten by worms while inscriptions from an allegorical poem known as '*Erthe oute of erth*' unfold around an angel. (100) At Newark-on-Trent (Notts), panels on the external wall of the Markham Chantry Chapel show Death holding a freshly plucked flower as it jigs towards a foppish young man. (101) It is similar to a now lost painting of around the same, early-sixteenth-century, date known as *Death and the Gallant*, previously visible on the south wall of the now demolished Hungerford Chantry Chapel in Salisbury Cathedral.

Figure 102 Pride purged by Death, the Seven Deadly Sins: Raunds, St Peter, *c.* 1420.

Pieties: Good versus Evil

Another set of 'moral' subjects focused on Christian duties, in life and in church. As mentioned in Chapter 1, from the early thirteenth century onwards a succession of papal degrees and Episcopal Constitutions stressed

Above:
Figure 103 The Seven Deadly Sins riding animals: Llangar, Church, fifteenth century.

the importance for lay people to make an annual 'Confession' to their priest, during which they would be questioned about their knowledge of Christian beliefs and how they lived their lives. Key to these values was that obligations to others superseded personal self-interest.

Using texts and pictorial models developed from other imagery, a number of wall paintings provided contrasting pictures of sin and salvation, good and evil, with potentially didactic, or self-teaching, implications for the rigours of Confession.

Known as the Seven Deadly Sins and the Seven Works of Mercy, paintings of these subjects began appearing on walls from around the first quarter of the fourteenth century and continued to be made until at least the last years of the fifteenth.

Right:
Figure 104 'Lust' – (top), and 'Anger', The Seven Deadly Sins: Raunds, St Peter, c. 1420.

More than fifty examples of paintings of the Deadly Sins have been recorded and slightly fewer of the Works of Mercy. Paintings of both subjects can appear in the same church, as at Hessett (Suffolk). In a few instances, the subjects were contrasted within the same painting, as at Oddington (Glos).

Unlike paintings of Christ or saints, there was never a fixed model or format for these particular schemes. Those showing the Sins appeared in at least eight different ways and those of the Works of Mercy in seven different schema. Nor was there any consistency in the order in which individual Sins or Mercies were shown or the position in the church where they appeared.

Wall paintings of the Sins (Pride, Envy, Anger, Lust, Avarice, Sloth,and Gluttony), might be depicted diagrammatically as sprouting from an evil tree, as at Crostwight (Norfolk); as spokes emanating from the hub of a wheel, as at Kingston (Cambs); surrounding a naked, and by implication, licentious man, as shown at Little Horwood, or issuing from a richly well-dressed woman symbolising Pride, the worse of all sins, who, at Alverley (Shrops) and Raunds, is

Opposite top:
Figure 105 The Seven Works of Mercy, Visiting a Prisoner: Potter Heigham, St Nicholas, fourteenth century.

Opposite bottom:
Figure 106 Christ surrounded by The Seven Works of Mercy: Linkinhorne, St Mellor, early fifteenth century.

herself purged by Death. (102) Other variations might emphasise the demonic paternity of the sins, showing them spewing from the mouths of dragons, as at Hessett, or sputtering from a belching Hell mouth, as depicted at South Leigh. At Hardwick (Cambs) and Llangar (Wales: Denbighshire) the sins ride allegorical animals. (103)

A further refinement was the depiction of individual sins within this overall design. Thus envy could be portrayed as a woman tearing her hair out; anger, as a man stabbing another with a knife; gluttony as a man guzzling from a wine jug; lust, as a man and woman lying side by side. (104)

Paintings of The Seven Works of Mercy (Feeding the Hungry, Giving Drink to the Thirsty, Clothing the Naked, Giving Hospitality to Strangers, Visiting Prisoners, Visiting the Sick and Burying the Dead) often employed a similar schematic format, illustrating the individual acts within a larger composition.

These might include scenes of a man or woman performing the separate acts of charity as a succession of good deeds, as at Ringshall (Suffolk); or again diagrammatically, as growing from the branches of a tree, as at Edingthorpe (Norfolk); set within a wheel, as shown at Arundel (West Sussex); arranged around an archetypal good man, as at Ruislip (Greater London); or good woman, as at Potter Heigham (Norfolk); (105). In other instances they were shown encircling an angel, as depicted at Dalham (Suffolk); and radiating from the grace of Christ himself, as at Linkinhorne (Cornwall). (106) At Ruabon (Wales: Denbighshire) angels inspire and accompany the good deeds. In several examples, as at Moulton St Mary (Norfolk) the scheme included an eighth scene of Christ blessing the Mercies.

TRANSGRESSIONS

Three other subjects shown by wall paintings also alluded to sin. They are known as the Sunday Christ, the Warning to Blasphemers and the Warning to Janglers and Idle Gossips. All three admonished transgressions from the standards expected of devout Christians.

The Sunday Christ

By far the most common of these painting to have survived are images of the Sunday Christ, an emblematic creation designed to convey the literal consequences of defying the edict to keep the Sabbath holy by refraining from work or misbehavior. At least twenty-four examples are

Figure 107 The Sunday Christ:
Breage, St Breaca, fifteenth
century.

known, with the first appearing on church walls from the middle of the
fourteenth century. A typical painting shows a full length image of Christ,
wearing only a loin cloth and bearing his five wounds, surrounded by an
assortment of the tools used by different tradesmen, such as axes, hammers,
saws, a wheelwright's shave, cleavers and combs. At West Chiltington
(West Sussex) and St Just (Cornwall), a pair of shears cut into his leg.
At Llangybi (Wales, Monmouth) and Poundstock (Cornwall), a two-
handed saw inflicts a similar injury. The message was uncompromising.
Working on the Sabbath added to the wounds suffered by Christ for
mankind. It should not be done. Various punishments entrenched the
point. Sometimes persistent Sabbath breakers were ordered to appear in
church bareheaded and barefooted in penance. An extreme case in 1470
saw a group of London cobblers excommunicated for flouting reprimands
not to sell shoes on holy days.

For much of the last century various romantic interpretations were
applied to this painting. Some writers thought it expressed the fourteenth-
century poem charting the quest of Piers Plowman, a humble labourer,
for a true Christian life. Others speculated that it might represent a quasi-
socialist Christ celebrating honest toil and artisanship and called it 'The
Christ of the Trades'. When a painting similar to the English examples
was discovered in Italy, at St Miniato outside Florence, in the 1930s, a
long inscription made the meaning very clear: *Cui no guarda la Domenica
sancta a christo no a devotione, Dio li glidade in eternale damnatione* (He
who does not keep the Sunday holy and with devotion to Christ, God
will consign him to eternal damnation).

This group of paintings does not seem to have occupied any particular site in the church. As late arrivals to church walls, many had to jostle for space or to rely on parishioners being willing to overpaint some earlier imagery, as at Oaksey (Wilts), where a large-scale figure of Jesus, possibly in a *Noli me Tangere* pose, was converted into a Sunday Christ. As a result, while some representations are tucked into window splays, as at West Chiltington, others are gigantic, as at Breage (Cornwall). (107) There are no examples of this image in glass.

Warning to Blasphemers

A now lost painting at Walsham-le-Willows (Suffolk), may have conflated a figure of the Sunday Christ with similar shock tactic imagery designed to make a related point about Christian behaviour. Its aim was to turn lines like those in Chaucer's 'The Pardoners Tale':

> *and many a grisly ooth thane hah they sworn;*
> *And crustes blessed body they to-rente*
> (and many a grisly oath then have they sworn;
> And Christ's blessed body they tear apart)

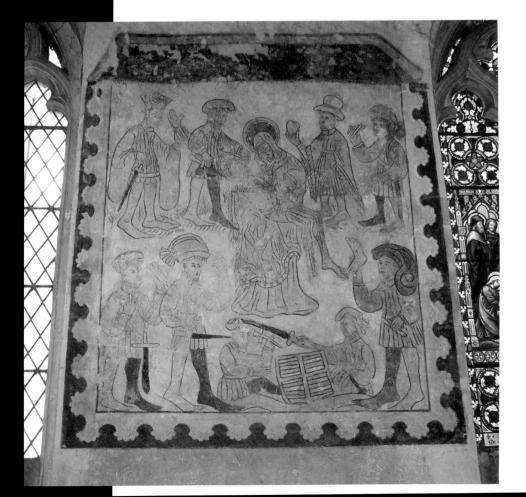

Figure 108 Warning to Blasphemers: Broughton, St Lawrence, late fourteenth century.

into a hard-hitting visual rebuke. Known as 'The Warning to Blasphemers', wall paintings of this subject attempted to shame those who misappropriated Christ's name by invoking parts of His body as they swore, by showing images of His arms, legs, or feet being wrenched from His body by their sins. In a painting made around 1400 at Corby Glen (Lincs), the swearers are swaggering young men, surrounded by devils. At Broughton (Bucks), a slightly later painting shows the culprits waving various limbs of Christ's torn and bleeding body. (108) Both paintings appear on a north wall.

Only two examples of this subject now survive – both some distance apart and with differences between them. A similar image, now lost, was painted on glass at Heydon in Norfolk. After the Bishop of Norwich died in 1499 a 'Visitation' was carried out in the diocese during which an investigator interrogated priests and churchwardens about the behaviour of their fellow parishioners. A man who was convicted of swearing by the limbs of Christ was ordered to offer a candle to his local church in honour of His body as a penance.

Below right:
Figure 109 Warning to Janglers: Slapton, St Boltolph, fourteenth century.

Below left:
Figure 110 Warning to Janglers: Berkeley, St Mary.

Warning to Janglers and Idle Gossips

The final subject in this category makes its point by linking transgressions in church to the snares of devils. Known as 'Warnings to Janglers' or 'Warnings to Idle Gossips', these paintings scolded chattering and inappropriate behaviour in church. Without exception they show two women in animated conversation while devils huddle around them. In some instances the women hold prayer beads, implying that they are tattling during the sacred ritual of the Mass itself. Such behaviour would be remembered on Judgement Day.

Wall paintings of this subject appeared from around 1300 onwards, with the earliest survivals at Brook and Crostwight. Nearly twenty examples can be seen. At Eaton (Norfolk), on the outskirts of Norwich, the devils defecate or fart as they prance around the women. At Slapton, a horned demon looms behind them. (109) Many of these paintings appear on walls towards the rear of the church (no doubt where the usual miscreants clustered) or above the north door where they would be seen as the congregation assembled. Only one painting is on the east wall of the nave where it confronts the entire congregation, at Melbourne (Derbys). Although paintings of this subject are nearly always found in the eastern counties of England, a mid-thirteenth-century carving on a south arcade pier at Berkeley (Glos), shows that the idea itself was known elsewhere and possibly at an earlier date. It portrays a menacing toad crouching above two chattering women. (110) Similar imagery can be found elsewhere in Europe.

Suggestions that these paintings are linked to witchcraft seem unfounded.

Although often accused of being misogynist in an unapologetically misogynist age, a window at Stanford (Northants) shows the janglers as a man and a woman. Court records in Norwich of 1430–33 document parishioners complaining about the behaviour of two men whose conduct included 'chattering continuously' during holy services. In the Norwich 'Visitation' of 1499, mentioned previously, eight people were reported as 'chattering' in church.

CHRISTIAN SYMBOLS & ALLEGORIES

Signs of the Zodiac

Wall paintings of this subject are rare in parish churches and none survive post-1200. They appear on chancel arches below images of Christ in Majesty where they use both the curves of the architecture itself and

their location to illustrate the idea of Christ as master not just of earth, but also of astrological time and space, as at Copford. Remains of a secular example survive in the Lower Ward of Windsor Castle (Berks).

The Labours of the Month

Like paintings of the signs of the Zodiac, this subject also illustrates God's mastery of time and seasons. It pairs the annual cycle of nature with the church calendar, manual labour with spiritual endeavour. A Victorian reconstruction of a thirteenth-century scheme appears on the presbytery vault at Salisbury Cathedral, while at Easby (Yorks) four scenes of a once much larger scheme survive in the window splays of the chancel. (111)

The Wheel of Fortune

More common, but still rare, are wall paintings of the Wheel of Fortune. Drawn from a Greek or Roman prototype, the allegory was based on the idea that the lives of men, especially kings, could rise and fall as favours were given or withdrawn by the goddess of luck. Adopted by Christian authors ranging from the sixth-century Boethius, in his influential *Consolation of Philosophy*, to fourteenth-century writers of

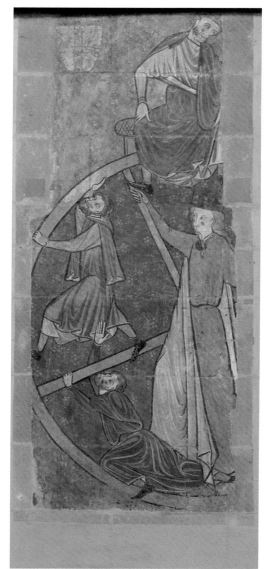

popular romances, the image often appeared in court circles, where political fortunes were insecure. At Catfield (Norfolk) a much faded painting seems to have included the Latin inscription '*regno, regnabo, regnavi, sum sine regno*' (I reign, I will reign, I did reign, I am without a kingdom). An example with the inscription '*regno*' can be seen at Ilketshall St Andrew (Suffolk). (233) In the choir of Rochester Cathedral (Kent), Fortuna spins the wheel. (112)

The Wheel of Life

Again rare, this scene shows a wheel depicting different phases of life. It might include the head of Christ at the hub and radiating spokes enclosing scenes such as infancy, youth, manhood, maturity, old age, decrepitude, death and burial, as at Leominster Priory (Herefordshire). Similar schemes are sometimes called 'The Seven Ages of Man'. At Kempley a painting with ten scenes survives on the north wall of the nave. (221)

Ecclesia and Synagoga

Only a few examples of this category of subject painting still survive. Depicted as two female figures, it contrasts the triumph of the Christian church, *Ecclesia*, with the defeat of the Jewish Old Testament *Synagoga*, which is shown blind-folded, unable to see the truth revealed by the New Testament and sometimes holding a broken spear, the symbol of its lost authority, as at Little Casterton (Rutland).

THE MISSING SUBJECTS

Opposite top:
Figure 111 The Labours of the Month: Easby, St Agatha, mid-thirteenth century.

Above:
Figure 112 The Wheel of Fortune: Rochester Cathedral, mid-thirteenth century.

In addition to the subjects that were shown, a surprising number of others were not. Although images of individual (and often unidentifiable) bishops are common, most of these omissions can be defined as subjects relating to the church itself: particularly its institutional history and sacraments.

Thus while fifteenth-century chancel screens were often painted with images of great theologians, the so-called Four Doctors of the Church,

St Ambrose, St Augustine of Hippo, St Gregory and St Jerome, there are few wall paintings of such figures. Only one instance survives on the walls of a parish church, at St Gregory's, Norwich (Norfolk). (130) With a couple of exceptions and in different contexts, the same is true of representations of the Four Fathers of the Church, the founding Popes who shaped its growth and organisation.

Figure 113 Battling Knights: Claverley, All Saints; early thirteenth century.

More significant are other omissions, such as The Apostle's Creed and The Seven Virtues.

Representations of the Creed or *credo*, the formal statements of Christian belief, were usually shown as inscribed scrolls being held by the Apostles. Although appearing frequently on chancel screens and on glass, such images were rarely painted on walls.

Again, with one exception at Cranbourne (Dorset), paintings of the Seven Heavenly Virtues (Fortitude, Justice, Prudence, Temperance, Faith, Hope and Charity) which St Gregory the Great had paired as the opposite to the Seven Deadly Sins, are also missing. A suggestion that a frieze fifty-two feet (15.8m) long of battling knights at Claverley (Shrops), made around 1210, represents an allegorical clash between these Virtues and

Figure 114 Water colour copy of a wall painting of The Seven Sacraments formerly in St Andrew's Church, Kirton-in-Lindsey (Lincs). By permission of the Society of Antiquaries, London. (Lincolnshire red Portfolio, f.25)

their opposing Vices stumbles as heavily as the falling riders it depicts. The number of combatants does not match the number described in the fourth-century Roman poem, the *Pyschomachia* by Prudentius, and it is impossible to tell which horseman is a Vice or a Virtue. (113)

Another inexplicable omission are paintings of the Seven Sacraments, the essential rituals of the church (Baptism, Confirmation, Mass, Penance/Confession, Extreme Unction, Ordination and Matrimony). Although depictions of these ceremonies can be mapped from the 1420s, only a few wall paintings of this subject are known, including a now lost example at Kirton-in-Lindsey (Lincs), which illustrated the Sacraments as streaming in lines of blood from Christ's wounds on the cross, very similar to an arrangement that can still be seen in a fifteenth-century stained glass window at St Anthony's Church, Cartmel Fell (Lancashire).(114)

It is impossible to say with any certainty why these omissions occurred. We were not there. We do not know. Certainly, the Romanesque Church was more focused on the Liturgy (rituals of public worship) than on textual

education. In later centuries, perhaps the use of paintings to define sacred spaces, to provide 'holy corridor routes' for processions and to complement supportive imagery for devotion continued to take precedence.

A network of customs, traditions and conventions may also have circumscribed what subjects were appropriate for showing on walls rather than in other locations or media. Perhaps the size of paintings dictated subject choices. Patrons, priests and worshippers might also have preferred familiarity, drama and immediacy, personal identification and spiritual bonds with the subject choices that were portrayed, rather than obscure theology or rigid pedagogism. Aesthetic values could have been influential.

At Salisbury Cathedral, for example, the thirteenth-century decoration of the Trinity Chapel saw the decoration of the walls subordinate to stained glass, with the glazing scheme providing most of the brilliant colour. And perhaps, like any speculation, the real explanation is possibly none of these ideas or elements of all of them.

Certainly such reasons fail to throw any light on another noticeable omission: the lack of any wall painting schema tailored to the baptismal font.

Such imagery was common in the early Mediterranean Church, as at Dura-Europos in Syria where a baptistery made about AD 230 featured wall paintings of the miracle of Christ walking on water and the story of the Samarian woman at the well, both of which allegorised baptism. But nothing similar seems to have appeared in English medieval churches.

Similarly, there are no explicit paintings attacking heresy, especially the late-fourteenth early-fifteenth-century movement derided as Lollardy, meaning mutterer or mumbler, whose supporters ridiculed the Mass and denied the Eucharist.

Despite the alarm that such threats posed, a scheme of now mainly lost paintings made around 1400 above the south arcade at Friskney in south Lincolnshire seems to be the only *prima facie* example which could be interpreted as having an intended anti-Lollard slant. The scheme included the Pope wearing the vestments of the Mass surrounded by the Doctors of the Church; the Gathering of Manna from Heaven by the Jews during their escape from Egypt ('man does not live by bread alone'); The Last Supper, with its obvious Eucharist symbolism; St Edward the Confessor receiving a vision of the Christ child in the host; the story of St Gregory

and the Irreverent woman, who mocked the idea that some bread she had baked could become the body of Christ, only for it to become flesh on the altar; and, lastly, the Jews stabbing the host as it bled. Of course, it is possible that such imagery formed an entirely self-enclosed scheme devoted to the Miracle of the Eucharist or the feast of Corpus Christi (the body of Christ), but with Friskney so close to the hotbeds of Lollardy in north Norfolk, other possibilities cannot be ruled out.

Certainly the paintings would have allowed a preacher to draw parallels between the desecration of the host by the Jews who crucified Christ and the heresies of Lollards, whose views could be accused of having the same effect. The decoration of twenty-five fonts in Norfolk with scenes of the Seven Sacraments, including the Eucharist and other rites rejected by the Lollards, has raised similar queries elsewhere.

And finally there are no paintings which directly address contemporary secular life such as the struggles with France during the Hundred Years war or the loss of Christian Constantinople to Muslim Turks in 1453. While soldiers and their relatives may have sought the protection of St George only one painting, at Hornton, appears to carry a reference to moments like Crecy and Agincourt: a diaper of single feathers similar to those found on the Arms of the Black Prince. (115) However, the fact that the same pattern extends as background decoration to other parts of the nave east wall dilutes even this association. (71)

Attempts to link paintings of the Last Judgement to the demise of around a third of the population in the wake of the Black Death in 1348 are also less convincing than they might seem at first glance. Equally prominent imagery can be seen at Houghton-on-the-Hill and in other Romanesque churches of the eleventh and twelfth centuries. Many of the Dooms we see today were painted when churches were rebuilt and enlarged during the late Middle Ages, providing artists with acres of new 'canvas'. On the other hand, the spread of death-related art during the fifteenth century, and, in particular, the talismanic popularity of St Christopher and instances such as the painting of St Roche at Pinvin, may well be related to recurrent outbreaks of pestilence, as lamented by the early-fifteenth-century inscription in the chancel at St Edmund's, Acle (Norfolk), wailing how death was snatching 'now these, now those, now people everywhere'.

With a handful of possible exceptions, it is clear that the subjects shown in wall paintings were never contemporary propaganda, but rather an institutional pictorial form that used architectural spaces in a distinct, well-understood and purposeful way to provide commonly known and valued images of Christian faith, moralities and liturgy to an expectant public audience. We may puzzle over some of their choices. Medieval viewers did not.

Patrons & Painters

B y medieval standards, it was the people who commissioned wall paintings who were regarded as having 'made' them, not the artists. This had far-reaching implications for what was painted and how. Artists were subordinate to patrons.

In the early Middle Ages, these 'makers', or patrons, of wall paintings were major institutions such as the Crown, religious foundations, and the governing aristocracy of big landowners who asserted their political, economic and religious leadership by building churches and providing religious art as proof of their virtuous piety and social ambition. In later centuries, the range of such patronage grew to include a much broader pool of donors, including local manorial families, affluent individuals such as farmers and merchants and finally, groups of devout lay people working together in guilds and as parishioners.

Thus the outstanding Anglo-Saxon wall paintings at Nether Wallop have been linked to ancestors of the powerful Godwin family mentioned in the Domesday Book as holding land in the area.

Again, the paintings in the 'Lewes Group' of churches in West Sussex have been attributed to a wealthy patron(s). Candidates include the local Cluniac Priory of St Pancras in Lewes and William de Warenne, second Earl of Surrey (d. 1138), whose father had founded the Priory between 1078–82. As we have already seen, at least parts of the schemes in these churches, including rhyming Latin scripts, were almost certainly unintelligible to the community they were supposed to serve. Such paintings were invariably 'imposed art' from above, simultaneously depicting religious imagery as well as the authority, learning and territory of the church, and the wealth, taste and piety of those who commissioned and approved the schemes.

Above:
Thomas Gifford: South Newington, St Peter ad Vincula, fourteenth century.

Complex imagery of a similar date elsewhere may provide a clue as to the kind of art painted in greater churches or private castle chapels around this time. At Kempley, on the borders of the Welsh marches, for example, the splendid paintings in the chancel of the tiny church of St Mary have been attributed to the patronage of Hugh de Lacey, a Norman lord who also gave a collegiate church founded by his father, Walter de Lacey, to St Peter's Abbey (now Gloucester Cathedral) in 1101. As a result, perhaps the *c.* 1130 wall paintings in St Mary's church illustrating themes from St John's astonishing visions of the end of the world, as described in the *Book of Revelation*, were conceived for the de Lacey household either by monks from St Peter's or by priests attached to his family.

A different and later example of sophisticated patronage can be detected at Brook, fourteen miles south of Canterbury, where Ernulf, the Prior of the Cathedral 1096–1107, added a formidable west tower with a first-floor chapel to the local church. Around 1250 another, but unknown, patron commissioned a scheme of at least fifty-six paintings of Christ's Holy Infancy and Passion for the chancel, each scene set within medallions measuring two feet, or 60 cm, across. Many of those on the south and east walls survive. They incorporate both Biblical and apocryphal stories and were painted in rich vermillion and gold leaf. Screened from local parishioners, they represent an immensely expensive and refined taste, clearly another product of the cathedral and its circle.

Figure 116 Heraldic decoration: Hailes church, early fourteenth century.

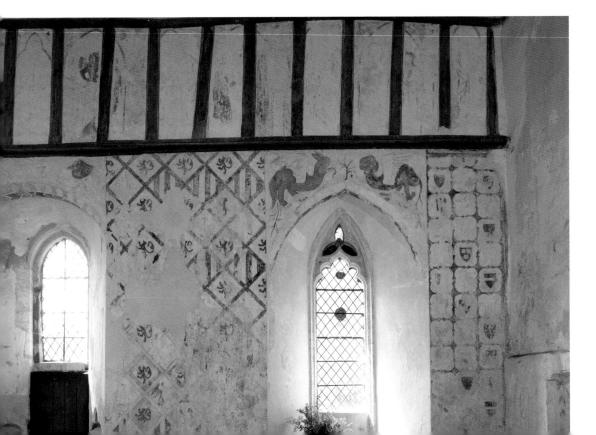

Better evidence about patronage in parish churches surfaces in the thirteenth century, when the laity assumed responsibility for the upkeep of the church and subjects more attuned with the religiosity of local donors began to appear.

Examples of patronage displayed through decorative heraldry were added to schemes in the first half of the century, as with the painting of the Bluett family arms made around 1230 in the chancel at Silchester. (23) Thereafter such pronouncements of remembrance and commemoration became increasingly common. Among the best examples are those at the *Capella ante Porta*, outside the gates of Hailes Abbey (Glos), a Cistercian monastery founded in 1246 by Richard, Earl of Cornwall, after he had survived a perilous voyage from Gascony to England. A diaper of his spread-eagle device appears on the south and north chancel walls together with those of two of his wives, Sancha, daughter of Raymond Berengar, Count of Provence, and Beatrix of Valkenburg. (116) Other heraldic shields in the same scheme include those of some of the great barons to whom Richard was related through marriage. Such tributes synthesised piety with patronage and 'ownership' of the church. At Camely (Som) the arms of its overlords, the de Clares, Earls of Gloucester, appear as a proprietorial signature on the inner walls of the chancel arch opposite those of the king. (117)

Bottom left:
Detail Heraldry: Hailes church, early fourteenth century.

Right:
Figure 117 Heraldry: Camely, St James, fourteenth century.

At Chalgrave, a display of eighteen shields (of an original twenty-one)

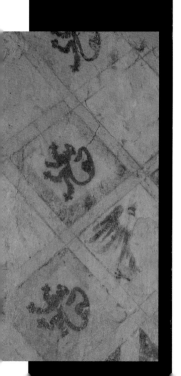

hanging from fictive straps, or guiges, are painted along the entire length of the nave arcades. They incorporate both the heraldry of the Loryng family, whose tombs survive in the church, and other Bedfordshire 'comrades-in-arms', such as the Mortaynes, who probably contributed to the cost of rebuilding the chancel and the south arcade around 1310. (118)

The inclusion of heraldic devices within schemes or individual paintings can also be seen, as with the arms of Richard Fitz Alan (died 1376), at Catfield (Norfolk), and at Ashby St Ledgers, where the arms of the Catesby family, the local manorial lords, crowd a painting of St Christopher (119). Lesser gentry followed suit. At Molesworth (Cambs), the arms of Sir Stephen Forster, a local boy made good as a fishmonger

Figure 118 Heraldry: Chalgrave, All Saints, mid-fourteenth century.

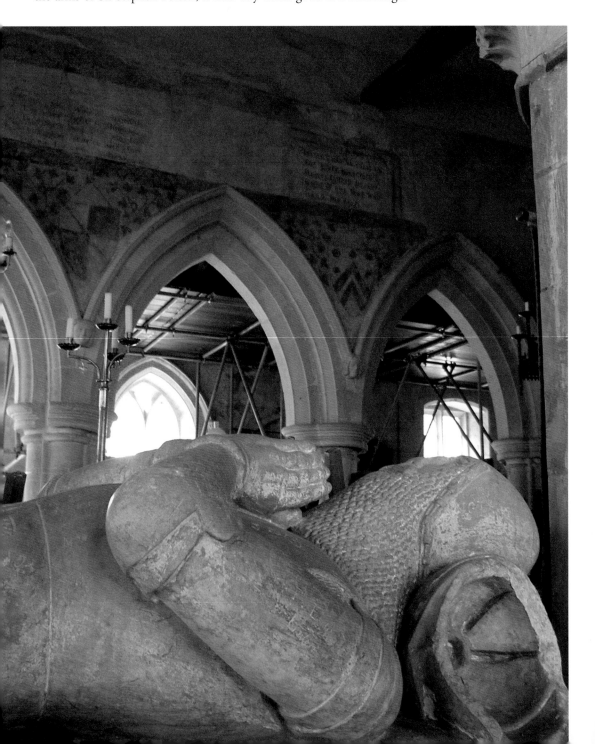

Figure 119 The arms of Catesby in a St Christopher painting: Ashby St Ledgers, St Mary and St Leodegarius, early fifteenth century.

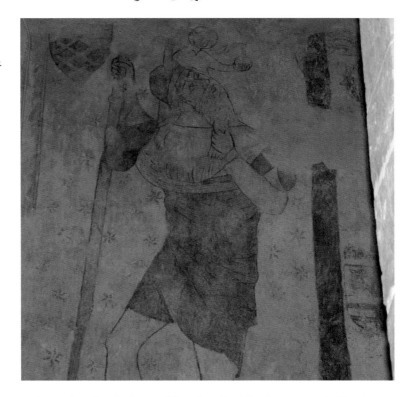

and one time Lord Mayor of London (1454), cling to survival in the top right corner of a painting of St Christopher. At St Gregory, Norwich, the arms of John Reede, an important figure in the town, appear on the south wall. At Henstridge, in Somerset, a now lost painting of St Christopher included the same heraldic shield as can still be seen on the tomb of William Carent (d. 1463) and his wife, Margaret.

In the fourteenth century, representative images of patrons and donors also began to appear in wall paintings sometimes accompanied by textual inscriptions saying who they were.

One of the most famous of these 'donor portraits' was made *c.* 1355 in St Stephen's Chapel at the Palace of Westminster, where royal power, divine kingship and Christian humility were fused for all to see. Now known only from a drawing, it depicted the king's wife, Queen Philippa, and their four daughters kneeling beneath scenes of the Infancy of Christ on the south side and the figures of Edward III and his five sons being presented to the Virgin and Child by St George on the north side of the east wall. (120)

Such paintings were always characterised by the donor or patron shown in smaller proportion than the holy figures they adored and with their hands tightly clasped in prayer. Although not portrait-type likenesses, these paintings were nonetheless personal. Donors were shown in contemporary dress and with distinguishing features such as

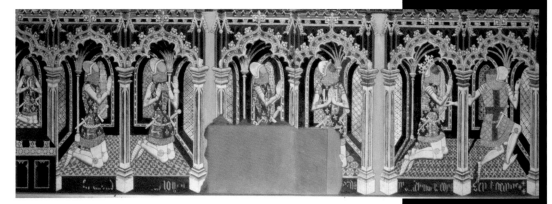

a tonsure for a monk as at Glatton (Cambs), or, if a married couple, as a man and a woman either side of the main figure in the painting, as at Cockthorpe (Norfolk). At Nassington (Northants), a single male donor has a trimmed beard. (121) At Westminster, in the painting mentioned above, Edward III was shown wearing the crown of England and his eldest son, a princely coronet.

Some inscriptions also survive. A scroll at Cawston (Norfolk) identifies one of the two priests kneeling before a painting of St Agnes as John Bridale, the vicar of nearby Wood Dalling. (123) At Brent Eleigh

Figure 120 Edward III and his family: St Stephen's Chapel, the Palace of Westminster, mid-fourteenth century (Painted by Richard Smirke, *c.* 1800–11 Copyright, Society of Antiquaries, London.)

Below left:
Figure 121 A donor pleads to the Virgin Mary during the Weighing of Souls: Nassington, St Mary and All Saints, fourteenth century

a tonsured figure labelled 'RICA (RDUS)', possibly the sacristan of St Osyth's Priory, Essex, which owned the living of the church, pleads for redemption in a painting of the Harrowing of Hell. (122)

Donor portraits and inscriptions often appear in the context of other gifts to the church. At Chalgrove, an extensively painted scheme of the Passion of Christ and the Death of the Virgin in the chancel includes a prayer for the souls of the probable patrons of the work, the de Barentyn

Figure 122 A tonsured figure pleads for redemption in a painting of the Harrowing of Hell: Brent Eleigh, St Mary, late thirteenth century.

Figure 123 John Bridale: Cawston, St Agnes, fifteenth century.

family: 'Saint Mary, begetter of God, Mother of our Lord Jesus Christ, pray to [our saviour] Jesus for the souls of the Lords of Warborough'.

At Raunds, portraits of some local fifteenth-century landowners, John and Sarah Catlyn, include a request for people to pray for their souls as they kneel either side of the painted clock they had donated. (159)

At Fritton (near Long Stratton, Norfolk), the will of John Alvard (or Alverd) encompassed a range of patronage. Dated 1506, among his bequests were gifts of land for the repair of the church and £7 in cash

Figure 124 The Camoys family at prayer: Trotton, St George, *c.* **1410.**

for the church roof. A wall painting of St Christopher in the church made around the same time includes part of an inscription which once mentioned John and his wife, Johanne.

An important scheme at Trotton combines heraldry, donor portraiture and inscriptions, as well as other symbols of status. The local lord was Sir Thomas Camoys (d.1421), who was inducted as a Knight of the Garter after commanding the left flank during Henry V's epic victory at the Battle of Agincourt in 1415. Sir Thomas is shown kneeling at a *prie dieu* and facing eastwards towards the altar near where he was buried. Behind him, Richard Camoys, his son (d.1416), and Joan Poynings, his daughter-in-law, also kneel in devotion. Family crests and shields proliferate. Around and below the kneeling figures are shields with the Camoys's plates (three roundels), and a tree hung with the Poynings crest of a dragon and a crowned key and the inscription 'Poynings' above. (124) Elsewhere in the church the theme continues on the north wall, where four uniformed retainers wear jupons, close-fitting jerkins, emblazoned with the Camoys arms and plumed helms, the Camoys crest. A later scheme in the same church maintains the tradition, showing shields bearing the arms of Camoys and Lewkenor (an important local family related by marriage) on the west wall.

Perhaps the most conceited heraldic display appears shortly before the Reformation at Boxgrove Priory, where the fourth Lord de la Warr commissioned the Chichester Cathedral artist, Lambert Barnard, to decorate the vaults of the nave with an immense heraldic history of his family set amid sprays of foliage. (34)

On some occasions, however, it is unclear whether the 'patrons' commemorated in 'donor portraits' had commissioned the paintings personally or merely presided over the institution at the time when they were made. At Westminster Abbey, for example, it is impossible to know if the image of a Benedictine monk praying to an image of the Virgin Mary with the words: 'Raise me oh sweet virgin, whom grave sin burdens; render unto me Christ's pleasure and blot out my iniquity', represents a specific individual or is symbolic of the Abbey community at large. (125)

The same is true of a painting of a monk kneeling before St Katherine in Hailes church. (126)

Again, sometimes it is ambigous as to what painting a donor(s) might have given. Although quite a number of patrons seem to have donated a single painting of St Christopher, at Peakirk an image of the saint with kneeling donors forms an integral, but separate, part of a long twelve-scene scheme above the north arcade illustrating Christ's Passion. From the available evidence it is impossible to tell if the unknown benefactors paid

Figure 125 A monk kneeling before St Faith: Westminster Abbey, early fourteenth century.

for all the paintings or just the St Christopher scene.

Apart from heraldry, portraiture and inscriptions, from the fifteenth century onwards evidence of other sources of patronage surface in churchwarden accounts. Examples include the 1503–04 churchwarden accounts of St Lawrence's in Reading that mention 'Item payd to Mylys paynt (Miles the painter) for the painting of Saint Christopher – ivd', and the 1512–13 accounts of St John the Baptist, Halesowen, in Worcestershire, which document, 'itm payed to peynt of Bromycham for pentyng the dome, xiss'.

Public subscription, as at Yatton (Som) where local parishioners of both sexes contributed to the cost of a painting of the Virgin Mary in 1467, or gifts by members of religious guilds were other sources.

Written bequests provide further evidence about late medieval patronage. In 1490, the executors of Sir Thomas Clopton, a former Lord Mayor of London and a leading member of Stratford-upon-Avon's Guild of the Holy Cross, commissioned a number of paintings for the Guild Chapel in the town.

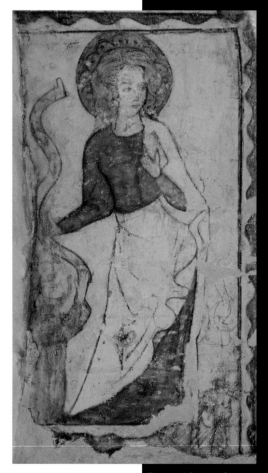

Figure 126 A monk praying before St Katherine: Hailes church, fourteenth century.

In 1491, John Cayser of East Peckham (Kent) left ten shillings for a painting of St Christopher. In 1515, the churchwarden accounts of Bassingbourn, in Cambridgeshire, include a bequest from John Dykan 'to the peynting of seynte christoffer and off seynt Nicholas'.

Finally, there are instances of inferred patronage. Just as donors of paintings, like John Alvard, who gave the St Christopher image at Fritton mentioned earlier, also provided additional monies for improvements to the church, (in John's case including the porch under which he was buried), so the patronage of other wall paintings can be inferred from contemporaneous art and monuments found in churches. At Corby Glen, for example, a large painting of St Anne and the Virgin in the north aisle is compatible with the will of Dame Margery Crioll, or Kyriel, dated 1319, which mentions 'the Chapel of our Lady, which I have built' in the church. At Ewenny Priory (Wales, Vale of Glamorgan), the tombs of the church's patrons, the de Londres family, survive in the south transept. These include the beautifully inscribed grave-slab of Maurice de Londres,

who was denounced by the pope in 1128 for robbing and defrauding the church at nearby Llandaff and killing merchants in the town.

At Slapton, a shield of the Lucy family, who held the medieval advowson of the church when many of the wall paintings were made, survives in the upper light of the nave east window. (127)

Yet despite their spiritual and altruistic underpinning, wall paintings could also capture snapshots of more earthly disputes about patronage and personal rivalry. At St Anne's Charterhouse, Coventry, for example, a large painting of the crucified Christ in the former refectory shows one of the Roman soldiers at the foot of the cross holding a banner emblazoned with the contemporary arms of John Langley of Atherstone-in-Stour, explicitly asserting its owner's victory in a long dispute about the Lordship of Shorley, on whose land the monastery stood. (32) A complicated web of multiple marriages and enfeoffments had led to the Lordship changing hands six times between 1381 and 1400, as four different families claimed proprietorial rights, until, in 1417, the wrangling was finally settled in Langley's favour just months before his death in that same year. A running text at the foot of the painting confesses the monks' relief that the uncertainty was over: 'This house has been finished, let there

Figure 127 Arms of the Lucy family: East window, Slapton, St Boltolph.

be the accustomed praise to Christ who shows favour to men … Prior Soland had a hard task, Thomas Lambard was Procurator, putting aside the problems, afterwards'.

More wall paintings with disputatious undertones can be seen at the town church of St Thomas', Salisbury. When the chancel and part of a side chapel collapsed in 1447 or early 1448 the building was repaired and

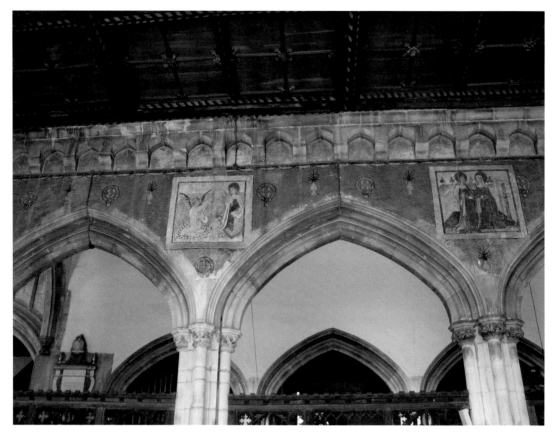

extended, with the new work being funded by wealthy parishioners. At first all appears to have gone well. The north 'Trinity' chapel was paid for by an assortment of donors while the south chapel seems to have been the sole gift of William Swayne, mayor of the town in 1444, 1454 and 1469. Painted inscriptions on the tie-beams asking for prayers to be said for his soul can still be seen along with wall paintings of the Holy Infancy appropriate for a chapel dedicated to Our Lady.

But simmering resentments and feuds also dogged the project. When Swayne obtained the support of his friend, Richard Beauchamp, the Bishop of Salisbury, to add a two-storied building onto the north-eastern side of the church in 1465 as a house for the priests who served his southern side personal chantry chapel, there was uproar, with John Halle (mayor 1450, 1456, 1464, and 1465 and a hot-tempered opponent of Beauchamp's) leading the objections. A contemporary report accused Halle of having 'by night time, riotously pulled down the said work and building to the great hurt of the said bishop'.

Significantly, after Beauchamp had been made a Knight of the Garter in 1473, wall paintings of the symbol of the order were added to Swayne's south side chapel. (128)

Figure 128 Garter arms of Richard Beauchamp: Salisbury, St Thomas, fifteenth century.

Entries in the churchwarden accounts of Yatton for 1468 tell a more parochial story of disagreement and probable unpleasantness. Without explanation it lists that two previous wardens were ordered to repay twenty shillings, the cost of a painting of St Christopher, which had either been commissioned without authorisation or had caused offence in some other way.

The significance of patronage to the making of wall paintings was pervasive. Donors, not artists, decided what subjects would be shown and how they would appear, with the richer the donor the more elaborate the commission. Without their munificence, there would have been little for us to see. But if patrons 'made' wall paintings, it was artists who painted them.

Who were they?

The short answer is that with a handful of exceptions, such as those recorded in royal or cathedral account books, we know almost nothing about them. Like most medieval art, the paintings they made were unsigned and if local records once listed payments to named artists, almost none now survive.

Contrary to some assumptions it is clear that most artists were not monks. Although a few schemes have been attributed to men like Brother John Wodecroft, who is recorded as having painted the choir at Bury St Edmunds Abbey in Suffolk around 1300, the vast majority of wall paintings were made by lay professionals who learned their trade as apprentices in workshops based in major religious and commercial centres and who remained in such localities painting churches and manor houses for most of their lives. The toponymic surnames of some of the artists recorded as working on the fourteenth-century paintings in the Palace of Westminster's St Stephen's Chapel – 'John Exeter', 'Ric.(hard) Lincoln', and 'John de Cambridge' – probably tell us not just where they came from, but also where they were trained.

A few artists may have been women. 'Agnete la peynturesse' is recorded in the Winchester tax records of 1285. An artist's wife is mentioned as working at St Lawrence's, Reading in 1511, where the churchwardens' accounts record: 'Payd to John Paynter for paynting of Sent Leonard, left by the wyff unpainted, 20 pence', but it is not entirely clear if the couple were decorating the walls or painting a statue of the saint. Despite such examples, however, most painters were male.

Nor is there any substantial evidence that these artists also illustrated manuscripts or were responsible for major glazing schemes.

Unlike painters, who belonged, especially in urban centres like London, Norwich and Coventry, to craft guilds associated with the building trades,

manuscript miniaturists by contrast seem to have been aligned with the book trade. Significantly, there is no mention of manuscript illumination in written references to painters' guilds.

There were also important differences in the way that the same subjects were depicted on walls and in manuscripts. Even more important, differences in the techniques and skills required to work at a desk producing miniatures an inch (2.5 cm) in diameter and painting the sixteen-foot (4.88m) Doom above the chancel arch at Marston Moretaine (Beds) also point to the trades being very distinct. (129)

Attempts, for example, to find links between the artists responsible for the illustrations in the famous Winchester Bible of *c.* 1175 and extremely fine wall paintings made around the same time in the same Hampshire cathedral have proven inconclusive. Again, at Brook, the wall painting of the Holy Family's *Flight into Egypt* is far less mannered than contemporary manuscript portrayals of the same scene. Of course, there were exceptions. Some medieval artists were enormously talented, such as Master Hugo of Bury St Edmunds, who was credited with painting the Bury Bible in 1135 and also casting a bell and making an 'incomparably carved' cross in the choir. In later centuries, the Italian genius Simone Martini (b. 1285/5 – d. 1344) seems to have moved effortlessly between different media, painting large-scale frescoes in the lower church at Assisi, a number of fixed and portable altar panels elsewhere and decorating at least one known manuscript leaf. Overall, however, it seems that wall painting and book illustration were wholly separate crafts, even if the artists involved sometimes borrowed freely from each other's imagery.

Much the same can be said of differences between wall painters and glass painters. Again, although there are exceptions, such as John Athlard, who was paid as a painter in the St Stephen's Chapel accounts for 1350 and then again as a master glass painter in 1352, examples of the same artists working in both media are rare. It is possible that Athlard had even switched crafts rather than practised both simultaneously.

Sometimes, however, the distinctions were fuzzier. In fifteenth century Norwich a glazing workshop owned by Thomas Goldbeater seems to have included painters. Vice versa, a glazier's apprentice became a freeman painter. Family groups meant that fathers and sons might follow different branches of the painting art. In general, however, just as there were important differences between painters and miniaturists, so the skills, materials and techniques used by wall and glass painters were also specific to each craft.

Nor were such differences just confined to the divisions between crafts. At least two classes of wall painters seem to have existed. The best were part of an elite based in centres like those already mentioned in London, Norwich and Coventry who moved in court circles and served cathedrals

and wealthy abbeys. Some of these men may have also produced panel paintings, particularly altar retables, which were made in workshops under very different conditions than any equivalent artwork in wall paintings. The second, more provincial branch, seem to have made a living either as itinerant jobbing artists or as the proprietors of small workshops decorating domestic interiors and poorer parish churches.

Even so, the numbers were never high in either category and most artists seem to have been extremely versatile, perhaps a necessary talent.

Records of the London Painters' Guild, a craft organization which regulated apprenticeships and standards of workmanship from at least its first ordinances in 1283, include references to painters decorating saddlebows (the arched front of a saddle) and livery barges. Similarities between some of the techniques and materials used in wall paintings and those used to decorate fourteenth-century tombs imply that the same artists may have undertaken both sorts of painting. When the Earl of Warwick (1382–1439) was appointed Captain of Calais he hired Will Seburgh, '*a Citizen and Peyntour of London*', to decorate his shields, banners and a 'stremour' for his ship emblazoned with his family crest of a '*grete Bere and Gryton holding a raggid staffe*'. Again, the accounts for Eton College listing the costs of a Christmas play in 1485–86 include payments which suggest that the artists responsible for the chapel's wall paintings were also the painters of the props. At Chester, members of the Painters' Guild made the scenery for 'The Shepherds Offering', a play they performed as part of the city's cycle of mystery plays. As we have

Figure 129 Large Doom painting above the chancel arch: St Mary, Marston Moretaine, *c.* 1505

already seen, in the sixteenth century, the Chichester painter, Lambert Barnard was paid for working on walls, on cloth and on sculpture. Other accounts in the same Cathedral show that he also painted wooden coffered ceilings and produced large-scale painted panels, some of which are now displayed in the south transept. The attention to detail in the *c*. 1500 wall paintings of St Gregory and other saints in the Four Doctors scheme at St Gregory's church in Norwich suggests that while not all wall painters may have been panel painters, some of the latter could certainly have painted walls. (130)

The work of elite artists can be seen in commissions such as the decoration of St Stephen's Chapel (fragments are displayed in The British Museum, London), Westminster Abbey Chapter House (London), or, in a provincial setting, at Little Wenham church where the manor was owned by Roger de Holbrok, a royal clerk with possible connections to the lucrative wool trade. (26) The output of particular workshops can also be discerned. In Norfolk, for example, the style and colouring employed in a much damaged painting of the Annunciation at Fring is similar to figures in Norwich Cathedral's Ante-Reliquary Chapel about thirty-five miles away. (131: 132) Again, a decorative dado border scheme at Horsham St Faith Priory of scrollwork and rosettes enlivened with a string of dotted decoration is sufficiently close to similar patterning once visible in the Cathedral, less than ten miles away, to suggest that both paintings were almost certainly the product of the same workshop.

Elite artists were also better paid, were able to work in a variety of techniques, were employed on larger commissions and were eagerly sought after by the wealthy.

When Edward III commissioned the redecorating of the upper floor of St Stephen's Chapel – a private reserve for the royal family and their clergy – he recruited some of the best artists in Europe to create a sumptuous interior, resplendent with sculpture, stained glass and wall paintings of extraordinary richness. Among those he employed in 1351 was the leading elite artist, Master Hugh of St Albans, who received one shilling a day while his senior assistants were paid nine pence per day; the juniors who primed the walls were given between four and six pence per day.

Whereas most artists seem to have been on a par with other tradesmen, Hugh's status can be measured by his will, dated 1361, which stipulated:

> *I bequeath my whole mansion-house in which I live to Agnes my*
> *wife … I bequeath to my said wife all the silver and bronze vessels,*

Opposite:
Figure 130 St Gregory: Norwich, St Gregory, *c.* 1500

Figure 131 Annunciation figures: Fring, All Saints, fourteenth century.

Figure 132 Paintings in a similar style: Norwich Cathedral, ante-Reliquary Chapel, fourteenth century.

the beds and all utensils and necessaries in any way belonging to my hall, chamber and kitchen and forty pounds.

… Also I bequeath to Agnes my wife for her maintenance and that of my children, a six-piece Lombard panel painting which cost me £20 when still unfinished and lacking a frame and other items … Also I will that my three belts garnished with gold should be sold …

The legacy of provincial artists can also be tracked. In Norfolk, the mid-fourteenth-century paintings of the Seven Works of Mercy under distinctive canopies at Moulton St Mary and Wickhampton, only three miles apart, are clearly the product of the same artists or workshop. (133: 134) Elsewhere, strong similarities between fragments of a painting at Upton Cresset and a much larger scheme at Claverley, both in Shropshire, also suggest the brush and palette of a single artist travelling between different commissions.

The lives of such men flicker momentarily into life on the pages of the Yatton churchwarden accounts for 1454, when the parish recruited some painters to work on a new rood screen and loft. '*For the paynter ys hyre a wyke (week) xxd; for the same payenter ys bedde, ijd; for coloers, jd; for feschyng (fetching) of a stone from chelvey to grynde colers therwith, jd.*'.

The expectations of clients who retained elite artists can be gleaned from a contract signed between the executors of the Earl of Warwick's estate and a London painter commissioned to paint the Last Judgement scene on the west wall of the Earl's chantry chapel in the church where he was buried just outside the castle walls:

[I] John Brentwood citizen and Steyner of London 12.Feb.28. H.6. [1450] doth covenant to paint fine and curiously to make at WARWICK, on the West wall of the new Chappell there, the Dome of our Lord God Jesus, and all manner of devices and Imagery thereto belonging, of fair and slightly proportion, as the space shall serve for, with the finest colours and fine gold: and the said Brentwood shall find all manner of stuffe thereto at his charge; the said Executors paying therefore xiii li. vi s. Vii d.'

Although brief by modern standards, this contract speaks volumes about the responsibilities of the artist. Brentwood is charged with securing the materials and painting 'the Dome' according to the architectural space and with, 'the devices and imagery' conventionally belonging to the subject. Significantly, he is also expected to contribute his flair and skill and to paint 'fine and curiously'. The executors not only chose the subject; they also expected a unique work of art.

Such elite artists also travelled abroad. The work of English painters has been identified in France (at the Chapel of Henry II's manor house at Petit-Quevilly, near Rouen, Normandy), Scotland (discovered during

Figure 133 The Seven Works of Mercy: Wickhampton, St Andrew, mid-fourteenth century.

excavations of Glasgow Cathedral crypt), the Irish Republic (Cormac's Chapel, Cashel), and in Spain, where one or more decorated the Chapter House of the Royal Nunnery at Sigena, 100 miles west of Barcelona around 1200. This last scheme survived largely intact until the building was sacked in 1936 by left-wing anarchists during the Spanish Civil War. A few surviving panels can be seen in Barcelona's National Museum of Catalan Art.

Nor was this migratory process one-way. In the fifteenth century English artists, especially those based in London, complained bitterly about competition from cheaper 'foreyns', wall painters and glaziers, who

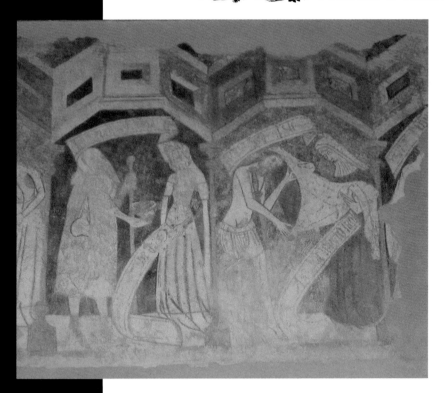

Figure 134 The Seven Works of Mercy: Moulton St Mary, St Mary, mid-fourteenth century.

avoided taxes and the jurisdictions of the Guilds by living just outside the city boundaries, mostly in Southwark. Although resented, these artists were often admired in royal circles, where the latest continental techniques and ideas were much sought after. The Netherlandish-style wall paintings of the Miracles of the Virgin at Eton College Chapel were possibly painted by a Fleming with an Anglicised name. Chichester's Lambert Barnard may easily have been another. Just as Christian art was international, so too were its painters.

Making Wall Paintings

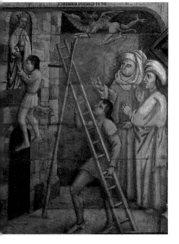

The first step towards making a wall painting was to choose the subject and the design. Most schemes were based on extremely traditional, yet slowly evolving, imagery which formed part of a continuous lineage of Christian iconography. Any subject painting of St Christopher, for example, made between 1300 and 1530 would have been instantly recognisable to a medieval Christian viewer living within those centuries, even though the image underwent subtle changes in its general appearance over this period and every painting was unique in terms of its composition, incidental detailing, border designs, size and colouring.

Professional artists would have a repertoire of such standard images which they had seen during their apprenticeships, memorised, painted before, admired somewhere else, or been shown by patrons and which they could reproduce in different locations and to different budgets.

They may also have kept model books/folders containing cartoons and woodcut prints, similar to those used by manuscript and glass painters.

Contemporary drama may also have provided occasional inspiration. Paintings of angels wearing feather costumes at Attleborough (Norfolk) bear a strong resemblance to similar images thought to have been derived from mystery plays.

In major cities artists were often grouped together in a particular street or parish where they could keep abreast of new designs and share ideas, such as in Norwich, where the Guild of St Luke included both panel and glass painters.

Images were also international: part of a common visual culture shared throughout western Christendom and disseminated by numerous networks, religious, economic and diplomatic. By the beginning of the sixteenth century new refinements may have appeared in tandem with the growth of printing and the wider circulation of books.

Exceptions to these general rules, such as at Brook, which included rare scenes from apocryphal gospels, or Eton College Chapel's lengthy sequence of Miracles of the Virgin, would have been painted by elite artists working closely with an educated patron or his agent.

At Eton College, for example, the accounts for 1482–83 mention a '*presbiter magister pictorum*' (priest, the master of the painters) and '*clericus operis*' (priest in residence) who was responsible for overseeing the painting scheme in the Chapel based on stories in *The Golden Legend* and Vincent of Beauvais's encyclopedic *Speculum Historiale*, another popular thirteenth-century book which featured details of miracles attributed to the Virgin Mary.

Figure 135 Grotesque winged Elephant: Hailes church, early-fourteenth century.

This 'master of the painters' was probably someone seconded from the household of William Waynflete, the Bishop of Winchester, and a former Provost of the college. Almost certainly the role of this 'master' would have been to choose the miracles for illustration, to write the inscriptions which accompany the scenes citing the manuscript source from which each story was drawn, perhaps even to help with the design and setting out the overall scheme. He has been tentatively identified as William Whyther, an occasional bursar of the College.

Another example of patrons contributing to the artistic composition of wall paintings can be seen at Westminster Abbey, where a scribe provided the written captions on vellum which were pasted onto the late fourteenth-century Chapter House scheme of The Apocalypse and the Life of St John the Divine. (27)

If in doubt, visual exemplars such as images in manuscripts or books might have been shown to an artist, as when a copy of the *Gestes of Antioch* was borrowed from the Master of the Knights Templars during the painting of a chamber at Westminster Palace for Henry III in 1250.

Manuscript paintings may have provided other inspirations.

The painting of grotesque animals in combat in the chancel at Hailes, literally at the gates of the Cistercian monastery founded by Richard,

Earl of Cornwall, so closely resemble those found in the margins of contemporary manuscripts as to suggest that they might be copies. (135)

Other parallels can be seen at Westminster Abbey, where wall paintings of St Christopher and *The Incredulity of St Thomas* show strong stylistic similarities with illuminated manuscripts made for royal patrons around 1270.

While court artists may have been influenced by such images, most wall paintings were made by provincial patrons and artists who were slow to adopt new ideas. Thus while the first known appearance of The Three Living and the Three Dead in English art has been attributed to a painting in a psalter made for the East Anglian nobleman Sir Robert de Lisle around 1310, wall paintings based on this allegory, as at Belchamp Walter, appeared only several decades later.

Differences in the way that images like the Seven Deadly Sins were painted, with little consistency in either the overall design concept – within a wheel, a tree, on animals, and so on – or the order in which the sins were portrayed, may have been caused by exactly the opposite: a lack of any definitive image or literary source which patrons and artists could rely upon.

Figure 136 The Virgin Mary wearing an ermine cloak: Great Hockham, Holy Trinity, fifteenth century.

Even when artists embraced new styles, they were still expected to know what the executors of the Earl of Warwick called '*and all manner of devices and Imagery thereto belonging*' to traditional subjects and to adhere to conservative forms of imagery that had developed over centuries.

Thus Christ was always shown as an adult man in his early thirties wearing loose Roman-style robes and never in contemporary clothes similar to those often worn by some of the other figures in a Passion sequence, such as soldiers and torturers. Generally the same was true of the Apostles and the Virgin Mary, although in an unusual scheme above the chancel arch at Great Hockham (Norfolk) which incorporates the Annunciation flanking a Rood cross, she wears an ermine-lined cloak. (136)

Similar conventions invariably saw evil-doers painted in profile and depicted as exaggeratedly ugly, with big noses, spiky hair, and sometimes wearing parti-coloured, or split coloured, clothing which made them as instantly recognisable as modern pantomime villains. (137)

Emperors sat cross-legged in judgement with over-large swords symbolising their unnatural cruelty and earthly power. (138) Actions and emotions were communicated visually by gestures and poses. Condemnation was shown by a single accusatory finger; argument by a raised arm and open palm with fingers and thumbs straight; wonder or listening by hands and arms held down.

Figure 137. 'Wicked and ugly': Cain: Kelmscott, St George, thirteenth century

Opposite
Figure 138 The Emperor Maxentius (with a large sword) judges St Katherine: Little Missenden, St John the Baptist, *c.* 1300.

The position of the painting also had to be chosen. As we saw earlier, images of St Christopher were nearly always located opposite a door where they could be seen easily. Elsewhere in the church, fictive spiral columns and ornate drapery effects were used to enrich sanctuaries. Related subject paintings could help define particular chapels. The views of priests would probably be decisive.

It has been suggested that some subjects may have been painted on particular sides of a church for specific reasons, with the north wall being chosen because of its proximity to the pulpit, or because it was the side where women tended to sit when congregations were segregated, or because it was reserved for scenes from the Old Testament or even because of ideas that the north side was the 'bad' side of the church. Apart from a wider problem of conflicting and inconclusive evidence, these ideas have also been challenged on other grounds: that some figurative paintings appeared on north walls rather than the south side because the light was better. At Raunds, for example, a spectacular scheme along the north arcade wall of The Seven Deadly Sins, St Christopher, and The Three

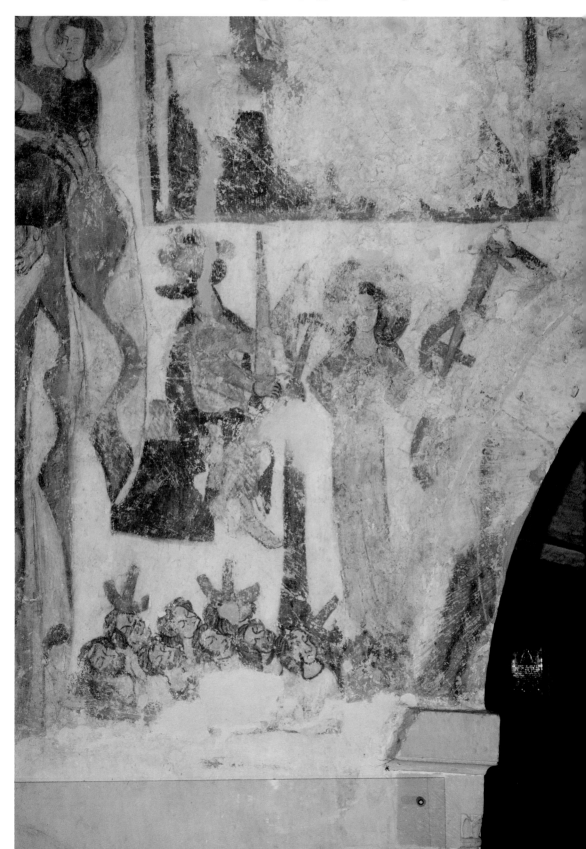

Living and the Three Dead does not seem to have been reciprocated with an equivalent display on the south wall.

Figure 139 The painted nave: Pickering, St Peter and St Paul, *c.* 1475.

Another uncertainty concerns the planning or order of paintings, especially in the fifteenth century, when patrons and painters often had the advantage of decorating the blank canvases of newly built churches. Such puzzles are compounded by the range of imagery embraced by popular taste. One possibility is that what existed before was just updated and extended. Another is that schemes were randomly assembled by donors, priests and artists choosing what they liked or knew which would fit appropriate architectural spaces. Perhaps modern concepts of order were unimportant. With a few exceptions, such as St Christopher opposite a door, it might have been sufficient that donors and congregations had their favourite images somewhere. At Pickering, however, the sequencing of a seemingly disparate assembly of paintings of different sizes and subjects, some with inscriptions, some without, made around 1475 corresponds to a liturgical church calendar, suggesting a well-planned coherent scheme. (139)

A separate question, but related to the order of paintings, concerns visibility. While images of St Christopher were usually large and imposing, other subject paintings were less easy to see at a glance. A scheme in the south transept of Lincoln Cathedral, for example, was eighty feet (24.4 m) above floor level with the paintings of Christ's head and other figures enclosed in roundels just sixteen inches (40 cm) in diameter, almost impossible to study at such a height.

With the general design decided, the next step was to prepare the surface (or *ground*) of the wall(s) for painting. In some instances, elite artists painted directly onto ashlar (regularly cut blocks of stone). At St Mark's Hospital – now The Lord Mayor's Chapel – in Bristol, for example, such a ground was bulked out with chalk and a Plaster of Paris paste (calcium sulphate) before being painted. Sometimes, the original masonry coursing can be seen through such paintings, as at the Guild Chapel in Stratford-upon-Avon. (140)

However, as most churches were built of rubble or materials such as flint and clunch, interior walls were generally covered with an initial levelling coat of coarse lime and sand plaster, before being finished with a thinner, finer, skim. Although final surfaces were often slightly uneven this was not necessarily a disadvantage to painters as it helped to give their work useful contours of light and shade.

At Kempley, and Ickleton (Cambs), the painters used both techniques, extending paintings from plastered walls onto the ashlar stone masonry surrounds of adjacent windows.

Sometimes walls had to replastered before painting could begin, as at St Lawrence's in Reading where the 1503–04 churchwarden accounts include a payment of sixpence for 'new plastering of the wall where St Christopher is painted'. At Corby Glen, old paintings were covered with a new ground of lime putty when other subjects were preferred. On many occasions, the plaster was polished or given luminous undercoats of brilliant lead white paint to enhance the final scheme.

After preparing the *ground* the next step was to begin the wall painting itself. Despite being called *frescos,* most paintings were not. *Fresco* is derived from the Italian word *affresco* and describes painting on fresh lime plaster where water-based paints and wet walls dry together forming an irreversible chemical process called carbonation that binds paint to the surface of the plaster in a web of tiny calcium carbonate crystals.

Only a handful of English wall paintings, such as those in the 'Lewes Group' of churches in West Sussex, are true *buon frescos* on a par with world-famous examples such as those in Assisi. Usually Romanesque

paintings combined aspects of the fresco method, such as painting the initial outlines of the design, the *sinopia*, onto fresh plaster before switching to a *secco*, or dry, technique for the finishing details. A rare example of a *sinopia* can be seen at Henham, where a twelfth-century drawing of the Virgin in the chancel was sketched on the penultimate layer of plaster. (141)

Most wall paintings, especially those made after 1200, were painted entirely in the *secco* technique, although some *fresco*-style carbonation could still be achieved by dampening the walls beforehand.

Painting in *secco* had major advantages over the *fresco* technique. It was better suited to northern European climates; painters and plasterers could work separately and at different speeds, and artists were able to use a much wider palette of pigments and materials than was otherwise possible.

The first step in any painting was to make a preparatory drawing of the overall design.

Figure 141 A *sinopia* of the Virgin Mary: Henham, St Mary, twelfth century.

At Bapchild (Kent), a vertical incision line was drawn through a central image of Christ on a fictive reredos behind the north chapel

Figure 142 Rosette patterning: Silchester, St Mary, early thirteenth century.

Figure 143 Thirteenth- or fourteenth-century lead stencil for rosette patterning, found at Meaux Abbey, Yorkshire: G H Beaulah FSA Collection: Cat No: 2110. By kind permission of Mrs Mollie Beaulah.

altar as a preparatory grid for the layout. At Charlwood, a grid of neatly drawn vertical and horizontal lines, each a foot square (30 cm), was discovered below a painting of The Three Living and the Three Dead during a restoration scheme in 1924; these were probably made to help the artist scale up his painting from a smaller sketch which was divided into squares.

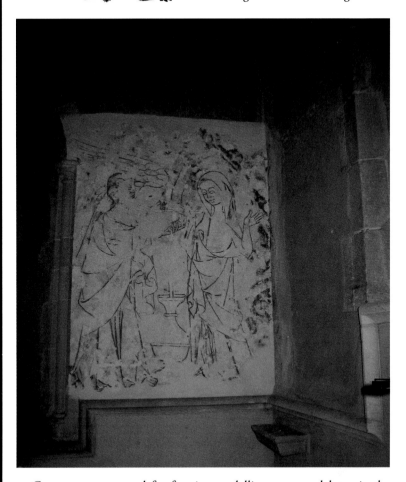

Figure 144 Outline drawing of The Annunciation: Enborne, St Michael, fourteenth century

Compasses were used for framing medallions or roundels, as in the Chapel of St Mary de Castro at Chester Castle where the compass holes can still be seen in the soffit (the underside of an arch) above the altar recess. At Cardiff, St Teilo, Christ's halo was incised in the plaster, probably with the aid of such a tool. Straight boards and cord lines pulled tight or 'snapped', were used to align borders and allocate dividing lines between scenes. At Ford (West Sussex), the masonry pattern lines were set out in lead pencil. At St Margaret's, Upton (Norfolk), scroll patterning in the north arcade follows an inscribed mason's line.

Decorative patterning was applied with stencils. In 1933 a lead stencil for making a six-petal rosette was discovered in the ruins of the south transept at Meaux Abbey, a Cistercian monastery near Beverley in Yorkshire. It is approximately 2.75 inches (7 cm) long. One end was bent so that it could be held by the painter as he dabbed the patterning. This is the only medieval stencil that has been found. Others may have been made from wood. (143: 142)

Large numbers of outline and preparatory underdrawings survive. Many wall paintings now only consist of such bold outlines, as at Enborne

(Berks). (144) A sophisticated example of underdrawing techniques can be seen in the chancel at Brook, where the artist sketched the scheme in yellow rather than the more common red or black.

Sometimes initial designs were changed. At Winslow (Bucks), both the discarded and final versions of St Christopher's head can be seen on the north wall. (145)

Designs were tailored to architectural spaces and how audiences might see the paintings. At Corby Glen, life-size figures above the nave arcades were deliberately broadened to compensate for how they would be seen from ground level. At Eton College Chapel, fictive statues of saints standing on plinths were cleverly foreshortened to suggest they were standing above eye-level.

Sometimes, the architectural 'canvas' itself was used to stress or highlight particular images. At Chalgrove, for example, a painting of Christ Carrying the Cross shows one of his executioners ascending the arch of a window as if he is climbing the Hill of Calvary. (146) At Cirencester (Glos), the opposite was shown – devils depicted descending the arch of a doorway. At Thornham Parva (Suffolk), the artist responsible for a cycle of paintings chronicling the Martyrdom of St Edmund was

Below:
Figure 145 Two heads of St Christopher: Winslow, St Laurence, fifteenth century.

Opposite top:
Figure 146 Christ 'climbing' a window: Chalgrove, St Mary, early fourteenth century.

Opposite bottom:
Figure 147 A door arch used as a hump-back bridge: Thornham Parva, St Mary, fourteenth century.

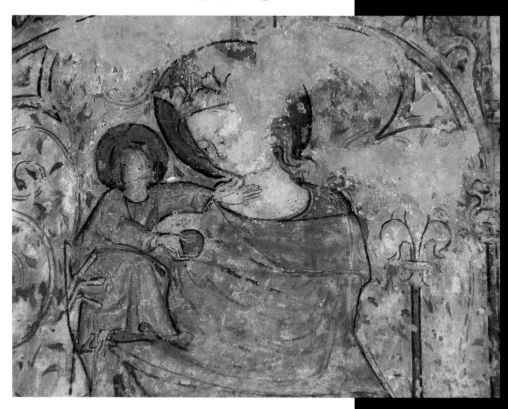

Figure 148 Painting in oil, the Virgin and Child: South Newington, St Peter ad Vincula, early fourteenth century.

equally inventive, incorporating the 'humpback' of a curved door head in the north wall to represent the narrow bridge that was miraculously widened when a cart carrying the saint's body needed to cross the river at Stratford in Essex. (147)

Different size brushes were used during different stages of the process. Large brushes made of hogs' bristles were ideal for undercoating or applying lashings of colour, while medium and smaller sized brushes were better for detailed painting. Pointed brushes made from squirrel tails are recorded in the household accounts of Henry III. Information about other tools is scarce.

Pigments were kept in storage jars. Shells of oysters, scallops and mussels were often used as palettes. An oyster shell recovered from Greyfriars Friary, Norwich, showed traces of several different pigments including blue (azurite) and red (vermilion).

Scaffolds were made of timber, such as alder, which could be grown straight and tall very quickly. In 1467 the churchwarden accounts for Yatton listed a payment of four pence 'to make the scafote to the peynter'.

Ingredients for paints were bought from specialist suppliers or other workshops, as when 'Richard the painter' is recorded as buying 'colours'

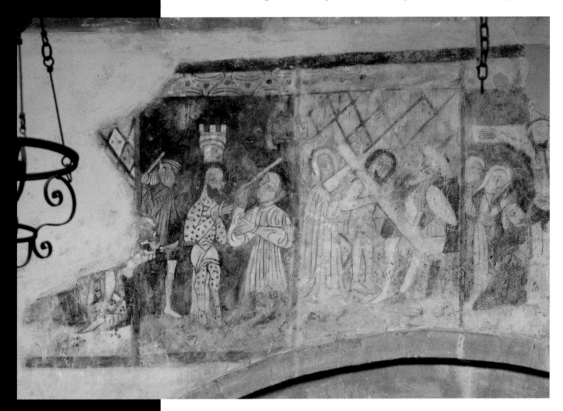

Figure 149 Painting in ochres: The Passion, South Newington, St Peter ad Vincula, fifteenth century.

in Newcastle prior to decorating the King's chapel in Edinburgh Castle in 1301. Thereafter they were mixed on site from two essential ingredients: a binding medium and a pigment, or colour. Sometimes artists seemed to have used stone altars as a workbench to grind their pigments, a profanity sternly rebuked by the Bishop of Lincoln in 1239.

Fresco painters were limited by the carbonation binding medium. Pigments made from metal-based ingredients, for example, could not be mixed with water and applied to wet plaster. *Secco* painters, on the other hand, enjoyed much greater choice and flexibility and were able to use both lime-bound pigments and more complicated paints and glazes which were mixed with organic binding temperas such as egg paste, size, (animal glue) or casein (curd from sour skimmed milk).

Elite artists also worked in linseed-oil-based mediums, of which the earliest known use is in the scheme made *c.* 1130 in St Gabriel's Chapel at Canterbury Cathedral.

The differences between oil- and lime-bound pigments can be compared at South Newington, where the warm tones of a fourteenth-century oil painting in the north aisle, depicting the Virgin and Child adored by donors, far surpasses the cruder, matt-like appearance of a water-based fifteenth-century Passion sequence painted above the north nave. (148: 149)

Research by Dr Helen Howard has discovered that at least thirty different pigments were used in medieval wall paintings, ranging from those extracted from precious stones at one extreme to others derived from home-grown plants at the other. The most exotic and expensive colours were imported from the Middle East or continental Europe, while the inclusion of English plant names in some of the recipes collected by the French painter and artist Master Peter of St Omer around 1300 prompts the possibility that some pigments were developed indigenously.

Many of these colours were obtained by techniques such as burning, grinding, crushing, washing or fuming different materials in astonishingly innovative processes.

A palette of the simpler pigments provided the basic colours used by most artists working in parish churches, who relied on their training and experience to turn a limited range of blacks and whites and earthy reds and yellows into a spectrum of shades and hues stretching from red through purple and pink, to cream and brown, deep yellow and grey. Elite artists, on the other hand, had access to a far larger palette, both of colours and materials, commensurate with both their skill and the wealth of their patrons.

Black was usually charcoal-based and derived from gently baking bundles of willow twigs overnight in an oven. Other chars might include roasted leather, hay or any wood except oak. Bone black was made from burnt animal bones, and flame black from coal soot. Variations included mixing charcoal black with the soot of rushes. Apart from being used to draw outlines or as a surface colour, black's capacity to reduce light scatter on otherwise white grounds saw it applied as an undercoat to deepen the intensity of green, or to produce a blue-grey effect when mixed with white.

Whites were as easily available as blacks. In the twelfth century, artists used lime white, which was made by mixing air-slaked lime with water and stirring for eight days. In the later Middle Ages, lead white became common. According to Master Peter's recipes, this could be made by burying a sealed vessel containing strips of lead suspended over vinegar in horse dung for thirty days. Chalk white was easier to prepare: as today chalk was ground under water, washed and then allowed to settle before being collected and dried.

Reds and yellows could be obtained from a variety of sources. For both colours the most commonly used pigments were iron-rich clay-based earths, known as ochres. Obtainable in different qualities and shades from many deposits across England, the clay was washed before being dried and sometimes roasted. Red ochres produced different shades of red, purple or brown depending on the density of ferric oxides, which

might be as low as ten or as high as ninety per cent. When combined, red and yellow ochres could produce shades of orange. The colour scheme in 'Lewes Group' churches, such as Clayton and Hardham in West Sussex, has often been likened to 'bacon and eggs' because of its predominate use of these simple pigments. (150)

Red and yellow ochres were also used for preparatory sketches and as an underpaint for other pigments. As ochres were versatile, common and cheap, most wall paintings in parish churches retain plentiful traces of them. At Oddington, the painter seems to have bought too much, as a large ball of reddle (red ochre) was discovered when the church graveyard was extended in the 1990s.

Richer reds included vermilion, red lakes and red lead. Vermilion was obtained either from the mineral cinnabar, a natural mercury ore (which was probably imported as a pigment from Spain) or synthesised, usually by a process entailing the heating of two parts of mercury to one of sulphur. The intensity of vermilion's effect can be seen in the fifteenth-century Last Judgement painting at Holy Trinity, Coventry, where it was

Below:
Figure 150 'Bacon and egg' palette: Hardham, St Botolph, *c.* 1100

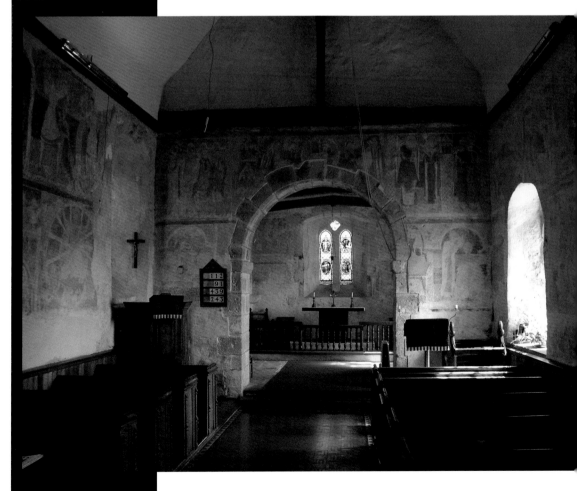

combined with red lead and red lake and applied over a thin layer of carbon black to portray fresh blood. (152) Red lakes were prepared from organic dyestuffs such as the madder plant, which was cultivated commercially around Norwich and used locally in the Cathedral. Specialist red lakes, such as those extracted from brazil wood imported from Ceylon via Alexandria, or made of the dried bodies of the Kermes beetle found around the Mediterranean and in the Middle East, were used by elite artists responsible for the wall paintings in Westminster Abbey Chapter House. Red lead was made by heating lead white until the colour altered to pale or bright orange. It was used in parish churches such as Witley (Surrey), as early as *c*. 1130, and was relatively inexpensive. According to the fourteenth-century accounts of Ely Cathedral, for example, red lead cost four pence per pound, compared to ten pence per pound for vermilion and sixteen shillings for the same weight of red lake.

Like other colours, some red pigments have discoloured over time. At Brook, vermilion red has deteriorated to black, giving the chancel paintings an almost 'modern' aesthetic appearance as black on white, white on black silhouettes. (43) At Witley, the original red lead orange effect has become brownish black.

Unlike red, rich **yellows** were more difficult to obtain, with the result that ochre yellows were used extensively, even by elite artists. Orpiment, imported as a mineral extract from Asia Minor, Hungary and Macedonia, or made synthetically by sublimation (heating sulphur and arsenic ores to a vapour which resolidified on cooling), appeared in a few paintings from the thirteenth century onwards. It was particularly appreciated for its intense yellow colour and glittering sparkle, which sometimes saw it

Opposite:
Figure 152 'Fresh blood': Detail from the Doom, Coventry, Holy Trinity, mid-fifteenth century.

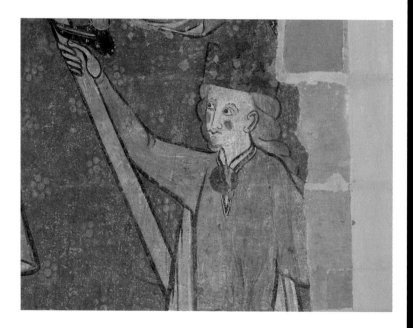

Figure 151 Orpiment as gold, Fortuna, The Wheel of Fortune: Rochester Cathedral, mid-thirteenth century.

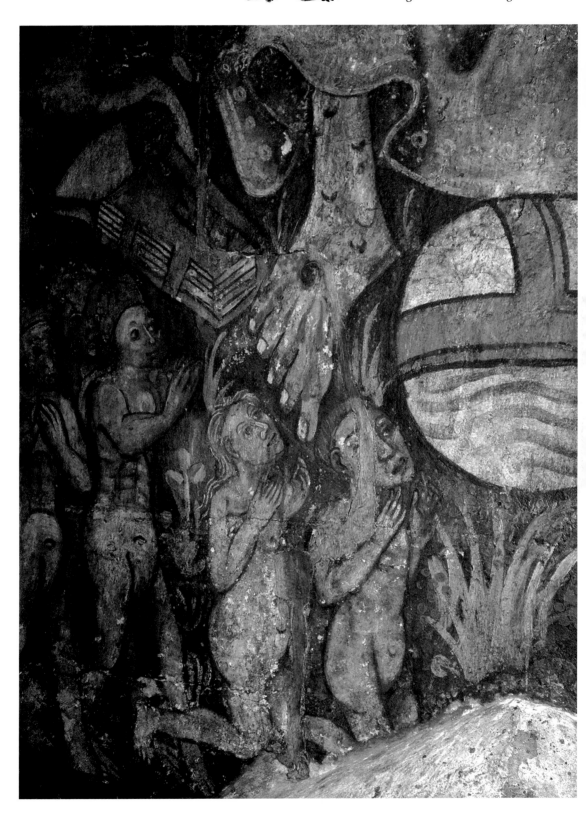

Figure 153 Salt green on haloes of the Annunciation figures with inscriptions above: Hardham, St Boltoph, *c.* 1100.

being used to imitate gold, as in Fortune's brooch in the mid-thirteenth-century Wheel of Fortune painting at Rochester Cathedral. (151) Lead-tin yellow, obtained by heating three parts of lead with one part of tin, produced a paler colour rarely used in wall paintings before the fifteenth century. It was applied to enhance highlights, such as jewellery, in the predominantly monochrome wall paintings in Eton College Chapel.

Green pigments could be made from washing and grinding green iron-rich clays containing glauconite, a mineral formed from decaying organic matter found in sea mud, or celadonite, a secondary mineral occurring in some basalts. Although these pigments may have been imported from Italy and Cyprus, some could have been sourced locally. Most Romanesque paintings used these green earth colours. From the thirteenth century onwards, however, the most popular green pigment was verdigris, a cheap and brilliant pigment made by coating thin sheets of copper with hot vinegar or urine and sealing them in warm containers for about two weeks. Traces of salt green, a rarer colour made from copper plates smeared with honey and coated with salt before being sealed in a pot with hot vinegar and urine, can be seen in some of the haloes painted above the chancel arch at Hardham. (153)

Figure 154 Azurite Blue, the vault of the ante-Reliquary Chapel: Norwich Cathedral, *c.*1300.

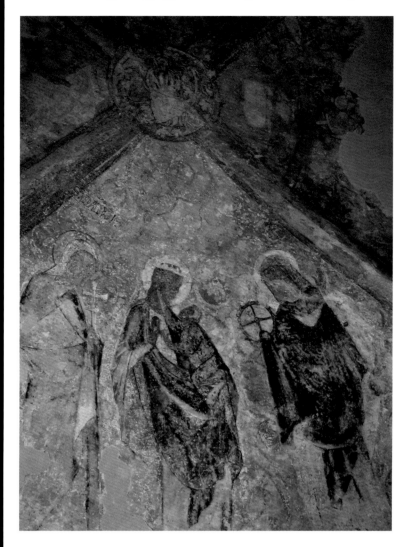

Blue was produced in several ways. The finest pigment was ultramarine, made from lapis lazuli, a mineral only found in north-eastern Afghanistan and probably imported via Venice and Constantinople. As expensive as gold, ultramarine was admired for its brilliance and was used extensively in Romanesque wall paintings of the twelfth century. Good examples as background colouring can be seen in the painting of St Paul and the Viper at Canterbury Cathedral (13) and surrounding the figure of St Cuthbert in the Galilee Chapel at Durham Cathedral. (15) Smaller quantities also survive in some parish churches, such as Ickleton, where it was employed in a twelfth-century Passion cycle to highlight Christ's hair and beard. Although the pigment continued to appear in later paintings, such as in the *c.* 1350 Annunciation scene at St Nicholas, Harbledown (Kent), where it was used to deepen the colour of St Gabriel's wings, from 1300 onwards less expensive pigments were preferred. Derived

Figure 155 'False blue',
and Eve in water: Hardh
Boltoph, *c.* 1100.

from a copper carbonate material of the same name, azurite (sometimes
known as German blue) has been found in a number of high-quality
paintings, including those in the fourteenth-century Apocalypse cycle
in Westminster Abbey Chapter House and on the vault of the Ante-
Reliquary Chapel in Norwich Cathedral. (154) Another commonly
used blue was synthetically manufactured from copper or verdigris
and sometimes involved lime, egg shells and other ammonias. Often
referred to as bice or verditer, synthetic blue pigments seem to have been
used extensively, as at Little Wenham, where it has now discoloured to
turquoise. (26) Occasional blue pigments included vivianite, made from
blue iron phosphate, and indigo, made from woad.

The 'impression of blue' could also be obtained by means of an optical
illusion known as the Rayleigh Scattering Effect. Artists replicated
the phenomenon that makes the sky seem blue by mixing very small
amounts of carbon black into white paint, causing blue's short waves to
be scattered by the white pigments without being entirely absorbed by
the black carbon, and thus re-emerging as reflected light. The painting
of Adam and Eve at Hardham, standing in blue-grey water (either to
quell their lust or possibly as part of an apocryphal story claiming that
they stood in a river in an ultimately unsuccessful act of penance after
their expulsion from paradise) is an outstanding example of this false blue
effect. (155)

Whereas most artists used combinations of brilliant colours, a style of painting in monochrome shades, wholly or largely without colour, began to appear on English walls from the mid-fourteenth century onwards. Known as **grisaille**, after the French word for grey (gris), this innovation was initially used to simulate stone carvings at St Stephen's Chapel, Westminster, and subsequently employed to superb effect in paintings of St Christopher and other scenes at Haddon Hall (Derbys). (156) As mentioned in Chapter 1, the most extensive – and finest – exemplar of this technique can be seen in Eton College Chapel, where the scheme was predominantly painted in tones of grey enlivened with dazzling flashes of colour, such as the (red) leather cover of a book and reds, pinks, lilacs and greens in the doubly-fictive stained glass windows. (157)

Foils such as gold, silver and tin leaf to intensify effects were used by elite artists working for wealthy patrons.

When Edward III commissioned the repainting of St Stephen's Chapel in Westminster Palace in the mid-fourteenth century, 2,300 gold leaves were acquired and laid over gesso, a calcium-based paste, before being stamped with warm dies to produce a textured surface which would glitter in candlelight. A close-up example of this technique can be seen in the prior's chapel at Castle Acre Priory (Norfolk), on two corbels which now support the ceiling. (158)

156 Grisaille, St pher: Haddon Hall early fifteenth century.

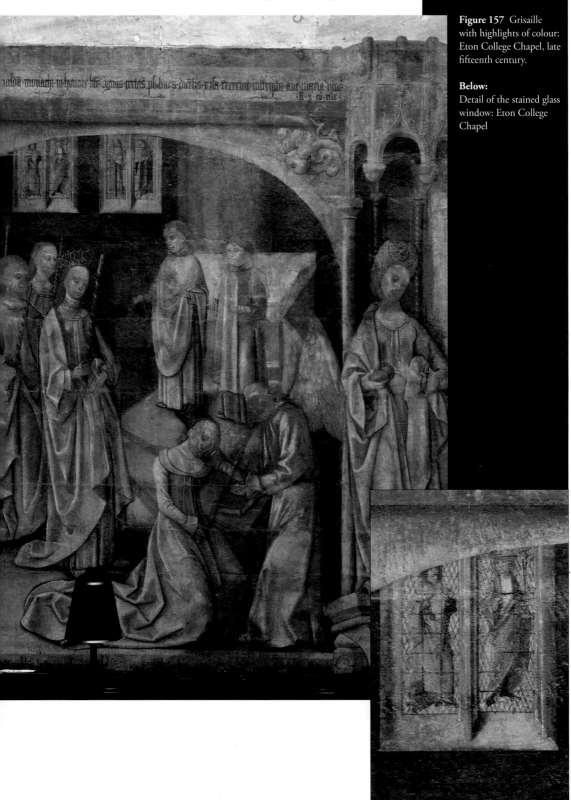

Figure 157 Grisaille with highlights of colour: Eton College Chapel, late fifteenth century.

Below:
Detail of the stained glass window: Eton College Chapel

Figure 158 Gesso stamping on a corbel: Castle Acre Priory, fourteenth century.

Foils were also used in parish schemes. Albeit less extravagantly than at Westminster, gold leaf was laid at Raunds to enhance the halos of angels and to embellish the face of the west wall clock with a sparkling golden sunburst. (159) At Llanynys (Wales, Denbighshire), the halo of the Christ child in a large painting of St Christopher was enriched with gold leaf (31).

A Benedictine monk's description of a wall painting of the Adoration of the Magi in Ely Cathedral captures the impact of gold leaf:

> *I sawe them myself, well paynted on the wall,*
> *Late gasing upon our churche cathedral…*
> *The thre Kinges with all their company,*
> *Their crowns glistening bright and oriently,*
> *With all their presentes and gifts misticall,*
> *All this I behelde in picture on the wall'*

(Barclay's Epilogues *c.* 1514)

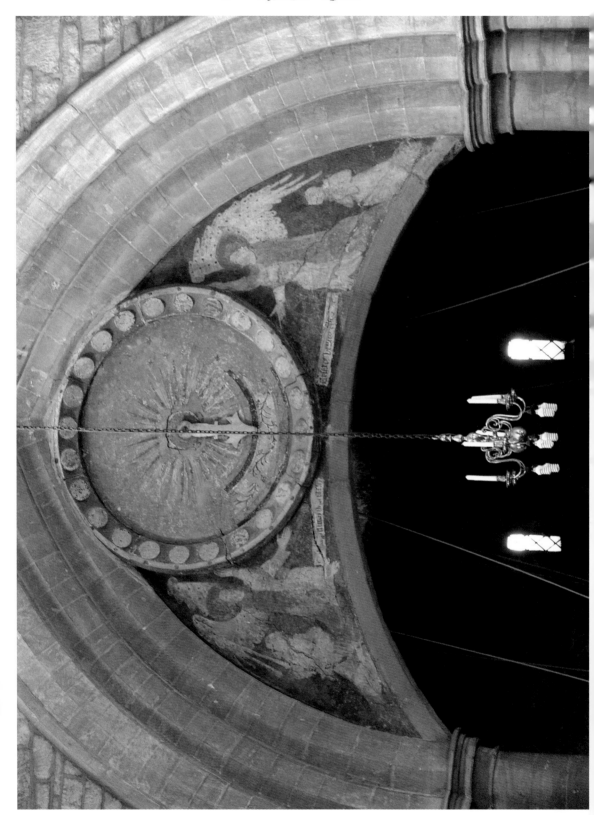

Opposite:
Figure 159 The gilded clock with angels and donors, John and Sarah Catlyn: Raunds, St Peter. *c.* 1400.

Relief ornaments, such as the gilded wooden stars and rosettes glued to the painted vault of the Guardian Angel's Chapel in Winchester Cathedral, were another refinement. (160) *Pastiglia* techniques of moulding pastes to create relief effects, such as haloes and crowns, can be seen in the Last Judgement scheme at Westminster Abbey Chapter House.

The extremes of ornamentation that could be achieved by elite artists can be seen in the mid-fourteenth-century decoration of the Chapel of Our Lady of the Undercroft in the crypt of Canterbury Cathedral. Probably intended as the burial place for Edward, the Black Prince (d. 1376), whose painted heraldic arms survive on the chapel walls, the scheme was a extravaganza of sophisticated effects.

As part of its embellishment the screens surrounding the chapel were covered in numerous small three-dimensional gesso reliefs embossed with various floral and scroll designs.

At the same time, silver leaf was applied to the canopy of the niche where the statue of the Virgin Mary stood in the chapel and thereafter skilfully glazed with verdigris in an oil medium to saturate the translucent effect. Glass beads imitating jewels were also added. The vault of the chapel was painted in red lead with a vermilion glaze and then transformed again with the addition of tiny suns and stars made from tin-lined moulds, some of which contained mirrors to reflect twinkling

Figure 160 Gold wooden reliefs, The Guardian Angels' Chapel: Winchester Cathedral, thirteenth century.

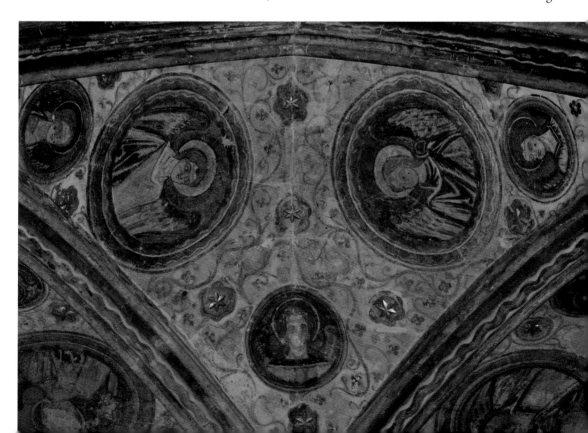

candlelight. An examination of one of these reliefs by the Cathedral Wall Painting Workshop revealed that they were made by an incredibly complex process. First, a convex glass disc was inserted into the centre of the mould, silvered and then surrounded with a red lead mixture. Next, tin leaf was carefully pressed into all the other parts of the mould, including the back, before the whole motif was warmed and softened so that it could be fitted to the curved shapes of the vault and glued. At the apex of the vault four of the suns were joined together to form a four-lobed quatrefoil.

The final impact would have been stunning; truly a wall painting fit for the Queen of Heaven and an English national hero. (161)

Figure 161 Mirrors and heraldry: Our Lady of the Undercroft Chapel, Canterbury Cathedral, fourteenth century.

Meaning & Understanding

Below:
Salvation. The Blessed are greeted by St Peter as they enter Heaven: North Leigh, St Mary, sixteenth century.

E arlier chapters described the history of wall paintings and explained the subjects they showed. It is clear that they were as common in cathedrals and abbeys as in parish churches and wayside chapels. Like most imagery their meaning could also have more than one application, depending on what they showed, where they were painted, when they were painted and for whom. Most paintings were capable of multiple interpretations and uses. This chapter explores the breadth of those different functions and applications. It answers the question – why were they made?

Although wall paintings could be complex and diverse, the short answer to that question is the same as it was from the third century onwards when Christian artists had first taken brushes to walls: to define places and worshippers as Christian; to remind audiences of holy narratives and the promise of Christ; to complement public worship; to honour God and the church; above all, to draw strength from monumental images of the divine and the promised reassurance of everlasting life.

These applications can be grouped as:

Making the Church

Proclaiming Faith

Private Devotion

Belonging to the Church

MAKING THE CHURCH

Wall paintings defined people and places as Christian. They were an integral part of the process which transformed otherwise ordinary buildings into sacred spaces. They made churches special and symbolic. In conjunction with other works of art, they converted even the poorest into a House of God, a harbinger of heaven, brimming with colour, holy heroes and stern reminders of faith and duty. In a world often without colour, wall paintings made entering a church unlike any other experience.

Consecrating the Church

One of the most common types of wall painting is a cross set within a circle. Known as a Consecration Cross, many are inscribed into the plaster. Some churches retain large numbers. Carleton Rode (Norfolk), has eight (some restored) and East Wellow (Hants), six. Sometimes they overlap other images, as at Brook. (43)

These painted crosses commemorated the formal sanctification of a building into the House of God and were the product of an elaborate set of ceremonies which consisted of a bishop circling the church three times and knocking on the door to announce 'The King of Glory shall enter in' before sprinkling the church with holy water and anointing both the exterior and interior walls with twelve crosses, some which were later painted or inlaid with metals such as brass. This could be demanding work. In admittedly busy years, David de Bernham, a thirteenth-century bishop of St Andrew's in Scotland, consecrated forty-two churches in 1242 and another forty in 1244.

According to the *Golden Legend*:

There are three reasons for painting twelve crosses upon the church walls. The first is to terrify the demons, who, being driven out of the church, and seeing the sign of the cross upon the walls, dare not enter it again, for they fear this sign mightily. The second is to show forth the triumph of the Cross; for the crosses are the banners of Christ and the signs of His victory, and thus they signify that the church is subjugated to Christ's dominion. Thirdly, these crosses represent the apostles; the twelve candles which are lighted before the crosses denote the light which the apostles brought to the world by the faith of the Crucified; and the crosses are anointed with chrism (consecrated oil) as a symbol of the cleanness of conscience and the odour of good renown with which they anointed the world.

Many painted Consecration Crosses are extremely elaborate. The most spectacular are the sixteenth-century examples at Bale (Norfolk), which measure over four feet (122 cm) across and are surrounded by a green wreath. (162) At Worstead, in the same county, several crosses with

Opposite:
Figure 162 Consecration cross (behind pulpit): Bale, All Saints, early sixteenth century.

similar garlands retain traces of black-letter inscriptions. A nineteenth-century description of a Consecration Cross at the church of St John de Sepulchre in Norwich reports that it was inscribed '*Adorabo ad templum sanctum tuum domine*' (I will worship in thy holy temple, O Lord).

Candles were regularly lit below these crosses. At Westminster Abbey, the Consecration Crosses in Henry VII's Lady Chapel had candleholders about twenty inches below them. At Ottery St Mary (Devon), the iron stumps of such holders protrude from carved (and once painted) Crosses on the west wall. At Hessett (Suffolk), scorch marks stain a Cross on the south wall. At Fairford, a painted Consecration Cross in the chancel can be dated to 20 June 1497, when the 'fair new church' formally took the place of an older building. (163)

Dedicating the Church

From at least the early fourth century churches were dedicated to God in the name of a Saint (or All Saints) or religious concepts such as the Holy Trinity. Wall paintings often commemorated such 'patron' saints, whom John Mirk likened to the role of powerful templar, or earthly barons:

Figure 163 Consecration cross: Fairford, St Mary, late fifteenth century.

> *For right as a temporall lord helpyth*
> *and defendyth all that hyn parechons or*
> *tenantys, right soo the saynt that ys*
> *patron of the chyrche helpyth and*
> *defendyth all that byn paryschons to*
> *hym, and don hym worschyp haloyng*
> *his day, and offyrne to hym.*

During the Romanesque period, if not earlier, images, usually statues, of the patron saint(s) were displayed beside the altar, often paired with a corresponding image of the Virgin Mary. At Ewenny Priory, the patron saint was probably shown under a part-painted niche on the south side of the wall, but in later centuries such pairings were usually reversed, as at Bramley (Hants), where a painting of St James appears on the north side and the Virgin Mary on the south. At Checkendon, the patron saints, Sts. Peter and Paul, are singled out in a wall painting of the Apostles adoring Christ by being portrayed in fictive carved niches. (3)

Sometimes the dedication of churches was changed. Wall paintings of a miracle of St Nicholas in the chancel at Ashmansworth (Hants) probably pre-date its later rededication to St James.

Churches dedicated to All Saints usually had a substantial number of paintings of Apostles and other holy figures. At Chalgrave, eighteen saints are shown and at Little Kimble (Bucks), at least eleven. At Little Wenham, the dedication of the church to All Saints is affirmed by the paintings of St Katherine, St Margaret and St Mary Magdalene on the east wall. (26)

Patron saints were also painted in monasteries and in other more important churches, of which the outstanding example is the painting of St Faith at Horsham St Faith Priory. (164)

Glorifying the Church – Interiors

Wall paintings invested churches with wonder and awe. Early church leaders saw painted images as powerful magnets for pagans to convert to Christianity. Emperors also demanded nothing less. In later centuries, Anglo-Saxon monks like Bede praised decorative effects as commensurate with a House of God, a concept which became particularly important from the twelfth century onwards, when influential church leaders like Abbot Suger in Paris championed beauty as an act of homage in itself. By the lavish use of different arts, many churches sought to recreate the heavenly Jerusalem on earth. Painted effects played a major role in that transformation, creating atmospheres and interiors inducive to worship.

Figure 164 St Faith: Horsham St Faith Priory, mid-thirteenth century.

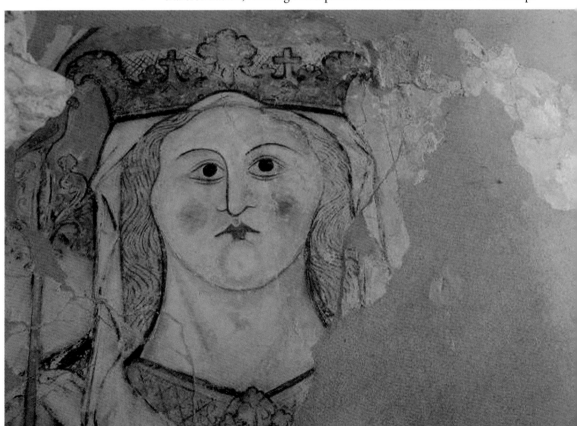

Evidence of coloured plaster, made by adding tile or brick dust to the wet mix, has been excavated from the remains of several Anglo-Saxon abbeys. Although some cathedrals, such as Durham and Winchester, seem to have used paint sparingly, from at least the tenth century parish churches appear to have incorporated colourful aesthetics as standard, routinely being washed with 'redying', probably a red ochre or 'mote', as it was sometimes called, with figurative painting confined to the more liturgically important eastern end.

Many Romanesque churches relied heavily on painted effects. Pelta and masonry patterns were common. When Sir Gilbert, the Sheriff of Surrey, founded Merton Priory (Surrey) in 1194, it was recorded that he, 'most liberally built a church at his own cost, and handsomely decorated it with paintings as was customary'. Similar conclusions were expressed around 1200 by the historian, William of Malmesbury, who opined that a building was 'not considered complete' until its walls 'glisten with colour'. At Ewenny Priory, the presbytery was decorated with masonry patterning and elaborate fictive stonework: the only Romanesque scheme still surviving in Wales. (165)

Nor did the use of painted effects diminish in later centuries, when it was applied to every type of surface – wood, alabaster, and iron – as well as to outstanding stonework and monuments.

Figure 165 Fictive niche: Ewenny Priory, twelfth century.

At Worcester Cathedral, for example, a decorative band of alternating white limestone and green Highley stone over the east arch of the south-west transept was itself plastered and painted in alternating bands of white and green in the thirteenth century.

Routinely piers, roof bosses, arches, soffits, voussoirs, window splays and spandrels were enlivened with vibrant zig zags, scrolls, trailing foliage and other patterns. Some of these schemes may have been designed in conjunction with masons and undertaken by assistants to the builders.

Painted effects added more than colour. They could also glorify the architecture of buildings by drawing the eye to the curvature of apses and vaults, 'extending' the depth of windows and stressing the height and length of sacred spaces. And if such lavish details were lacking, painted effects could be used to replicate them.

At Bushmead Priory (Beds), support shafts for the west window were painted to imitate Purbeck marble with small black strokes, like commas, resembling fossil shells. At Ampney St Mary (Glos), the window shafts have fictive capitals. (166) At Blyth (Notts), a plain block capital was enriched with painted scrolling. (167) In Norwich Cathedral, artists took this conceit a step further and painted a fictive vault in the Ante-Reliquary Chapel. (154)

Painted effects were also used to enhance 'fittings' such as chancel screens. At South Walsham (Norfolk), the patterning of an intricately carved wooden chancel screen was copied and extended in paint to an adjoining wall. At Chalfont St Giles (Bucks), a daring idea saw a plain chancel wall transformed into an imitation of a prestigious carved stone screen complete with an embattled parapet and pierced tracery. (168)

Many churches commissioned painters to create fictive painted image niches for statues, again imitating more expensive carved examples. (169: 179)

Opulence and expense, such as simulated textiles, could also be suggested by painted effects. Some schemes could be astonishingly realistic. At Hardham, a full-length painting of *The Temptation* in the chancel retains fictive hooks, imitation folds and a hanging loop. (37) At Lakenheath (Suffolk), the fictive drapery includes a fringe.

At West Walton (Norfolk), the walls between the clerestory windows above the south arcade were 'hung' with a decorative succession of imitation textile panels in different designs, including Fleur de Lys and birds. (246)

Similar illusions were used to enhance chancels, altars, sculptures and stonework.

At Corhampton, imitation curtains on the inner west wall of the chancel seem ready to be drawn across the arch. At Exeter Cathedral (Devon), the back wall of the sedilia was painted to resemble fine silk held in the mouths of lions. (172)

At Martley, swags of painted drapery behind the altar are enriched with fabulous beasts. (170: 24). At Inglesham (Wilts), the scheme was simpler; a fictive cloth of alternating red and white stripes. (171)

Elsewhere, imitation drapery folds were sometimes painted in the nave below the dado where fussier schemes might be scuffed or damaged by rising damp.

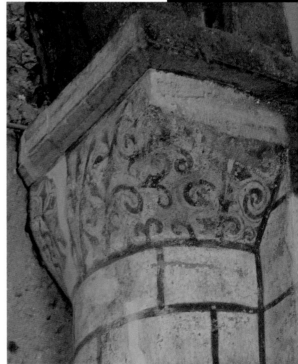

Other Arts

Wall paintings also harmonised with other arts such as sculpture, painted glass, and embroidery to enrich the overall visual effect of the medieval church.

Sculpture

Some wall paintings appeared in conjunction with primarily sculptural schemes. They could also support the spiritual significance of particular sculptures. Coloured backdrops helped to 'throw' images forward. Elaborate fictive frames completed many schemes.

Opposite top:
Figure 166 Fictive capital: Ampney St Mary, St Mary, thirteenth century.

Opposite below:
Figure 167 Fictive carved capital: Blyth, St Mary and St Martin, *c.* 1180.

Below:
Figure 168 Fictive chancel screen with pierced tracery: Chalfont St Giles, St Giles, fifteenth century.

Some of the best examples of painted effects complementing sculpture focused on the most important carving in the medieval church – the symbol of Redemption showing the crucified Christ, known as the Rood. This often life-sized and painted sculpture was flanked by figures of the Virgin Mary and St John the Baptist and enriched by a painted ceiling above, known as a *celure*, as at Stowlangtoft (Suffolk).

Wall paintings exalted this ensemble in several ways. At Llantwit Major (Wales, Vale of Glamorgan), and Compton (Surrey), an imitation textile, a 'cloth of honour', was painted on the chancel arch behind the statue. (173) In other instances, where the Rood was attached to the wall of the chancel arch itself, paint was used to construct a complementary scheme

around the sculpture. At Raunds, volanting angels carrying the Instruments of the Passion encircle white silhouettes where the Rood and its flanking statues once hung. At Kingston (Cambs), the treatment is similar but more vivid. The wall painting shows angels holding chalices to catch the blood of the missing Christ figure. (174) At Stratford-upon-Avon, the silhouette of the Rood is highlighted against a painted background which also incorporates Doom-associated imagery: divine mercy and divine judgement juxtaposed. (140) A particularly fluid idea can be seen at Ickleton, where a sequence of wall paintings telling the story of the Passion on the north wall seems poised to switch media as it reaches the place where the sculpted figure of Christ on the Rood would have hung.

Medieval churches were crammed with a multiplicity of other statues embellished by wall paintings. At Faversham (Kent), for example, there were eight altars and possibly as many as forty-seven images in the church which had candles lit before them.

As with the Rood schemes just described, some of these collaborations have left silhouettes highlighted by painted effects. At Brent Eleigh, paintings of angels cense the space left by a lost statue on the chancel east wall, almost certainly that of the Virgin Mary. (175) At Stanion (Northants), a painted stag and unicorn kneel before a similar silhouette on the east wall of the south aisle. (176)

Some wall paintings went further and directly interacted with statues. At Combe (Oxon), a wall painting of St Gabriel with a scroll inscribed with traces of his Annunciation salutation faces a now empty image niche

Figure 169 Image niche with fictive pierced tracery: Soham, St Andrew, fifteenth century.

Figure 171 Fictive drapery behind altar: Inglesham, St John the Baptist, fourteenth century.

Opposite:
Figure 170 Swag from fictive drapery: Martley, St Peter, fourteenth century.

on the east wall where a statue of the Virgin would have stood. (177) At Asgarby (Lincs), a painted donor, again with a scroll, kneels before a now vacant plinth.

Many churches retain lavishly decorated image niches where such statues were displayed, as at Edingthorpe (Norfolk). The interiors of such niches were also painted. In 1532, a parishioner at Pattishall, in Northamptonshire, gave barley to the church to pay someone to 'payent the wall behynde our Lady of the Natyvite'. At Great Ellingham (Norfolk), painted angels on the rear wall of a flamboyantly carved stone niche hold a painted 'cloth of honour' behind the place where a statue of the Virgin Mary once attracted devotion. (178) Sometimes, as mentioned earlier, highly ornate fictive image niches were 'made' in paint, complete with gables, finials and crockets. (179) Occasionally, the same wall might include both real and feigned examples, as at Boxford (Suffolk).

Accomplished artists could produce entire 'sculptural' schemes in paint. At Westminster Abbey, for example, a painting of St Faith, resembling a statue standing on a pedestal, is set within an equally fictive gabled tabernacle. (125) Other examples of fictive statues can be seen in Eton College Chapel, where the figures of over a dozen saints seem genuinely three-dimensional. (35) At Weston Longville, a painted 'statue'

of St John the Baptist stands on a painted pedestal within a painted canopied niche. (180)

Glass

Wall paintings also appeared in conjunction with stained glass.

At Canterbury Cathedral, for example, the refurbishment of the Holy Trinity Chapel in 1220 saw the Chapel's windows glazed with the miracles of St Thomas Becket, while up to as many as seventy-two paintings portraying saints and royal benefactors like Henry III adorned the vaults and walls. As subjects the compositions had nothing in common. As a whole, however, both arts enriched the chapel immeasurably.

At York Minster a scheme in the Chapter House of *c.* 1285 highlighted some of the fundamental differences between the two media. While the glazing of the vertical lights consisted of rectangular panels of clear non-figurative glass alternating with coloured panels creating rhythmic

Top:
Figure 172 Fictive drapery, painted Sedilia: Exeter Cathedral, fourteenth century.

Above:
Detail of painted Sedilia: Exeter Cathedral, fourteenth century.

Figure 173 Rood 'Cloth of Honour': Compton, St Nicholas. fifteenth century.

horizontal bands of bright and dark colour, a now mostly lost scheme of wall paintings of Kings and Clerics in a blind window above the west door depicted two tiers of large standing figures, totally disrupting the visual unity which was otherwise such a feature of the interior.

Iconographical harmony can be seen to a better extent in a chapel dedicated to St Nicholas at Haddon Hall (Derbyshire). Decorated in 1427 by Sir Richard Vernon and his wife, Benedicta, it includes wall paintings of the saint's miracles on the north wall of the chancel and the damaged remains of a prelate figure in the east window which may have been a further representation of this bishop.

Elsewhere in the same chapel images of another favoured saint, St Anne, appear as the Mother of the Virgin teaching her daughter to read

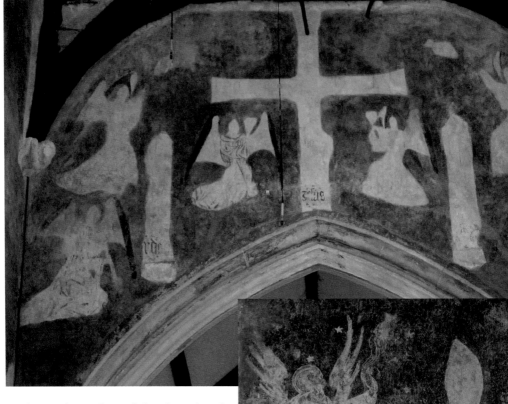

in the north window of the chancel and as a wall painting on the opposite south wall.

However, in none of these instances do wall paintings and glazing schemes depict subjects or scenes from the same narrative cycle partly in one medium, partly in another.

The nineteenth-century decoration of the church of St Mary the Virgin at Lower Swell (Glos), by the Victorian artists Clayton and Bell might provide part of the explanation. Their attempt to tell the Passion story on alternating walls and windows fails if for no other reason than the richer the colours of the glass, the darker the paintings appear on the adjoining walls. Differences in technique and manufacture were also powerful factors mitigating against dual media schemes.

Wall paintings could be made quickly, on site, by artists painting directly onto plaster using a variety of pigments, including ochres mixed with lime water. Glass paintings, on the other hand, were cut, painted, fired and assembled in workshops often miles from the commissioning

Top:
Figure 174 Angels encircle los Rood sculpture: Kingston, All Saints and St Andrew, fifteenth century.

Below:
Figure 175 An angel adores a lost statue of The Virgin Mary: Brent Eleigh, St Mary, early fourteenth century.

church, and were pre-designed to fit rigid architectural spaces. Moreover, glazing schemes were often installed in stages and the finished result was inevitably seen in a 'different light' than any nearby wall paintings.

As single images, however, wall paintings and glass could have a range of relationships stretching from simple to highly sophisticated.

Similar subjects might appear in different parts of the same church, as at Raunds, where the Martyrdom of St Katherine was told in paint on the west and north walls while an image of the saint was included in the glazing of the south aisle.

Sometimes different subjects might appear side by side as at Little Kimble, where grisaille glazing interspersed with heraldic devices bears neither a thematic or overshadowing relationship to contemporary wall paintings of saints in the adjacent splays. (182)

Because the ratios of coloured to clear glass in churches is unclear and the process of adding stained glass was often

Top:
Figure 176 Stag and Unicorn adore a lost statue of The Virgin Mary: Stanion, St Peter, fifteenth century.

Right:
Figure 177 Annunciation angel facing image niche with a lost statue of the Virgin Mary: Combe, St Laurence, fifteenth century.

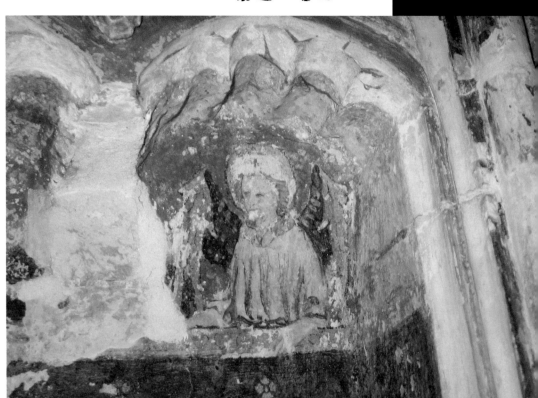

slow and accretive, it is also possible that some wall paintings in window splays were specifically intended to be 'lit' by clear glass from the outset. A modern arrangement at Gisleham might resemble such a scheme. (181)

In other instances, however, the evidence seems to lean tantalizingly in the other direction, with paint subordinate to glazing schemes. At Easton Neston (Northants), the remains of a now lost east end window in the north aisle is embellished by a wall painting of fabulous architecture with pinnacles and gables surmounted by angels. One possibility is that it was intended to represent the celestial city surrounding a now lost image of Christ painted on the glass.

Again, a barely visible fourteenth century wall painting of people praying on the west wall below an oculus window in the chancel arch at Merevale church and abbey (Warks) might be related to a now lost image in the glass.

Opposite top:
Figure 178 Angel holding
'Cloth of honour' in image niche
behind lost statue of the Virgin
Mary: Great Ellingham, St James,
fifteenth century.

Opposite below:
Figure 179 Fictive image niche
with crockets: Westhall, St
Andrew, c.1400.

Right:
Figure 180 Fictive statue of
St John the Baptist: Weston
Longville, All Saints, mid-
fourteenth century.

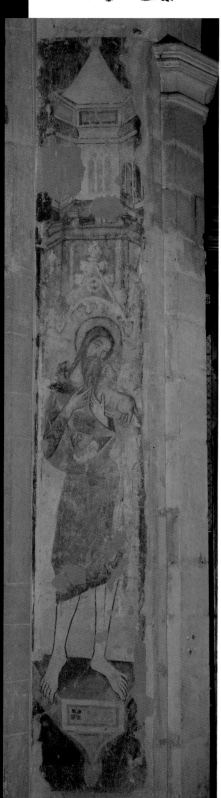

Similar intriguing possibilities are raised by paintings of *The Annunciation* in the splays of the east window at Harbledown and of angels censing a now plain-glass east window at Hailes. (183) If these windows had originally contained schemes of Christ on the Cross, the wall paintings would have added further layers of emphasis to the redemptive imagery in the glass itself. Such east wall schemes incorporating iconographical glazing and complementary paint above altars and sculpture would have certainly been seen by the priest as he performed the Mass. They might also have been regarded as part of an extensive multi-media scheme by wider audiences.

Paint was also integral to other glazing schemes. When the north wall at Bledington (Glos) was rebuilt in the fifteenth century, five large windows with brackets and canopies for images in the reveals, were inserted to spectacular effect. With images of saints like St Christopher ravishingly depicted in glass, polychromed statues occupying the plinths and scroll-like paintings decorating at least the splays of the upper tier of clerestory windows, the final effect would have shone like a beatific vision.

Other questions affecting the relationship between wall and glass paintings are more subtle. They revolve around whether the stronger emphasis put on light and illumination by glass from 1200 onwards found an echo in the translucency sought by some wall painters.

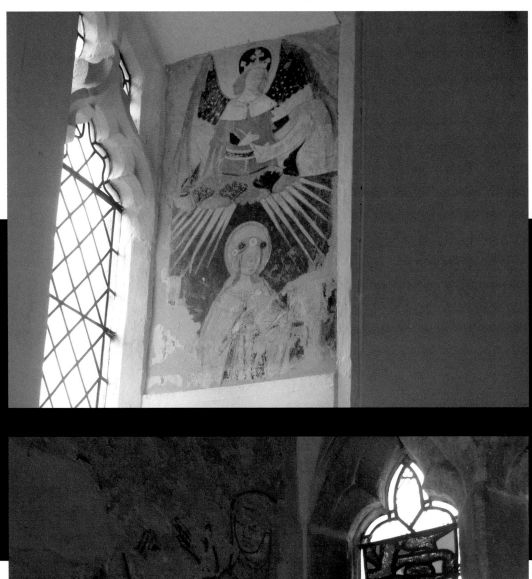

Defining Liturgical Spaces

Wall paintings were also used to differentiate or 'map' liturgical spaces within churches. At Salisbury Cathedral, for example, the vault webs of the nave were decorated with simple red masonry while the liturgically more important eastern end saw the vault ribs and mouldings of the triforium arcade and clerestory windows picked out in red, green and black. Again, the richest painted effects in the Cathedral were reserved for the choir, presbytery and eastern transepts.

Similar differences can be found in parish churches like Brook and Chalgrove. Specific paintings were also used to emphasise particular

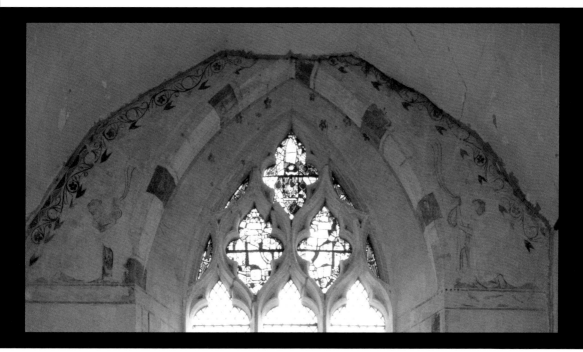

chapels and their dedications, as when images of the Virgin Mary and other female saints were grouped together in Lady Chapels, as at Soberton (Hants) and Cold Overton (Leics).

Programmes of wall paintings tailored to specific routes within pilgrimage churches may also have appeared. At Ely Cathedral, for example, pilgrims to St Etheldreda's shrine saw paintings of seven Anglo-Saxon benefactors, perhaps a gentle reminder for them to make their own offerings to the church.

Glorifying the Church – Exteriors

Exteriors of churches could also be painted. At Worcester Cathedral the entire exterior of the Norman church was whitewashed and overlaid

with a dark paint masonry pattern. At York Minster at least parts of the late-eleventh-century exterior were painted in a similar way.

Figure 184 A white washed church, 'shining like a star': Llangattock Lingoed, St Cadoc.

In later centuries colour seems to have been used more dramatically. At Salisbury, the central western portal of the Cathedral was known as the 'Blue Porch'. Remarkable survivals of fourteenth-century exterior paintwork can still be glimpsed at Ely Cathedral, where the west end dado niches of the Lady Chapel retain faint traces of a pattern of red lozenges and circles. External carvings were also painted. At Wells Cathedral the entire west front façade of nearly four hundred statues was richly decorated.

Information about the external appearance of parish churches is scantier. A twelfth-century description of the town of Gwynedd in north-west Wales said that it, 'came to shine with white-washed churches, like stars in the firmament'. Some Welsh churches still maintain that tradition, as at Llangattock Lingoed (Monmouthshire). (184)

If accurate, a nineteenth-century report that the exterior walls of a church at High Wycombe in Buckinghamshire were painted with representations of the Seven Works of Mercy suggests that external figurative schemes might also have appeared.

PROCLAIMING FAITH

Images of Christ

Wall paintings of Christ had numerous applications. Their presence alone defined buildings and people as Christian. Representations of Christ in Majesty, Christ on the Cross, Christ Resurrected and Christ in Judgement expounded the promise of everlasting life and salvation. Just as when St Augustine and his fellow monks carried illustrated books and panel paintings of Christ when they converted the 'Angles' to Christianity, so too did wall paintings of Christ make the divine real.

Single images of Christ provided a focus for devotion. Extended cycles of the Holy Infancy and the Passion of Christ gave further visual form to the miracles of redemption and resurrection. Without exception, the narratives careered from elation and wonderment to despair and horror, followed by triumph and hope: inescapably overwhelming, eternally memorable.

Ceremonies and Rituals

The Mass

Figure 185 Crucifixion retable: Dorchester Abbey, early fourteenth century (re-painted)

Apart from adding splendour and solemnity, some wall paintings complemented the most important rite of medieval faith, the Eucharist or Mass. It was a ceremony of the miraculous, involving prayers and

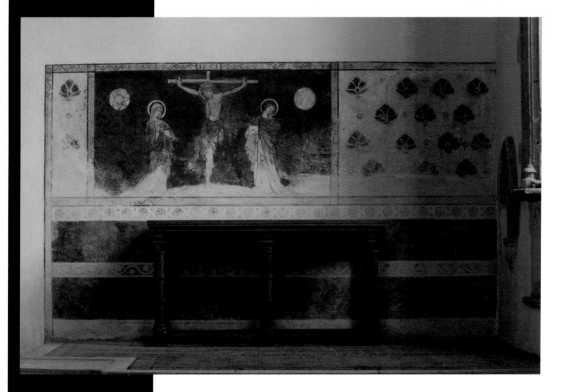

scriptural readings or chanting (in Latin) which transformed consecrated bread (the host) and wine into the body and blood of Christ as a physical presence. It was performed by a male priest in front of a sanctified altar with his back to the congregation and screened from general view. Contemporary liturgical manuscripts stressed the importance of the priest focusing on the miracle as he elevated the host.

Wall paintings provided fictive altar retables for this sacrament. Good examples can be seen in the north chapel at Bapchild (Kent) and on the east wall at Brent Eleigh. (241) A repainted retable serving the parish part of Dorchester Abbey (Oxon) survives on the east wall of the south aisle. (185) A sixteenth-century scheme in the Gatehouse Chapel at Berry Pomeroy Castle (Devon) combines a retable painting of the *Adoration of the Magi* on the east wall with remnants of the sockets for the accompanying altar furniture below.

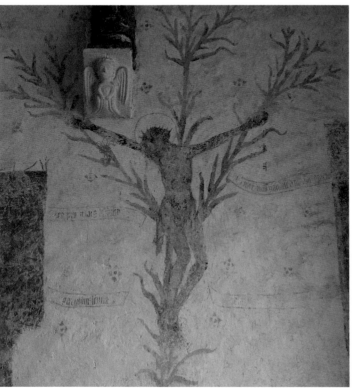

Top:
Figure 186 Altar dedicated to St Thomas Becket: Hauxton, St Edmund, thirteenth century.

Below:
Figure 187 The Lily Crucifixion Godshill, St Lawrence, mid-fifteenth century.

Apart from retables, paint was also used to enhance reredoses: decorative schemes behind and above altars. At St Peter and St Paul, Northleach (Glos), the painted silhouette of a once elaborate sculptured scheme survives in the south aisle.

In addition to their main altars in the chancel or sanctuary, most churches had others scattered in side chapels or against piers. Paintings which complemented additional altars in the nave include those of the Crucified Christ, Ulcombe (Kent); the *Pieta*, Hornton; or of saints such as St Thomas Becket, at Hauxton (Cambs). (186) Good side chapel examples include the altar painting in the south transept at Godshill (Isle of Wight), showing the crucified Christ hanging from an Annunciation Lily. (187)

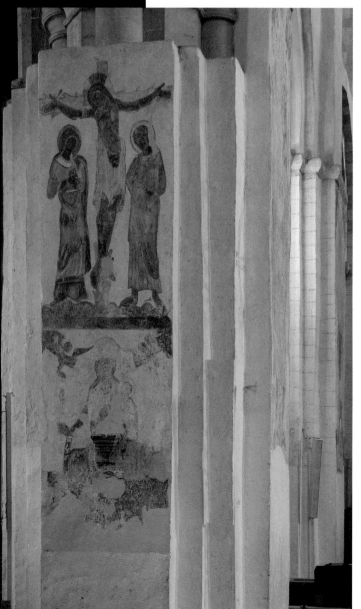

Piers were another popular location for supplementary altars, of which the most well-known sequence is at St Albans Abbey, where six two-tier reredoses were painted in the nave from 1230 onwards. Added at intervals of between ten and twenty years, running from west to east, the paintings show the Crucified Christ in the higher tier and a Marian subject below, such as the Virgin Mary with child. (188) Examples of pier altar paintings in parish churches can be seen at Little Missenden, Lydiard Tregoze (Wilts) and Broughton (Oxon). (239)

Figure 188 Nave pier altar: St Alban's Cathedral, thirteenth century.

In addition to adorning altars, wall paintings also decorated piscinas, or sacrariums, the basin where the priest rinsed the chalice and plate after the Mass. Usually set within a canopied niche on the south side of the chancel, many seem to have been painted in a single colour or pattern. At Prior Crauden's Chapel in Ely (Cambs), the canopy of the piscina was gilded and the back wall of the niche painted with a now indecipherable scheme. A complete figurative design can be seen at Lichfield Cathedral, where a piscina at the east end of the south choir aisle still retains a painting of the Crucifixion on its back wall, adding a further layer of Eucharistic meaning to the ritual. (189)

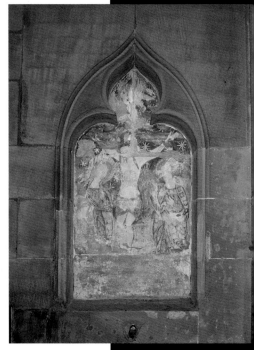

Narrative paintings in chancels may also have complemented the Mass conducted at the High Altar. The extensive scheme of Christ's Infancy and Life at Brook and the Passion sequence on the north wall at Chalgrove both added visual substance to the miracle of the transubstantiation being enacted before them. At Maids' Moreton (Bucks), the sedilia where the priests sat was itself painted with a representation of *The Last Supper*: the moment when Christ gave voice to the miracle of the Mass.

In monastic refectories, such as at St Thomas's Hospital in Canterbury and the Refectory of St Martin's Priory Dover, (now Dover College), the walls were decorated with large-scale paintings of the Last Supper which provided the monks with exemplary 'food for thought' imagery as they ate. (191)

Easter

Wall paintings also provided complementary imagery for Easter, the holiest week in the Christian calendar, when Christ died and was resurrected. Rituals began on Palm Sunday and grew in emotional intensity as the week progressed. On Maundy Thursday the priest consecrated three wafers, two of which were reserved for the events which followed. After the Mass, the altars of the church were stripped of their cloths and washed, with each act representing the stripping of Jesus for crucifixion. Good Friday was reserved for solemn mourning of the Passion,

when the whole of the story was read aloud and clergy and laity alike crept barefoot to kiss a cross that had been brought into the church. Later that same day one of the previously consecrated hosts was ritually entombed in either a carved stone or temporary wooden Easter Sepulchre, re-enacting the burial of Christ. After being guarded until Easter Sunday, the host was returned to the altar and the joy of the Resurrection celebrated with the raising of the Lenten veil which had shrouded the Rood for forty days, as well as processions, singing and annual communion.

Opposite top:
Figure 189 A painted piscina: Lichfield Cathedral, fifteenth century.

Opposite bottom:
Figure 190 'The Mass of St Gregory': Slapton, St Botolph, fifteenth century.

Above:
Figure 191 The Last Supper: the Refectory, Dover Priory, late twelfth century. Now lost.

Numerous wall paintings provided integrated visual imagery for these moving ceremonies of faith.

The most common were Passion story narratives in the nave. But sometimes, as at Madley (Herefordshire), and Ashby St Ledgers, these paintings of the Passion shared the same wall as the Rood. At Kempley, a painting on the nave east wall to the right of where the Rood would have hung invokes part of a liturgical drama, the '*Visitatio Sepulcri*', with *The Three Marys at the Tomb* standing around a temporary frame cloaked by an embroidered cloth, possibly a copy of a contemporary example. (63)

Wall paintings could also embellish Easter Sepulchres. At St Mary de Crypt in Gloucester (Glos), paintings of the Three Marys survive above the Easter Sepulchre in the chancel. At East Bergholt (Suffolk), the interior of a recess in the north wall of the chancel was painted with a scene of the Resurrection, adding visual truth to its use as the Easter Sepulchre. At Exeter Cathedral a painting of the Resurrected Christ enclosed within the Sylke chantry chapel suggests that the space may have housed the Easter Sepulchre. (192) A sequence of post-Resurrection wall paintings in the north chapel at Yaxley (Cambs) hints that this part of the church may also have had a special function during these ceremonies.

The way that different imagery could be combined for a particular meaning is cleverly illustrated at Bradwell-juxta-Coggeshall (Essex), where the soffits and splays of the north-east chancel window are painted with a Throne of Mercy Trinity on the eastern splay, Christ showing his wounds flanked by angels carrying the Instruments of the Passion (Abbreviated

Doom) on the soffit and a swaying Christ in a *Noli me Tangere* posture on the western splay, forming a cohesive backdrop for any temporary Easter Sepulchre placed against this wall. (193)

Resurrection-related paintings above tombs may indicate that they were used as platforms or housings for temporary Easter Sepulchres.

Powerful patrons frequently claimed this honour. At Long Melford (Suffolk), for example, the church was lavishly rebuilt in the late fifteenth century by a wealthy landowner and some-time sheriff of the county, John Clopton. As befitting his status, his flat-topped tomb chest on the north side of the chancel not only includes painted images of him and his wife looking at the resurrected Christ holding an inscribed banner – '*Omni qui vivet et credit in me non morietur in aeternum*', (All who look on me and believe in me will have eternal life), but its position and accompanying text meant that it almost certainly hosted the Easter Sepulchre. (194)

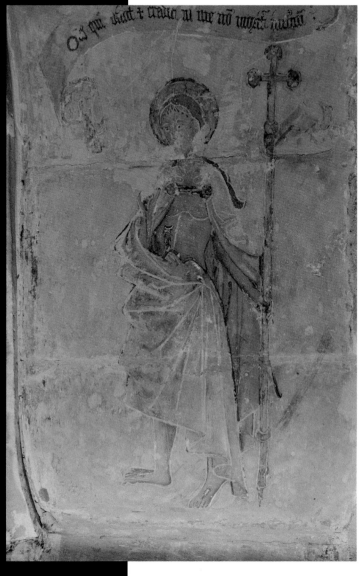

Other Ceremonies

The contribution of wall paintings to the other great Christian ceremonies of the year, such as Christmas and Epiphany, are less pronounced, although cycles of the Holy Infancy and images of *The Adoration of the Magi* could obviously be invoked. Again, paintings such as the miraculous Mass of St Gregory and images of Christ as the Man of Sorrows would have resonated with clergy and congregation alike during the Eucharistic feast of *Corpus Christi*. (190)

Two other Feasts which became popular towards the end of the Middle Ages, those of the Holy Name and the Transfiguration, were also represented in paint.

Devotion to the Holy Name, repetitions of pronouncements of the name of Jesus as a word of power, of healing and salvation, began in the mid-fourteenth century and grew steadily until an official feast was added to the liturgy in the 1480s. These ideas are eloquently displayed in the chapel of St John the Baptist at Ewelme (Oxon), where a (repainted) regular diaper pattern of holy I H S monograms covers the walls, and selected quotations from biblical texts decorate the coving: 'and hath given him a name which is above all names. That in the name of Jesus every knee should bow, of those that are in heaven, on earth and under earth' (Philippians II); 'But I will rejoice in the Lord: I will joy in God my Jesus' (Habakkuk III); 'For there is no other name under heaven given to men whereby we may be saved' (Acts IV); and 'Everyone that shall call upon the name of the Lord shall be saved;' (Joel II). (195) Similar Holy monograms appear in many churches.

Opposite top:
Figure 192 The Resurrected Christ: Sylke Chapel, Exeter Cathedral, fifteenth century.

Opposite below:
Figure 193 Throne of Mercy Trinity, probable backdrop for temporary Easter Sepulchre: Bradwell-juxta-Coggeshall, Holy Trinity, fourteenth century.

Above
Figure 194 The Resurrected Christ: Long Melford, Holy Trinity, late fifteenth century.

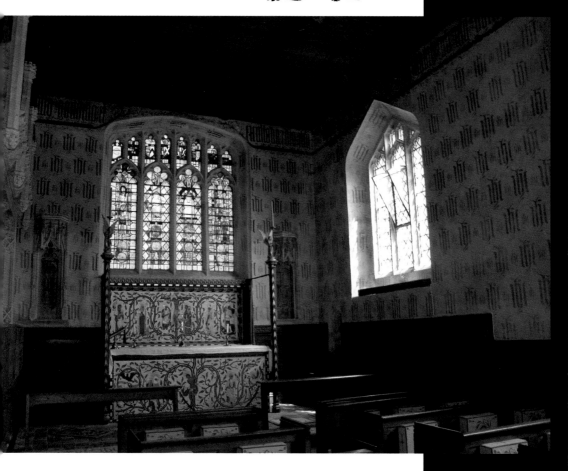

Figure 195 Holy monogram decoration: The Chapel of St John The Baptist: Ewelme, St Mary, mid- fifteenth century.

The Feast of the Transfiguration celebrated the manifestation of Jesus's future glory when he was seen with the prophets Moses and Elijah on Mount Tabor, after which God spoke to St Peter, John and James, telling them 'This is my son whom I have chosen, listen to him'. A (now illegible) wall painting of this subject was discovered above the east window at Hawkeden in Suffolk in the 1930s, while references to the Feast appear as extant textual inscriptions on the inner wooden screens of the Chudleigh Chantry Chapel at Ashton (Devon). (208)

Saints

Wall paintings of saints revered their holy sanctity, showed exemplars of Christian virtues and often told stories of miracles and martyrdom. (196) Some depicted saints in poses reminicent of the sufferings of Christ, '*imitatio Christi*'. They provided a visual focus for worshippers who invoked their help.

Images of the Virgin Mary were particularly common, especially in Lady Chapels. Some schemes included scenes of her Life and Miracles. A painting on the north wall of the chancel at Broughton (Oxon), which

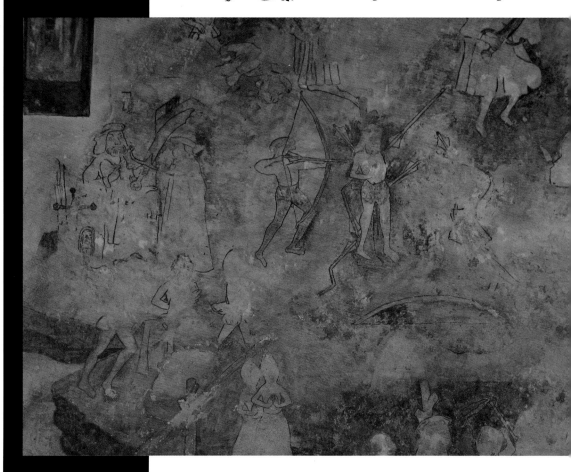

Figure 196 Scenes from the Life and Martyrdom of St Christopher: Hemblington, All Saints, fifteenth century.

shows a priest, possibly John Wykeham, rector in 1398, holding a scroll inscribed: 'Lady, by your Five Joys, lead me to the way of clean living', is part of such a sequence illustrating the Death of the Virgin. A painting, now inaccessible to the public, in the former Prior's Chapel at Durham Cathedral celebrates all five of the joys: the Annunciation, the Nativity, the Resurrection, the Ascension and the Assumption. At Eton College both sides of the Chapel nave were graced with stories of her Miracles.

Wall paintings of saints decorated other chapels. At Cirencester, a chapel in the north chancel aisle was dedicated to four saints, St Katherine, St Christopher, St Nicholas and St Anthony, and wall paintings of the first two named still survive. Such altars were used by worshippers to implore the support of saints during prayers to God. Many also attracted gifts. At Littlebourne, in Kent, William Davyson left 2lbs of wax for tapers (candles) for St Christopher in 1514, while at East Haddon, (Northants), a T (homas?) Chapman left vjs, viijd in 1529, 'To Saynt Nycholas altar an hyt (it) to be payd when they paynt the walls'.

Unfortunately it is often difficult to know whether such gifts specifically related to a wall painting or to a statue of the saint. At Trottescliffe

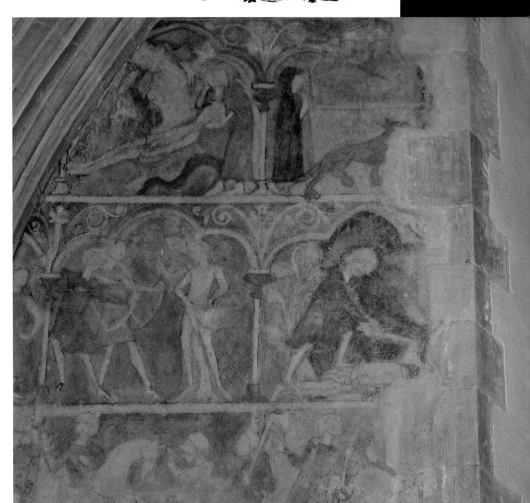

Figure 197 Scenes from the Martyrdom of St Edmund: Cliffe-at-Hoo, St Helen, thirteenth century.

(Kent), for example, the fifteenth-century churchwarden accounts list several bequests of between four to six pence for lights for an image of St Christopher, which was quite possibly a wall painting but more likely to be a statue that is known from contemporary accounts to have existed below the Rood. Again, it is not entirely clear if she was referring to wall paintings or statues when Margery Dogett of Norwich left money in 1515 for lights to be lit below images of St Michael, St Anne, St Nicholas and St Christopher, all of whom were commonly represented in wall paintings.

Evidence that candles were lit and prayers said before wall paintings of saints is provided by the discovery of scorch marks during the cleaning of a painting of St Christopher at St John's Church, Winchester (Hants), in 1958 and by repairs to the wall below another painting of the Saint, at Wyken (Warks), where a ledge for candles may have once protruded.

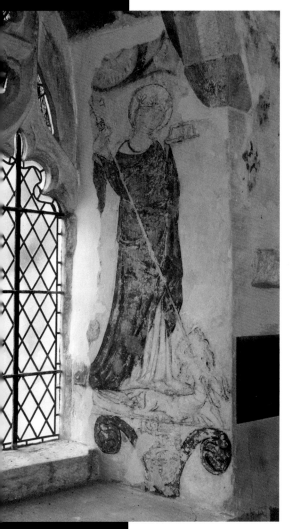

Figure 198 St Margaret defeats the dragon: South Newington, St Peter ad Vincula, fourteenth century.

The example mentioned earlier of a priest at Broughton holding a scroll pleading to the Virgin to help him lead a 'clean' life is essentially a painted prayer.

Wealthy patrons might commission paintings of their preferred saints for altars. Henry III had 'stories' from the life of his favourite royal saint, St Edward the Confessor, painted in several of his private chapels and scenes from the martyrdom of St Katherine painted above the altar in a chapel which bore her name at Guildford Castle. Thomas Tropnell (d. 1488), an important Wiltshire landowner, was another who had his family chapel at Great Chalfield decorated with paintings of this popular female virgin martyr.

The astonishing decorative scheme at St James's, Stoke Orchard (Glos), probably commissioned by a member of the local Archer family, lords of the manor, 1182–1351, is a paradigm of extreme devotion. When made, in the first half of the thirteenth century, the wall paintings would have transformed the church into a virtual painted shrine for the eponymous saint. Around forty scenes of his life were depicted, dominating the south, west and north walls, entirely at odds with the usual mixture of imagery found in other churches of the same period, possibly reflecting an emotional pilgrimage by the donor to the Saint's shrine in Compostela.

The scheme is interesting in other ways, with a sharp mismatch between the vigour of the borders and the indifferent artistic quality of the paintings, despite their surprisingly strict adherence to the text of one of the earliest accounts of the saint's life. Might a literate priest have advised a local painter who found it difficult to create images without a visual template? It is impossible to know, but there is nothing uncertain about how these wall paintings articulated the donor's personal devotion to St James. (249)

A wall painting of St Faith, the patron saint of prisoners, in a side chapel at Westminster Abbey might throw some light on why particular saints attracted intense devotion.

Figure 199 A painted chancel: Chalgrove, St Mary, early fourteenth century.

In October 1303 the Abbey was rocked by a major scandal after the royal treasury in the Chapter House crypt was robbed. When suspicion fell on the Abbot and his monks, forty-eight of them were imprisoned in the Tower of London. It is possible that the painting, which was made around this date, could have been a post-votive offering to a saint whose help had been invoked by the Chapter as they sought their release. (125)

At parish levels, guilds dedicated to particular saints probably commissioned wall paintings celebrating the lives of their patrons. At Burton Latimer (Northants), for example, a thriving local guild of St

Katherine could have been responsible for commissioning the life cycle images of the saint which can still be seen in the north aisle.

Wall paintings and altars dedicated to saints would have had practical uses, as when travellers sought the protection of St Christopher's image before leaving their parish, and pregnant women invoked the aid of St Margaret during childbirth. They could also be used in more subtle ways. Images of St Anne preparing her daughter for her destiny as the mother of Christ, *The Education of the Virgin*, may have also been interpreted as a symbol of the saint herself, as an example of a wise and attentive mother, even as an early role model for encouraging women (and men) to learn to read. The exemplary lives of other saints may have proved equally inspirational. Their fortitude, chastity, self-denial, endurance, courage, kindness and other virtues provided idealistic role models for people in every walk of life. Perhaps because of this ability to resonate with different audiences in different ways, the appeal of wall paintings was not only monumental and public, but also personal and intimate.

Wall paintings were almost certainly invoked by priests when they spoke about saints on their dedicated day or during the run-up to them. The contents list of a book bought from a London stationer in 1463 by the rector of Cliffe-at-Hoo in Kent contained sermons for 'teaching for a curate to tell the people about the lives of saints throughout the year'. (197)

Such services were often followed by re-enactments and communal events. In Coventry, the annual procession of the Corpus Christi Guild included actors dressed as the Virgin Mary, the Angel Gabriel, King Herod and other biblical characters. In Leicester, members of the Guild carried torches and a Eucharistic Host through the streets, followed by the mayor and priests. In Norwich, St George's day was celebrated with a mounted man dressed in armour and another disguised as a dragon staging a mock battle through the city streets while gunpowder contributed special effects, such as flames and smoke. Similar pageantry occurred in other towns. In London, St Margaret's feast day in the Westminster church which bore her name began with a Mass followed by a procession and a play of her life. A suggested homily by John Mirk for such an event invoked her imagery:

> *Herfor Margaret ys payntnyd over coruen*
> *wher scho ys with a dragon undyr her fete*
> *and a cros yn her hond, schowyng how by*
> *vertu of ye cross scho gate ye victory of ye fynde.*
> (Margaret is painted with her crown and a dragon under
> her feet and a cross is in her hand, showing how by virtue
> of the cross she gained victory over the fiend.) (198)

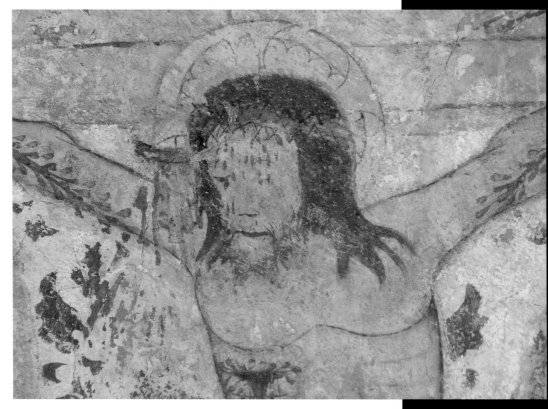

Such stories were not just yarns. Mirk's sermons stressed the need for parishioners to attend mass on the saint's feast day if they wanted her help and warned that the devil had told St Margaret that his favourite pastime was making Christians forget their baptismal vows.

Figure 200 Christ with the Crown of Thorns: Combe, St Laurence, fifteenth century.

Apart from giving visual form and focus to the saints whom worshippers invoked, wall paintings could also recall sacred rites and promises, good times, past, present. Faith and memory, hope and joy, discipline and obedience were indivisible.

Communicating Faith

The role of wall paintings as 'books for the illiterate', as they are frequently called, is more complex than often assumed. There are very few contemporary accounts of how medieval people 'saw' or reacted to wall paintings and it is easy to fall into the trap of imagining how they were regarded, or accepting justifications for imagery at face value.

Although often quoted, Pope Gregory the Great's famous dictum, written around AD 600, that 'Pictures are used in churches so that those who are ignorant of letters may at least read by seeing on the walls what they cannot read in books; what writing does for the literate, a picture does for the illiterate looking at it, because the ignorant see in it what they ought to do,' cannot be taken literally.

It is simply impossible for anyone to 'read' or understand wall paintings without any prior knowledge of what the stories mean. How else would anyone know that snake curled around a Tree represented the beginning of the Temptation and Fall of Mankind?

The idea that wall paintings were primarily 'poor men's bibles' or picture substitutes for books is equally unsustainable. Apart from the complexity of some of the images, such interpretations totally disregard the profusion of wall paintings in cathedrals like Canterbury, where books were relatively plentiful, or the extensive decoration of chancels like those at Brook and Chalgrove, from which ordinary parishioners were excluded. (199) In addition, such explanations miss the implications of lengthy textual inscriptions, such as the Latin verses and names painted in the small parish church at Hardham, around 1100; the labelling which often accompanied pictorialisations of schemes such as the Seven Deadly Sins; or the inscribed scrolls which hang like ticker tape from the Allegory of the Soul painting at Swanbourne. (89) It also forgets that by the end of the Middle Ages a growing proportion of the population could read and yet still commissioned wall paintings for their churches. And, as was seen in Chapter 2, if wall paintings were a curriculum to teach the faithful, most books of the Bible were ignored and other key 'texts' never shown.

These reservations aside, it seems reasonable to assume that wall paintings cemented the familiar, helped people remember stories,

Figure 201 Pieta with The Virgin crying tears of blood: Thame, St Mary, fourteenth century.

encouraged devotion and stimulated curiosity. Different audiences may have responded to them in different ways at different times. According to a French source, the ferocious Duke of Lorraine, one of the first crusaders to enter Jerusalem in 1099, who was known as the *Advocatus Sancti Sepulchri* (Defender of the Holy Sepulchre), often stayed behind after services to ask priests about the meaning of wall paintings he did not understand.

Figure 202 Bishop Losinga pays simony to the king's agent: Norwich Cathedral, *c.* 1200.

Again, it seems reasonable to assume that the paintings would have helped to give flesh and form to familiar characters and incidents that were at the core of medieval Christian beliefs.

But they were not only the only art performing that function. Images depicting the Passion of Christ or the martyrdoms of popular saints were not exclusively confined to church walls. Similar images often abounded in different media elsewhere in the same church. Moreover, medieval life was drenched with religious symbolism and iconography, from wayside crosses and statues to personal 'Christian' names and domestic furnishings. Churches were the biggest buildings in every parish and often the largest landowner. Every day church bells told the time, every week began and ended with the Sabbath, every year was defined by

great festivals such as Easter and Corpus Christi. Church processions and rituals, itinerant preachers and travelling actors, re-enactments and feast days were the public highlights of private lives. Religious dramas, in particular, could make lasting impressions. People did not 'learn' from wall paintings alone: from the moment they could talk, religious ideas and imagery formed part of who they were.

Wall paintings were not commissioned because people were 'unlettered' or to remedy their ignorance of the holy. And once they are no longer 'seen' only as books, they can be 'seen' in new ways: as works of art, sufficient in their own right that they existed where they did; as homages to Christian history and belief; as participants in the liturgy and the daily rituals of prayer and introspection; as expressions of authority and patronage; as visual incarnations of spiritual virtue and reassurance. And finally, as imagery that could be averred to and explored during homilies, private devotions and daily conversation, where they provided 'mind's eye' pictures for familiar words and stories.

The lasting power of such paintings to imbed themselves on groups or individuals was nostalgically recalled in a poem written by John Lydgate (*c.* 1370–1450), a monk of Bury St Edmunds Abbey, in the fifteenth century:

> *Which now remembering in my later age*
> *Time of my childhood, as I rehearse shall,*
> *Within 15 holding my passage.*
> *Mid of a cloister, depicted upon a wall*
> *I saw a crucifix, whose wounds were not small.*
> *With this word 'vide' [see], wrote there beside,*
> *'Behold my meekness, O child, and leave thy pride.'*
>
> (Testament, verse 99)

Seeing wall paintings only as 'books for the unlettered' ignores the meditative impact described by Lydgate and the admonitory inscription to 'leave his pride' when he saw images of Christ and His suffering. Again, just as St Francis epitomised the suffering of Christ by receiving the stigmata, the scars of Christ's wounds upon his body, so wall paintings showing images of Christ's bleeding and torn body urged worshippers to think about their saviour nailed to a cross and the pain He suffered for their sake.

The impact of such imagery could be extremely powerful. According to John Mirk, there were 'many thousands of people that could not imagine in their hearts how Christ was crucified if they did not learn it by looking at sculpture and painting'. Angela of Foligno, a thirteenth-

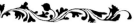

century Franciscan mystic, went further, confessing, 'whenever I saw the passion of Christ depicted, I could hardly bear it and came down with a fever and feel sick'.

Others, such as Richard Rolle (*c.* 1300–1349), a prodigious fourteenth-century religious writer sometimes called 'the Hermit of Hampole', conjoined images and thoughts of Christ's Passion to arouse people as they prayed and meditated:

Thinke the than hoe (thei) toke him oute (fro) prisone, and bonde his hondes behinde him that the blode brest oute at the nales ... Sithen how thei naked him. Sithen how thei led him to a piler and bonde him. Sithen how thei scourged him that fro the hede to the feete ... Sithen how thei corouned him with thornes that..the blode oute brest.. Sithen what sorowe comme to his herte when he sawe his moder

(Think then how they took him from prison and bound his hands behind him so that the blood burst out of his nails. See then how they stripped him and tied him to a pillar. See then how they scourged him from head to foot. See then how they crowned him with thorns so that the blood burst from his skin. See then what sorrow came into his heart when he saw his mother.)

Figure 203 Episodes from the Foundation of the Priory: Horsham St Faith Priory, mid-thirteenth century Retouched in the fifteenth century.

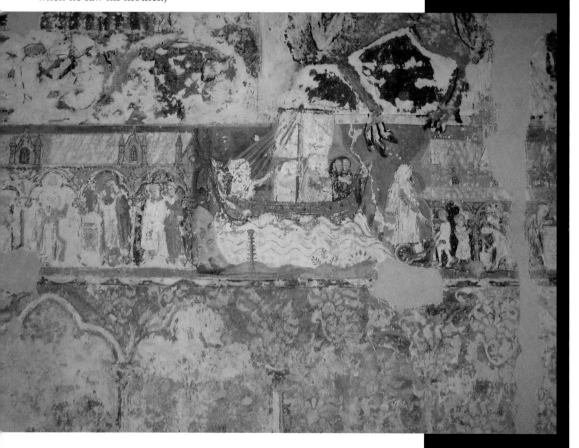

Numerous late medieval wall paintings provided the imagery for people to do exactly that: to see then (*sithen*), to think and to see again in their mind's eye the story of the Passion and the horrors it told. Three Oxfordshire paintings make the point: at South Newington, Christ's body is spattered with ugly weals as he is scourged (149); at Combe, blood spurts from his temple as the crown of thorns tears his flesh (200); at Thame, his mother, the Virgin Mary, weeps tears of blood as she cradles her dead son. (201)

After such images Rolle's command to his readers that: '*Thinke the how thou hast spended this day ... and say, 'Lord, I aske mercy and forgyunesse for thi mercu and thi pitte',* has a compelling intensity.

In fact, once such paintings are no longer 'seen' as substitute 'texts', their impact becomes sharper, not less. They become reminders of sacred promises, visual prompts to belief, and monumental proclamations of faith inseparable from the life and fate of every Christian and their piety.

Wall paintings might also provide inspiration for 'unlettered people' in the same way that a theological manuscript might provoke literate monks to grapple with some of the most profound philosophical ideas of their age. Others may have come close to a form of wondrous entertainment. Significantly, almost all would have provided a visual orthodoxy; a set of recognizable images which formed an international Christian visual language which supported doctrinal beliefs and provided a shared imagination for every community.

PRIVATE AND PERSONAL DEVOTION

Patronage

Wall paintings often commemorated individual patrons, via heraldry, donor portraits or inscriptions. They were used as statements of status, obligation, lineage, belonging, hope and virtue. Some revealed the donor's personal devotion to a particular saint. Others canvassed prayers. A few showed representations of donors holding small images of the church they had bequeathed. Many decorated funerary chapels and tombs.

A sixteenth-century wall painting in the Lady Chapel of Winchester Cathedral combines some of these themes. It shows the then Prior, Thomas Silkstede, (1498–1524), kneeling in prayer before an image of the Virgin Mary within a much larger scheme devoted to the Miracles of the Saint. In addition to an inscribed prayer declaring his love for St Mary, the paintings also include a further inscription acknowledging that he caused the walls to be painted. Faced with such imagery, no one could be in any doubt about Silkstede's piety.

Another group of paintings commemorating patronage had wider purposes. Their aim was to honour both the patron and the foundation of their institution. They provided roots, histories, legitimacy and traditions.

At Norwich Cathedral, for example, three scenes from a once larger sequence of paintings in a south aisle vault tell the gripping tale of sin, repentance and atonement which led to the rebuilding of the church around 1100. Known as the 'Losinga cycle', it recalls how, as the Abbot of Ramsey Abbey in Cambridgeshire, Herbert de Losinga bought the See of Thetford (the forerunner of Norwich) in 1091 from the king's agent, Ranulf Flambard in a flagrant act of simony (so-called after the efforts of the magician, Simon Magus, to buy apostolic powers), which he later came to regret. The first scene shows Losinga handing a bag of money over to Flambard; the next shows him bereft in remorse, and the third illustrates the rebuilding of the Cathedral by the penitent Bishop. (202)

A better-preserved sequence of paintings in the refectory at nearby Horsham St Faith Priory tells the story of a different reason why a church might be endowed. Although made nearly two hundred years later than the events they chronicle, the scheme shows the miraculous escape of the Priory's founders, Robert Fitzwalter of Caen, the lord of Horsham, and his wife Sybilla, after they had been kidnapped by bandits in the south of France on their way home from a pilgrimage to Rome in 1106. Imprisoned by their captors, the couple invoked the aid of St Faith, who then appeared to them in a vision, loosened their fetters and enabled them to flee to Conques, the home of her principal shrine. Overwhelmed with gratitude, the couple vowed to found a daughter house of the Abbey in her memory, and subsequently paid for two monks to come to Norfolk and establish the Priory where these wall paintings still survive. (203) The paintings show every episode of the story and one can imagine similar schemes being made at other monastic institutions which owed their foundation to repentance, gratitude and miracles.

Private paintings

Wall paintings were also commissioned by wealthy patrons to adorn private chapels and domestic chambers, where they would never be seen by large or illiterate audiences.

At Chichester Cathedral, the Bishop's personal chapel was painted with one of the most exquisite masterpieces of the mid-thirteenth century: an eye-level roundel of the Virgin and Child which personifies purity and love. (204: 21)

Similarly, a chapel in the Byward Tower (Tower of London), includes exceptional paintings apparently created for Richard II in the 1390s. Unfortunately they are currently inaccesible to the general public.

About one hundred years later, William Worsley, the Dean of St Paul's Cathedral (1479–99), commissioned paintings for the chapel of his private residence, Brook House, in Hackney. Now displayed in the Museum of London, the only surviving fragment shows a tonsured figure kneeling before St Peter together with the arms of Roger Radclyffe, Worsley's steward.

At Cleeve Abbey (Som), a private room where the Abbot received special guests was painted with an allegorical 'conversation' scene illustrating the story of a man trapped between the sea (the world), a lion (the flesh) and a dragon (the devil), with angels offering eternal life or divine punishment if he succumbs to temptation. (205)

The solar block of the Treasurer's House in Martock (Som), so-called because it was the home of the Treasurer of Wells Cathedral, retains a wall painting of a more standard kind in an upstairs room – a *c.* 1260 scene of the Crucified Christ.

Figure 204 Detail of The Virgin and Child: The Bishop's Palace, Chichester, mid-thirteenth century.

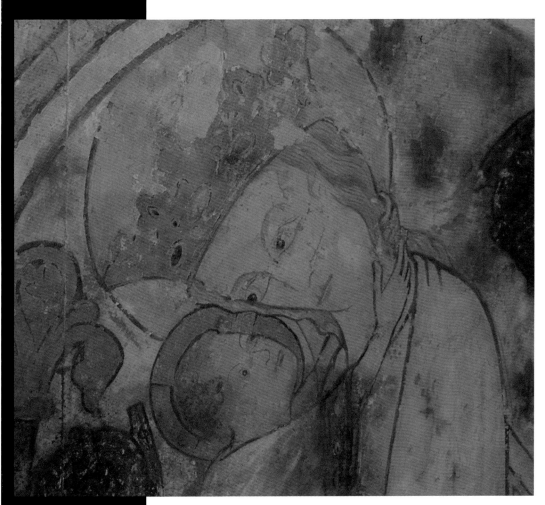

Figure 205 Detail of an allegorical painting: The Painted Chamber, Cleeve Abbey, late fifteenth century.

Not all private wall paintings were religious. Now lost early-fourteenth-century paintings said to have decorated the walls of the Bishop's palace at Lichfield (Staffs) recorded Edward I's coronation, marriage, wars and funeral. At Amberley Castle, in Sussex, the walls of Bishop Sherborne's country seat were lined with a roll-call of the 'Heroes and Heroines of Antiquity' painted by the Chichester Cathedral artist, Lambert Barnard.

At Eton College, a school room was painted with a scene of rows of boys sitting on wooden benches at the feet of their tutor. A translated latin script says 'A good teacher is able to distinguish and foster the talents of individual boys and should not try to make men into automatons'.

In some cases wall paintings of religious subjects and secular stories shared adjacent spaces. At Longthorpe Tower (Cambs), the Great Chamber of the de Thorpe family (fourteenth-century stewards of Peterborough Abbey) effervesces with themes and images ranging from dynastic heraldry and a standard image of The Three Living and The Three Dead, to a unique painting of the Wheel of the Five Senses with a monkey, a vulture, a spider's web, a boar and a cock symbolising respectively taste, smell, touch, hearing and sight.

The greatest of these combined schemes was Henry III's Painted Chamber at Westminster Palace. It included an ensemble of Old Testament tales about kingship, a Bestiary, a Map of the World (Mappa Mundi), a Tree of Jesse and other subjects. It was almost totally destroyed by fire in 1834. Two surviving ceiling panels can be seen in the British Museum.

Name-Saints

Wealthy people commissioned wall paintings which linked them to their personal name saint(s).

In late medieval Norwich almost a third of the men were christened John, in honour of St John the Baptist and St John the Evangelist. Another fifteen per cent were baptized as William, after a local boy who was allegedly murdered by Jews in 1154 and subsequently revered as a saint. Although this phenomenon was not as pronounced among the city's women, twenty-five per cent of girls were given the Christian names of two virgin martyrs: Margaret (eighteen per cent) and Katherine (seven per cent). When Henry III's second son was born in 1245 he was named after St Edmund, whom the King had invoked during prayers for a boy. The future Earl of Lancaster's painted tomb can still be seen in Westminster Abbey, where an extensive scheme of wall paintings in the Chapter House, based on the apocalyptic vision of St John the Divine, also seems to have owed much to a donor's strong affinity with his 'name saint'.

Records in the Abbey list a Brother John of Northampton, a monk between 1372 and 1404, as having 'caused to be made the painting of the Apocalypse for £4 10s in the Chapter'. A further entry in the same book, the Abbey's *Liber Niger Quatermus*, also mentions that Brother John contributed towards the cost of another 'St John' painting: the altar of St John the Baptist in the main church. In both instances the donor's patronage seems allied to his name-saints.

An unequivocal assertion of such affinity can be seen in a multi-figure scheme at South Newington in north Oxfordshire. Donor images of Margaret Mortayne and her husband Thomas Gifford are shown praying before an image of the Virgin Mary, while adjoining walls include a painting of Margaret's namesake, St Margaret, and representations of two other saints, each with the same 'Christian name' as Thomas. While the first of these, a standard scene of The Martyrdom of St Thomas Becket, is notable for its quality, the second is remarkable for its iconography. It shows a picture of the beheading of Thomas of Lancaster, a northern lord who was executed at Pontefract Castle in 1322, after leading uprisings against Edward II. (206) When miracles were said to have occurred at

the dead noble's tomb, attempts were made to canonize him as a saint. The reason for his inclusion in the South Newington scheme around five years after Edward's own overthrow and murder is unknown. Possible explanations include networks of kinship or support for Thomas's canonization. Political subtexts cannot be ruled out.

Chantry Chapels

Wall paintings were also made for more important personal reason – to aid salvation. Sometimes they linked gifts to a church with pleas for audiences to pray for donors' souls. They were also an integral feature of the decoration of funeral chapels, known as chantries. Established by wealthy people who paid for a priest(s) to sing masses for their souls, more than two thousand were licensed between the second quarter of the thirteenth century until their suppression in 1547 during the Reformation.

Wall paintings in these chapels were often combined with personal imagery such as heraldic glass and sculpture to honour the founder and his family.

Figure 206 The Execution of Thomas, Earl of Lancaster: South Newington, St Peter ad Vincula, fourteenth century.

At Tewkesbury Abbey, the chapel of Lord Edward Despencer (d. 1375), described in Froissart's chronicle of the Hundred Years War as 'the most honourable, gallant and valiant knight in all England', was built by his wife, Elizabeth, sometime between 1390 and 1400. It included an effigy of Sir Edward facing the high altar from the roof of his chapel and a wall painting of the couple kneeling before an image of the Trinity. (207)

A few miles away, at Winterbourne (Glos), the chantry chapel of an earlier royal favourite, Sir Thomas de Bradeston, bristles with martial symbolism. The walls are painted with shields and banners and several images of the knight's great helm surmounted by his family crest of a boar's head. Sir Thomas is even painted wearing his armour while a faded prayer inscription rises from his clenched gauntlets as if it were a brandished sword.

The purpose of such imagery was spelled out in another chantry chapel, the 'Golden Chapel', built in 1510 at Tong (Shrops) for an even more important family. Below a barely visible painting of the Crucified Christ an inscription reads:

Pray for the soul of Sir Harry Vernon, knight, and dame Anne his wife, which Sir Harry in the year of owre Lord 1515 made and founded this chapel

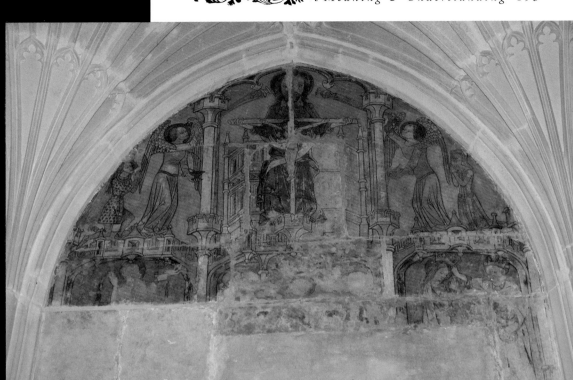

Figure 207 Donors adore The Trinity: The Despencer Chantry Chapel, Tewkesbury Abbey, fourteenth century

and chantry. And the said Sir Harry departed the 8th day of April in the year above said. And of your charity for the soul of Sir Arthur Vernon, priest son of the above said Sir Harry, on whose souls the Lord have mercy. Amen.

The Chudleigh family chantry chapel at Ashton added further strata to such schemes. Apart from heraldic glass in the windows and a wall painting of Christ with the emblems of the Passion on the north wall, even the wooden walls which separated the chapel from other parts of the church were painted with a scheme of demi-figures of prophets and scrolls exclaiming the miracles of incarnation and the resurrection. (208)

Tombs

Wall paintings decorated personal tombs, commemorating the dead, visualising their hopes for everlasting life and revealing their life-time affection for particular saints.

At Northmoor (Oxon), a local manorial family's hope for everlasting life is displayed by a painting of angels carrying the deceaseds' souls to heaven in a napkin while the resurrected Christ raises his hand in blessing on the adjacent wall. Such imagery seems to have been relatively common. Other examples can be seen at Wingrave (Bucks) and Winchelsea (East Sussex). (209)

Figure 208 Christ with
Instruments of the Passion and
painted screens: The Chudleigh
Chantry Chapel, Ashton, St
John the Baptist, fifteenth
century.

At Maidstone (Kent), a painting in the recess above the altar-tomb of
John Wootton (d. 1417), the first master of the Collegiate Church, shows
him praying to the Annunciate Virgin Mary witnessed by several other
saints, including St Katherine. (210)

At St David's Cathedral (Wales, Pembroke), the tomb of another
important cleric includes a wall painting of the Crucified Christ on the
west wall behind his head and symbols of the Four Evangelists above
him. (211)

Probably the most intimate wall paintings of personal devotion
are those found within the 'cage' of Alice de Pole's double effigy tomb
at Ewelme, in Oxfordshire. In contrast to her upper effigy, the lower
sculpture shows the Duchess of Suffolk as a shrivelled cadaver. Above her
half open eyes a painting of the Annunciation promises salvation while
at her feet paintings of St John the Baptist and St Mary Magdalene dip
their eyes to meet her sightless gaze. Exclusive photographs for this book
reveal the details of these images for the first time since they were painted
around the time of her death in 1475. The colours are fresh. The detail
is fascinating for images that were never meant to be seen by any wider
audience. (212: 213: 214: 215)

Pilgrimage

Wall paintings complemented another form of personal devotion which was simultaneously both private and public: pilgrimage. Wall paintings were used to decorate shrines, to record and enhance devotion, to lure pilgrims to particular sites and to provide inspiration for those who made sometimes long and perilous journeys.

Pilgrimages were undertaken for many reasons: for the sake of Christ, as penance, frequently to seek aid from a saint whose relics the devout could see or touch.

St Peter's tomb in Rome; Palestine, the Holy Land where Jesus had lived, preached and died and St James's shrine in Spain were the main destinations for English pilgrims travelling abroad. It is possible that some painted churches, such as Stoke Orchard, which were devoted to St James sought to attract or support pilgrims making their way to a channel port. A wall painting of the same saint presenting pilgrims to Christ, at Wisborough Green, suggests such a purpose, as the church also claimed to possess a relic of the saint – 'the comb of St James'. (81)

Figure 209 An angel carries a soul to Heaven: Winchelsea, St Thomas, fourteenth century. The effigy is not original to this tomb.

Figure 210 The Tomb of John Wootton: Maidstone, All Saints, fifteenth century.

England and Wales had numerous shrines for home-based pilgrims, some of which also attracted international visitors.

For centuries, one of the most famous destinations was St Thomas Becket's shrine at Canterbury, where wall paintings of Christian kings added to the sublimity of the Holy Trinity Chapel where the murdered archbishop lay.

Wall paintings en route to the Cathedral sustained such pilgrims. The so-called Pilgrim's Way from London to Canterbury, included a stop at Stone (Kent), where a large, but faded, painting of the saint's martyrdom can still be seen on the north wall.

Other important shrines with wall paintings were at Bury St Edmunds (Suffolk), St Mary's Walsingham in Norfolk, and at Chichester Cathedral in Sussex, where the remains of St Richard Wych, bishop between 1245 and 1253, were translated, or moved from their original burial place, to a special chapel built in 1276 after his corpse was said to have thaumaturgical, or miracle-working, powers. Records show that in 1373, Bishop William de Lenne left money so that the shrine to the saint (now the chapel of St Mary Magdalene) could 'be painted anew on the left side, that is where the head of St. Richard is placed, with good and lasting pictures of the life of St Richard'.

Pilgrims entering St Albans Abbey through a door in the north transept were first ushered past wall paintings, including a representation of the *Incredulity of St Thomas*, before entering the chapel where the proto-martyr's remains were kept. (66) Several paintings belonging to the decoration of this chapel survive, including a representation of St William of York which probably formed part of an altar retable. (216)

The most important pilgrimage site in Wales also contained wall paintings. After the Prior of Ewenny had a dream about where the body of St David could be found, the saint's remains were recovered and translated to a new shrine in the Cathedral in 1275. Paintings of the saint decorated the tomb.

Two other painted schemes deserve mention in this context. The first survives in a private house at Piccotts End, Hemel Hempstead

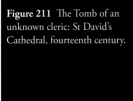

Figure 211 The Tomb of an unknown cleric: St David's Cathedral, fourteenth century.

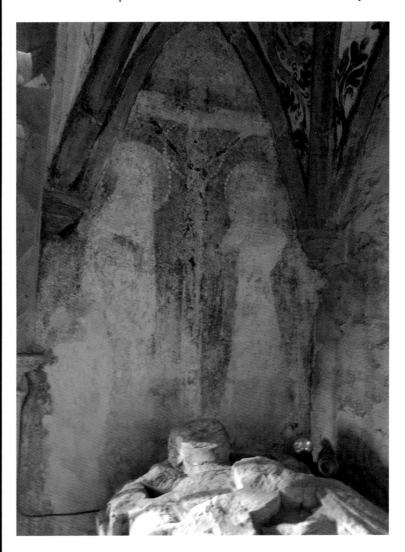

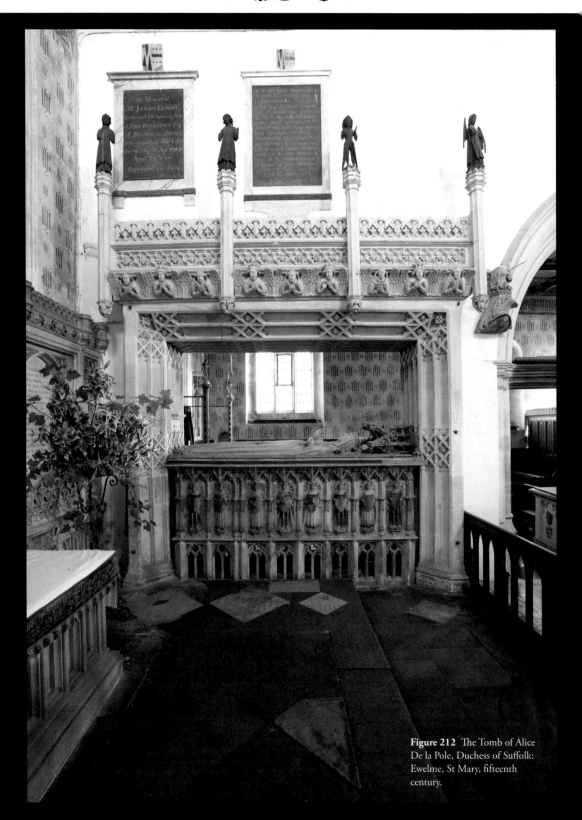

Figure 212 The Tomb of Alice De la Pole, Duchess of Suffolk: Ewelme, St Mary, fifteenth century.

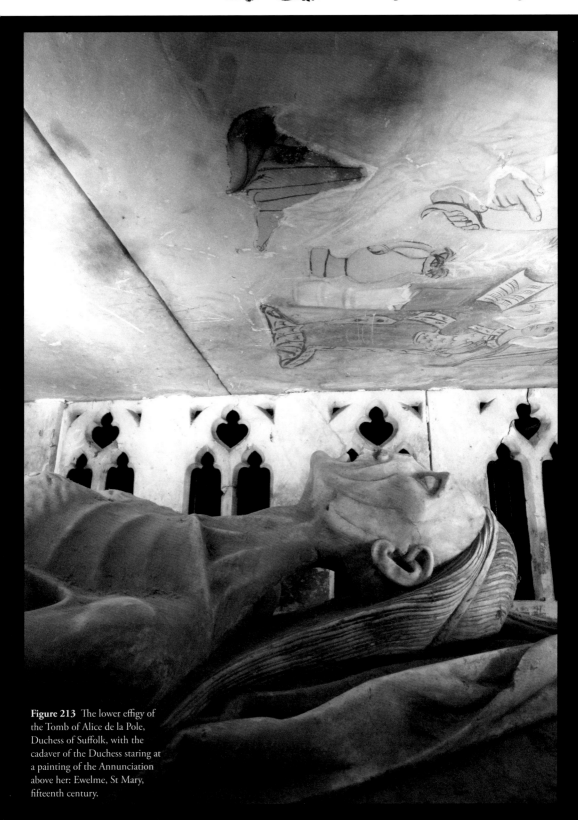

Figure 213 The lower effigy of the Tomb of Alice de la Pole, Duchess of Suffolk, with the cadaver of the Duchess staring at a painting of the Annunciation above her: Ewelme, St Mary, fifteenth century.

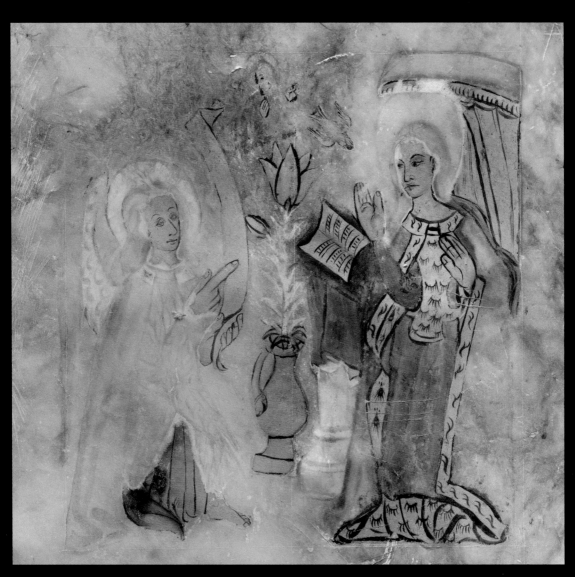

Figure 214 The Tomb of Alice de la Pole, Duchess of Suffolk, lower level, The Annunciation: Ewelme, St Mary, fifteenth century.

Figure 215 The Tomb of Alice de la Pole, Duchess of Suffolk, lower level, St Mary Magdalene and St John the Baptist: Ewelme, St Mary, fifteenth century.

(Herts), about half-way between St Albans and another popular pilgrim's destination, the College of St Mary's at Ashridge, which purportedly owned a phial of Christ's blood. The former open hall of this house contains impressive wall paintings of Christ and various saints, prompting suggestions that the building may have been a hostel serving the two sites.

The other painting is on the back of the wooden choir stalls (now enclosed) at Gloucester Cathedral and shows St Margaret and other saints together with scenes from the fable of Reynard the Fox, perhaps intended as an allegory for pilgrims queuing to see the tomb of the deposed and murdered king, Edward II, further along the same aisle.

Pilgrimages were not confined to greater churches. Smaller abbeys and chapels also had shrines which attracted local followings.

Claims that a statue of the Virgin Mary at Bradwell Abbey (Bucks) had miracle-working powers saw the image enclosed within a special chapel and paintings celebrating the Virgin's life commissioned to decorate its newly built walls. This scheme also included paintings of pilgrims bringing votive offerings (wax, wood or clay models of the parts of their body for which they sought divine cures) to the shrine; a unique still-life snapshot of medieval people in the act of personal devotion. (217)

Figure 216 The Shrine of St Alban, St William of York: St Albans Abbey, early fourteenth century.

Provincial churches, such as St Kenelm's Chapel, Romsley, (Worcs), said to be built where a Saxon boy king's body had been found after his murder and which owned a sacred well, were also pilgrim magnets. A now lost cycle of wall paintings of the saint's life in the Chapel provided visual edification for those whose personal devotions had led them to this remote spot.

It is possible that the elaborate inscriptions which accompany the Eton College Chapel wall paintings also had a practical relevance for pilgrims visiting the church's Marian shrine. As they were within that part of the Chapel used as the parish church, the inscriptions could have been used as literary prompts, almost tourist guides, by priests (or scholars) deputed to greet pilgrims.

Figure 217 Pilgrims bringing votive offerings: Bradwell Abbey, late fourteenth century

BELONGING TO THE CHURCH

Although the exact role of wall paintings as teaching aids remains problematic and complex, there is less doubt about their function as statements of Christian observances.

Such images might include reminding audiences of ceremonies, such as Easter and saints' days, as well as instructing worshippers how they should behave as Christians. From the Fourth Lateran Council in 1215, the medieval Church poured enormous resources and efforts into ensuring that people knew the tenets of Christian teaching. The message was repetitive. Being a medieval Christian required more than faith. Salvation had to be earned: divine mercy deserved.

Knowing the Faith

The introduction of annual confession imposed obligations on both the clergy and the laity. Priests had to know how to 'confess' their parishioners, what questions to ask, how to differentiate between deadly and minor (venial) sins and what penances to impose on the not so

perfect. The laity also had duties: to prove their knowledge of good and evil; to understand and repent their failings; to show contrition and to make amends.

Books written for priests to help them 'confess' their parishioners stressed these points, such as when the priest tackled the sin of envy and quizzed his flock:

> *Have you hadde anie envie to your neighbours … or be glad … when the adversite or desese that hath falle to them … have ye backbited and … tolde evill tales … or procured others to hate them?'*

The laity was expected to know the Ten Commandments, the Seven Works of Mercy, both spiritual and corporal, the Lord's Prayer and more. Often these observances were catechized, a series of formulaic answers to questions that had to be learned. Many came in easily remembered numbers, such as fives and sevens. Some wall paintings may have had a self-teaching purpose in this process.

The fact that paintings of the Seven Deadly Sins and the Seven Works of Mercy appear less frequently in private manuscripts than on public walls lends credence to suggestions that they could have been used to prepare groups of parishioners for their annual confession. However, it remains unclear how this might have been done, especially if diagrammatic

Figure 218 The Tree of the Seven Deadly Sins: Cranbourne, St Mary and St Bartholomew, *c.* 1400.

paintings were above the nave where they would be awkward to look at for any length of time, as at Cranborne (Dorset). (218)

Again, other subject scenes may have combined both Rolle's desire to make people *sithen*, think and 'see' again, with the practical benefit of helping the forgetful to remember recitations. It has been suggested that paintings formerly in the chapter house of St Mary's Priory, Coventry (Warks), showing scenes from the Apocalypse, may have been used as a memory aid by Benedictine monks required to recite the text during Sunday services.

Respecting the Church

Wall paintings of the Sunday Christ, the Warning to Blasphemers and the Warning to Gossips and Janglers provided another layer of meaning and purpose for practising Christians. They were the equivalent of spiritual posters. Although paintings of the Sunday Christ could be interpreted as a pictorial representation of the Fourth Commandment to keep the Sabbath holy, its appearance as a single image usually unconnected to others suggests that it was not seen in the context of the other Nine, but as a persuasive image in its own right.

The absence of this imagery from stained glass iconography also suggests that it was regarded as a subject better represented as a wall painting addressing a public audience than either as a particularly attractive or inspiring work of art. Similar conclusions probably explain its omission from devotional manuscripts, such as Books of Hours, where the very act of ownership might be regarded as implying religious observance.

The paucity of examples of the Warning to Blasphemers as a subject, plus the incorporation of devils into the scene at Corby Glen, and its pairing with a wall painting of the Sunday Christ in the lost scheme at Walsham le Willows (Suffolk), make it difficult to draw many conclusions other than that it rebuked an obviously troublesome offence.

Wall paintings of the Warning to Janglers used particularly vivid imagery to admonish unholy behaviour. Significantly, most of these paintings seem earlier rather than later and may be connected to the way that services were conducted before the introduction of formalised seating and sermonising. Evidence before 1400 is mixed and unclear. It seems that people stood and that the sexes were segregated. Most of the service was in Latin. Priests appear to have delivered short homilies rather than lengthy sermons. As late as the mid-fifteenth century authors of model sermons, such as John Mirk, imply that Sunday services consisted of talks on the essence of the Christian faith and the meaning of major feasts, rather than preaching as we understand the word today.

Perhaps it is hardly surprising that people chattered to each other during services and other church events such as feast days. For the Church, however, trivial jangling was noisy, disrespectful and distracting. One of the criticisms of sixteenth-century reformers was that solemn services were often disorderly affairs with people rushing from altar to altar to see the miracle of transubstantiation rather than behaving in a dignified and sober manner.

Just as images of other subjects could have multiple applications it is possible that these paintings may have also been used as moralising rebukes to 'malicious gossip', sexual rumouring and scandalmongering within tightly knit parishes: again, the work of the Devil.

Death and Judgement

Although not exactly a teaching script, death imagery of The Three Living and The Three Dead, St Michael Weighing Souls and, above all, wall paintings of the Last Judgement could not fail to make an impact on their audiences.

Figure 219 The Tomb of Bishop Walter de Stapledon: Exeter Cathedral, fourteenth century.

Like other paintings, they could function on different levels in different contexts depending on a viewer's knowledge and personal circumstances. Primarily, however, they were a foretaste of what Richard Rolle warned was the moment when everyone would come face to face with Christ and 'look upon him whom they pierced' and discover whether they were recipients of his love or the bitter condemnation of the damned. At Exeter Cathedral, this encounter becomes reality in the tomb of Bishop Stapledon (1261–1326). Murdered by a mob of insurgents during the overthrow of Edward II, the prelate's effigy stares forever at a painting of the risen Christ dripping blood from his five wounds. (219: 220) Fears of purgatory saw people in every walk of life help to build churches, fund hospitals, construct bridges and give alms to the needy.

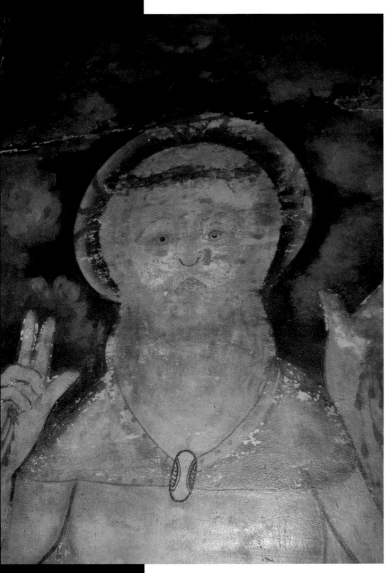

Figure 220 The Tomb of Bishop Walter de Stapledon, Christ bearing His wounds: Exeter Cathedral, fourteenth century.

Only by public acts of mercy and reparation could the devout earn years off their confinement in Purgatory and avoid the torments envisaged by St Bridget of Sweden as including: ears being burnt, eyes pulled from sockets until they hang loose on cheeks, arms cracked and broken, skin pulled off the head and bones drawn out of the body as if they were a 'thred of clothe'.

The will of the elite artist Hugh of St Albans, mentioned earlier, stands proxy for countless others with his wish that: 'I will that all my equipment with divers colours competent for my art shall be wholly sold and the money thence arising be distributed to the poor where the greatest need shall be for the benefit of my soul'.

The same chapter of *The Gospel of St Matthew* which described the Last Judgement also spelt out the implications of not doing so, with Christ quoted as saying that those who did not help the sick and hungry also 'did it not to me' and would pay for their sins by going into everlasting punishment.

The patronage of wall paintings showing Death and Judgement and associated imagery such as St Michael Weighing Souls was inseparable from these fears. Instances of donor portraits can be found within such imagery, as at Denham, or as with the donor kneeling before St Michael at Nassington. (121)

At Marston Mortayne (Moretaine), a local parishioner William Wodill, bequeathed the money for a painting of 'the loft and the Dome [Doom]',

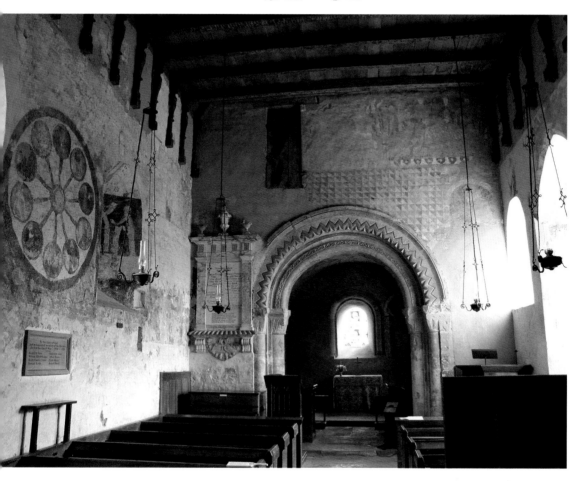

which can still be seen above the chancel arch, in his will of 1505. (129) Similar gifts are known elsewhere. John Saulbryge gave 10 shillings to 'the paynteng of a dom(e)' at Brington (Cambs) around 1531.

Figure 221 Accumulated history, A Wheel of Fortune, the Weighing of Souls and other images facing a Romanesque painted chancel arch and apse beyond: Kempley, St Mary.

Doom paintings were also commissioned for chantry chapels, as in Richard Beauchamp's at Warwick. The outer wall of Robert Markham's cage-type chantry chapel at Newark-on-Trent, commissioned in his will of 1505, has a painting of *Death and the Gallant*, a theme related to the Dance of Death. (101)

Everyone together

Wall paintings had a final use. Not as demarcations of sacred space, not as liturgical aids, not as didactic prompts. Their meaning could be social as well as specific. In a physical sense they belonged to every parish. They were part of its inherited tradition, its history, the kinship of men and women who worshipped beside them, before them and beneath them. They embraced generations of audiences, enveloping them in security,

love, sacrifice, repentance and renewal. They gave pride and definition, identity and memory, to a parish and its patrons. They were a peoples' art for a peoples' faith. (221)

Reformation & Rescue

T he wall paintings described in this book were not destroyed overnight. Like the Reformation itself, the forty-year process that transformed English churches from colour to whitewash was fitful, uneven, and almost reversed during one brief period.

The first paintings to be obliterated were those in the monasteries, incidental casualties of a campaign to assert royal authority and to seize their wealth. Having declared himself 'Supreme Head of the English Church' in 1534, Henry VIII used his newly acquired powers to dissolve over 300 of the smaller monastic houses in 1536, with the remainder meeting a similar fate three years later – their lands sold, their roofs stripped, and their buildings quarried for stone. Among the innumerable losses of wall paintings that accompanied the outright demolition of such churches were those at St Mary's Priory, Coventry, from whose ruins tiny fragments of high quality paintings have since been recovered and put on display in the Priory Gardens Visitors' Centre (242). The gradual decay of other buildings also caused systematic losses, as at the Abbey at Bury St Edmunds, from where the crucifixion scene recalled by John Lydgate disappeared, along with a monumental cycle cataloguing the life and miracles of the martyred King Edmund, from whose relics the Abbey took its name. Even when abbey churches survived they were often truncated. At Romsey, for example, the Nunnery's eastern chapel was demolished shortly after the townspeople had bought the church for their own use. Only a few of a once much longer cycle of paintings chronicling the life and miracles of St Nicholas now remain. (25)

The next battle was directly ideological. Sixteenth-century religious reformers despised many of the traditional church's beliefs and practices

Below:
'The Destruction of Images'. Christ overpainted with Biblical texts. Wooden panel painting, Binham Priory, Norfolk.

atur &
ymus i
ugnas
us, atq̃
rtenta
Sacrifi
natori,
eſt, hic
di mira
icta, &
æſtum,
orque,
t, q̃ ma
naxime
taxare
tes ſan
rtenta
rum.)
ine fin
undas
t, Mon
it, & ue

Supſtitio/
ſus imagi/
nũ cultus.

Opposite:
Figure 222 'A Fool Praying to Superstition' by Hans Holbein the Younger: Kuntmuseum Basel, early sixteenth century.

which they said 'deceived' and 'deluded' the unlearned with superstitious ideas, idolatrous images and phoney relics. After the Dutch humanist Desiderius Erasmus (1466 – 1536) had published his satirical masterpiece 'Praise of Folly' in the early sixteenth century, the artist Hans Holbein the Younger (1497–1553) sketched 'A Fool praying to St Christopher' in the margin of a Swiss schoolteacher's copy. (222)

Protestant enthusiasm for English versions of the Bible and scripture was matched only by their scorn for the veneration of the Mass, the popular devotion to saints, the appeal of ancient relics to pilgrims, the doctrine of Purgatory and the assorted paraphernalia of Latin chants, candles and smoking censers which sanctified the old religion. With the often ambivalent support of Henry, radicals like the Archbishop of Canterbury, Thomas Cranmer, steadily curbed and outlawed centuries of such beliefs, quietly dropping the earlier justification for wall paintings as 'books for the unlearned'. John Hooper, a later Bishop of Gloucester, was typical of the reformist vanguard, scoffing that '*the forme [of paintings and images] is nothing but the skill and draught of the craftsman, proportioning a*

Right:
Figure 223 St Thomas Becket defaced: the tomb of John Wootton, Maidstone, All Saints, fifteenth century with sixteenth-century damage.

shape not like unto Christ whom he never sawe, but [where] his owne fancie leadeth him ... and in that case you worshippe not the similitude of our saviour, but the conceite of this maker'.

In 1536, Ten Articles were proclaimed condemning images; two years later the attack was stepped up, with further royal injunctions outlawing 'candles, tapers or images of wax to be set afore any image or picture'. Among the doomed was a 'peynyng of Syntt Myghell' (Michael), gifted by Robert Traves at East Haddon (Northants) in 1515, an image derided by reformers, like the Bible translator William Tyndale, as offensive to scripture: 'When we paint St Michael weighing the souls, and stick up a candle to flatter him, and to make him favourable to us ... we regard not the testament of Christ nor the laws of God.'

A particularly vicious campaign was launched in the same year against wall paintings and other images of St Thomas Becket, whose memory was detested by Henry as a reminder of the humbling of a King of England by a cleric. The former Archbishop was denounced as a traitor and a rebel, and his Canterbury shrine smashed by soldiers in September 1538. As part of the same purge churches were ordered to erase his name from books and to 'put down' all of his images. At Earl Stonham (Suffolk), the churchwardens responded by commissioning an artist to transpose a wall painting of Becket's martyrdom at the hands of four knights into a painting of the martyrdom of St Katherine. Now only surviving as a drawing, it shows the murdered St Thomas repainted to resemble a woman and his cope converted into a cloak. (225) Elsewhere, as at Maidstone, wall paintings of the martyred saint were either whitewashed over or defaced. (223)

The accession of the nine-year-old Edward VI in 1547 and the appointment of the Duke of Somerset as his Lord Protector led to more extreme royal injunctions. The clergy were instructed to: 'take way, utterly extinct and destroy all shrines ... pictures, paintings and all other monuments of feigned miracles, pilgrimages, idolatry or superstition so that there remain no memory of the same in wall, glass-windows'. Paintings

Figure 224 'wasshyng out of ye dome [Doom]', Entry in the Churchwarden accounts of Wing, All Saints: Centre for Buckinghamshire Studies, PR 234/5/1, Fol 51., 1551.

Figure 225 Drawing of a wall painting formerly in Earl Stonham, St Mary, showing the transposition of a wall painting of the Martyrdom of St Thomas Becket into the Martyrdom of St Katherine: sixteenth century.

that had survived the first wave of onslaughts under Henry succumbed to the second under Edward. By September, a London chronicler described churches in the city as being 'new white-limed'. Provincial churchwardens' records tell equally depressing stories. At Bethersden in Kent, a workman was paid for 'blottynge out Saynt Chrystouer'. In Reading, Myles's painting of St Christopher suffered a similar fate when workmen were hired to 'whytelyme' the church. Subsequent years tell similar stories. In 1551, the wardens of All Saints church in Wing, Buckinghamshire, paid sixteen pence for the 'wasshyng out of ye dome [Doom]' above the chancel arch. (224) Two years later Eton College paid six shillings and eight pence 'To the Barber for wypinge oute the imagery worke vppon the walles' in the Chapel, while elsewhere, as at Seething (Norfolk), paintings of Christ's Passion were physically attacked and the heads gouged out. (226)

Figure 226 Christ defaced: Seething, St Margaret and St Remigius, fourteenth century with sixteenth-century defacement.

Figure 227 Attacked with Chisels: Prior Silkstrede praying at a prie dieu : Winchester Cathedral, sixteenth century.

Nor were cathedrals exempt. At Ely and Carlisle paintings were whitewashed. At Winchester and Norwich, the treatment was cruder. In the former's Lady Chapel, Thomas Silkstede's cycle of paintings celebrating the Miracles of the Virgin, similar to those in Eton College Chapel, was scored with chisels and now only survive behind modern copies. (227) At Norwich, the face of St Gregory the Great was scratched from a retable on a pier in the north arcade of the presbytery. Universities also suffered. In 1548, the subwarden of Merton College, Oxford, paid eighteen pence to a painter for blotting out the chapel wall paintings.

In keeping with the Protestant emphasis on the word of God, black letter texts such as the Ten Commandments were painted on church walls and the Royal Coat of Arms was raised above the chancel

The certificate of Mr Henry Daubeney and Edward Sway churchwardens of Sharrington... and Thomas Barwycke and Edward Tompson being churchwardens ther in the yer of our lorde god 1546...

Bestowed by us for whiting of the church and makinge of a glasse wyndowe and for the byenge of a book of the paraphrases of Erasmus and also for reparinge of the heigh way vli xiiis iiiid

Certificate of the churchwardens, Sharrington, Norfolk, 1547.

Figure 228 Counter-Reformation Doom: Stoke-by-Clare, St John the Baptist, *c.* 1550.

arch. At Berkeley (Glos), a white Tudor rose flanked by the initials E R on the east wall of the north aisle reminded worshippers of their English faith. (231)

The short-lived Counter-Reformation launched after Edward's death by his Roman Catholic half-sister, Queen Mary I, in 1553 was too brief to reverse the ravages of nearly two decades of destruction, although a Last Judgement painting was reinstated at Stoke-by-Clare (Suffolk). (228)

Elsewhere, while angry traditionalists defiled biblical texts at Devizes (Wilts), in 1555 and the parishioners at Ludham (Norfolk), hoisted a panel painting of the Rood above their chancel arch, most churches were too poor, too unsure about the future, or too divided within themselves to restore all of their imagery. Mary's death after just five years on the throne and the accession of her half-sister Elizabeth in 1558 quashed the revival of religious imagery before it was able to gather any lasting momentum.

Opposite:
Figure 229 and detail Old Testament Prophets: Passenham, St Guthlac, seventeenth century.

Above:
Figure 230 Funerary Monument in a thirteenth-century Passion cycle: Great Tew, St Michael.

Medieval paintings that had somehow survived earlier attacks now faced their final hours. Losses incurred under Elizabeth I included paintings in the Guild Chapel at Stratford-upon-Avon, which were whitewashed over in 1563–64 at a cost of two shillings under the supervision of John Shakespeare, the playwright's father. For the parishioners of towns like Long Melford, the turmoil of the previous twenty years must have been bewildering. In the late fifteenth century, they had begun to enjoy the riches of a newly built and extravagantly decorated church. In 1547–48, the walls were whitewashed and painted with Biblical texts and the King's arms; in 1555, these were in turn erased, when traditional religious paintings were restored; and in 1562, these too were despoiled when the walls were once again whitened.

While traditionalists palled at these attacks, many evangelists felt that they were dangerously insufficient. They complained that it was not enough for the paintings to be 'slubbered over with a white wash that in an hour may be undone, standing like a Diana's shrine for a future hope and daily comfort of old popish beldames and young perking papists, and a great offence to all that are Christianly minded', and demanded that they be hacked off the walls. By the end of the sixteenth century, hardly

any visible trace of medieval England's wall painting legacy remained. A brief, and less contentious, revival of the art in the early seventeenth century, which saw churches like Passenham (Northants) decorated with paintings of prophets and apostles, soon succumbed to another wave of militant protestant disapproval. (229)

Even buried under thickening layers of whitewash, wall paintings continued to be damaged, albeit unknowingly. As in previous centuries, renovations and additions to the fabric of churches took a steady toll. The installation of an organ at Eton in 1613–14 led to the loss of some of the paintings on the north wall of the Chapel. The fashion for wall-mounted funerary monuments destroyed many others, as at Wootton Wawen (Warks), and Great Tew (Oxon), where a memorial to an Edwardian vicar which was erected before the paintings were discovered now squats like an uninvited houseguest in the centre of a revealed five-tiered Passion cycle. (230) Dwindling congregations in the eighteenth and early nineteenth centuries caused more damage, as churches were neglected. When the top section of the tower at Chalgrave collapsed in 1889, the fallen rubble was left uncleared for years while trees grew in the chancel. Even as late as 1916, parishioners at Hornton had to bring umbrellas to church.

Paradoxically, it was the restoration of the churches in the nineteenth century that led to both the discovery of most of the paintings we see today and conversely, the destruction of a far larger number of others. Guided by influential advisors, such as the Cambridge Camden Society, several generations of architects routinely stripped walls of their ancient plaster to reveal the original stone coursing: a style which dogmatists insisted was closer to 'the original scheme as conceived by the first builder'. At Lichfield, thirty men were employed for four months in the 1840s stripping the choir of the cathedral. Even well-known figures like G. E. Street, who wrote several books about gothic architecture, had no compunction about destroying a painting of St Christopher at Burford (Oxon), when he ordered the removal of the churches centuries' old plaster and paintwork.

In one of the least explained aspects of medieval art, contemporary manuscript images may have given credence to these views. While panel paintings reproduced wall paintings, manuscript images of church interiors almost always showed bare stone walls. Looking at these 'pictures' as 'sources' it would be easy to conclude that painted interiors were an aberration, rather than the customary rule.

Nor was fashion and restoration the only threat. A painting of the Seven Deadly Sins discovered

The certificate if the inhabytauntes of the townshipe ther maide the iii day of Novembre in the first year of the Reign of our most Dreade Sovereygn Lord King Edward the VI... As hereafter ffollowithe...

Ffirst for the whything of the Churche xxxs
It'm for newe pulpytt vs
It'm for the defecyng of the glass windowes xls

Certificate of the churchwardens, Weybourne, Norfolk, 1547.

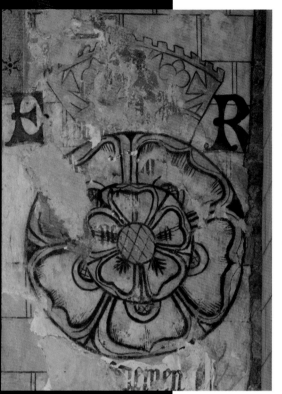

Figure 231 A crowned double rose flanked by the letters 'ER' attributed to the period of the reformation under Edward VI: Berkeley, St Mary the Virgin, mid sixteenth century

at Kidlington (Oxon) in 1892 was promptly re-whitewashed as its imagery was thought unsuitable for Sunday school children. At Cirencester, a scene of St Erasmus being disembowelled by a windlass was scraped from the walls after the local patron, the Hon. Georgina Bathurst, took exception to its gruesome imagery. When the Eton College Chapel paintings were discovered during a refit of the choir in 1847, the Provost wanted them immediately whitewashed as they were 'unfit to be seen in a building dedicated to the use of the Church of England'. The following year a tier of paintings was scraped from the walls so as not to spoil the look of some newly installed choir stalls, and in 1881 two further figures were destroyed when a new organ was built.

As the poet John Betjeman observed:

The Church's Restoration
In eighteen-eighty-three
Has left for contemplation
Not what there used to be.

Of course, not everyone was indifferent or hostile. Antiquaries were stunned when the superb paintings in St Stephen's Chapel, Westminster, were 'swept away with haste so barbarous as scarcely to allow a moment to artists to preserve them by copies', during restorations to the Houses of Parliament in 1800. At Slapton, the paintings we see today were saved and painstakingly cleaned by the vicar and his wife after their discovery in 1876. A year later William Morris was so outraged by Street's work at Burford that he formed the so-called anti-scrape campaign, The Society for the Protection of Ancient Buildings, to safeguard other churches from arrogant vandalism. Charles Keyser is another who deserves a mention in dispatches. A wealthy businessman, prominent freemason and three times unsuccessful Conservative parliamentary candidate, he compiled several lists of surviving wall paintings before publishing his monumental *List of Buildings in Great Britain and Ireland having Mural and other Painted Decoration* in 1883: a book that still remains a treasure chest for enthusiasts and experts alike. His delight in wall paintings even saw portraits of himself and his family painted in the chancel of his local church at Aldermaston (Berks).

Despite rapidly changing attitudes, destruction continued, sometimes until quite recently. Misunderstandings at Padbury (Bucks) saw a painting of the Sunday Christ limewashed over in 1964–65. Worse still, when traces of wall paintings were discovered during the repair of All

> Item - payd to Duffyn James Dysley and Richard Parker for whyte lymyng and dressing the church xlviis
> Item - to James Dysley for raysing the aulter stone iiiid
> Item - to paynters that shuld have wryten the church iid
> Item - payd to Duffyn for wasshyng out the images for iii dais and a half xxid
> Item - payd to Henry Boreg for takyng down the ymages xiid
>
> Certificate of the churchwardens, Wylliam Chapman & John Adams. Baldock, Hertfordshire, 1548.

Saints, Brightlingsea (Essex), in 1974, local parishioners are said to have 'attacked the walls with electric sanding machines' before any specialists could arrive.

Nor did the discovery and retention of paintings always prevent further damage. Many of those listed by Keyser in 1883 have since disappeared due to indifference and damp. Slapton itself has suffered losses. Perhaps the saddest irony is that whereas repeated coats of whitewash had unintentionally protected the paintings, as soon as they were removed the harmful salts that once passed straight through them began to crystallise on the surface of the paintings themselves.

Misjudged conservation techniques also inflicted unforeseen damage. In the late nineteenth century, the Professor of Chemistry at the Royal Academy of Arts recommended removing any whitewash with an ivory or bone spatula and then applying a coat of beeswax melted with lavender and orange peel oil and mixed with measures of varnish and turpentine to the revealed pictures. The effects were disastrous. Instead of preserving the paintings, the wax attracted dirt and sealed moisture into the plaster, causing it to blister.

Repainting proved another contentious problem. Without such 'improvements' the paintings at Pickering would have been lost entirely. But there are other instances, including the twelfth-century scenes in the apse at Copford (Essex), where the repainting has been so extensive as to make them essentially Victorian reconstructions. Nor are these the only examples of repainting and 'refreshing'. In the sanctuary of Salisbury Cathedral a late-nineteenth-century repainting of the Labours of the Month has been mocked for having more of an 'accent of 1879 Gothic – instead of 1270 Gothic'. Some images of St Christopher have also been garishly repainted, as at Ditcheat (Som).

Current practice, in contrast, is exceptionally restrained. Minimal intervention and conservation rather than restoration prevail. Paintings

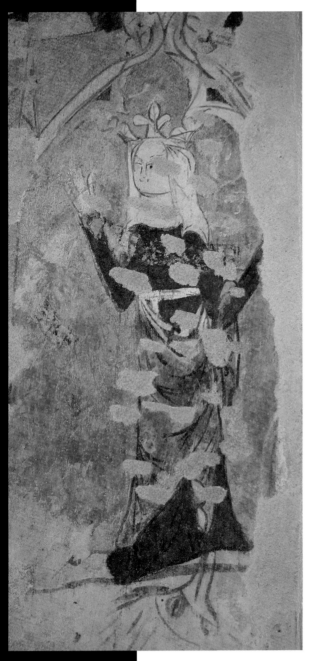

Above:
Figure 232 Female figure in arcade with a grotesque creature pecking her dress: Ilketshall, St Andrew, early fourteenth century.

are stabilised and cleaned, flaking paint is carefully re-fixed, leaking walls are repaired, and environmental conditions monitored. Wax or sealants are never used.

Despite past losses and huge discrepancies in survival rates, with hardly any in Scotland and more in East Anglia than any other part of the United Kingdom, every year now brings new and exciting discoveries, as at Ilketshall St Andrew in Suffolk. Repairs to the church after it had been struck by lightning revealed rare Romanesque and fourteenth-century paintings, including a well-preserved 'Wheel of Fortune'. (232: 233)

The efforts of English Heritage, CADW, The Council for the Care of Churches, The Historic Churches Preservation Trust and The Churches Conservation Trust in saving paintings has often been outstanding. Despite more pressing priorities, the Church of England and its Diocesan Advisory Committees cannot be reproached. Local authorities, amenity societies and the efforts of church congregations also deserve praise. At Slapton, local villagers held a barbeque and jazz night with stars such as Chris Barber and Monty Sunshine to raise money for the conservation of the paintings. Dozens of other parishes have made immense sacrifices to protect their heritage. Grants from charities such as The Pilgrim Trust have often been invaluable.

Enormous debts of a different kind are also owed to scholars and conservators such as Professor Ernest Tristram, E. Clive Rouse, John Edwards, Audrey Baker, Pamela Tudor-Craig, David Park,

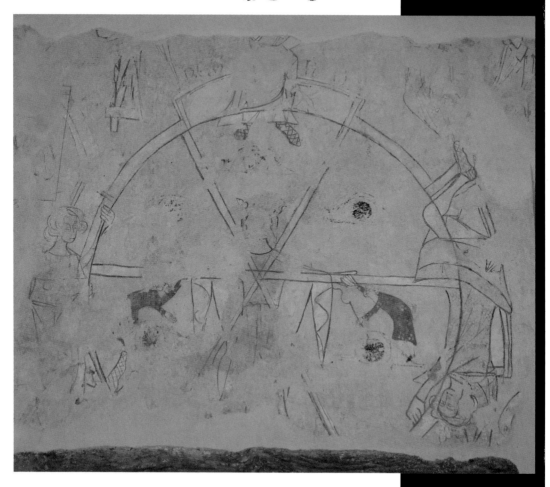

Above:
Figure 233 The Wheel of Fortune: Ilketshall St Andrew, early fourteenth century

Paul Binski, Helen Howard, Miriam Gill, Athene Reiss, Eve Baker, David Perry, Anna Hulbert, Pauline Plummer, Anne Ballantyne, and members of the Institute of Conservation's Wall Paintings Section. The contribution of the Department for Wall Painting Conservation at London's Courtauld Institute of Art and its students deserves special mention. Both as art historians and conservators their expertise is unrivalled.

Inevitably anyone who enjoys wall paintings suffers tinges of regret: so much has been lost which could have been saved: so much could be seen if churches were awash with funds to reveal what remains hidden. But, even so, there is still much to see and seeing is the only way to marvel at what was once commonplace. Art for everyone: art which promised more than life itself.

The Gazetteer

Introduction

This Gazetteer lists over five hundred religious buildings where medieval wall paintings can be seen. Examples which are inaccessible to the public have been excluded. Since new discoveries are made every year such a list can never be definitive. Inclusions and omissions are based on various factors, including: condition, quality, number, subject type, rarity and geography. Figurative scenes take precedence over patterning.

As local government re-organisations have destroyed traditional county boundaries, buildings are listed wherever they are designated in 2006 road atlases. As some churches are difficult to find, ordnance survey maps are a useful aid.

Due to theft and vandalism many churches are now routinely locked. Before making long journeys it is sensible to check whether a church will be open. Sometimes it may be necessary to book appointments in advance. *Crockford's Clerical Directory*, available from Church House Publishing, Great Smith Street, London SWIP 3NZ, lists the clergy in England and Wales. Copies may be available in local libraries. Diocesan offices maintain details of churchwardens. Church websites should also be checked.

Other buildings listed, such as those in the care of English Heritage, CADW, or the National Trust, may have restricted opening hours and charge admission fees. Some cathedrals levy admission charges from visitors.

The Gazetteer also lists the subjects that are portrayed in these paintings, usually beginning with any on the north wall. Not all paintings are possible to decipher and not every fragment of paint is described. Some interpretations may be tentative or differ from other views. The list is a guide to the main schemes that can be seen, not a comprehensive catalogue of every remnant of medieval paint that might

Below:
The south door. Kempley, St Mary.

be found. A number of the churches listed in this Gazetteer also include interesting post-Reformation textual or figurative paintings. They are not described.

 And please remember to give generously to every church you visit. Caring for wall paintings is expensive.

ENGLAND

Bedfordshire

Bolnhurst, St Dunstan – north wall, over north door: worn St Christopher.

Bushmead Priory (near Bolnhurst) – north wall: very damaged Creation cycle, including a now indecipherable scene of The Making of Adam; fragments of The Making of Eve; masonry pattern. West wall: masonry pattern; border emanating from a bird; simulated marble. In the care of English Heritage. Viewing by appointment only.

Chalgrave, All Saints – north aisle, north wall, west to east: canopy for two Apostle saints; St James the Great; St Thomas (?); slight remains of St Christopher (his staff). North aisle, east wall: Annunciation. South aisle, south wall: unidentified saints under canopies; St Martin over south door; heraldry; fictive canopies for now lost images of apostles. South aisle, north wall: heraldry, including Talbot Lion. West wall, south side: elaborate fictive canopies with buttresses, crockets and pinnacles enclosing St Bartholomew; St Peter; St Paul. West wall, north side: four Apostle Saints, including St John the Evangelist holding a cup. Nave, north arcade: impressive heraldry with scroll banding; Nave, south arcade: impressive heraldry with scroll banding including the arms of Loryng.

Edworth, St George – south arcade: two kings from The Three Living and The Three Dead.

Houghton Conquest, All Saints – north wall: lower third of St Christopher, including the outline of a mermaid. Nave, east wall, above the chancel arch: Abbreviated Doom with Christ in a mandorla flanked by angels holding Instruments of the Passion. Chancel, east wall: silhouettes in niches.

Marston Mortaine, St Mary the Virgin – Nave, east wall, above the chancel arch: large Doom.

Shelton, St Mary – north wall: faded St Christopher; faded The Weighing of Souls surrounded by stencilled Ms.

Sundon, St Mary – north wall, west end: *Noli me Tangere* with Christ censed by an angel; devils with cart. South wall: Doom figures above the south door.

Toddington, St George – Several layers of painting with losses. North wall: trees and outline of two large heads; border of Instruments of Passion. South wall, east to west: The Coronation of the Virgin; around the south door, two tiers separated by a border of lion heads and swans; upper tier, indecipherable figurative fragments (The Seven Works of Mercy?); lower tier, king; Virgin and Child, both sets of figures below ornate canopies; unidentified figure holding a cross; The Weighing of Souls above the south door.

Turvey, All Saints – south aisle, south wall, tomb recess: very fine Crucifixion scene with Christ on a Tau cross.

Wymington, St Lawrence – nave, east wall, above the chancel arch: Doom with continuations on both nave side walls. South aisle, east wall: Trinity.

Yelden, St Mary – south aisle, south wall: lower half of St Christopher over some earlier masonry pattern. South aisle, east wall: St James the Great.

Berkshire

Aldermaston, St Mary – north wall: fragments of indecipherable scenes in roundels. South chapel, east wall: Miracles of St Nicholas (Miracle of The Cup?); south wall: St Christopher under cusped canopy with an eel spear and a mermaid; remains of The Annunciation below lavishly vaulted canopy; masonry pattern.

Ashampstead, St Clement – north wall: lower half of St Christopher; four Holy Infancy scenes in elaborate frames, The Annunciation; The Visitation; The Nativity; The Appearance of the Angel to the Shepherds (and their dog); decorative patterns. Nave, east wall, above the chancel arch: Doom with Apostles and Rood Cross. Chancel: patterning.

Baulking, St Nicholas – north wall: fragmentary scenes, possibly The Seven Works of Mercy; St George with dragon.

East Shefford, St Thomas – north wall: pelta patterning. Nave, east wall, north side: upper part of a king (Adoration of the Magi?); nave, east wall, above the chancel arch: Rood cross; large I H S monograms; sun and moon;

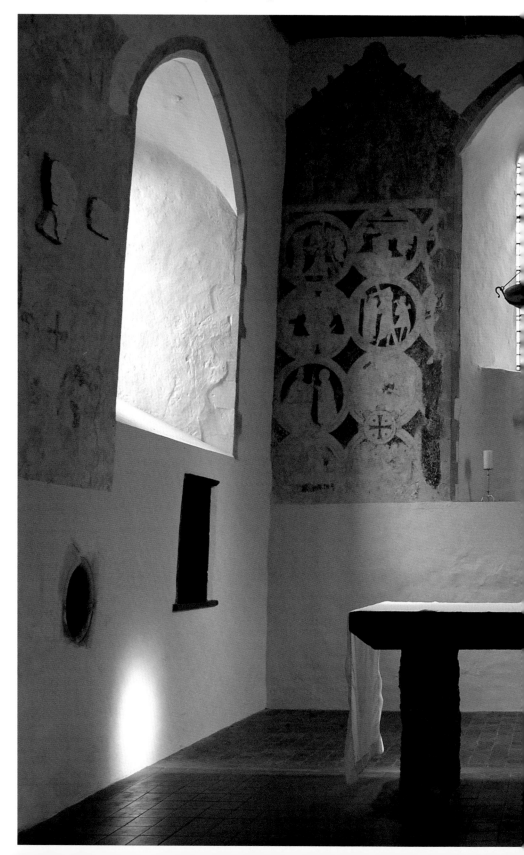

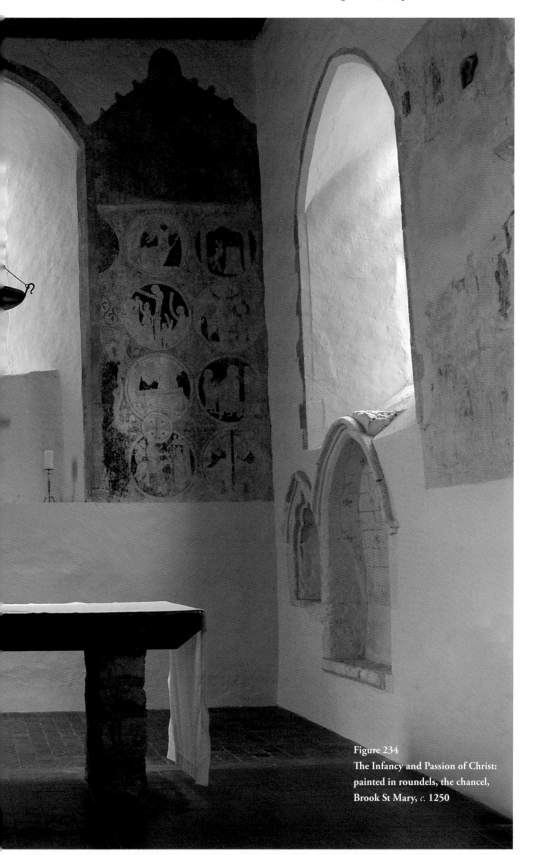

Figure 234
The Infancy and Passion of Christ:
painted in roundels, the chancel,
Brook St Mary, *c.* 1250

nave, east wall, south side: pelta patterning; remains of Annunciation angel. South wall: indecipherable traces of chancel wall scheme. West wall: Consecration Crosses.

Enborne, St Michael – chancel, north wall: the Annunciation.

Kingston Lisle, St John Baptist – chancel, north wall, window soffit: head of Christ; north wall, window splay and wall: scenes of the Decollation of St John the Baptist, including Salome dancing and the Martyrdom of St John. Chancel, east window splays: St Peter; St Paul; east wall: flanking Angels; rosette patterning; painted niches with silhouettes.

Padworth, St John Baptist – nave, east wall, south side: fragmentary figure of St Nicholas above faded scene of the Miracle of the Three Boys.

Ruscombe, St James – chancel, east wall, window splays: St Stephen (with stone); St Paul; St Laurence (?); St Peter.

Stanford Dingley, St Denys – north arcade soffit: St Edmund; repainted patterning. South aisle, east wall: masonry pattern. Elsewhere, fragments of figure painting.

Tidmarsh, St Laurence – north wall, window splays: east side, St John the Evangelist; west side, St Bartholomew. South wall, window splays: possibly St Peter; St Paul.

Bristol

Bristol, Lord Mayor's Chapel (previously St Mark's Hospital) – south aisle, north wall: three reset panels including an unusual Trinity with Christ as The Man of Sorrows; the Nativity; and *Noli me Tangere*. Check opening times.

Buckinghamshire

Bledlow, Holy Trinity – north wall: fragmentary St Christopher with hermit. Nave, east wall: rosette patterning. South wall, over south door: The Labours of Adam and Eve. Nave, south arcade: masonry pattern and foliage in spandrels.

Bradwell, Bradwell Abbey, St Mary's Chapel – north wall: St Anne, *The Education of the Virgin*; The Annunciation; The Visitation; The Flagellation; 'M' patterning. East wall: faint Crucified Christ. South wall: The Weighing

of Souls, 'M' patterning; unique painting of pilgrims with votive offerings. The site is in the care of Milton Keynes Discovery Centre. Check opening times.

Broughton, St Lawrence – north wall: unusual Doom including The Weighing of Souls with souls sheltered under Virgin's cloak; Warning to Blasphemers. South wall, west to east: St George; fictive drapery with holy monogram I H S patterning; St Helena (?); assorted tools and a horse, possibly St Eloi.

Chalfont St Giles, St Giles – nave, east wall, beside and above the chancel arch: unique fictive stone chancel screen. Nave, south aisle, east wall, north side: St Anne, *The Education of the Virgin*; south side: fragmentary scenes said to show The Life of The Virgin. South aisle, south wall, east to west: Miracles of the Virgin including The Miracle of the Jew of Bourges (see Eton College Chapel entry for explanation); scene with birds and animals, possibly part of The Creation; thereafter, The Temptation; The Expulsion of Adam and Eve; The Crucifixion above the Resurrection; two scenes from the Decollation of St John the Baptist including Salome dancing; faint traces of The Adoration of the Magi over the south door; west end of wall, large Tree of Jesse.

Denham, St Mary – south wall, over south door: Doom with a female donor.

Dorney, St James the Less – chancel, north wall: fragmentary Annunciation, Virgin and St Gabriel in fictive canopies either side of archway.

Eton, Eton College Chapel – nave walls: extensive remains on the north and south walls of a two-register scheme, each with eight narrative scenes showing apocryphal Miracles of the Virgin, separated from one another by fictive statues. North wall: upper tier, lost. Thereafter, lower register, east to west, The Miracle of the Woman who gave birth on the Causeway to Mont St Michel; the Miracle of the Wounded Image, the story of the man who threw a stone at an image of the Virgin and Child and who fell down dead when the image began to bleed; The Miracle of the Knight's wife who was sold to the devil by her indebted husband and saved after praying to the Virgin who then took her place; The Miracle of the Jewess, who prayed to the Virgin for the safe delivery of her child; The Miracle of the Candle, the story of a pious woman who had a vision of a Candlemass service attended by the Virgin and who was miraculously given a real Candle; The Miracle of a woman who took an image of the Christ Child to force the Virgin to restore her captive son to her; The Miracle of a woman who was restored to life by the Virgin so that she could make a confession of a Deadly Sin. South wall: upper tier, east to west, The Jew of Bourges, the Miracle of a Jewish boy who was rescued by the Virgin after being pushed into an oven by his father

as a punishment for taking communion with his schoolmates; lower tier; east to west, The Miracle of the Chaste Empress in eight scenes: The Emperor departs; His Brother imprisoned after molesting the Empress; The Empress falsely accused of infidelity by the Brother and condemned; The Empress rescued by a Knight; The murder of the Knight's child by his Brother; The Empress falsely accused of murder and banished; The Empress marooned on an island; The Empress's vision of the Virgin with the leprosy healing plant growing at her feet; The healing and confession of the Knight's brother; The healing and confession of the Emperor's Brother; The Empress takes the veil in honour of the Virgin. South wall: a panel of fictive brocade drapery.

The fictive statues are – north wall, east to west: Sts Mary Magdalene; Veronica (modern insertion); Margaret; Elizabeth; Agatha; Mary of Egypt; Etheldreada; Martha; Sidwell. South wall, east to west: Sts Katherine; Barbara; Apollonia; Agnes (?); Ursula; Dorothy; Cecilia; Juliana; Winifred. Check opening times. Admission charge.

Lathbury, All Saints – nave, north arcade: fragment of The Weighing of Souls. Nave, east wall, above the chancel arch: fragments of a Doom with Heavenly Jerusalem on adjoining north wall. South arcade: figures from The Seven Works of Mercy including Burying the Dead.

Little Hampden, Church – north wall: west to east, St Christopher; St Peter; St Paul; the head of the Christ Child above the north door suggesting another (now lost) St Christopher. Nave, east wall: unidentified Saints under arches. Nave, south wall: The Weighing of Souls with the Virgin protecting souls below her cloak; the Seven Deadly Sins with Pride being stabbed by a naked man armed with a dart. Traces of two other St Christopher schemes can also be seen.

Little Horwood, St Nicholas – north wall: The Seven Deadly Sins with Pride sitting above a naked man around whom dragons and illegible scrolls emerge; palimpsests of earlier paintings, west to east, St Nicholas and the Miracle of the Three Boys; The Martyrdom of St Thomas Becket. Further east on the same wall, traces of a well-dressed figure below a scroll, probably The Seven Works of Mercy; faint traces of the head of the Christ Child (St Christopher).

Little Kimble, All Saints – north wall: west of the north door, The Martyrdom of St Margaret; St James the Great; east of the north door above the main figures, faint traces of a lengthy indecipherable scheme; lower level, including window splays, west to east, St Christopher; unidentified Bishop holding a triptych or shrine enclosing both a seated figure of the Virgin and Child, and The Trinity with God the Father holding Christ on the Cross; two further unidentified Bishops within ornate canopies; St George with the

inscription, GEOR[G]IUS and the arms of England; possible Princess to his right with the girdle she used to leash the vanquished dragon; St Clare; St Agnes; remains of a scene which once showed St Francis and birds; St Laurence with the gridiron of his martyrdom. Nave, east wall, north side: fictive niche with ornate cusping. South wall: The burial of St Katherine; unidentified male saint. West wall: devil pushing women into the Hell Mouth, possibly part of a Doom.

Little Missenden, St John Baptist – nave, west pier: The Crucified Christ; above the north arcade: large St Christopher; five scenes from The Martyrdom of St Katherine. Lady Chapel, north wall: tomb recess with a two-tiered scheme of the Resurrected Christ above a now very faint Crucifixion scene, (possibly used as an Easter Sepulchre). Nave, east wall, above the chancel arch: patchy traces of a Doom.

Maids' Moreton, St Edmund – chancel, north wall: The Last Supper on the back wall of the Sedilia.

Padbury, St Mary – north aisle: fragmentary St George; very fragmentary St Christopher with traces of illegible text; Consecration Cross (behind organ) with central repair where the candleholder once fitted; very faint Wheel of The Seven Deadly Sins (obscured by the organ); (remains of a painting of St Katherine are also said to be behind the organ). South nave arcade, south side: a wolf guarding a crowned head from The Martyrdom of St Edmund; lower part of the Martyrdom of an unidentifiable Saint.

Radnage, St Mary – north wall: small fragment of St Christopher above post-Reformation text from The Book of *Exodus* condemning the making of images. Nave, east wall, above the chancel arch: masonry pattern; rare Tree of Life. Chancel, east wall, north side window splays: figures said by conservators to include Moses; central east window splays: The Annunciation with The Virgin and St Gabriel on facing returns with angels above adoring an image of Christ in Majesty; south side window splay: St Peter.

The Lee, Old Church – north wall: fragmentary St Christopher with hermit. South wall: Consecration cross. West wall: lower part of The Weighing of Souls; extremely fragmentary St George with faint remains of royal family and castle battlements in the right-hand corner.

Swanbourne, St Swithin – north aisle, north wall: five of originally nine scenes depicting an Allegory of the Soul scheme with a probable portrayal of Purgatory in the sixth compartment. The scheme also retains extensive textural inscriptions.

Whitchurch, St John the Evangelist – north wall: very damaged St Margaret with dragon.

Wingrave, St Peter and St Paul – vaulted chamber off the north side of the chancel, south wall: two angels holding a napkin.

Winslow, St Laurence – north aisle, north wall: west to east, fragmentary remains of an unusual Doom; fragmentary St Christopher (two heads visible); patchy traces of The Martyrdom of St Thomas Becket.

Cambridgeshire

Bartlow, St Mary – north wall: large dragon (probably St George). South wall: The Weighing of Souls; upper half of St Christopher.

Barrington, All Saints – south arcade: lower half of three skeletons from The Three Living and The Three Dead.

Barton, St Peter – north wall, west to east: figures within a red pavilion, said to include St Thomas de Canteloupe; knight attacking devil in a larger scene of The Weighing of Souls; indistinct head of St Christopher; St Anthony Abbot (holding a crozier) with his pig; donor figure below?; figure said to be St John the Baptist; St Martin of Tours mounted. Below windows: St Dunstan using tongs against the devil. South wall, east to west: remnants of a two-tier scheme, The Last Supper in lower tier; Annunciation angel by the south door; St George's horse over the door. All the scenes are very fragmentary.

Burwell, St Mary – north wall: upper two-thirds of St Christopher.

Broughton, All Saints – nave, east wall, above the chancel arch: Doom including sinners in a cauldron. South wall, east end: The Expulsion of Adam and Eve; The Labours of Adam and Eve.

Castor, St Kyneburgha – north wall, west end: scenes from the Martyrdom of St Katherine, including the miraculous shattering of the wheel.

Also close by: Longthorpe Tower, Peterborough – see Other Sites.

Chesterton, St Andrew – nave, east wall, above the chancel arch: Doom with figures and inscribed scrolls extending onto adjoining north and south nave walls.

Chippenham, St Margaret – north wall: St Christopher; faint Martyrdom of St Erasmus.

Duxford, St John – north wall, west to east: two unidentified bishop saints; The Coronation of the Virgin; The Sunday Christ. Nave, soffit of tower arch: Romanesque *Agnus Dei* flanked by angels and patterning. Chancel, south wall: incomplete traces of Holy Infancy cycle; fictive drapery hanging from a rod. Chancel, west wall: three tiers, top to bottom, two devils and the remains of a wheel (figures and borders similar to Risby, Suffolk); Passion scenes, The Crucifixion (with Longinus); Joseph of Arimathea pleading before Pilate for Christ's body; the Deposition; The Three Marys at the Sepulchre with sleeping soldiers by the Tomb; lowest tier: scenes from The Martyrdom of St Margaret.

Ely Cathedral – nave: traces of masonry pattern on some piers. South transept, St Edmund's Chapel, north wall: The Martyrdom of St Edmund; fictive drapery. South wall: indistinct scene; fictive drapery decorated with circles. Entrance arch: unidentified heads in roundels on soffit. Lady Chapel, all walls: many painted statue niches. Exterior of Lady Chapel, west end: faint traces of decorative painting in dado niches.

Ely, Prior Crauden's Chapel – east wall: south side piscina with traces of gilding and an unidentifiable figure on the back wall. South wall, west end: very faded Crucifixion. West wall: remains of a once very fine Annunciation.

Glatton, St Nicolas – north-east angle of nave and chancel: female saint inscribed St Mary Magdalene; South-east angle of nave and chancel: unidentified donor priest supplicating before Christ as The Man of Sorrows.

Great Shelford, St Mary – nave, east wall, above the chancel arch: Doom.

Hardwick, St Mary – nave, south wall: fragmentary remains of a two-tiered scheme, upper tier; The Seven Works of Mercy; lower tier, The Seven Deadly Sins riding animals (Pride on a Lion).

Hauxton, St Edmund – nave, east wall, south side: altar painting of St Thomas Becket blessing inscribed, THO.

Ickleton, St Mary – nave, north arcade: Romanesque scheme of Christ's Passion, including The Last Supper; The Betrayal; The Flagellation; Christ Carrying the Cross; North arcade spandrels, west to east: The Martyrdoms of St Peter; St Andrew; and St Laurence, all accompanied by unidentified figures. North arcade window splays: Christ and the Apostles; St James the Great (?); crowned woman. Nave, east wall, above the chancel arch: fourteenth-century Doom with the Virgin Mary baring her breasts before Christ.

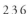

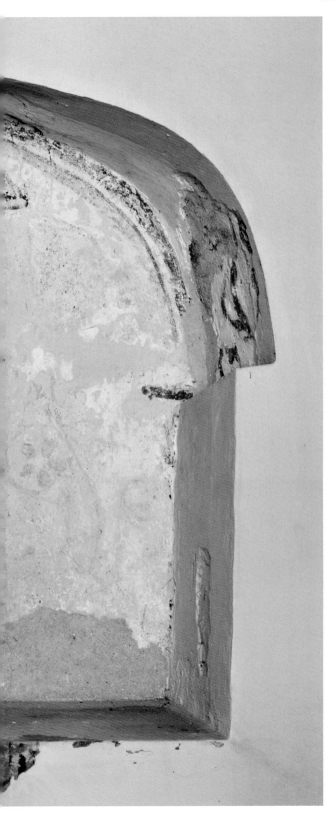

Figure 235
Unidentified bishop Saint in altar
niche: Littleham, St Swithin,
thirteenth century.

Impington, St Andrew – north wall: St Christopher with the hermit. Chancel, east wall: fictive image niche with an angel.

Kingston, All Saints and St Andrew – north wall: lower half of St Christopher; fragmentary St George. Nave, east wall, above the chancel arch: Rood with silhouette for statues surrounded by flying angels with chalices poised to catch Christ's blood. Chancel, north wall: two soldiers wearing mail attacking unknown foe. Chancel, east wall; Consecration Cross. Nave, west wall, north side: Wheel of The Seven Deadly Sins with a devil turning the wheel; The Seven Works of Mercy within a wheel.

Molesworth, St Peter – north wall: St Christopher with heraldry in upper right-hand corner thought to be the arms of Sir Stephen Forster, a one-time Mayor of London. South wall: indistinct St Anthony Abbot, otherwise known as St Anthony of Egypt, with a stylized (palm?) tree.

Old Weston, St Swithin – south aisle, east wall: window splay, north side, St Margaret with the dragon; window splay, south side, St Katherine with the wheel. South wall: the Consecration of a Bishop; The Decollation of St John the Baptist; fragment of a wheel with figures.

Orton Longville, Holy Trinity – nave, north wall: upper half of St Christopher.

Peakirk, St Pega – north aisle: faded Warning to Janglers; The Three Living and The Three Dead. Nave, north arcade: Passion cycle in two tiers interrupted by St Christopher with donor(s). Top tier, The Last Supper, Christ washing Feet, The Mocking of Christ, lower tier, The Flagellation, The Crucifixion (with Longinus pointing to his eye), The Deposition, The Entombment, The Resurrection, *Noli me Tangere*.

Peterborough Cathedral – north aisle, vault, west end: Arms of the See. Apse, around and behind the High Altar: heraldic shields and crescent patterning belonging to the Knights of the Barony. South aisle: masonry pattern in vaults.

Also, close by: Longthorpe Tower, Peterborough – see Other Sites.

Soham, St Andrew – chancel, north wall: unidentified bishop facing sedilia; east wall: elaborate image niches with fictive battlements and tracery.

Willingham, St Mary and All Saints – nave, north arcade: lower part of St George framed in a twisted rope border; St Christopher; heraldic shields (behind the organ pipes, the arms of the See of Ely); pomegranate patterning; The Annunciation. Nave, East wall, above the chancel arch: fragments

of a Doom; nave, east wall, north side: Consecration Cross. Nave, south arcade: continuation of the east wall Doom (a demon); The Visitation with inscriptions; pomegranate patterning; three Passion shields with The Crown of Thorns; The Five Wounds; a Tau Cross with scourges. West wall, window splay: St Etheldreda and an unidentified Saint.

Yaxley, St Peter – north chapel, south arcade: faint scenes from the Road to Emmaus, including The Incredulity of St Thomas. Nave, south arcade: east end: fragments of a mainly lost Doom with souls emerging from their graves.

Cheshire

Astbury, St Mary – north clerestory wall: single scene of St George with the Virgin from a once longer cycle of the Life and Martyrdom of the Saint.

Chester Castle, Agricola Tower, Chapel of St Mary de Castro – fragmentary remains of paintings commissioned by Henry III. Vault, east bay: Holy Infancy scenes, The Visitation; remains of The Adoration of the Magi. North wall: fragments of The Apocryphal Miracles of the Virgin, The Miracle of St Bonnet of Clermont, a Bishop of Clermont (France), who was presented with a vestment by the Virgin after celebrating a Mass before her image; The Miracle of the repentant thief, Ebbo, whom she saved from hanging. East wall, altar recess, soffit: angel portraits in roundels. West wall: The Miracle of Theophilus. In the care of English Heritage. Check opening times.

Chester, St Mary-on-the-Hill (now St Mary's Centre) – south aisle, east wall: Crucifixion retable with other figures.

Marton, St James and St Paul – west wall: fragmentary Doom.

Mobberley, St Wilfrid – north arcade: fragmentary St Christopher; fragmentary St George.

Cornwall

Breage, St Breaca – north aisle, north wall: St Christopher with mermaid; large Sunday Christ; local bishop saints said to include St Hilary; St Corentine; and possibly St Augustine. South aisle, south wall: crowned figure, possibly Henry VI; window splay, St Thomas Becket, inscribed HOMAS.

Calstock, St Andrew – north aisle: remains of once much larger St George scheme.

Lanteglos-by-Fowey, St Willow – south chancel aisle, south wall: Resurrection above Mohun family tomb.

Linkinhorne, St Mellor – south aisle, east to west: The Seven Works of Mercy around the figure of Christ; near south door, unidentified scene with demons, possibly The Seven Deadly Sins.

Poughill, St Olaf – north wall: St Christopher; south wall: St Christopher. Both figures heavily repainted.

Poundstock, St Winwaloe – north aisle: Sunday Christ; Tree of the Seven Deadly Sins. Both paintings are very fragmentary. They have also been remounted.

St Just in Penwith, St Just – north wall: Sunday Christ; St George (repainted).

St Keverne, St Keverne – north wall: fragmentary St Christopher with scenes of his Life and Martyrdom.

Derbyshire

Dale Abbey, All Saints – north wall: The Visitation. Before the Reformation this church was the infirmary chapel of Dale Abbey.

Haddon, Haddon Hall Chapel – nave, north arcade: jungle with monkeys and wild beasts. Chancel, north wall: The Miracles of St Nicholas, including The Miracle of the Cup; South wall: scenes of the Holy Family. Nave, south arcade: extremely fine St Christopher with hermit and anglers. West wall: The Three Living and The Three Dead; extensive foliage with heraldry. All in semi-grisaille.

Melbourne, St Michael and St Mary – nave, east wall, north side: Warning to Janglers.

Wingerworth, All Saints – chancel arch inner face: roundels enclosing busts of Christ and four saints.

Devon

Ashton, St John Baptist – Chudleigh Chapel, north wall: Christ with Instruments of the Passion; also demi-figures of Prophets and contemporary texts on wooden screen walls.

Axmouth, St Michael – south aisle, south wall: faded Martyrdom of St Erasmus. Nave, east end piers: unidentified Saint; Nave, south side pier: Christ as Man of Pity.

Berry Pomeroy Castle – Gatehouse Chapel, east wall: The Adoration of the Magi. In the care of English Heritage. Check opening times. Admission charge.

Branscombe, St Winifred – nave, north wall: fragments of The Seven Deadly Sins, (Lust); south wall: recess with fictive capital.

Dittisham, St George – chancel, south wall, sedilla: upper body and head of cleric.

Exeter Cathedral – north aisle: angel heads above door. North transept, Sylke Chantry Chapel, north wall: The Resurrection; (modern copy of the Entombment below). Lady Chapel: north side of the tomb of Walter Branescombe (Bishop of Exeter 1257–80), paintings of Saints. Retrochoir, Lady Chapel entrance, south side: The Ascension and Coronation of the Virgin attended by the Nine Orders of Angels; Chapel of St Gabriel the Archangel, east face of screen: The Annunciation. Choir: north side, tomb of Bishop Stapledon with Christ showing his wounds on the tester above the effigy; south side, sedilia, with elaborate fictive drapery supported by lions.

Littleham, St Swithin (near Bideford) – north transept, east wall: unidentified bishop Saint in altar niche.

Sidbury, St Giles – north transept, south wall: above arch, ecclesiastical figure. Chancel, north wall: masonry pattern and fictive column with stiff leaf capital. Tower arch: figure behind Warren monument, possibly St Christopher.

Weare Gifford, Holy Trinity – south aisle: the martyrdom of a saint, probably St Sebastian.

Dorset

Cerne Abbas, St Mary – chancel, north-east corner: four of originally six scenes of the Life and Martyrdom of St John Baptist including The Baptism

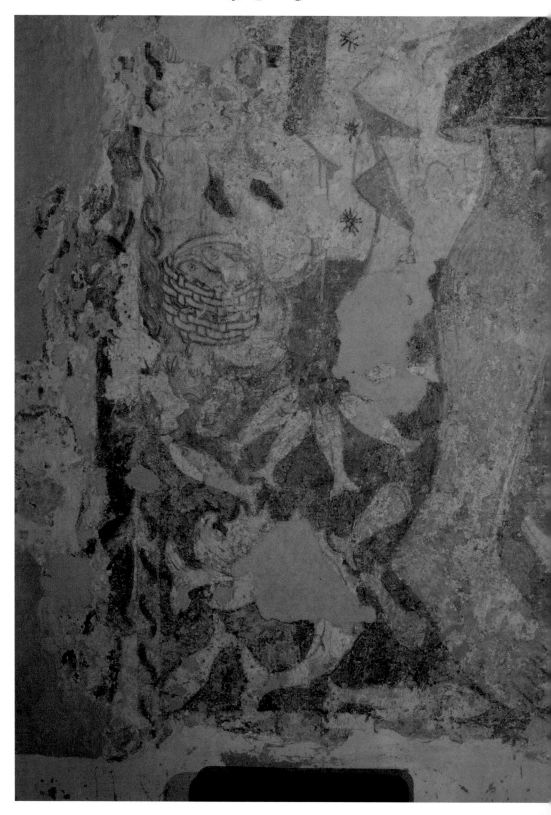

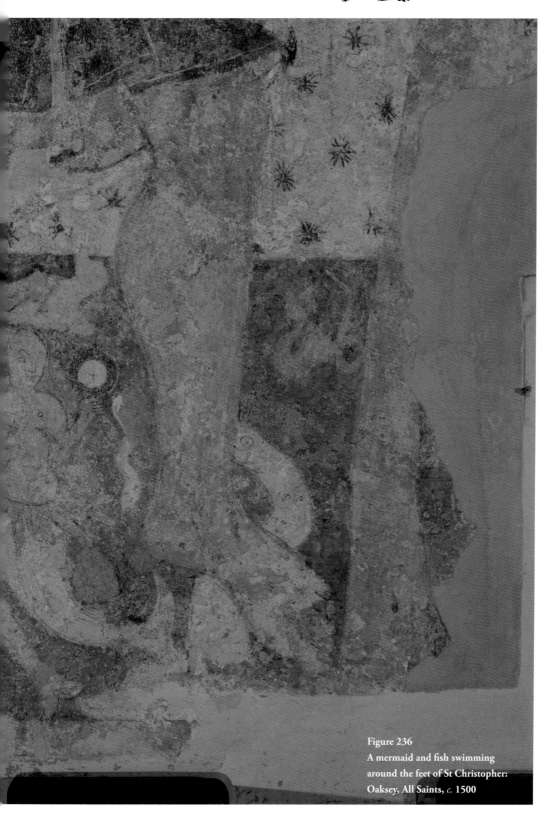

Figure 236
A mermaid and fish swimming
around the feet of St Christopher:
Oaksey, All Saints, *c.* 1500

of Christ; (The Feast of Herod with Salome dancing?); St John before Herod; The Decollation of St John; South wall, window splay: Annunciation Virgin under canopy.

Christchurch Priory – Berkeley Chancery Chapel, south wall: red and white roses above broad striped pattern. Nave, south aisle vault: roundel of an unidentified saint.

Cranborne, St Mary and St Bartholomew – nave, south arcade, east to west: remains of The Three Living and The Three Dead; lower third of St Christopher; Tree of The Seven Deadly Sins growing from the head of a woman; unique Tree of the Seven Virtues.

Forde Abbey (four miles south of Chard) – former Cistercian abbey, now a private house. Undercroft/north wing: The Crucified Christ. Check opening times. Admission charge.

Gussage St Andrew, St Andrew – north wall: Passion cycle in two tiers including The Betrayal; The Suicide of Judas; Christ Carrying the Cross; The Crucifixion; The Deposition; and fragments of probable post-Resurrection scenes.

Tarrant Crawford, St Mary – north wall: The Annunciation; The Martyrdom of St Margaret (fourteen scenes, many faded); The Three Living and The Three Dead; The Crucifixion; faint St Christopher.

Wareham, St Martin – chancel, north wall: two scenes from The Life of St Martin; pelta patterning.

Whitcombe, Church – north wall: St Christopher with a mermaid; fictive arcading; Consecration Cross.

Wimborne Minister, St Cuthberga – north transept, east wall: damaged Crucifixion in altar recess.

County Durham

Durham Cathedral – Gaililee Chapel, north side arcade: The Decollation of St Paul; St John the Evangelist in a tub of boiling oil; The Martyrdom of St Peter; the Crucifixion; The Martyrdom of St Andrew; kneeling monks in a spandrel; west wall, altar recess: St Oswald in north jamb; fictive drapery with space for an image in the centre; south jamb, St Cuthbert; damaged Coronation of the Virgin above; nave: fragments of patterning; choir. Hatfield Chantry Chapel, fragments of angels at head and foot of effigy.

Pittington, St Lawrence – nave, north arcade: two scenes from the Life of St Cuthbert including, his consecration as Bishop in AD 685 and his vision at the table of The Abbess of Whitby, when he saw the soul of a holy man being carried to heaven at the same time as he was told that a faithful servant had fallen from a tree to his death. N.B. to find church follow signs to Hallgarth.

East Sussex

Battle, St Mary – nave, north arcade: substantial remains of a twenty-four scene cycle of The Martyrdom of St Margaret; and, at the east end above the organ: a smudged scene apparently St Peter with souls related to a now lost Doom painting on the Nave, east wall, above the chancel arch. North clerestory window splays: saints and figures including St Christopher; Moses; St John the Baptist.

Beddingham, St Andrew – nave, south arcade, pier: unidentified saint.

Clayton, St John the Baptist – Lewes Group. North wall: west to east, upper tier, Angel sounding the Last Trump; The Fall of the Anti-Christ; Procession of the Good entering Heaven; Reception of the Blessed in arcaded Holy City; lower tier, remains of The Resurrection; The Weighing of Souls. Nave, east wall, north side: Christ giving the Keys of Heaven to St Peter; nave, east wall, above the chancel arch: Christ in Majesty sitting in a vesica held by kneeling angels and adored by Apostles; nave, east wall, south side: Christ giving the Book of Law to St Paul; nave, south wall: two tiers divided by a scroll border; upper tier: west to east, Angel sounding Last Trump; figures led by St Gabriel towards the Cross; the damned seized by a devil riding a beast.

Hastings, All Saints – nave, east wall, above the chancel arch: Doom with a man hanging from a gibbet.

Mountfield, All Saints – nave, east wall, above the chancel arch: masonry pattern with holy I H S monograms.

Patcham, All Saints – nave, east wall, above the chancel arch: Doom.

Plumpton, St Michael – Lewes Group. North wall: upper tier, west to east, Procession of Saints led by St Peter who holds keys, remains of an inscription above; Christ in arcaded Holy City with figure before him; lower tier: The Flight into Egypt; decorated window with painted sill.

Preston, St Peter – north wall: unusual Adoration of the Magi with the infant Christ in a crib on a table draped with a fictive cloth watched by

adoring animals. Nave, east wall, north side: The Martyrdom of St Thomas Becket; nave, east wall, south side: The Weighing of Souls.

Rotherfield, St Denys – north aisle, east wall: The Incredulity of St Thomas. Nevill Chapel, north wall, window splays: Eve spinning; probable remains of Adam opposite; east wall, window splay: St Gabriel; west wall; patterning. Nave, east wall, north side: The Weighing of Souls; nave, east wall, above the chancel arch: Doom; nave, west wall (enclosed by closet): Consecration Cross.

Winchelsea, St Thomas – north aisle: remains of an Angel (once holding a soul in a napkin) above a wall tomb recess. The effigy is a later insertion following a reorganization of the monuments. Although small and incomplete, this wall painting is included as an example of its type.

Essex

Belchamp Walter, St Mary – nave, north wall, west to east: mythical Phoenix rising from a fire (analogy with the resurrection of Christ); The Lactating Virgin and Child under a canopy censed by angels and attended by a possible donor figure; two-tier scheme, upper tier: Passion scenes, The Entry into Jerusalem; Christ washing Feet; The Last Supper; The Betrayal; Christ before Pilate; lower tier; The Martyrdom of St Edmund; The Pelican in her Piety (pecking her breast to give blood and life to her young: another analogy with Christ); Three kings from the Three Living and The Three Dead. South wall, upper tier: The Resurrection; scene of a man at the centre of a large wheel with a naked man to his right.

Bradwell–juxta–Coggeshall, Holy Trinity – north wall: over the north door, fragment of St Christopher (Christ Child's head only); north wall, window soffit: roundel enclosing Eagle, (the Gospel symbol of St John the Evangelist); window splay: lost scene with only canopy visible. Chancel, north wall, window soffit: abbreviated Doom with Christ showing his wounds and angels holding Instruments of the Passion; eastern splay: The Trinity; western splay: *Noli me Tangere* (the whole scheme forming a probable complement to a temporary Easter Sepulchre); east wall, north side: angel holding cloth of honour on rod; east wall, south side window: masonry pattern with fictive voussoirs; east wall, south side: fictive canopy for statue. Nave, south wall window, soffit: *Agnus Dei*; east splay: The Incredulity of St Thomas; west splay: St James the Great.

Colchester, St Martin – nave, east wall, above the chancel arch: fragments of a Doom. Chancel, east wall: textile patterning.

Copford, St Michael and All Angels – north wall: mixture of original Romanesque scheme and nineteenth-century repainting. Romanesque scenes include the lower half of a figure with a lion, either Samson and the Lion (a prefiguration of the Harrowing of Hell) or David with the Lion (the weak overcoming the strong); and, in a lunette, The Raising of Jairus's Daughter. Nave, east wall, chancel arch and in apse beyond: a mixture of Victorian repainting and reconstruction of the Twelve Signs of the Zodiac (around the chancel arch soffit) and in the apse Christ in Majesty. South arcade, north side: angels over arch, patterning and much repainting.

East Ham, St Mary Magdalene – apse arch: head of Christ in roundel; masonry pattern.

Fairstead, St Mary – nave, east wall, above the chancel arch: Passion cycle in four tiers, first (top) tier, The Entry into Jerusalem; second tier, The Last Supper; The Betrayal; third tier, Christ Crowned with Thorns; Christ before Pilate; Christ Carrying the Cross; fourth tier, indecipherable, possibly The Resurrection. Nave, north wall: St Christopher; Shepherds and Angel; unidentified head; unidentified figures; Consecration Crosses with candleholder holes below.

Great Burstead, St Mary Magdalene – south wall, west end: twenty-four from thirty scenes of The Martyrdom of St Katherine (not all decipherable); five scenes from the Holy Infancy and Life of Christ, The Annunciation; The Nativity; The Adoration of the Magi; The Resurrection; The Incredulity of St Thomas; also The Weighing of Souls; The Three Living and The Three Dead; The Coronation of the Virgin.

Great Canfield, St Mary – chancel, east wall: altar painting of The Lactating Virgin; fictive capitals in masonry pattern scheme.

Hadleigh, St James the Less – north wall, window splays: upper part of St Thomas Becket with faint remains of an inscription; angel.

Henham, St Mary the Virgin – chancel, north wall: rare *sinopia* of the Virgin Mary reclining on a couch; east wall: head of an Apostle, probably part of a border.

Inworth, All Saints – nave, east wall, north side: masonry pattern; East wall, south side: five scenes from The Life and Miracles of St Nicholas including his Gift to the Three Daughters to save them from prostitution; The Miracle of the Ship, St Nicholas calming a stormy sea.

Lambourne, St Mary and All Saints – nave, south wall: upper half of St Christopher.

Layer Marney, St Mary the Virgin – nave, north wall: St Christopher.

Little Baddow, St Mary the Virgin – nave, north wall: St Christopher with a hermit's hut and belfry; devil from a lost scene; masonry pattern.

Little Easton, St Mary – nave, north wall: seated Prophet or Apostle. Nave, south wall: Passion cycle in two tiers set below canopied arches: lower tier left to right, The Last Supper; The Agony in the Garden; The Betrayal; Christ before Pilate (or Herod?); upper tier, left to right, Christ Carrying the Cross; The Crucifixion (including Longinus); The Deposition; probably The Entombment.

Little Tey, St James the Less – north wall: east of north door, St Christopher, (only the Christ Child is visible); three kings from The Three Living and The Three Dead. Apse: damaged Passion Cycle scenes, traces of Christ washing Feet; The Last Supper, The Betrayal; The Flagellation; The Crucifixion; The Entombment; The Three Marys at the Sepulchre; The Harrowing of Hell; *Noli me Tangere.* Nave, south wall: The Virgin with the Christ Child.

Woodham Ferrers, St Mary the Virgin – nave, east wall, above the chancel arch: Doom.

Waltham Abbey, Abbey Church – Lady Chapel, east wall: Doom with Christ and sword of wisdom, textual inscriptions listing sins emitting from Hell Mouth. The Chapel was originally built as the Chapel of the Resurrection by a local guild.

Wendens Ambo, St Mary – chancel, south wall: indistinct scenes from The Martyrdom of St Margaret.

White Notley, St Etheldreda – nave, south arcade: patchy fragments of three Passion Cycle scenes, including The Flagellation.

Gloucestershire

Ampney Crucis, Holy Rood – north transept, west wall, window splays: St Helena; St Paul; between windows: elaborate fictive canopies; North side: St James the Great. North wall: fictive textiles of roundels enclosing Fleur de Lys; heraldry including shield with arms of Fitzhamon of Tewkesbury; masonry pattern. East wall, window splay: The Virgin Mary; masonry pattern. South arch: the Ring of St Edward the Confessor. Wall paintings discovered in 1870 and since lost included an image of St Christopher apparently inscribed 'Thomas ye payntre of Malmesburie'. It was undated.

Ampney St Mary, St Mary – nave, north wall: fragments of St George (the royal family); masonry patterning including fictive capitals and voissoirs; very faded head of St Christopher. Chancel, north wall: 'stone and roses' masonry pattern. Nave, south wall: fictive niche; Sunday Christ with assorted tools; patterning around door; possible Doom at the west end.

Baunton, St Mary Magdalene – nave, north wall: St Christopher with windmill, hermit, fisherman with basket, faint mermaid, and a top border of illegible script.

Berkeley, St Mary – nave and chancel walls: extensive patterning (mostly repainted); gilded capital. Nave, east wall, above the chancel arch: fragmentary Doom. West wall: Consecration Cross and decorative patterning.

Bledington, St Leonard – nave, north clerestory: scrolls in window splays. Nave, east wall, north side: crowned Virgin and Child. Chancel, west wall: masonry pattern.

Buckland, St Michael – nave, north wall, west end: three painted stone panels with angels, once part of a reredos by repute from Hailes Abbey.

Circencester, St John the Baptist – Lady Chapel, south wall: demons with cart. St Katherine's Chapel, north wall: St Christopher; patterning; south wall: faded St Katherine with wheel. Nave, south aisle, east wall, entrance to St John the Baptist Chapel: fictive masonry with traces of figurative scene above.

Deerhurst, St Mary – chancel, east wall: Anglo-Saxon standing nimbed figure on the upper north side, possibly designed to be seen in a now lost upper room. The painting is very faded and is best seen in morning light.

Duntisbourne Rouse, St Michael – chancel, north wall: masonry pattern with sprigged flowers; arcade with heads in spandrels, one with a scourge.

Fairford, St Mary – nave, east tower wall: angels with shields (probably depicting Instruments of the Passion) flanking former Rood. Inner tower wall, north side return: faded St Christopher. Chancel, north wall: Consecration Cross of 1497.

Gloucester, St Mary de Crypt – chancel, north wall: The Adoration of the Magi; Resurrection scenes on Easter Sepulchre.

Hailes, Church – nave, north wall: fragment from The Weighing of Souls; St Christopher. Chancel, north wall: heraldry including the arms of Richard, Earl of Cornwall (eagle); Castille (tower); de Valence and others; grotesques

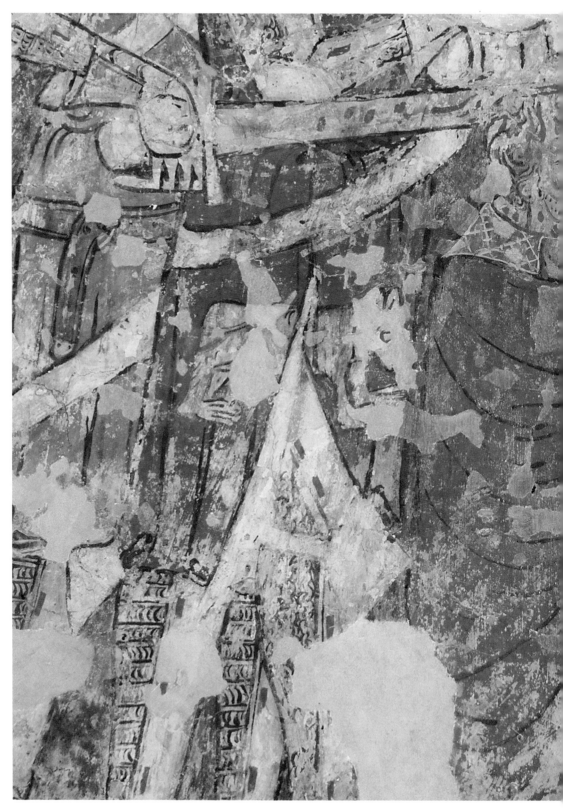

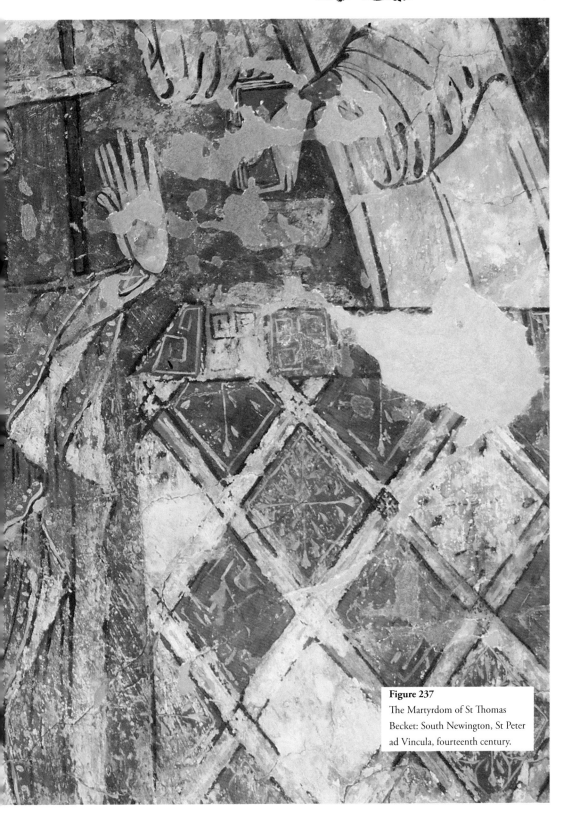

Figure 237
The Martyrdom of St Thomas
Becket: South Newington, St Peter
ad Vincula, fourteenth century.

of winged elephant facing a dragon and goat and hare (?) in combat; frieze of Apostles with angels standing behind tomb; St Katherine in window splay with a kneeling monk and former inscription PRO NOBIS DEUM. East wall: angels censing around window; masonry pattern and fictive voussoirs. South wall: St Margaret with a monk; Arms of Cornwall, Provence and Valkenburg; owl; damaged frieze. West wall: heraldic leopard and patterning. Nave, south wall: hunting scene with hare chased by man and hounds.

Kempley, St Mary – nave, north wall: faint St Christopher; Wheel of Life; window splays: St Anthony of Padua with a pig; The Weighing of Souls; Consecration Cross. Chancel, Romanesque scheme of c.1130. North wall: Apostles adoring Christ on the vault; vault: Christ in Majesty seated on a rainbow, his feet resting on a globe (the Earth) while he holds a book in His left hand with the Greek monograms, I H C and X P S; four Seraphim; four Evangelist symbols; sun, moon, stars, seven golden candlesticks as described in St John's Apocalyptic vision, *The Book of Revelation;* the Virgin Mary holding a book; St Peter with keys; east wall: unidentifiable bishop blessing two figures carrying swords and pilgrim's hat and staff (possibly the patrons, Hugh de Lacy and his father, Walter); south wall: Apostles in adoration. Nave, east wall: pelta patterning; The Three Marys at the Sepulchre. Nave, south Wall: small demon, possibly part of a lost Doom; unidentified figures in window splays; The Martyrdom of St Thomas Becket; St Margaret. In the care of English Heritage. Admission free.

Oddington, St Nicholas – nave, north wall; large Doom with Christ in Judgement including a man hanging from a gibbet, sinners in a cauldron, angels saving souls; adjacent large and unusual combined painting of The Seven Deadly Sins and The Seven Works of Mercy. South tower chapel, east wall: faint scenes in arcading (Death of the Virgin?).

Oxenton, St John Baptist – nave, south wall: St Margaret.

Shorncote, All Saints – chancel, north and west walls: extensive masonry pattern.

Stanton, St Michael – north trancept, north wall: two unidentified figures.

Stoke Orchard, St James the Great – north, south and west walls: extensive, but extremely fragmentary, remains of the Life of St James, including his battle with Hermogenes. Impressive foliate borders with profiled heads and dragons.

Stowell, St Leonard – nave, north wall: lower part of a Romanesque Doom with the Virgin and Apostles; St Peter; St Paul; soul emerging from coffin; souls in a napkin; The Weighing of Souls. South transept, east wall: several

scenes from the Martyrdom of a saint (possibly St Margaret).

Tewkesbury Abbey – Despencer Chantry Chapel, east wall: The Trinity with Despencer family donors and remains of the Resurrected Christ and the Coronation of the Virgin below.

Winterbourne, St Michael – Chapel of St Michael, east wall, arch soffit: faint head of Christ; patterning; east wall, south jam: Sir Thomas de Bradeston in prayer; east wall, south side: helm with Bradeston crest of boar's head; south wall: above window, east side, skeleton from The Three Living and The Three Dead; shield; above window, west side: shield; unidentified figure; south wall, window splays: shields and banners; unidentified figure on west splay; west wall: top to bottom, unidentified figure; remains of The Weighing of Souls (scale and pans); helm with Bradeston crest of boar's head.

Greater London

Cranford, Holy Angels and St Dunstan (in Cranford Park) – chancel, east wall, over east window: stenciled crowned 'M's.

East Bedfont, St Mary the Virgin – nave, east wall, north side recesses: The Crucifixion; Abbreviated Doom.

Hayes, St Mary the Virgin – north wall: large St Christopher.

Ruislip, St Martin – north aisle chapel, east wall, south-east corner: The Weighing of Souls; St Laurence (?). Nave, south wall: St Christopher. Nave, north arcade: The Tree of The Seven Deadly Sins; south arcade: The Seven Works of Mercy around a good man in kingly attire.

Hampshire

Alton, St Laurence – nave pier: top to bottom, three figures, St Cornelius (inscribed); an unidentified king; an unidentified bishop.

Ashley, St Mary – chancel, south wall, window splay: unidentified female saint holding book and staff under a fictive canopy.

Ashmansworth, St James – north wall: two Consecration Crosses; fragments of St Christopher; nave, east wall: two-tier scheme from a Passion cycle which may have begun on the north wall (see remains of the same border at the east end of the north wall), north side, lower tier: The Harrowing of Hell; nave, east wall, above the chancel arch: fragment of a Doom and borders of lost

scenes from the Passion cycle; nave, east wall, south side: two scenes (?) with faded representation of Pentecost with a church to the south. Chancel, north wall: west to east, faint remains of The Martyrdom of St Thomas Becket; The Annunciation; window splays: The Miracle of St Nicholas and the cup. St Nicholas was the original patronal saint of the church. Nave, south wall: two Consecration Crosses, one with a central hole for a candle.

Bramley, St James – nave, north wall: Consecration Cross with central candle hole; large St Christopher with ship, hermit, two mermaids, and a sea monster. Chancel, north wall: masonry pattern; Consecration Cross; east wall, north side: large St James and patterning; east wall, south side: faded Virgin Mary; south wall, window splay: remains of St Gabriel. Nave, south wall: jumbled overlapping scenes including a head under an arch and indecipherable scenes, possibly of the Martyrdom of a saint; further west, The Martyrdom of St Thomas Becket.

Breamore, St Mary – south porch, west wall: fragmentary Suicide of Judas; (also reset painted Saxon Rood on north wall). Chancel, east wall, south side: ornate canopy for image bracket below.

Catherington, All Saints – nave, north wall: The Weighing of Souls. Hyde Chapel, east wall: very fragmentary scene of angels censing lost image; east window soffit: scroll work.

Corhampton, Church – north wall: two indistinct scenes from a Passion cycle. Chancel, north wall: unidentified scenes probably showing Miracles of St Swithin; elaborate drapery with medallion of a lion; south wall: Miracles of St Swithin, including the restoration of the widow's broken eggs; drapery with medallion of two birds.

East Wellow, St Margaret – nave, north wall, west to east: masonry pattern; Consecration Crosses; remnants of St George with royal family watching from their castle; St Christopher; scenes from The Martyrdom of St Margaret. Chancel, north wall, window splay: St Edmund holding arrows; east wall: patterning and Consecration Crosses; east window soffit: two king's heads; fictive voussoirs; south wall: remains of The Martyrdom of St Thomas Becket. Nave, South wall: decorated holy water stoop.

Farnborough, St Peter – north wall: three female saints with inscriptions above, St Eugenia; St Agnes; St Mary Magdalene.

Freefolk, St Nicolas – north wall: St Christopher.

Hartley Wintney, St Mary – north wall: The Seven Deadly Sins encircling Pride (mostly hidden by inserted gallery) but with Lust visible; St Christopher.

Chancel, north wall, window splay: St Margaret; east wall: St George over east window; masonry and fleur-de-lys patterns.

Hurstbourne Tarrant, St Peter – north aisle, north wall: The Three Living and The Three Dead; north aisle, east wall, window splay: chequerboard patterning.

Idsworth, St Hubert – chancel, north wall: two tiers, top tier, scene of a grotesque man in a hunting scene possibly St John the Baptist or St Hubert; lower tier, The Decollation of St John the Baptist with Salome dancing; east wall, east window splays: St Peter; St Paul standing on plinths within elaborate canopies; angels in the soffit of the window arch.

Nether Wallop, St Andrew – nave, east wall, either side of the chancel arch: Anglo-Saxon angels censing a now lost image of Christ. South aisle, window splay: St Nicholas. Nave, south arcade: St George and the dragon; Sunday Christ.

Portsmouth Cathedral – south transept, east wall, south side recess: Christ in Judgement.

Romsey Abbey – ambulatory, former Lady Chapel entrance, south wall: scenes from a once much larger scheme of the Miracles of St Nicholas including, lower right, the Miracle of the Image when a Jew left his possessions in the care of a statue of the saint only to beat it with a scourge when a thief robbed him. After the image retrieved the Jew's property both the Jew and the thief converted to Christianity. Fictive drapery below.

Silchester, St Mary – chancel, north wall: masonry pattern with rosettes; east wall: masonry pattern; fictive voussoirs, heraldry of Bluett family; south wall: masonry pattern with rosettes.

Soberton, St Peter and St Paul – Lady Chapel, east wall: St Anne, *The Education of the Virgin*; St Katherine with the Emperor Maxentius underfoot; St Margaret; patterning; painted image niche.

Stoke Charity, St Michael – north chapel, south wall: unidentified king and saint.

Tufton, St Mary – north wall: St Christopher.

Winchester Cathedral – north transept, Holy Sepulchre Chapel, east wall: *c.* 1170 scheme of The Deposition and The Entombment; vaulting: thirteenth-century Christ; roundels with Holy Infancy scenes and Prophets holding scrolls; south wall, east end: The Entry into Jerusalem; The Raising of Lazarus;

Noli me Tangere; west wall: *c.* 1220 The Deposition; The Entombment of Christ. North-east (Guardian Angels') Chapel, vaults: twenty angel portraits, relief stars and foliage. Lady Chapel, north and south walls: modern copies of an early-sixteenth-century scheme of The Miracles of the Virgin (the originals were defaced during the Reformation and are preserved behind the copies); painted frieze above. South transept, north wall: (access by permission only), monk with quill, probably St Benedict.

Winchester, St Cross – north chapel, south wall: faded scheme of bishops under arcades. Chancel: patterning on vault and walls. South chapel, north wall: masonry pattern. South transept, east wall, in recess: extremely fragmentary remains of a once extensive altar scheme dedicated to St Thomas Becket with Christ Carrying of the Cross and the Crucifixion just visible.

Winchester, St John the Baptist – north wall, west to east: St Christopher, devil above; unidentified bishop; masonry pattern in door arch; St John the Evangelist; unidentified saint.

Winchester City Museum – gallery display: fragment of an Anglo-Saxon wall painting discovered in 1968 during excavations of the former minster site. Check opening times.

Herefordshire

Aston, St Giles (near Elton, also sometimes called Pipe Aston) – nave walls: extensive 'stone and roses' masonry pattern.

Brinsop, St George – chancel, south wall, east end: unidentified figures; south wall, window splay: The Annunciation. Nave, south wall: outlines of the Crucified Christ above south door.

Byford, St John Baptist – Lady Chapel, east wall: The Weighing of Souls with the Virgin Mary sheltering souls in her cloak; fictive image canopy; much stencilled patterning; south wall: St Margaret.

Clodock, St Clydawg – south wall, window splay: Annunciation Virgin.

Hereford Cathedral – north-east transept, south wall: indecipherable figures. Lady Chapel, Audley Screen: Christ, Twelve Apostles and Six Saints on fictive plinths, including St Peter; St Andrew; St Bartholomew; St Paul; and others.

Hereford, All Saints – chancel, east wall, south side: Annunciation Virgin with remains of an earlier scheme visible above.

Leominster, Priory of St Peter and St Paul – north wall: Wheel of Life with seated figure; masonry pattern.

Madley, Nativity of the Virgin – nave, east wall, above the chancel arch: Passion cycle including The Betrayal; The Flagellation; The Resurrection; The Harrowing of Hell; indistinct remnants of The Last Supper; and The Crucifixion. Background decoration includes Fleur de Lys and stars.

Michaelchurch, St Michael – chancel, east wall: extensive masonry pattern; tessellated patterning; Consecration Crosses. Elsewhere, much masonry patterning.

Michaelchurch Escley, St Michael – north wall: Sunday Christ.

Pipe Aston, St Giles – See: Aston, above.

Stretton Grandison, St Lawrence – south wall, over south door: unidentified figure.

Hertfordshire

Abbots Langley, St Lawrence – south aisle, east wall: St Thomas Becket; St Laurence with gridiron.

Cottered, St John Baptist – north wall: St Christopher with hermit, fisherman, and church.

Flamstead, St Leonard – north aisle, north wall extending onto the east wall of the aisle (former Beauchamp Chantry Chapel): Passion cycle in two tiers. Upper tier: The Last Supper; The Betrayal (with Malthus falling to the ground); Christ Crowned with Thorns. Lower tier, The Crucifixion; The Entombment; faint remnants of The Resurrection; patterning in adjacent arcade arches. Nave, east wall, above the chancel arch: Doom. Nave, north arcade: faint St Christopher. South arcade: The Three Living and The Three Dead; lower half of unidentified figures, possibly Apostles.

Hertford, Bengeo, St Leonard – nave, east wall, north side: The Deposition. Chancel walls: extensive patterning.

Newnham, St Vincent – north wall: lower quarter of St Christopher; fragmentary remains of a roundel with possible dragon; unidentified figure. West wall: Consecration Cross.

Ridge, St Margaret – north wall: St Christopher.

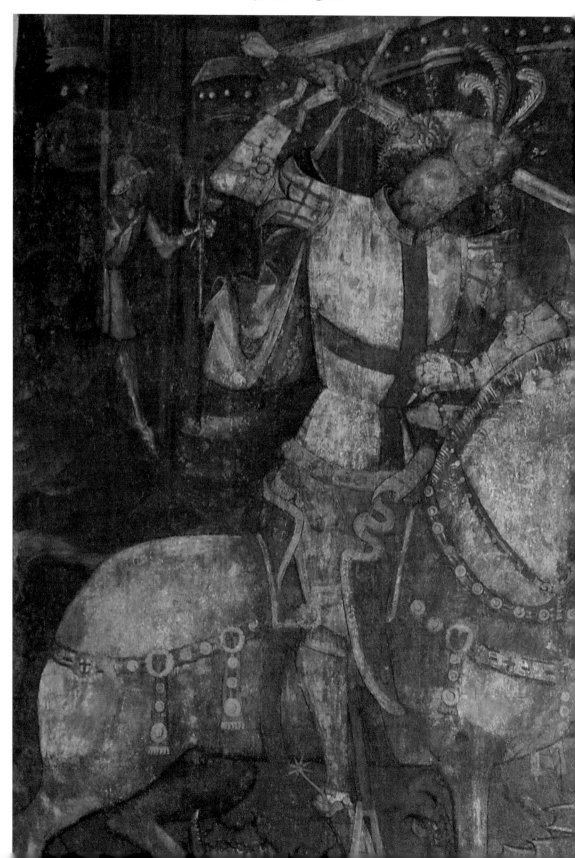

Figure 238
St George slays the dragon:
Norwich, St Gregory, *c.* 1500.

St Albans Abbey – nave: five two-tier altars on piers with The Crucified Christ above and Marian scenes below, The Virgin and Child (2); The Annunciation (2); and The Coronation of the Virgin; also on nave piers, St Zita; St Thomas Becket; St Christopher. Choir clerestory: two Apostles. South choir aisle: St John the Evangelist; St James the Great; tomb with Black Letter inscription. South transept, north-east corner: censing angel. North transept, south-east corner: The Incredulity of St Thomas. Presbytery, west wall: below three shields, faint Christ in Majesty. St Alban's Chapel, north-east corner: St William of York; South-east corner: fragment of an unidentified bishop. Elsewhere, extensive patterning and heraldry throughout the building.

Sarratt, Holy Cross – south transept, east wall: two-tier remains of The Holy Infancy and The Passion of Christ, including, upper tier, The Annunciation; The Appearance of the Angel to the Shepherds (with shepherd playing pipes); lower tier, very fragmentary, The Last Supper; The Resurrection (only *The Vexillum* visible); the Ascension.

Widford, St John the Baptist – chancel, north wall: Christ in Judgement with sword; east wall, north side: unidentified figure; south side: unidentified bishop saint.

Isle of Wight

Godshill, St Lawrence – nave, south wall: Consecration Cross. South transept, east wall: Christ crucified on a Lilly Cross with angels holding scrolls and flanked by fictive drapery bearing outlines of St Mary and St John.

Shorwell, St Peter – north wall: St Christopher with ships, fisherman and hermit together with conflated scenes of his Life and Martyrdom, St Christopher with the devil; St Christopher at a wayside cross; The Martyrdom of St Christopher with arrows veering towards King Dagarus.

Kent

Bapchild, St Lawrence – north chapel, east wall: fictive altar retable of The Crucifixion.

Bishopsbourne, St Mary – north arcade: The Martyrdom of St Edmund; The Weighing of Souls; Christ with the Swords of Judgement; The Miracle of St Nicholas and the Three Boys; masonry pattern. South arcade and wall: St Michael with figures in chains and devils; masonry pattern.

Borden, St Peter and St Paul – north arcade: St Christopher.

Boughton Aluph, All Saints – north transept, east wall: large Trinity.

Brook, St Mary – nave, north wall: St Christopher; Warning to Janglers. Chancel, significant remains of an extensive scheme of 56 roundels in four tiers depicting scenes from The Holy Infancy and The Passion, originally in vivid colours, beginning on the south wall and continuing on the east and north walls. The scheme begins on the south wall, left to right, upper tier: first tier mainly lost, thereafter visible scenes include The Annunciation; The Visitation; The Adoration of the Shepherds; The Journey of the Magi; The Magi before Herod; The Dispute with the Doctors. The scheme then switches to the east wall, south side, where recognizable scenes include: The Flight into Egypt; The Fall of the Idols; The Temptation of Christ; The Raising of Lazarus; Christ Healing Jairus's Daughter; The Entry into Jerusalem; Consecration Cross. The story continues on the east wall, north side, with scenes including: The Betrayal; The Flagellation; Christ Carrying the Cross; Joseph of Arimathea pleading before Pilate for Christ's body; The Entombment; The Three Marys at the Sepulchre. North wall, a few indecipherable fragments of the larger scheme. Also on the east wall: two canopies contemporary with the main scheme; later foliage pattern around the central window; south wall: masonry pattern in recess. Nave, south wall: two of originally ten scenes of the Life and Death of the Virgin, far west, The Assumption of the Virgin; The Coronation of the Virgin. Tower chapel, north wall: demi-Christ blessing (access by prior appointment only).

Brookland, St Augustine – south aisle chapel, south wall: The Martyrdom of St Thomas Becket; stencilled patterning in piscina.

Canterbury Cathedral – north transept, Lady Chapel, east wall: frieze of angels. north choir aisle, north wall: The Legend of St Eustace. St Andrew's Chapel: masonry pattern; fictive striped drapery; holy I H S monograms. St Anselm's Chapel: St Paul with the Viper. Crypt: St Gabriel's Chapel, vault: Christ in Majesty flanked by angels with the Seven Churches of Asia; St John the Evangelist writing the Apocalypse; north wall: The Annunciation to Zacharais; The Naming of St John; The Annunciation to the Virgin Mary; text dedicating altar to St Gabriel; various Seraphs. Crypt, Our Lady of the Undercroft Chapel: donor heraldry; ornate decoration including ceiling mirrors. Chapter house: repainted decoration.

Canterbury, Eastbridge Hospital – refectory, north wall: Christ in Majesty with symbols of the Four Evangelists (reconstructed).

Capel, St Thomas of Canterbury – north wall: two-tier scheme divided by bold zig-zag border, upper tier, mostly obliterated; lower tier, Passion

cycle with The Entry into Jerusalem; The Last Supper; The Betrayal; *Noli me Tangere*; north wall, window splay: masonry pattern; north wall, window splay: The Murder of Abel; The Conviction of Cain; also possibly the Annunciation to Zacharias (see: Subject Guide: St John the Baptist); Consecration Crosses.

Cliffe-at-Hoo, St Helen – north transept, east wall: The Martyrdom of St Edmund in six scenes. South transept, east wall: The Martyrdom of St Margaret; window splay: fragment of The Last Judgement with Christ holding a sword. Nave arcade: chevrons on piers; patterning.

Darenth, St Margaret – apse: masonry pattern with fictive boss in vaulting (repainted).

Dartford, Holy Trinity – south aisle chapel, east wall: large St George and the dragon.

Doddington, Beheading of John the Baptist – chancel, north wall, window splays: St Francis receiving the stigmata; St Peter (?); patterning of rosettes, stars and scrolls.

Eastry, St Mary – nave, east wall, above the chancel arch: five tiers of roundels with the middle tier blank. Twenty-eight roundels decorated with repetitive patterns of a trefoiled flower; a lion, a griffin and doves.

Faversham, St Mary of Charity – north transept, south-east pier: ten scenes from the Holy Infancy and the Passion of Christ in three tiers, bottom tier, The Annunciation; The Visitation; The Adoration of the Magi; middle tier, The Nativity; The Appearance of the Angel to the Shepherds; The Presentation in the Temple; upper tier, The Crucifixion; The Three Marys at the Sepulchre; a stylized tree. Chapel of St Thomas, south wall: St John the Evangelist in the guise of a pilgrim, part of a once much larger scene of St Edward the Confessor and the Miracle of the Ring; masonry pattern.

Frindsbury, All Saints – chancel, east wall, window splay: fragmentary St Laurence.

Halling, St John the Baptist – nave, east wall, either side of the chancel arch: remains of a Passion cycle, south side, Christ Crowned with Thorns; north side, Christ washing Feet; The Last Supper with tonsured apostles.

Harbledown, St Nicholas – nave, north arcade: indistinct scenes in medallions. Chancel, north wall, patterning; east wall: Annunciation either side of east window, St Gabriel and the Virgin under fictive canopies; Abbreviated Doom above; figures on east wall; south aisle, Lady Chapel, east

wall: crowned Ms. Nave, south wall: lower part of St Christopher; west wall, north side: fictive drapery extending to the north arcade wall.

Lenham, St Mary – chancel, south wall, window splay: unidentified bishop giving blessing; masonry pattern. Nave, south wall: The Weighing of Souls.

Lower Halstow, St Margaret – chancel arch soffit: feather patterning. South arcade piers: east end, a figure stretched as if on a saltire cross (St Andrew?); a ship with seated figures and a figure falling overboard, perhaps part of a Miracle of St Nicholas; west end, a crowned woman with image niche below. West wall: Warning to Janglers.

Maidstone, All Saints – St Thomas Becket Chapel, north wall, tomb recess: abraded figure of John Wootton, the first master of the Collegiate church, before the Annunciate Virgin Mary; St Katherine and an unidentified female saint; possibly St Mary Magdalene, defaced St Thomas Becket; unidentified bishop in pontificals.

Milton Regis, Holy Trinity – north wall: Saints Peter and Paul before Nero; St Laurence(?) above. Sacristry, east wall: unidentified figure. Nave, south wall: faint St Christopher with fragment of the Christ Child. West wall: Consecration Cross.

Newington-next-Sittingbourne, St Mary – north wall: The Dream of Joseph with a reclining St Mary above; lower half of St Christopher; window splays, west to east: St Andrew; St John the Evangelist; St Paul; St Peter; extreme end of the wall, faint remains of St Margaret with a dragon. North aisle, east wall: Doom with sinners hanging from a gibbet. Nave, south wall, tomb recess: Christ being censed by angels. West wall and adjoining north wall corner: extensive leaf scroll patterning.

Rochester Cathedral – north-east transept, north wall, tomb recess: fictive drapery with addorsed popinjays. South transept, east wall: indistinct Annunciation; St Margaret; unidentified Saints and angels. Nave, south arcade, pier, west end: faint St Christopher. Choir, north wall: Wheel of Fortune. Crypt vaults: fragments of The Miracles of the Virgin in roundels.

Selling, St Mary – south chapel, east wall, window splays: St Peter; St Paul; St Bartholomew (with knife); St John the Evangelist (with eagle); masonry pattern.

Stone (near Dartford), St Mary the Virgin – north wall: large Virgin and Child under canopy; faded Martyrdom of St Thomas Becket; another painting of the Virgin Mary under an elaborate canopy. South wall: dado height patterning.

Ulcombe, All Saints – chancel, north wall: heads of bishops. Nave, east wall, south side: The Crucified Christ. South aisle pier, arch soffit: The Crucified Christ; pier spandrel: Dives and Lazarus; south aisle pier: The Crucified Christ; St Michael with Satan; Consecration Cross.

Upchurch, St Mary the Virgin – nave, south wall: slight remains of the Miracles of St Spiridon. This painting is included for its rarity.

West Kingsdown, St Edmund – nave, south wall, window splay: Cain and Abel offering sacrifices to God; The Murder of Abel.

Lancashire

Ribchester, St Wilfred – North wall: upper half of St Christopher.

St Michael's-on-Wyre, St Michael – Chancel, North wall: The Ascension of Christ.

Leicestershire

Cold Overton, St John Baptist – south aisle, east wall: St Katherine with wheel; staff of St Margaret; south aisle, south wall: The Assumption of the Virgin; The Nativity; The Funeral of the Virgin (with pall bearers); St John the Baptist.

Great Bowden, St Peter and St Paul – north chapel, north wall: Doom with inscriptions. South chapel, south wall: female head.

Lutterworth, St Mary – north aisle, north wall: three kings from The Three Living and The Three Dead, (kings of different ages). Nave, east wall, above the chancel arch: Doom (heavily repainted).

Lincolnshire

Asgarby, St Andrew (near Sleaford) – north aisle, east end: unknown donor figure with scroll adjacent to an image bracket.

Corby Glen, St John Evangelist – north aisle, north wall: west to east, The Weighing of Souls with souls under Virgin's cloak *Vierge de la Misericordia*; St Christopher; St Anne, *The Education of the Virgin*; The Seven Deadly Sins and The Warning to Blasphemers conjoined; painted image niche; patterning. Nave, east wall, above the chancel arch and continuing onto

adjacent side walls: remains of a Doom with a sinner swinging on a gibbet above a Hell Mouth on the south side. South aisle: faint Tree of Jesse. Nave arcades: unusual Holy Infancy scenes between windows in the clerestory, north arcade: west to east, two of the Three Magi holding gifts and with inscribed scrolls; The Birth of Christ with the Virgin and Child surrounded by animals, shepherds and the Magi; south arcade: west to east, Shepherds with sheep; Shepherds, one with pipes; Herod on his Throne.

Friskney, All Saints – south arcade: The Last Supper.

Goxhill, All Saints – south porch, east wall: The Crucifixion; remains of an adjacent scheme, possibly The Entombment.

Nettleham, All Saints – nave arcade: foliate and chequer board patterning.

Pickworth, St Andrew – north arcade, west to east: St Christopher; The Three Living and The Three Dead; The Weighing of Souls; The Ascension of Christ; background patterning; nave, east wall, above the chancel arch and continuing onto adjacent side walls: Doom with sinners in a cauldron and a devil with a pitchfork.

Stow-in-Lindsey, St Mary the Virgin – north transept, east wall: reredos recess, lower half of St Thomas, previously flanked by scenes of The Martyrdom of St Thomas Becket and The Last Supper of St Thomas Becket.

Swinstead, St Mary – north arcade pier: seven heraldic shields including Hastings.

London

British Museum – gallery displays: Roman Christian wall paintings from Lullingstone villa, Kent; fragments from St Stephen's Chapel, Westminster Palace, painted *c.* 1355 for Edward III. Scenes include 'The Destruction of Job's children'. Also, painted wooden ceiling panels from The Painted Chamber: a lavishly painted state chamber commissioned by Henry III.

Museum of London – medieval London gallery: St Peter with tonsured donor. Inscribed: 'Jesus Christus Dominus'. The painting includes the arms of Radclyffe. Removed from Brooke House, Hackney, before its demolition.

Westminster Abbey – nave, north aisle, spandrels of arcade: heraldry. Chapel of St John the Baptist: decorative paint in vestry and image niche. North ambulatory: painted tombs; Lady Chapel, west wall: three Consecration Crosses. South transept, south wall: *The Incredulity of St*

Thomas; St Christopher. St Faith's Chapel, east wall: St Faith with altar retable below with monk and prayer. Chapter house wall arcades: extensive remains of Apocalypse and Judgement painting schemes. The chapter house is in the care of English Heritage. For comparisons with panel painting see also: The Westminster Retable in the Abbey Museum. Check opening times. Admission fee for visitors.

Norfolk

Attleborough, St Mary – nave, east wall, above the chancel arch: Rood scheme with prophets and feathered angels. Nave, south wall: lower half of St Christopher with donor; Consecration Crosses.

Bale, All Saints – north wall: fragmentary St Christopher. north transept, east wall; nave, east wall and south wall: large foliate Consecration Crosses.

Banningham, St Botolph – north aisle, north wall: Martyrdom of an unidentified saint. North arcade: St George on foot fighting the dragon; lower third of St Christopher. South arcade pier: fictive canopy for image.

Barton Bendish, St Mary – nave, south wall: large figure in a wheel above a bier, probably a Morality subject.

Belton, All Saints – north wall: St James the Great; St Christopher; small amount of text accompanying barely visible fragments of The Three Living and The Three Dead. According to a drawing in the church, the kings were shown as mounted.

Bradfield, St Giles – nave, east wall, above the chancel arch: Doom.

Brisley, St Bartholomew – north wall: head of St Christopher and the Christ Child. North aisle, north-east corner Annunciation angel. South aisle: St Christopher; St Andrew; unidentified figure; Consecration Cross.

Burnham Overy (Town), St Clement – north wall: St Christopher; small patch of black line masonry pattern.

Carleton Rode, All Saints – chancel, north, east and south walls: eight unusual Consecration Crosses, some repainted.

Castle Acre, Priory – Prior's Chapel, east wall altar recess: traces of several scenes including an unidentified figure on the north wall. South wall: painted gesso corbels. In the care of English Heritage. Check opening times. Admission charge.

Opposite.
Figure 239
The Crucified Christ on a pier in the nave: Broughton, St Mary, fourteenth century.

Catfield, All Saints – north arcade, west to east: faint Wheel (of Fortune); now lost Tree of The Seven Deadly Sins; heraldic shield (Fitz-Alan); faint traces of The Seven Works of Mercy. South arcade, east to west: indistinct Holy Infancy scenes, possibly The Adoration of the Shepherds; The Magi before Herod; The Adoration of the Magi; faint scenes of the Martyrdom of St Laurence; indecipherable scenes of the Martyrdom of St Katherine recorded previously; The Martyrdom of St Stephen in a spandrel.

Cawston, St Agnes – nave, east wall, above the chancel arch: Rood cross silhouette against red background. South chapel, east wall: St Agnes with two donors carrying scrolls, the right hand side figure inscribed 'Bridale'.

Cockthorpe, All Saints – north wall: St Christopher with two kneeling donors.

Colton, St Andrew – north wall: Consecration Cross. West wall: Warning to Janglers.

Crostwick, St Peter – south wall: lower two-thirds of St Christopher.

Crostwight, All Saints – north wall, west to east: Tree of The Seven Deadly Sins emerging from Hell Mouth; Warning to Janglers; St Christopher; Consecration Crosses; damaged two-tier Passion cycle, lower tier, The Entry into Jerusalem; The Last Supper; Christ washing Feet; upper tier, Christ before Caiaphas or Pilate; Christ Crowned with Thorns; The Crucifixion.

East Harling, St Peter and St Paul – north aisle, north wall: figures and cat-faced demon under architectural arcades, possibly a fragment of an unusual Doom scheme.

Eaton, St Andrew (near Norwich) – north wall: Consecration Cross. South wall: Warning to Janglers above south door. One devil defecating.

Edingthorpe, All Saints – north wall: St Christopher; The Seven Works of Mercy on a Tree; decorated border to a large image niche.

Fring, All Saints – north wall: St Christopher with scrollwork border (a mermaid was once visible). Nave, east wall, south side: painted niche with silhouette; The Annunciation with the Virgin below a canopy. South wall: St John the Evangelist with palm; window splay: unidentified figure. The style of the latter paintings are similar to those in Norwich Cathedral's ante-Reliquary Chapel.

Fritton, St Catherine (near Long Stratton) – nave, north wall: faded Life of St Christopher, including scenes of his conversion, with now illegible donor

inscription but once naming John Avelard, *c*.1506; St George; St Edmund of Abingdon (with inscription); Consecration Cross.

Fritton, St Edmund (near Great Yarmouth) – north wall: St Christopher. Chancel apse: *Ecclesia*; *Synagoga*; The Martyrdom of St Edmund; Saint and key (St Peter?); bold scrolling. Nave, south wall: bold scrolling; window splay: St John the Baptist.

Great Ellingham, St James – south wall, east to west: image niche with angel holding cloth of honour behind silhouette of a lost statue of the Virgin Mary; window jamb: St Michael; Consecration Crosses: fragmentary remains of Life of St Christopher with a scene of the Saint near a wayside cross.

Great Hockham, Holy Trinity – north wall: The Adoration of the Magi; fragments of a Passion cycle behind monument, The Last Supper; The Betrayal; Consecration Crosses. Nave, east wall, above the chancel arch: unusual scheme with God the Father and the Holy Spirit forming the Trinity with the Rood below flanked by Annunciation figures with scrolls. The Virgin Mary wears an ermine-lined cloak. Other components of the scheme include a red diapered background, a Trinity shield and a shield with the Cross of the Passion and two kneeling donor figures.

Great Yarmouth, Greyfriars Cloister – tomb recesses with painted tracery and faint figures, possibly a kneeling donor and the Virgin Mary. In the care of English Heritage. Check opening times and viewing arrangements in advance as the recesses are in a locked part of the site and viewing hours are restricted.

Haddiscoe, St Mary – north wall: St Christopher (heads only); skull of a skeleton from The Three Living and The Three Dead; Consecration Cross.

Hales, St Margaret – north wall, window splay: image niche with canopy. Nave, east wall, above the chancel arch: angels with trumpets. Chancel, north wall: Consecration Cross, east wall: decorated image niches; chancel, south wall: Consecration Cross. Nave, south wall, window splay: St James the Great; south wall: St Christopher.

Hardley, St Margaret – nave, south wall: St Christopher with heron; St Katherine holding a wheel. West wall: Consecration Crosses.

Hardwick, St Margaret – north wall: St Christopher.

Heacham, St Mary – south-west crossing pier (now enclosed within a normally locked vestry): St John the Baptist with *Agnus Dei*.

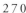

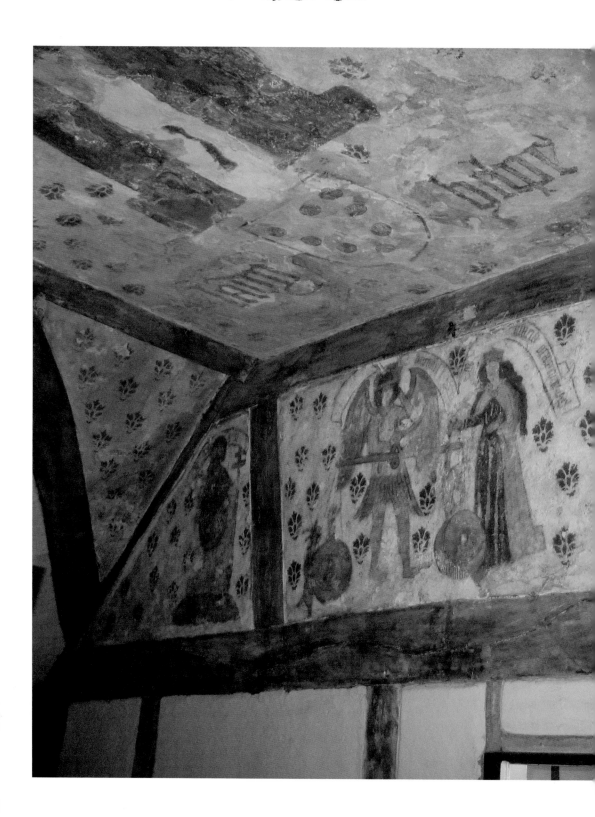

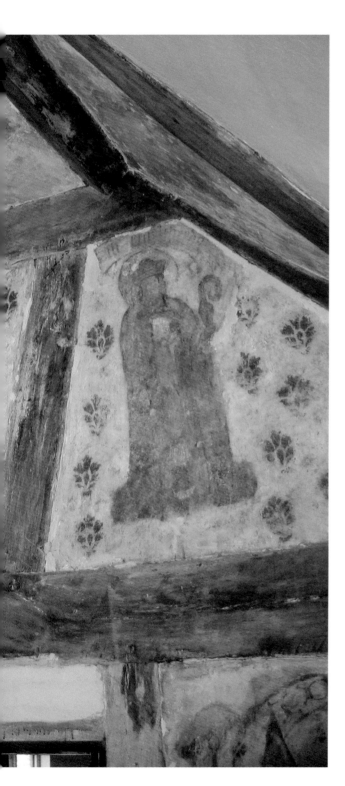

Figure 240
The Weighing of Souls, with saints
in side panels and the Trinity on
the ceiling: The Painted Chamber,
The Commandery, Worcester
(formerly the Hospital of St
Wulstan), *c.* 1500.

Hemblington, All Saints – north wall: St Christopher and ten episodes from his Martyrdom. Starting from the bottom left, St Christopher arrested; St Christopher before King Dagarus; St Christopher in prison with two prostitutes sent to tempt him; St Christopher before Dagarus again; The Martyrdom of the prostitutes after they converted to Christianity; the Scourging of St Christopher; St Christopher before Dagarus; St Christopher being shot with arrows; Dagarus struck in the eye by an arrow; St Christopher beheaded; The Healing and Conversion of Dagarus.

Heydon, St Peter and St Paul – north aisle, north wall: two kings and skeleton heads from The Three Living and The Three Dead; scenes of the Decollation of St John the Baptist in panels separated by border. South aisle, south wall: the head of St Margaret; south aisle, north wall: three kings from The Adoration of the Magi.

Horsham St Faith, St Faith's Priory – refectory, east wall: large Crucifixion with flanking figures; north side, St Faith; south side, unidentified figure;. Below, remains of remarkable nine-scene Founder's cycle, north to south: first scene hidden in wall; Ship, probably Lord Robert and Lady Sybilla Fitzwalter returning from their pilgrimage to Rome via France; The capture of the Fitzwalters by brigands; The Fitzwalters imprisoned; The Fitzwalters invoking the aid of St Faith; St Faith opening the door to their cell; The Fitzwalters at the Abbey of Conques giving thanks to St Faith; The Fitzwalters returning to Norfolk by sea with monks; The Building of the Priory. Important decorative scheme similar to that previously extant at Norwich Cathedral. Upstairs rooms: masonry pattern. Privately owned. Viewing by prior appointment only. Apply in writing to: The Owner, St Faith's Priory, Horsham St Faith, Norfolk, NR10 3JJ.

Houghton-on-the-Hill, St Mary (near South Pickenham) – eleventh-century scenes. North wall: west to east, Noah's Ark; The Making of Eve; The Tree of the Knowledge of Good and Evil with Adam and the serpent. Nave, east wall, above the chancel arch: 'Throne of Mercy' Trinity with Last Judgement and adoring saints looking upwards on north side; Traces of Hell scenes on the south side. Below, a band of Christ and Apostles holding scrolls confronted by Satan and demons. To the left and below an angel blowing the Last Trump as souls clamber from their graves; South wall: traces of a wheel and faint remains of St Christopher.

Langley, St Michael – nave, south wall: scene from a once much larger scheme showing The (Life?) and Martyrdom of St Christopher with the oversized saint before King Dagarus.

Lingwood, St Peter – nave, north wall: upper half of St Christopher.

Little Melton, St Mary and All Saints – nave, north wall: Warning to Janglers. Chancel, east wall: Annunciation Angel and Virgin flanking east window.

Little Witchingham, St Faith – north wall: upper tier, row of standing Apostles flanking Christ; lower tier: thirteen-scene Passion cycle (some scenes lost). The visible scenes are, The Flagellation; Christ before Caiaphas; The Deposition; The Entombment; The Resurrection; The Harrowing of Hell; *Noli me Tangere*; *The Incredulity of St Thomas*; The Ascension of Christ; also on the same wall, vine scroll pattern with grapes extending into doorway; very damaged St Christopher. Chancel, north wall: fragmentary St George. Nave, south wall: unidentified scenes, including a king; south aisle arcade: Evangelist symbols in cusped roundels surrounded by vine scroll pattern with grapes (see also Weston Longville). West wall: over the arch, part of Christ in Majesty flanked by angels and kneeling donor figures.

Moulton St Mary, St Mary – north wall: St Christopher. South wall: The Seven Works of Mercy with an eighth scene of Christ Blessing the Acts. Made by the same workshop as Wickhampton (also Norfolk).

Norwich Cathedral – ante-Reliquary Chapel; fictive vaulting with boss of Christ seated on a vine surrounded by St Andrew; St Peter; St Paul; St Margaret; The Virgin and Child; St Katherine; Martyrs (badly damaged); Confessors with inscriptions, St Martin; St Nicholas; St Richard of Chichester. East wall: bishop's head in roundel; censing angel. Western arch soffit: Apostles. North aisle: Jesus Chapel entrance: decorated piers and capitals. South aisle, soffit of arch: three roundels of Losinga cycle, part of a once much larger scheme, Losinga buying the See; Losinga in repentance; The building of the Cathedral in penance. Presbytery, north arcade, pier: 'Erpingham reredos' with very faded scenes of The Trinity and the Virgin Mary, St John and the Four Doctors. For comparisons with panel paintings see also: the Despencer Retable in St Luke's Chapel.

Norwich, St Gregory – north aisle, west wall: very fine St George. South aisle, south wall, east end: heraldry, arms of John Reede; remains of Three of the Four Doctors with St Gregory in good condition; Annunciation over window; fictive brocade. In the care of the Norwich Historic Churches Trust. Check opening arrangements in advance as the church is normally locked.

Paston, St Margaret – north wall: St Christopher; incomplete remains of The Three Living and The Three Dead; devil from The Weighing of Souls.

Potter Heigham, St Nicholas – north wall: St Christopher; St Anthony Abbot; indistinct Holy Infancy scenes, including The Annunciation; also on the same wall, The Miracle of St Nicholas and the Three Boys; Window

splay: fictive image canopy. South wall: The Seven Works of Mercy enacted by a woman in tiered scenes.

Scottow, All Saints – north wall: lower half of St Christopher in a decorated border.

Seething, St Margaret and St Remigius – nave, north wall: The Three Living and The Three Dead; St Christopher; defaced Life of Christ cycle, The Annunciation; The Nativity; The Resurrection; The Ascension of Christ; also, The Coronation of the Virgin; St John the Baptist. South wall: Warning to Janglers; figure playing harp.

Shelfanger, All Saints – chancel, east wall, north side: foliate design in recess; south side recess: The Virgin and Child flanked by the Magi and Shepherds.

South Burlingham, St Edmund – nave, north wall: damaged St Christopher; window splay: fictive image niche. Chancel, south wall: large painting of The Martyrdom of St Thomas Becket.

South Pickenham, All Saints – north wall: lower two-thirds of St Christopher.

South Walsham, St Mary – nave, east wall, south side: rare instance of painted continuation of wooden chancel screen.

Sporle, St Mary – south aisle, south wall: twenty-five scenes in four tiers of The Martyrdom of St Katherine, with the upper and lower sections by two different artists.

Swannington, St Margaret – south aisle, north wall: St Christopher.

Tattersett, All Saints – south wall: The Martyrdom of St Erasmus.

Thurlton, All Saints – north wall: St Christopher with flatfish and dolphins.

Thurton, St Ethelbert – north wall: faded St Christopher with lobster and crab; Angel.

Weston Longville, All Saints – north wall: Tree of Jesse with vine scrolls similar to those at Little Witchingham (also Norfolk). Nave, east wall, north side: fictive statue of St John the Baptist with *Agnus Dei* standing on a plinth; Nave, east wall, south side: upper half of St John the Evangelist holding a cup with a dragon.

West Somerton, St Mary – north wall: damaged Passion cycle, The Entry into Jerusalem; The Mocking of Christ; The Flagellation; The Resurrection. South wall: St Christopher; Doom with the Virgin baring her breasts to Christ.

West Walton, St Mary – south arcade clerestory: fictive decorative hangings between windows, including patterns of Fleur de Lys; rows of fish; birds in roundels; masonry pattern.

Wickhampton, St Andrew – north wall: The Three Living and The Three Dead; St Christopher; The Seven Works of Mercy with an eighth scene of Christ Blessing the Acts. Made by the same workshop as Moulton St Mary (also Norfolk).

Wilby, All Saints – north wall: faded two-thirds of St Christopher.

Worsted, St Mary – north chapel, north wall: large Consecration Cross with remains of textual inscription. Nave, east wall: fictive image canopy. Chancel, north wall: faded large foliate Consecration Cross.

Northamptonshire

Ashby St Ledgers, St Mary and St Leodegarius – north wall: St Christopher with Catesby arms. North aisle, east wall, entrance to Arnold Chapel: assorted heraldry. Nave, east wall, above the chancel arch and continuing on adjoining side walls: apparent Triptych of extensive Passion cycle but actually several different schemes with those above the chancel arch the most faded. A wooden Rood was originally attached to this wall. Visible scenes, north side: upper tier, The Entry into Jerusalem; Christ washing Feet; The Last Supper; The Agony in the Garden; lower tier, The Virgin Mary at the Crucifixion and The Death of Christ; The Pieta; above the chancel arch: many lost scenes but on the north side, The Betrayal; Christ before Caiaphas; on the south side: The Entombment; south arcade: Christ Nailed to the Cross; lower part of The Crucifixion; thereafter, The Resurrection; The Three Marys at the Sepulchre. Elsewhere, nave, south wall: east end, behind the organ, scene from The Martyrdom of St Margaret.

Burton Latimer, St Mary – north aisle: fragment of The Weighing of Souls; three scenes from the Martyrdom of St Katherine, east to west: St Katherine debates with the Emperor (the Saint missing); St Katherine taken to prison by a jailer with keys; St Katherine survives her torture as the wheel breaks.

Chacombe, St Peter and St Paul – north aisle, north wall, window splay: The Martyrdom of St Peter.

Croughton, All Saints – north wall: remains of a once extensive Passion cycle, including east to west, upper tier, The Entry into Jerusalem; The Last Supper; Christ Carrying the Cross; The Deposition; also St Anne, *The Education of the Virgin* (the earliest recorded example of this subject, *c.* 1310); and The Annunciation below. South wall; fragmentary remains of a twenty-five-scene cycle of the Life and Death of the Virgin and the Holy Infancy with most scenes difficult to decipher, but including The Massacre of the Innocents; and The Flight into Egypt at the west end. Nave, north arcade: The Weighing of Souls. South arcade, east end: Hell scene from lost Doom on adjoining nave, east wall, chancel arch.

Easton Neston, St Mary – north aisle east end: fabulous architecture (The Holy City?) with angels surrounding a lost east window. Chancel, east wall: niches with statue silhouettes.

Glapthorn, St Leonard – north wall: faded St Christopher. Nave, east wall, above the chancel arch: Rood cloth of honour.

Great Harrowden, All Saints – nave, east wall, above the chancel arch: Doom.

Holcot, St Mary and All Saints – north wall: very damaged remains of a two-tiered scheme, upper tier (formerly The Martyrdom of St Katherine) now lost; lower tier, faint figures of Apostles including St John with the cup; window splay: saint (previously identified as St Andrew). West wall, south side: The Ascension of Christ; Pentecost; The Weighing of Souls (The Virgin Mary just visible on the south side).

Nassington, St Mary and All Saints – north aisle: The Weighing of Souls with a bearded donor; St Katherine and the wheel; two unidentified saints in window splays. Nave, east wall, above the chancel arch: upper remains of Doom with Christ and Apostles. North arcade, south side: St Martin.

Raunds, St Peter – north aisle, north wall: faint remains of The Martyrdom of St Katherine extending to adjoining west wall, in two schemes (one grisaille); faint St George over north door; north aisle, east wall: decorative patterning. Nave, East wall, above the chancel arch: scheme with angels holding Instruments of the Passion and silhouette of the former Rood. North arcade, west to east: impressive scheme of The Seven Deadly Sins around Pride; St Christopher (with mermaid?); The Three Living and The Three Dead. West wall: painted clock with donors; west wall, north side: Remains of St Katherine scheme, continuing from north wall.

Slapton, St Botolph – north wall: St Christopher with mermaid. Arcade, south wall: St George; The Weighing of Souls; arcade soffit: The Mass of

St Gregory; arcade spandrel: St Francis receiving the Stigmata. North wall arcade, west to east: The Suicide of Judas; The Annunciation; indecipherable patches. South aisle, south wall: St Eloi; St Anne, *The Education of the Virgin*; The Three Living and The Three Dead. West wall: Warning to Janglers.

Stanion, St Peter – south aisle, east wall: large unicorn and stag kneeling before lost statue in highly decorative fictive niche. Nave, south arcade: adjacent to the chancel arch, The Weighing of Souls.

Thorpe Mandeville, St John Baptist – north wall: upper part of St Christopher.

Towcester, St Lawrence – Lady Chapel, north wall: crowned female figure; south wall, niche: The Pelican in her Piety.

Nottinghamshire

Blyth, St Mary and St Martin – nave, east wall: upper level, large Doom with sinners in a cauldron; lower level, remains of a two-tier Passion cycle, very abraded, but including Christ carrying the Cross; The Resurrection. South chapel, east wall: painted pier and capital.

Newark-on-Trent, St Mary Magdalene – south aisle, Markham Chantry Chapel panels: 'Death and the Gallant'.

Oxfordshire

Beckley, St Mary – nave, east wall, above the chancel arch: Doom with illegible inscription and St Peter and St Paul below. Lady Chapel, pier: The Lactating Virgin with the Christ Child; The Weighing of Souls (2), including torments of the damned with a sinner being spit-roasted.

Black Bourton, St Mary – north arcade: west to east, The Vesting of St Thomas Becket; The Tree of Jesse; St Christopher; The Martyrdom of St Thomas Becket; The Coronation of the Virgin censed by angels; The Baptism of Christ; roundel of St Peter and St Paul; The Martyrdom of St Stephen; indecipherable remains. South wall: east to west, upper register: St Richard of Chichester with faint inscription above; lower level, Holy Infancy scenes, including The Adoration of the Magi; window splay: The Massacre of the Innocents; The Angel appearing to Joseph in his dream; south wall, west end: unidentified bishop; unknown bishop with two women (?); very faint Christ from now lost scene; St Katherine.

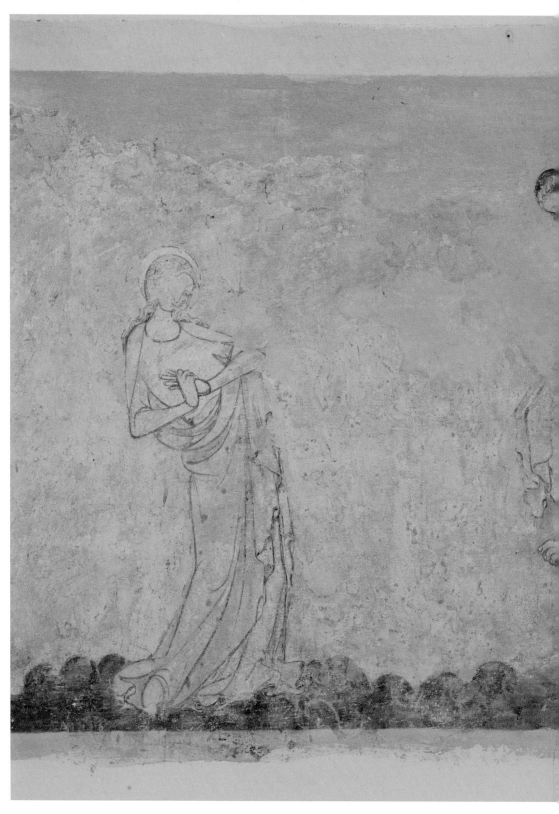

Figure 241
The Crucifixion: Brent Eleigh, St
Mary, fourteenth century.

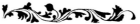

Bloxham, St Mary – nave, north wall: lower two-thirds of St Christopher with a hermit, fisherman, mermaid. Nave, east wall, above the chancel arch: fragment of Doom. Milcombe Chapel, south wall: Martyrdom of an unidentified saint.

Broughton, St Mary – nave, north wall: indecipherable remains of St Christopher and St George; Chancel, north wall: patchy remains of a cycle illustrating the Death of the Virgin, west to east: an angel holding a palm branch tells the Virgin of her approaching death; several unclear scenes possibly including the Gathering of the Apostles at her deathbed and the Funeral of the Virgin; thereafter, the Assumption of the Virgin (in a almond-shaped mandorla); and above, The Coronation of the Virgin with a kneeling cleric holding a scroll inscribed 'Leuedy for thi Joyzes five led me to the wey of clene lyve'. Chancel, east wall: Penitential Seraph. Nave, west end, pier near the font, The Crucified Christ.

Cassington, St Peter – north wall, window splay: St Katherine under fictive canopy. Nave, east wall, above the chancel arch: fragments of Doom. South wall, window splay: St Margaret under fictive canopy; west wall, Consecration Cross.

Chalgrove, St Mary – north aisle, St James's Chapel, east wall, north side: elaborate canopy, probably for a statue. Chancel, extensive scheme linking the Holy Infancy and Passion of Christ to The Death of the Virgin in up to three tiers, interspersed with saints. North wall: west to east, lower and middle tier, The Tree of Jesse; window splay: The Annunciation; thereafter, The Nativity; The Adoration of the Magi; middle tier, The Massacre of the Innocents; The Presentation in the Temple; upper tier, west to east, The Betrayal; Christ before Pilate; The Mocking of Christ; The Flagellation; Christ Carrying the Cross; window splay: St Helena; St Mary Magdalene; thereafter, three-tier scheme, top to bottom, very slight remains of The Crucifixion; followed by The Deposition; The Entombment. East wall, north side: top to bottom, The Ascension; The Resurrection; The Harrowing of Hell (with donor's prayer); east window splays: St Peter; St Paul.

The south wall scheme begins at the west end of the Chancel, proceeding west to east: The Last Judgement; window splay: St Bartholomew; St Laurence; three tiers of two scenes, west to east; The Virgin receiving a palm from an angel; indecipherable scene; The Virgin and the Apostles; The Death of the Virgin; The Funeral of the Virgin; The Conversion of the High Priest; window splay: St John the Evangelist; St John the Baptist; three-tier scheme, top to bottom, The Entombment of the Virgin; St Thomas with the girdle, lost scene. East wall, south side: two-tier scheme, bottom to top, The Assumption of the Virgin; The Coronation of the Virgin.

Checkendon, St Peter and St Paul – apse, north wall: fragment of horseman and other figures. Apse, east walls: Christ and Apostles, with the Patron Saints under canopies.

Combe, St Laurence – north wall, over north door: faded St Margaret spearing dragon; faded St Katherine with book and sword. Nave, East wall, north side: The Crucifixion; nave, east wall, above the chancel arch: Doom with Apostles bearing attributes, including St Andrew; (and possible female donor); nave, south wall: upper part of St Gabriel with an inscribed scroll addressing a now lost statue of The Virgin Mary in the adjacent east wall, image niche; further west, lower quarter of St Christopher with an otter.

Also close by: Church Hanborough, St Peter and St Paul – north aisle chapel, east wall recess: brocade type-textile of white roses on a red background.

Dorchester Abbey – south aisle, east wall; large Crucifixion retable and recessed cross in the former parish part of the church (repainted). South chancel aisle, south wall: remains of St Christopher.

Elsfield, St Thomas of Canterbury – chancel, east wall: silhouetted image niche; chancel, west wall: masonry pattern.

Ewelme, St Mary – St John the Baptist Chapel. Extensive decoration of Chapel walls with diapered holy I H S monograms with textural inscriptions in coving above. Although much repainted, a fragment of the original scheme is visible. Also, Duchess of Suffolk double effigy, 'transi' tomb chest, with paintings above cadaver. In the lower level: above her eyes, The Annunciation; above her Feet, St John the Baptist; St Mary Magdalene (need to kneel to look inside).

Great Tew, St Michael – south aisle, south wall: The Weighing of Souls above Passion cycle in five tiers, reading left to right, top to bottom, interrupted by a funerary monument, remnants of The Entry into Jerusalem; Christ washing Feet; The Betrayal; The Crowning with Thorns; Christ before Pilate (?); The Flagellation; Christ Carrying the Cross; The Crucifixion; The Deposition; The Entombment; The Harrowing of Hell; The Resurrection; *Noli me Tangere*. North aisle piers: scrolls under capitals.

Hook Norton, St Peter – nave, east wall, above the chancel arch: St Peter and St Paul with censing angels (originally adoring a Rood). Nave, south arcade: fragment of The Seven Deadly Sins (dragon emerging from Hell Mouth).

Horley, St Etheldreda – north wall: large St Christopher with inscription

(church transcription: 'What art thou and art so young? Bore I never so heavy a thing. Yea I be heavy, no wonder this, for I am the King of Bliss.'); indecipherable figure scene. Tower arch, north side: imitation drapery patterning in circles enclosing lower case 't'. Nave pier, west end: St Zita holding a rosary surrounded by household implements.

Hornton, St John Baptist – nave, east wall, north side: traces of Pieta as altar; east wall, south side: standing St George; east wall, above the chancel arch: Doom with a Throne of Mercy Trinity.

Kelmscott, St George – north arcade: patterning. North chapel, north wall, above window: Abbreviated Doom; window splay, north side: supplicating donor figure (?); The Expulsion of Adam and Eve; north wall, east side: The Visitation; east wall: indistinct scenes from the Holy Infancy including The Presentation in the Temple; west wall: story of Cain and Abel under trefoiled headed arcades with heads in spandrels, including the Murder of Abel; and the Conviction of Cain.

Kidlington, St Mary – north transept, east wall: St Margaret in fictive niche slaying dragon; fragmentary female Saints; painted image canopy.

Kirtlington, St Mary – north wall: St Christopher; St George.

North Leigh, St Mary – nave, east wall, above chancel screen: Doom

Northmoor, St Denis – north transept, north wall, tomb recess: faint outlines of an angel with a soul in a napkin with similarly faint, resurrected Christ on the adjacent west wall.

Also close by: Stanton Harcourt, St Michael – chancel, north wall: small amount of heraldry above the tomb of Maud de Grey.

North Stoke, St Mary – most scenes very faded. North wall: west to east, The Three Living and The Three Dead; upper tier, The Trial and Martyrdom (stoning) of St Stephen; lower tier, The Martyrdom of St Katherine; The Martyrdom of St Laurence. Nave, east wall, north side (behind pulpit): The Martyrdom of St Thomas Becket; nave, east wall, above the chancel arch: fragmentary Doom. Nave, south wall: three-tier Passion cycle; lower tier, The Last Supper; The Betrayal; middle tier, Christ before Pilate or Herod; The Flagellation; upper tier, The Deposition; over south door: St Christopher (?); window splays: faint St John the Baptist; upright winged dragon.

Oxford, Christ Church Cathedral (in Christ Church College) – Lady Chapel vault: fragmentary remains of angels swinging censers above the former site of the tomb of Lady Elizabeth Montacute who gave land to the

church in 1346. Chapter house (now shop) vault: repainted masonry pattern with roundels of an angel and saints, including St Peter and St Paul.

Piddington, St Nicholas – north wall: St Christopher.

Shorthampton, All Saints – north wall: window splay: remains of an unidentified figure; thereafter, masonry pattern; St Anne, *The Education of the Virgin*; unidentified bishop. Nave, east wall, above the chancel arch: fragmentary Doom extending to adjacent south wall with sinners in a large cauldron. Nave, east wall, south side respond: The Virgin and Child with a bird and the outline of a kneeling donor. Nave, east wall, south side: fragments of a largely indecipherable Passion sequence with drops of blood. Nave, south wall, window splay: St Zita; south wall: The Miracle of St Eligius (Eloi). West wall: St George (only dragon's wing visible).

South Leigh, St James – nave, north wall: west to east, The Seven Deadly Sins emerging from Hell Mouth; St Clement with anchor. Nave, east wall, above the chancel arch: Doom extending to nave walls (all repainted). Chancel: east wall, south side: The Annunciation Virgin. Nave, south wall: The Weighing of Souls, repainted 1872, traces of the original scheme visible below the Victorian overpainted copy.

South Newington, St Peter ad Vincula – north aisle: The Martyrdom of St Thomas Becket; The Execution of Thomas of Lancaster; window splay: upper scene, The Annunciation; lower scene, St James the Great with donor (Thomas Gifford); The Virgin and Child with donors (Thomas Gifford and his wife, Margaret Mortayne). East wall, window splay: St Margaret slaying dragon; patterning. Nave, east wall, above the chancel arch: fragmentary Doom. Nave, north arcade: west to east, damaged Passion cycle, The Entry into Jerusalem; The Agony in the Garden; The Flagellation; Christ Carrying the Cross; The Crucifixion; The Resurrection; in spandrels; 'Trinity Trees' with Shields of the Passion; also on the same wall at the eastern end: The Weighing of Souls; heraldry.

Swalcliffe, St Peter and St Paul – south aisle: The Weighing of Souls.

Thame, St Mary – tower, south east pier: upper half of The Pieta in a fictive niche with figure of the Virgin Mary weeping tears of blood.

Widford, St Oswald – nave, north wall: St Christopher. Chancel, north wall: The Three Living and The Three Dead with kings of different ages; north wall, window splays: unidentified saints. East wall; image silhouette. South wall: two tiers of an indecipherable scheme.

Wood Eaton, Holy Rood – north wall: St Christopher (head repainted)

holding scroll once inscribed '*Ki cest image verra le jur de mal mort ne murra*' (Who sees this image shall not die an ill death this day). South wall: masonry pattern with fictive quoins, scrollwork around south door. There is also a painted text on the Rood beam *Venite benedicte patris mea ite maledicte in ignem internam.*

Yarnton, St Bartholomew – nave, east wall, above the chancel arch: fragmentary Passion scenes.

Rutland

Braunston, All Saints – south aisle, east wall: part of an altar reredos with a fictive canopy flanked by angels above a stone image bracket. South wall: remains of a painting of an altar with candlesticks and a processional cross.

Empingham, St Peter – north transept, east wall: slight remains of The Annunciation; The Visitation. South transept, south wall window splay: The Virgin Mary; patterning.

Little Casterton, All Saints – south wall: indecipherable scenes. West wall, window splays: faint figures of *Ecclesia* and *Synagoga*.

Also close by: Great Casterton, St Peter and St Paul – north aisle, north and east walls: masonry pattern.

Lyddington, St Andrew – nave, east wall, north side: king holding an orb or ring. South arcade, adjacent to nave east wall: Hell Mouth once part of a larger Doom scheme.

Stoke Dry, St Andrew – chancel, east wall: The Martyrdom of St Andrew with donor; The Virgin and Child. South chapel, south wall: east to west, window splay, The Martyrdom of St Margaret; thereafter, The Martyrdom of St Edmund; St Christopher.

Shropshire

Alveley, St Mary – south wall: The Seven Deadly Sins with dragons emerging from Pride speared by Death.

Claverley, All Saints – north wall piers: white masonry pattern; The Annunciation. North arcade spandrels: four scenes from The Martyrdom of St Margaret. North wall arcade: unique scheme of battling knights, (subject unidentified); north wall clerestory; figures of saints between windows. South

wall: angel and stylized tree, possibly The Legend of the True Cross. Tower, ground floor, east wall: seraph; nave, west wall: Consecration Crosses.

Edstaston, St Mary – north wall: fragmentary St Christopher; The Adoration of the Magi; Consecration Crosses.

Heath Chapel – north wall: fragmentary St George. Nave, east wall: south side, white line masonry pattern.

Leebotwood, St Mary – north wall: lower fragment of The Adoration of the Magi.

Upton Cresset, St Michael – south chapel, west wall: angel and foliage decoration similar to the style of Claverley (Shrops).

Tong, St Bartholomew – Golden Chapel, east wall: faint Crucifixion with donor (Vernon family); inscription below; painted image niche above adjoining tomb.

Somerset

Cameley, St James – north wall: St Christopher (only fish and crab visible); masonry pattern with reddish brown blocks and white pointing; fictive textile; remains of a indecipherable scene with armour and horse (St George?). Chancel arch, inner wall, north side: heraldry, arms of England; south side: arms of de Clare, Earls of Gloucester.

Cleeve Abbey – sacristry: masonry pattern with rosettes; decorated piscina. Library: masonry pattern. Chapter house: masonry pattern. The Painted Chamber: allegorical painting. In the care of English Heritage. Check opening times. Admission charge.

Ditcheat, St Mary Magdalene – north wall: St Christopher, heavily repainted in modern colours.

Farleigh Hungerford Castle – St Anne's Chapel, east wall: south side: standing St George fighting dragon adored by the fragmentary remains of a donor on the adjoining south wall. In the care of English Heritage. Check opening times. Admission charge.

Martock, The Treasurer's House – upstairs room, former Solar of the Treasurer of Wells Cathedral: The Crucifixion. In the care of The National Trust. Check opening times. Admission fee.

Figure 242
Fragment of Apocalypse painting
from Coventry Cathedral Priory: 30
by 20 cm (11 inches by 7 inches); c.
1360–70.

Marston Magna, St Mary – Lady Chapel, north wall: The Martyrdom of St Thomas Becket; window splay: Apostles (St Paul? and others) adjacent to a highly carved image niche; fictive image niche.

Muchelney Abbey – chamber over south cloister walk: fictive drapery with pomegranate pattern. In the care of English Heritage. Check opening times. Admission charge.

South Cadbury, St Thomas Becket – south aisle, window splay: unidentified bishop.

Sutton Bingham, All Saints – nave, north wall: upper part of Crucified Christ; large Death of the Virgin. Chancel, much patterning throughout, north wall: The Coronation of the Virgin; unidentified saint; Consecration Cross; window splays: bishop saint and unknown female saint; east wall, bishop saint in window splay; south wall; kneeling figure; window splays: bishop saint and female saint (St Margaret?); unknown saint between window; unidentified figure at west end. Nave, south wall: Consecration Crosses.

Wedmore, St Mary Magdalene – tower arch, north return: St Christopher with ships and mermaid. Overpainted on an earlier scheme.

Wellow, St Julian – Hungerford Chantry Chapel, east wall: Christ (in centre above window) with Apostles carrying their attributes and including St Simon with a saw; St Andrew with a book; St Peter with keys; St Bartholomew with a knife; St James the Great with a pilgrim's staff; St Paul with a sword; St John the Evangelist with a cup; St Matthew holding a mason's T square; St Mathias with a battle-axe; St Thomas with a spear; St James the Less with a club; St Philip with three loaves of bread.

Staffordshire

Alton, St Peter – north wall: remains of The Three Living and The Three Dead.

Clifton Campville, St Andrew – south aisle, tomb recess: The Coronation of the Virgin with donors. Heraldic shields superimposed later.

Lichfield Cathedral – chapter house, west wall: The Assumption of the Virgin. South choir aisle, east wall, piscina: Crucifixion. South wall: angels with fragmentary Trinity above a tomb.

Suffolk

Alpheton, St Peter and St Paul – north wall: faded St Christopher. Nave, east wall: painted image niche. South wall: painted image niche with silhouette.

Bacton, St Mary – nave, east wall, above the chancel arch: Doom fragments with sinners and texts, also St Peter wearing Papal tiara.

Bardwell, St Peter and St Paul – north wall: fragment of The Deposition. South wall: fragment of The Martyrdom of St Katherine showing the Philosophers who were martyred after being converted by her.

Barnby, St John Baptist – south wall: The Crucifixion with two thieves; top half of Tree of The Seven Works of Mercy: faded St Christopher. North wall: The Annunciation.

Boxford, St Mary – south aisle, east wall: St Edmund holding arrow; two painted image niches, one with silhouette.

Bradfield Combust, All Saints – north wall: mounted St George with plumed helmet; St Christopher with hermit, fisherman, and sprouting staff.

Bramfield, St Andrew – north wall recess: angels adoring (now lost wooden) cross. Formerly included textual scrolls with words from the hymn *Gloria in Excelsis Deo* (Glory to God in the highest).

Brent Eleigh, St Mary – chancel, east wall: north side, censing angels adoring now lost statue of the Virgin and Child; centre, Crucifixion reredos; south side; earlier painting of the Harrowing of Hell with tonsured priest donor and inscribed +RICA[rdus], possibly the cellarer of St Oswyth's Priory which owned the living of the church.

Cavenham, St Andrew – north wall: small scene of St Walstan holding scythe with angel and people.

Chelsworth, All Saints – nave, east wall, above the chancel arch: Doom.

Cowlinge, St Margaret – nave, east wall, either side of the chancel arch: The Weighing of Souls. South wall: unidentified saint.

Creeting St Peter, St Peter – north wall: upper half of St Christopher together with a long scroll.

Dalham, St Mary – north wall: Tree of The Seven Deadly Sins with dragons;

indistinct scene of the Seven Works of Mercy around an angel. Nave, east wall, around chancel arch: lower third of unidentified figures. Stencilled crowned Ms.

Earl Stonham, St Mary – nave, east wall, above the chancel arch: Doom with angels carrying Instruments of the Passion. South transept, west wall: large fragment of St George with royal family watching from castle battlements; framed drawing of a now lost painting, formerly of The Martyrdom of St Thomas Becket, which was transposed into The Martyrdom of St Katherine after the Archbishop had been denounced by Henry VIII.

East Bergholt, St Mary – chancel, north wall recess: Resurrection scene in Easter Sepulchre.

Framlingham, St Michael – north arcade: The Trinity.

Gisleham, Holy Trinity – north wall, window splays: The Annunciation; angel with an unidentified saint.

Great Livermere, St Peter – north wall: two figures; Consecration Cross.

Grundisburgh, St Mary – north wall: St Christopher with text and mermaid; indistinct figures above a door (possibly part of a Passion cycle). South wall: Warning to Janglers with a woman surrounded by fragments of illegible text and a demon/devil's wing.

Hessett, St Ethelbert – north wall: indistinct St Christopher with two donors (?); Tree of The Seven Deadly Sins with demons; Sunday Christ. South wall: St Barbara with her attribute of a tower; Consecration Cross with scorch marks; The Weighing of Souls above south door.

Hoxne, St Peter and St Paul – north arcade: west to east, St Christopher with hermit; Tree of The Seven Deadly Sins with dragons and Pride at the apex; two-tier scheme of The Seven Works of Mercy; indistinct Doom.

Huntingfield, St Mary – chancel, north wall: faint resurrected Christ in apex above tomb recess, probably used for Easter Sepulchre.

Ickworth, St Mary – chancel, east wall: south side, Annunciation angel. In the park of Ickworth House, a property in the care of the National Trust. Check opening times. Admission charge. Check in advance if the chapel is open.

Ilketshall St Andrew, St Andrew – north wall: Romanesque fragment of an unknown subject showing the interior of a church with altar, chalice

and font. South wall: female figure(s) in an arcade with angels above and grotesques below; Wheel of Fortune with figures and inscription REGNO [I rule]; traces of a Doom with souls emerging from coffins.

Kentford, St Mary – north wall: faint St Christopher; The Three Living and The Three Dead.

Kersey, St Mary – north wall: angel; fragmentary St George.

Lakenheath, St Mary – north aisle: large figure of Christ; north arcade pier: fictive textile with hooks and fringe and scrolls and a bird above; superimposed St Edmund with arrows; superimposed and difficult to disentangle Passion cycle painted over scrollwork, including The Flagellation; Christ Carrying the Cross; The Angel at the Tomb; north arcade spandrels: angels.

Little Wenham, All Saints – north wall: large Virgin and Child. Chancel, east wall, north side: The Virgin and Child under an elaborate canopy adored by two saints; east wall, south side: three saints under canopies, St Margaret with staff; St Katherine with wheel; St Mary Magdalene with her jar of ointment.

Long Melford, Holy Trinity – Clopton Chapel: painted text in coving. Chancel, north side: Clopton Tomb tester, Christ with donors and inscription.

Martlesham, St Mary – north wall: upper half of St Christopher.

Naughton, St Mary – north wall, west to east: Warning to Janglers; upper half of St Christopher.

Newton Green, All Saints – north wall: scenes from the Holy Infancy, including The Annunciation; The Visitation; The Nativity.

North Cove, St Botolph – chancel, north wall: high up near the beginning of the Passion cycle, a woman emerging from a coffin; Passion cycle in three tiers, including: upper tier, The Last Supper; middle tier, The Entry into Jerusalem; The Betrayal; The Flagellation; lower tier, Christ Carrying the Cross with a tormentor sticking his tongue out and carrying a whip with 'tails'; Christ being Nailed to the Cross: The Crucifixion with executioners in striped clothing; upper tier, The Resurrection; The Harrowing of Hell; scheme continuing onto the south wall. South wall, east end: The Ascension; Thereafter, Doom with the Virgin baring her breasts to Christ and St Michael driving sinners into Hell.

Figure 243
Scenes from the martyrdom of an
unidentified saint: Bloxham, St
Mary, *c.* 1500

Ringshall, St Katherine – nave, south wall, just below the wall plate: fragmentary remains of scenes from The Seven Works of Mercy.

Risby, St Giles – north wall, west to east: bishop bestowing blessing; *Noli me Tangere*; thereafter, two separate schemes divided by strong borders: upper tier, Holy Infancy cycle including The Appearance of the Angels to the Shepherds; The Massacre of the Innocents; The Flight into Egypt; lower tier, very faded scenes from The Miracles of the Virgin including The Miracle of Theophilus with the Virgin wresting his bond from the devil.

Shadingfield, St John Baptist – nave, south wall: slight remains of a Passion cycle, The Flagellation.

Stanningfield, St Nicholas – nave, east wall, above the chancel arch: Doom with illegible text.

Stoke-by-Clare, St John the Baptist – north chapel, east wall: Counter-Reformation Doom.

Stowlangtoft, St George – north wall: very damaged St Christopher. Also painted *celure* above the Rood.

Stradishall, St Margaret – north wall: St Christopher.

Troston, St Mary – north wall: large St George; St Christopher; St George (again); The Martyrdom of St Edmund; Consecration Cross.

Thornham Parva, St Mary – north wall: east to west, five scenes from the Martyrdom and Miracles of St Edmund. South wall: west to east, five of at least six scenes of The Holy Infancy, some faded and damaged by the insertion of a window: The Visitation; The Nativity; The Appearance of the Angel to the Shepherds; The Adoration of the Magi; The Presentation in the Temple; masonry pattern; Consecration Crosses and decorative border. For comparisons with panel paintings, see also: the Thornham Parva Retable in the chancel.

Westhall, St Andrew – north wall: St Christopher in canopied frame; 'horned' Moses scenes including God with tablets. South wall: medallion framing; fictive niche; foliate Consecration Cross.

Wilby, St Mary – north wall; St Christopher with eels and fish.

Wissington/Wiston, St Mary – north wall, west to east: Consecration Cross; Dragon of St George; above north door, Warning to Janglers; thereafter, a three-tier scheme: top tier, entirely lost except for the final scene at the east

end, St Francis's sermon to the birds; middle tier, seven-scene Passion of Christ cycle, mostly unclear: The Last Supper; Christ washing Feet; The Crucifixion; The Entombment; are discernible; bottom tier, indecipherable. South wall: upper tier, east to west, Holy Infancy cycle including The Annunciation; The Nativity; The Appearance of the Angel to the Shepherds; The Adoration of the Shepherds; The Adoration of the Magi; The Dream of the Magi (Three Kings in a bed as an Angel appears); fragmentary Massacre of the Innocents; other remnants; lower tier, Miracle of St Nicholas and the Three Boys; Miracle of St Nicholas and the Cup; St Margaret spinning. West wall: faint Doom (now behind galleries).

Yaxley, St Mary – nave, east wall, above the chancel arch: Doom with Hell Mouth scene only.

Surrey

Albury, St Peter and St Paul (in Albury Park) – south wall: upper half of St Christopher with a ship.

Byfleet, St Mary – north wall: seated nobleman on 'throne' above north door; masonry pattern; Consecration Cross.

Caterham, St Lawrence – nave, east wall, above the chancel arch: censing angel either side.

Chaldon, St Peter and St Paul – west wall: large 'Ladder of Salvation' scheme including, in the upper tier, St Michael Weighing Souls; Angel with the Three Marys; Angel greeting the Saved; The Harrowing of Hell; lower tier, sinners in a cauldron; Bridge of spikes; The Seven Deadly Sins in torment; demons torturing sinners; wild animals attacking sinners; Consecration Cross.

Charlwood, St Nicholas – south wall: six scenes from The Martyrdom of St Margaret; The Miracle of St Nicholas and the Three Boys; The Three Living and the Three Dead with the kings riding horses; The Martyrdom of St Edmund.

Compton, St Nicholas – nave, east wall, above the chancel arch: lozenge pattern fictive cloth of honour textile behind the Rood.

Godalming, St Peter and St Paul – south chapel, east wall, blocked window splay: head of a male saint; South wall, blocked window splay: St John the Baptist with *Agnus Dei*; patterning.

Pyrford, St Nicholas – north wall: Romanesque paintings of unidentified

scenes including a mounted horseman (blowing a horn?) and the outline of a ship (?). South wall: similar unidentified scenes as on north wall, including figures with staves queuing for a ship and mounted horsemen fighting with lances; later overlapping Passion scenes with only The Flagellation visible; Consecration Cross. West wall: Consecration Cross.

Sanderstead, All Saints – chancel, east wall: St Edmund holding arrows; unidentified bishop administering blessing.

Stoke D'Abernon, St Mary – chancel, east wall, south side: four tiers, top to bottom, angel; angel blowing trumpet; crowd of figures; figure playing harp (King David?). All part of a now mainly lost scheme which once dominated the east wall. Chancel, south wall: masonry pattern with rosettes.

Warlingham, All Saints – north wall: St Christopher.

Witley, All Saints – nave, south wall: Romanesque sequences in three tiers divided by borders which once included textural inscriptions, upper tier, subjects unclear; middle tier, The Three Marys at the Sepulchre; Christ appearing to the Marys; The Three Marys watching at the Sepulchre; The Harrowing of Hell; lower tier, post-Resurrection miracles; Christ commanding St Peter, 'Feed my Sheep'; Christ appearing to St Peter at Lake Tiberias; Consecration Cross painted on raised plaster. West wall: unidentified scenes with Christ and saints in lower register.

Warwickshire

Burton Dassett, All Saints (church in country park) – north transept, north window splays: two kings; king with cup; decorative patterning. Nave, east wall, above the chancel arch: Rood scene of The Crucifixion with angels carrying Instruments of the Passion; also, faint traces of much faded Passion scenes (possibly linked to a similar scheme at Ashby St Ledgers, Northants).

Coventry, St Anne's Charterhouse – first floor room, formerly part of the monastic refectory: lower half of large Crucifixion with donor heraldry carried by soldier; large flanking figure of St Anne. In the ownership of Coventry City Council. Check opening times.

Coventry, Holy Trinity – nave, east wall, above the chancel arch: very fine Doom.

Coventry, St Mary's Priory Visitors Centre – gallery display: small fragment of high-quality paintings of The Apocalypse recovered from excavations of the demolished priory chapterhouse.

Packwood, St Giles – nave, east wall, either side of the chancel arch: The Three Living and The Three Dead.

Stratford-upon-Avon, Guild Chapel – north wall, west end: faded St Morwenna in niche; very damaged remains of Dance of Death behind nave panelling, which are not accessible. Nave, east wall, above the chancel arch: combined Doom with silhouette of The Rood. West wall, south side: faint Martyrdom of St Thomas Becket; remains of 'Earthe to Earthe' painting behind the south side panelling which are normally inaccessible; north side: faint traces of St George.

Wootton Wawen, St Peter – south chapel, east wall: The Coronation of the Virgin; possibly St Anne, *The Education of the Virgin*; south wall: mostly indecipherable scenes within two tiers of quatrefoils, but including scenes from The Martyrdom of St Katherine to the left of the Somervile monument; The Seven Deadly Sins to the right of the Henry Knight monument; extensive rosette patterning.

Wyken, St James – nave, north wall: upper half of St Christopher with windmill.

West Sussex

Amberley, St Michael – nave, east wall, south side, bottom to top: The Crucifixion; The Flagellation; Christ carrying the Cross; The Resurrection; Post-Resurrection scenes; Christ in Majesty. South aisle: fragment of The Visitation; Consecration Crosses.

Arundel, St Nicholas Priory – north aisle: The Seven Deadly Sins arranged around a man; The Seven Works of Mercy within a wheel; The Coronation of the Virgin; Consecration Crosses. South wall: Consecration Cross.

Binsted, St Mary – chancel, north wall, window splays: St Margaret of Antioch; stylised tree.

Boxgrove Priory – nave vaulting: foliage and heraldry by Lambert Bernard. South transept, south wall: indistinct remains of a figure said to be St George.

Burton, Church – north wall, window splay: saint crucified upside down, possibly St Uncumber.

Chichester Cathedral – The Treasury (formerly Chapel of the Four Virgins), south wall: west end, upper tier, lower half of three figures below ornate

border; lower tier enthroned bishop (?). South nave aisle and Lady Chapel Vaults: delicate foliage and heraldry by Lambert Bernard.

Chichester, Bishop's Palace – Palace Chapel, south wall: roundel of Virgin and Child. Applications to view this painting must be made in writing to: The Chaplain, The Bishop's Palace, Canon Lane, Chichester, PO19 1PY.

Cocking, Church – south arcade, window splay: Romanesque painting of The Appearance of the Angel to the Shepherds.

Coombes, Church – Lewes Group. south wall: Holy Infancy cycle, beginning west to east and continuing on the north wall, two tiers with many scenes missing and some with illegible white Lombardic inscriptions: upper tier, The Annunciation; The Visitation; Joseph's Dream; lower tier, indecipherable. North wall, upper tier, continuation of the Holy Infancy cycle, including The Nativity; The Flight into Egypt; lower tier, seated figure possibly Herod; also St Christopher and indistinct scenes. Nave, east wall, north side: Christ giving Keys to St Peter and the Book of Law to St Paul (*The Traditio Legis*); Evangelist symbol (Lion of St Mark); nave, east wall, above the chancel arch: Christ in a mandorla held by angels. Chancel arch soffit, north side: Strongman supporting beam; hachette or double axe head decoration. Chancel walls: masonry pattern; chancel, east window splay: Annunciation Virgin.

Also close by: Botolph, St Botolph – nave, east wall, north side: a bishop's mitre; nave, east wall, above the chancel arch: unidentified figure.

Ford, St Andrew – nave, east wall, above the chancel arch: fragmentary Doom with soul emerging from a grave and some devils. Nave, south wall: remains of a Passion cycle, window splay; The Agony in the Garden; thereafter, south wall: The Betrayal.

Hardham, St Botolph – Lewes Group. Nave, north wall: upper tier, west to east, continuing a Holy Infancy cycle (originally fifteen scenes) begun on the east wall, The Adoration of the Magi; The Dream of Joseph; The Dream of the Magi; The Flight into Egypt; The Fall of the Idols; The Massacre of the Innocents; lost scene (possibly The Presentation in the Temple); lower tier, St George fighting the Infidels; St George seized by torturers; The Torture of St George; St George on the Wheel; lost scene (the beheading of St George?); nave, east wall, north side: upper tier, The Dispute with the Doctors; lower tier, (The Burial of St George?). Nave, east wall, above the chancel arch: Agnus Dei with censing angels; east wall, south side: upper tier, The Annunciation; The Visitation with inscription reading, VIRGO SALUTATUR STERILIS FECUNDA PROBATUR; lower tier, remains of The Labours of the Month (the original scheme would have followed the

rise and fall of the arch); The Baptism of Christ. South wall: upper tier, The Nativity; The Appearance of the Angel to the Shepherds; unidentified scene; The Journey of the Magi; Herod ordering The Massacre of the Innocents; lower tier, The Feast of Dives; The Soul of Lazarus carried to Heaven by angels; Abraham with Lazarus's soul; The Death of Dives. West wall: Hell scenes including, on the north side, lower tier, Sinners in a cauldron. Chancel, north wall: originally part of a scheme culminating in an image of Christ in Majesty in the centre of the east wall. Upper tier, Apostles; Elders of the Apocalypse; lower tier, continuation of a Passion cycle begun on the south wall, The Last Supper; The Betrayal; east wall: upper tier, Elders of The Apocalypse; a Censing angel; Elders of the Apocalypse; lower tier, The Flagellation; The Entombment (?); south wall: upper tier, Elders of the Apocalypse; Apostles; lower tier, The Three Marys at the Sepulchre; Christ washing Feet; west wall, south side: upper tier, The Temptation of Adam and Eve; lower tier, Adam and Eve in water, possibly either in penance or to abate lust; west wall, north side: upper tier, The Labours of Adam and Eve with Eve milking a cow (a unique scheme: Eve is usually shown spinning); lower tier, Adam and Eve hiding their nakedness.

North Stoke, Church – nave, east wall: floral patterning; two painted image niches.

Trotton, St George – north wall: helmeted figures with heraldry. South wall: Camoys donor family; heraldry; faint St Christopher. West wall: unique painting of Christ in Judgement with Moses holding The Ten Commandments above scenes of The Seven Deadly Sins emerging from dragons encircling a naked man and The Seven Works of Mercy in medallions surrounding a good man; later heraldry on lower north side.

West Chiltington, St Mary – north wall; upper tiers, Holy Infancy cycle, The Annunciation; The Visitation; The Nativity; The Appearance of the Angel to the Shepherds; lower tier, subject unclear, perhaps scenes of the Death of the Virgin. Nave, north window splay: The Sunday Christ. North wall: St Christopher. South aisle, east wall: knotted rope Cross in medallion. South arch soffit: censing angels and Apostles. South arcade, north side: Passion cycle, The Entry into Jerusalem; The Last Supper; Christ washing Feet; The Betrayal; The Flagellation; Christ Carrying the Cross; The Crucifixion; The Angel at the Tomb; The Resurrection.

Wisborough Green, St Peter ad Vincula – nave, east wall: south side, upper painting, Christ and St James the Great welcoming pilgrims; lower scene, unusual painting of The Crucified Christ and the two thieves sharing the same cross.

Wiltshire

Bradford-on-Avon, Holy Trinity – chancel, east wall: St Anne, *The Education of the Virgin*.

Durnford, St Andrew – north wall: strawberry patterning; extremely faint St Christopher. Nave, east wall above the chancel arch: floral pattern. Chancel: masonry pattern with sprigs. Nave, south wall: fictive canopy in window splay; floral pattern.

Great Chalfield, All Saints – Tropnell Chapel, west wall: six scenes of The Martyrdom of St Katherine, mostly indecipherable. Consecration Crosses.

Imber, St Giles – nave, north aisle: fragment of The Seven Deadly sins (Avarice); The Weighing of Souls. Nave arcade: leaf and vine scroll patterning. The Church lies on Ministry of Defence land. Now in the care of The Churches Conservation Trust. Contact The CCT for access details.

Inglesham, St John Baptist – atmospheric jumble of paintings in different layers. North chapel, east wall: female figure. Nave, east wall, above the chancel arch: censing angels either side. Nave, east wall, south side: fictive image canopy. Chancel, north wall: masonry pattern; Consecration Cross. East wall: dado height fictive striped textile behind altar; Consecration Cross; patterning; fragment of painted sculpture from a reredos?; south wall: masonry pattern.

Laycock Abbey, Nunnery buildings – chaplain's room, north wall: The Martyrdom of St Andrew; St Christopher; east wall: The Crucified Christ. The sacristy: decoration on east vault. North cloister walk: unidentified bishop blessing Agnes Frary, Abbess 1429–1445. In the care of The National Trust. Check opening times. Admission charge.

Lydiard Tregoze, St Mary – nave, north arcade: knight from The Martyrdom of St Thomas Becket; hermit and background from St Christopher. Nave, east wall, above the chancel arch: Rood cross with heads. Nave, south arcade: north side, patterning; The Weighing of Souls with the Virgin Mary interceding; nave, west end pier: Christ as Man of Sorrows. South porch, south wall: The head of Christ. The church is within a park owned by the local authority.

Oaksey, All Saints – south aisle, south wall: St Christopher with mermaid; very damaged Christ as Man of Sorrows perhaps surrounded by The Seven Deadly Sins or Warning to Blasphemers; upper part of Sunday Christ (transposed from an earlier image). West wall: masonry pattern.

Purton, St Mary – nave, over east end crossing arch: *Noli me Tangere*; angels playing musical instruments; The Weighing of Souls. Nave, south wall: upper half of Sunday Christ with St Peter above wearing papal tiara and receiving souls. South transept, south wall: The Death of the Virgin; south transept, east arch: indecipherable scenes.

Salisbury Cathedral – north-east transept, St Martin's Chapel, east wall: traces of a retable with The Crucifixion. Nave vaults and clerestory: patches of masonry pattern, mostly overpainted. Choir vault: nineteenth-century repainting of original scheme, Christ in Majesty within a vesica; Evangelists; Prophets; Patriarchs; Apostles and Sibyls holding scrolls. Presbytery vaults: repainted Labours of the Month. Chapter house vestibule, vault: original foliage decoration. The cloisters, north walk: traces of figures; heraldry of Lovell.

Salisbury, St Thomas – nave, east wall, above the chancel arch: extensive Doom (repainted). South aisle, Lady Chapel, north wall: Holy Infancy scenes, The Annunciation; The Visitation; The Adoration of the Magi; heraldic Garter badges and pots of lilies.

Wanborough, St Andrew – north aisle, north wall: fragment of Passion cycle, The Entry into Jerusalem.

West Harnham, St George – nave, east wall, south side: *Noli me Tangere*.

Worcestershire

Belbroughton, Holy Trinity – Lady Chapel, north wall: female saint in elaborate fictive canopy.

Kyre Wyard, St Mary (in Kyre Park) – Lady Chapel, south wall, window splay: female saint.

Martley, St Peter – nave, north wall: main scene is unclear with suggestions of St Martin or The Entry into Jerusalem; The Adoration of the Magi; The Incredulity of St Thomas and the Ascension Of Christ. Chancel, north wall: extensive 'stone and roses' masonry pattern with diminishing perspective in window splays. East wall, north side: elaborate fictive canopy; dado level fictive drapery behind alter 'hung' in swags with a fox, hare, stag and fabulous winged beasts including fire-breathing dragons. South wall, window splay: heraldry of Teme family; south wall: The Annunciation; unknown figure below.

Pinvin, St Nicholas – south wall: scenes from The Life of Christ in two

Opposite
Figure 244
St Christopher: Willingham, St Mary and All Saints, *c.* 1400.

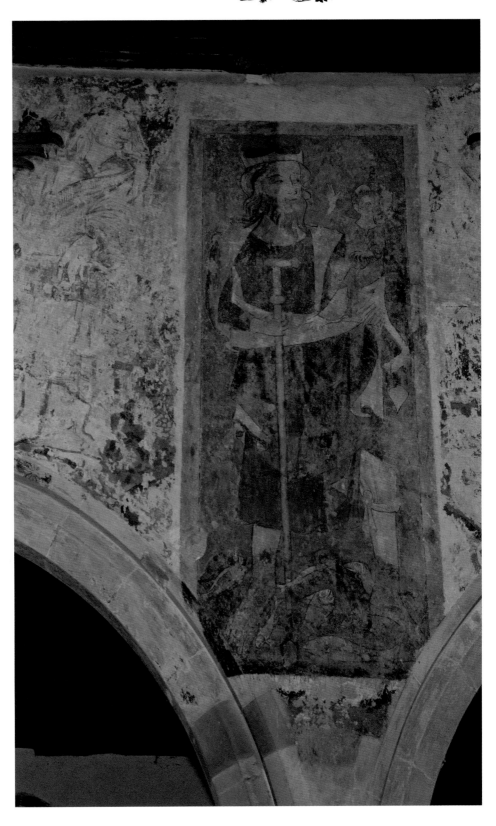

tiers, upper tier, east to west, remains of The Annunciation (the Lily pot); The Visitation (lower part of dresses); Lost scene (the Nativity?); lower tier, The Adoration of the Magi; The Crucifixion; The Resurrection; The Ascension; St Roche with an angel pointing to his leg painted over parts of the previous painting. Further west on the same wall: remains of St Christopher below post-Reformation text.

Romsley, St Kenelm – north wall, east end: unknown youth. (The church once had an extended cycle of paintings chronicling the Life of St Kenelm.)

Wickhamford, St John Baptist – chancel, east wall, south side: The Virgin and Child.

Worcester Cathedral – Lady Chapel, north wall: faded heraldic shields; nave: traces of painted decoration on piers. Crypt, south-west bay: two lunettes with bishops, western pair with inscription for St Thomas Becket, the other St Peter (?); south-east corner, masonry pattern. Chapter house, north-west quadrant: drapery and remains of angels holding books behind monk's seats; faint remains of The Tree of Jesse on the central pier.

Worcester, The Commandery – The Painted Chamber, north wall: The Weighing of Souls; St Godwall, a local saint and patron saint of the Commandery Chapel; St Etheldreda. South wall: upper tier, St Roche with angel pointing to his plague boil; The Martyrdom of St Erasmus; St Peter; lower tier, St Anne, *The Education of the Virgin*; The Martyrdom of St Thomas Becket. Ceiling: Trinity with inscriptions, 'Jesu merci' and ' Lady Helpe'; shield with Passion wounds; shield of See of Worcester; stencilled background.

Yorkshire

Bedale, St Gregory – north aisle, north wall: mounted St George and dragon. Nave, east wall, above the chancel arch: south side, censing angel. Chancel, east wall, over east window: heraldry. All scenes heavily repainted.

Easby (near Richmond), St Agatha – chancel, north wall: upper tier, Old Testament scenes, The Making of Eve; The Garden of Eden; The Temptation and Expulsion of Adam and Eve; The Labours of Adam and Eve; north wall, window splays: four scenes from originally twelve Labours of the Month. South wall: upper tier, east to west, Holy Infancy scenes, The Annunciation; The Appearance of the Angel to the Shepherds; The Adoration of the Magi; lower tier, Passion scenes, east to west: The Flagellation (unrestored); The Deposition; The Entombment; The Three Marys at the Sepulchre; all heavily restored. Sedilia: Three Archbishops on back wall. Nave, south arcade: chevron pattern on arcade arches.

Fountains Abbey – south transept, east wall: Cistercian white masonry pattern. Lay brothers' refectory, south wall: white masonry pattern. Cloister, west side, above door to Cellarer's parlour: white fish scale pattern on jamb.

Kirkstall Abbey – chapter house, north wall: Cistercian white masonry pattern.

Pickering, St Peter and St Paul – nave, north arcade: west to east, St George and the dragon; St Christopher; The Decollation of St John Baptist with Salome dancing; The Martyrdom of St Edmund; The Martyrdom of St Thomas Becket; The Coronation of the Virgin (above St John the Baptist). Nave, south arcade: three scenes, The Death of the Virgin; The Funeral of the Virgin; and an indecipherable scene, probably The Ascension or Assumption of the Virgin; The Martyrdom of St Katherine in nine scenes; The Seven Works of Mercy in scenes; The Passion of Christ in a nine-scene scheme, The Betrayal; Christ before Pilate; The Flagellation; Christ Carrying the Cross; The Crucifixion; The Deposition; The Entombment; with The Harrowing of Hell and The Resurrection, shown in the spandrels. All repainted in the nineteenth century.

Ripon Cathedral – south transept, north wall (formerly part of a Lady Chapel, now a store room): scenes from the apocryphal Miracles of the Virgin, The Legend of Theophilus; The Virgin with Lilies.

Wensley, Holy Trinity – north wall: lower part of The Three Living and The Three Dead with earliest English inscription, '[AS] WE A[RE NOVE [THUS] SAL THE BE [B] WAR WYT (Beware with) ME'; The Martyrdom of unknown saint; unknown scene.

WALES

Bridgend

Newton, St John Baptist – north wall: either The Martyrdom of St Thomas Becket or the Decollation of St John the Baptist. South wall: The Weighing of Souls.

Denbighshire

Llangar, Church (near Corwen) – north wall: unidentified bishop in the doorway of a church; rustic framing for now lost (Passion?) cycle. South wall:

east to west, remains of The Seven Deadly Sins shown as figures (now lost) riding animals, lion (Pride); pig (Gluttony); goat (Lust); beyond south door, fragment of a mainly lost painting of St Christopher. Access, via Rug Chapel office. In the care of CADW. Check opening times. Admission charge.

Llanynys, St Saeran – north aisle, north wall: large St Christopher with windmill, hermit and assorted fish, including a swordfish.

Ruabon, St Mary – south aisle, south wall: five scenes of The Seven Works of Mercy shown as separate acts accompanied by angels; inscription in Welsh added in the 1870s.

Monmouthshire

Llangattock Lingoed, St Cadoc – south wall: mounted St George.

Llangybi (sometimes written Llangibby), St Cybi – north wall: The Weighing of Souls; Sunday Christ; Consecration Cross.

Pembrokeshire

St David's Cathedral – nave, south side, piers: king with sword; upper part of a fictive image niche. Nave, pulpitum (the stone screen separating the nave from the choir), central passage, north side: tomb of unknown cleric, including The Crucifixion above his head; unidentified scene at his feet; four Evangelist symbols on vaulting above him; west wall, above central arch of passage: owl and magpies.

Powys

Llanelieu, St Ellyw (from centre of Talgarth take narrow road beside the Town Hall for approximately two miles) – west wall: faded lower remains of The Temptation of Adam and Eve. Painted silhouette of the Rood on wooden boards.

Vale of Glamorgan

Cardiff, St Fagans, National History Museum (four miles west of Cardiff city centre) – Museum gallery: St Katherine and other figures from St Teilo church, Llandeilo Tal-y-bont; museum park: reconstructed St Teilo's with a recreated late medieval interior including a modern replica of the early-

sixteenth-century Passion cycle found in the church during its dismantlement prior to re-erection at St Fagans. Check opening times. Admission free. Other paintings recovered from the church may be seen by written appointment with the Senior Curator, St Fagans, National History Museum, Cardiff, CF5 6XB.

Also close by: The National Museum Wales, Cathays Park, Cardiff – other painting(s) from St Teilo's, including The Mocking of Christ, from the Passion cycle. Check opening times.

Colwinston, St Michael – nave, east wall, north side: upper tier, The Consecration of St Nicholas; lower tier, a Miracle of St Nicholas, the story of a child left in a bath over a fire by a forgetful mother who attended the service and returned to find her infant unharmed; painted image niches either side of the chancel arch.

Ewenny Priory – Presbytery, east wall: fragmentary remains of two schemes including the only surviving Romanesque painting in Wales. The original double line masonry pattern was embellished with flowers *c*. 1250. See also fictive voussoirs with bands of alternating colour and other patterning; fictive capitals for image niche and fictive drapery; painted vaulting. Nave, north arcade pier: faint remains of an unidentified figure.

Llantwit Major, St Illtud – west church, south wall: fictive drapery pattern. East church, nave, north arcade: St Christopher. Nave, east wall, over the chancel arch: fictive cloth of honour for the Rood. Chancel, north wall: St Mary Magdalene with her jar of ointment; unidentified female saint.

Llanmaes, St Cattwg – north wall: St George.

Wrexham

Wrexham, St Giles – nave, east wall, above the chancel arch: Doom.

OTHER SITES

In addition to the paintings listed in this book, medieval wall paintings can also be seen in some domestic properties:

Belsay Castle – Northumberland
Fiddleford Manor – near Sturminster Newton, Dorset
Longthorpe Tower – near Peterborough, Cambs
All in the care of English Heritage. Check opening times and admission fees.

CHANNEL ISLANDS

Jersey – Saint Brelade, The Fishermen's Chapel

Subject Guide

T his Guide lists where wall paintings of the main subjects can be seen. It is not a catalogue of every painting. It also includes brief summaries of the Lives and Martyrdoms of the most commonly depicted Saints.

THE OLD TESTAMENT

The Creation:

Bushmead Priory (near Bolnhurst) (Bedfordshire); Chalfont St Giles, St Giles (Buckinghamshire).

The Making of Eve:

Bushmead Priory (near Bolnhurst) (Bedfordshire); Easby, St Agatha (Yorkshire); Houghton-on-the-Hill, St Mary (Norfolk).

Below:
Souls shelter under the cloak of the Virgin Mary: Byford, St John the Baptist.

The Temptation and Fall:

Chalfont St Giles, St Giles (Buckinghamshire); Easby, St Agatha (Yorkshire); Hardham, St Botolph (West Sussex).

The Expulsion from Paradise:

Broughton, All Saints (Cambridgeshire); Chalfont St Giles, St Giles (Buckinghamshire); Easby, St Agatha (Yorkshire); Kelmscott, St George (Oxfordshire).

The Labours of Adam & Eve:

Bledlow, Holy Trinity (Buckinghamshire); Broughton, All Saints (Cambridgeshire); Easby, St Agatha (Yorkshire); Hardham, St Botolph (West Sussex). A later, apparently unrelated scene of the Labours appears at Rotherfield, St Denys (East Sussex).

The Murder of Abel:

Capel, St Thomas of Canterbury (Kent); Kelmscott, St George (Oxfordshire); West Kingsdown, St Edmund (Kent).

The Conviction of Cain:

Capel, St Thomas of Canterbury (Kent); Kelmscott, St George (Oxfordshire).

The Story of Noah:

Houghton-on-the-Hill, St Mary (Norfolk).

Moses:

Battle, St Mary (East Sussex); Radnage, St Mary (Buckinghamshire); Trotton, St George (West Sussex); Westhall, St Andrew (Suffolk).

Prophets:

A Victorian reconstruction of a thirteenth-century scheme of prophets holding scrolls survives in the Presbytery of Salisbury Cathedral.

Ecclesia and Synagoga:

Little Casterton, All Saints (Rutland); Fritton, St Edmund (near Great Yarmouth, Norfolk).

Tree of Jesse:

Black Bourton, St Mary (Oxfordshire); Chalfont St Giles, St Giles (Buckinghamshire); Chalgrove, St Mary (Oxfordshire); Corby Glen, St John the Evangelist (Lincolnshire); Weston Longville, All Saints (Norfolk); Worcester Cathedral Chapterhouse (Worcestershire).

THE NEW TESTAMENT

The Holy Infancy

Cycles:

Ashampstead, St Clement (Berkshire); Black Bourton, St Mary (Oxfordshire); Brook, St Mary (Kent); Chalgrove, St Mary (Oxfordshire); Chester Castle, Agricola Tower (Cheshire); Coombes Church (West Sussex); Corby Glen, St John Evangelist (Lincolnshire); Croughton, All Saints (Northamptonshire); Easby, St Agatha (Yorkshire); Faversham, St Mary of Charity (Kent); Great Burstead, St Mary Magdalene (Essex); Hardham, St Botolph (West Sussex); Kelmscott. St George (Oxfordshire); Newton Green, All Saints (Suffolk); Potter Heigham, St Nicholas (Norfolk); Risby, St Giles (Suffolk); Salisbury, St Thomas (Wiltshire); Sarratt, Holy Cross (Hertfordshire); Thornham Parva, St Mary (Suffolk); West Chiltington, St Mary (West Sussex); Winchester Cathedral (Hampshire); Wissington/Wiston, St Mary (Suffolk).

Scenes from the Holy Infancy

NB: this list includes separate scenes as well as those belonging to cycles of paintings.

The Annunciation

Ashampstead, St Clement (Berkshire); Ashmansworth, St James (Hampshire); Barnby, St John Baptist (Suffolk); Bradwell, Bradwell Abbey, St Mary's Chapel (Buckinghamshire); Bramley, St James (Hampshire); Brinsop, St George (Herefordshire); Brook, St Mary (Kent); Canterbury Cathedral (Kent);

Chalgrave, All Saints (Bedfordshire); Chalgrove, St Mary (Oxfordshire); Claverley, All Saints (Shropshire); Clodock, St Clydawg (Herefordshire); Combe, St Laurence (Oxfordshire); Coombes, Church (West Sussex); Dorney, St James the Less (Buckinghamshire); Easby, St Agatha (Yorkshire); Ely, Prior Crauden's Chapel (Cambridgeshire); Empingham, St Peter (Rutland); Enborne, St Michael (Berkshire); Ewelme, St Mary (Oxfordshire); Exeter Cathedral(Devon); Faversham, St Mary of Charity (Kent); Fring, All Saints (Norfolk); Gisleham, Holy Trinity (Suffolk); Great Burstead, St Mary Magdalene (Essex); Great Hockham, Holy Trinity (Norfolk); Harbledown, St Nicholas (Kent); Hardham, St Botolph (West Sussex); Hereford, All Saints (Herefordshire); Little Melton, St Mary and All Saints (Norfolk); Maidstone, All Saints (Kent); Martley, St Peter (Worcestershire); Newton Green, All Saints (Suffolk); Norwich, St Gregory (Norfolk); Radnage, St Mary (Buckinghamshire); Salisbury, St Thomas (Wiltshire); Sarratt, Holy Cross (Hertfordshire); Slapton, St Botolph (Northamptonshire); South Leigh, St James (Oxfordshire); South Newington, St Peter ad Vincula (Oxfordshire); St Albans Abbey (Hertfordshire); West Chiltington, St Mary (West Sussex); Willingham, St Mary & All Saints (Cambridgeshire); Wissington/Wiston, St Mary (Suffolk).

The Visitation

Ashampstead, St Clement (Berkshire); Bradwell, Bradwell Abbey, St Mary's Chapel (Buckinghamshire); Brook, St Mary (Kent); Chester Castle, Agricola Tower (Cheshire); Coombes, Church (West Sussex); Dale Abbey, All Saints (Derbyshire); Empingham, St Peter (Rutland); Faversham, St Mary of Charity (Kent); Hardham, St Botolph (West Sussex); Kelmscott. St George (Oxfordshire); Newton Green, All Saints (Suffolk); Salisbury, St Thomas (Wiltshire); Thornham Parva, St Mary (Suffolk); West Chiltington, St Mary (West Sussex); Willingham, St Mary & All Saints (Cambridgeshire).

The Nativity

Bristol, Lord Mayor's Chapel (previously St Mark's Hospital) (Bristol); Chalgrove, St Mary (Oxfordshire); Cold Overton, St John Baptist (Leicestershire); Coombes, Church (West Sussex); Faversham, St Mary of Charity (Kent); Great Burstead, St Mary Magdalene (Essex); Hardham, St Botolph (West Sussex); Newton Green, All Saints (Suffolk); Thornham Parva, St Mary (Suffolk); West Chiltington, St Mary (West Sussex); Wissington/Wiston, St Mary (Suffolk).

The Appearance of the Angel to the Shepherds

Ashampstead, St Clement (Berkshire); Cocking, Church (West Sussex); Easby, St Agatha (Yorkshire); Faversham, St Mary of Charity (Kent); Hardham, St Botolph (West Sussex); Sarratt, Holy Cross (Hertfordshire); Thornham Parva, St Mary (Suffolk); West Chiltington, St Mary (West Sussex); Wissington/Wiston, St Mary (Suffolk).

The Adoration of the Shepherds

Brook, St Mary (Kent); Wissington/Wiston, St Mary (Suffolk).

The Presentation in the Temple
Faversham, St Mary of Charity (Kent); Hardham, St Botolph (West Sussex); Kelmscott, St George (Oxfordshire); Thornham Parva, St Mary (Suffolk).

The Journey of the Magi
Brook, St Mary (Kent); Hardham, St Botolph (West Sussex).

The Magi before Herod
Brook, St Mary (Kent).

The Adoration of the Magi
Berry Pomeroy Castle (Devon); Black Bourton, St Mary (Oxfordshire); Chalfont St Giles, St Giles (Buckinghamshire); Chalgrove, St Mary (Oxfordshire); Easby, St Agatha (Yorkshire); Edstaston, St Mary (Shropshire); Faversham, St Mary of Charity (Kent); Gloucester, St Mary le Crypt (Gloucestershire); Great Burstead, St Mary Magdalene (Essex); Great Hockham, Holy Trinity (Norfolk); Hardham, St Botolph (West Sussex); Heydon, St Peter and St Paul (Norfolk); Leebotwood, St Mary (Shropshire); Pinvin, St Nicholas (Worcestershire); Salisbury, St Thomas (Wiltshire); Thornham Parva, St Mary (Suffolk); Wissington/Wiston, St Mary (Suffolk).

Joseph's Dream
Black Bourton, St Mary (Oxfordshire); Coombes, Church (West Sussex); Newington-next-Sittingbourne, St Mary (Kent).

The Magi's Dream
Wissington/Wiston, St Mary (Suffolk).

The Massacre of the Innocents
Black Bourton, St Mary (Oxfordshire); Chalgrove, St Mary (Oxfordshire); Croughton, All Saints (Northamptonshire); Hardham, St Botolph (West Sussex); Risby, St Giles (Suffolk); Wissington/Wiston, St Mary (Suffolk).

The Flight into Egypt
Brook, St Mary (Kent); Coombes, Church (West Sussex); Croughton, All Saints (Northamptonshire); Hardham, St Botolph (West Sussex); Plumpton, St Michael (East Sussex); Risby, St Giles (Suffolk).

The Fall of the Idols
Brook, St Mary (Kent); Hardham, St Botolph (West Sussex).

The Dispute with the Doctors
Brook, St Mary (Kent); Hardham, St Botolph (West Sussex)

The Baptism of Christ
Black Bourton, St Mary (Oxfordshire).

The Passion of Christ

Cycles:
Amberley, St Michael (West Sussex); Ashby St Ledgers, St Mary & St Leodegarius (Northamptonshire); Barton, St Peter; Belchamp Walter, St Mary (Essex); Blyth, St Mary and St Martin (Nottinghamshire); Brook, St Mary (Kent); Burton Dassett, All Saints; Capel, St Thomas of Canterbury (Kent); Chalgrove, St

Overleaf: Figure 245

The Legend of St Katherine: Sporle, St Mary, late fourteenth – early fifteenth century.

According to the *Legenda Aurea*, St Katherine was the staunchly Christian daughter of the king of Alexandria. She was extremely well educated and succeeded her father after he died. When she was eighteen, the pagan Roman Emperor, Maxentius, visited Alexandria. This is where the narrative begins. *Top row, first panel, left to right:*

1. Katherine leaves her palace to investigate the commotion caused by Maxentius making sacrifices and demanding that her people do the same.
2. The Emperor worships his pagan idol.
3. Katherine objects and is taken to his palace where she preaches against paganism.
4. The Emperor summons fifty philosophers to refute Katherine.
5. The philosophers are converted by her arguments and are burned to death by the enraged tyrant.
6. Maxentius tells Katherine that if she will sacrifice to his gods he will make her second only to the Empress.
7. Katherine refuses and is sent to prison.

Second row:
8. Porphirus, the captain of the Emperor's guard, visits Katherine in prison.
9. Porphirus and 200 guards convert to Christianity.
10. A half-naked Katherine is brought before Maxentius and scourged for her obstinacy.
11 The Emperor's evil advisor, Cursates, suggests that she is tortured on the wheel.
12. (double panel) The wheel is miraculously destroyed by angels.
13. The Emperor's wife condemns Maxentius's cruelty, renounces paganism and is seized.

Third row
14. The Empress is executed.
15. Porphirus secretly buries her body in defiance of orders that it be left for wild dogs to eat.
16. (double panel) Porphirus admits to burying the body and declares his conversion to Christ.
17. The Emperor summons executioners.
18. (double panel) Porphirus and the soldiers are slain.

Fourth row
19. Katherine is brought before Maxentius who promises to make her Empress if she submits. She refuses.
20. Katherine is scourged.
21. Devils gloat and struggle for her soul (suggested interpretation).
22. Katherine is taken for execution.
23. Katherine is beheaded. Milk flows from her neck, not blood.
24. Katherine is carried to Mount Sinai by angels.
25. Pilgrims visit her shrine.

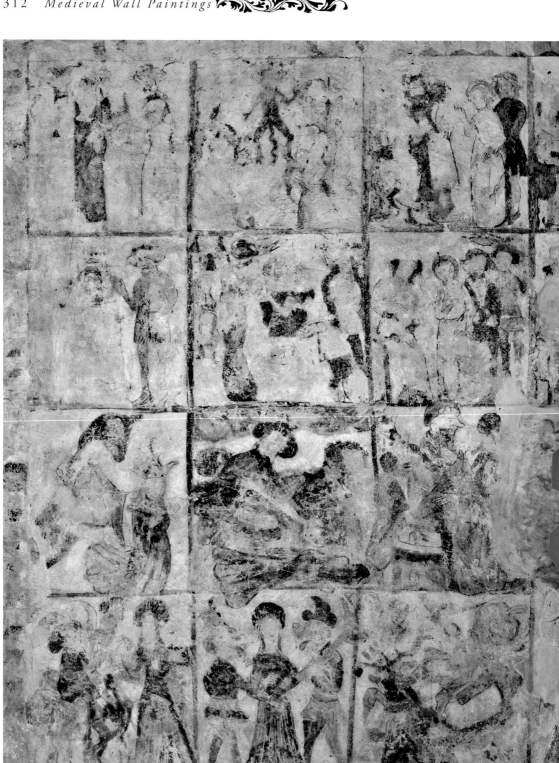

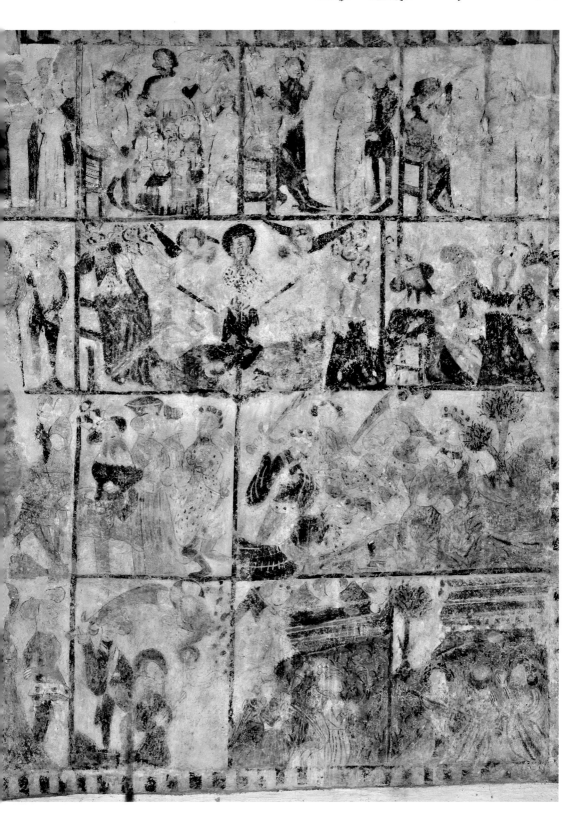

Mary (Oxfordshire); Corhampton, Church (Hampshire); Crostwight, All Saints (Norfolk); Croughton, All Saints (Northamptonshire); Fairstead, St Mary (Essex); Faversham, St Mary of Charity (Kent); Flamstead, St Leonard (Hertfordshire); Ford, St Andrew (West Sussex); Great Tew, St Michael (Oxfordshire); Gussage St Andrew, St Andrew (Dorset); Hardham, St Boltoph (West Sussex); Halling, St John the Baptist (Kent);

Ickleton, St Mary (Cambridgeshire); Little Easton, St Mary (Essex); Little Tey, St James the Less (Essex); Little Witchingham, St Faith (Norfolk); North Cove, St Botolph (Suffolk); Madley, Nativity of the Virgin (Herefordshire); Martley, St Peter (Worcestershire); North Stoke, St Mary (Oxfordshire); Peakirk, St Pega (Cambridgeshire); Pickering, St Peter and St Paul (Yorkshire); Pyrford, St Nicholas (Surrey); Sarratt, Holy Cross (Hertfordshire); Shadingfield, St John Baptist (Suffolk); Shorthampton, All Saints (Oxfordshire); South Newington, St Peter ad Vincula (Oxfordshire); St Teilo, Llandeilo Tal-y-bont (National Museums of Wales) ; Wanborough, St Andrew (Wiltshire); West Chiltington, St Mary (West Sussex); West Somerton, St Mary (Norfolk);White Notley, St Etheldreda (Essex); Winchester Cathedral (Hampshire); Wissington/Wiston, St Mary (Suffolk); Yarnton, St Bartholomew (Oxfordshire).

The Raising of Lazarus
Brook, St Mary (Kent); Winchester Cathedral (Hampshire).

The Entry into Jerusalem
Ashby St Ledgers, St Mary & St Leodegarius (Northamptonshire); Belchamp Walter, St Mary (Essex); Brook, St Mary (Kent); Capel, St Thomas of Canterbury (Kent); Crostwight, All Saints (Norfolk); Croughton, All Saints (Northamptonshire); Fairstead, St Mary (Essex); Great Tew, St Michael (Oxfordshire); North Cove, St Botolph (Suffolk); South Newington, St Peter ad Vincula (Oxfordshire); Wanborough, St Andrew (Wilts); West Chiltington, St Mary (West Sussex); West Somerton, St Mary (Norfolk); Winchester Cathedral (Hampshire).

Christ washing Feet
Ashby St Ledgers, St Mary & St Leodegarius (Northamptonshire); Belchamp Walter, St Mary (Essex); Crostwight, All Saints (Norfolk); Great Tew, St Michael (Oxfordshire); Halling, St John the Baptist (Kent); Hardham, St Botolph (West Sussex); Little Tey, St James the Less (Essex); Peakirk, St Pega (Cambridgeshire); West Chiltington, St Mary (West Sussex); Wissington/Wiston, St Mary (Suffolk).

The Last Supper
Ashby St Ledgers, St Mary & St Leodegarius (Northamptonshire); Barton, St Peter (Cambridgeshire); Belchamp Walter, St Mary (Essex); Capel, St Thomas of Canterbury (Kent); Crostwight, All Saints (Norfolk); Croughton, All Saints (Northamptonshire); Fairstead, St Mary (Essex); Flamstead, St Leonard (Hertfordshire); Friskney, All Saints (Lincolnshire); Great Hockham, Holy Trinity (Norfolk); Halling, St John the Baptist (Kent); Hardham, St Botolph

(*West Sussex); Ickleton, St Mary (Cambridgeshire); Little Easton, St Mary (Essex); Little Tey, St James the Less (Essex); Madley, Nativity of the Virgin (Herefordshire); Maids' Moreton, St Edmund (Buckinghamshire); North Cove, St Botolph (Suffolk); North Stoke, St Mary (Oxfordshire); Peakirk, St Pega (Cambridgeshire); West Chiltington, St Mary (West Sussex); Wissington/Wiston, St Mary (Suffolk)*

The Agony in the Garden

Ashby St Ledgers, St Mary & St Leodegarius (Northamptonshire); Ford, St Andrew (West Sussex); Little Easton, St Mary (Essex); South Newington, St Peter ad Vincula (Oxfordshire).

The Betrayal

Ashby St Ledgers, St Mary & St Leodegarius (Northamptonshire); Belchamp Walter, St Mary (Essex); Brook, St Mary (Kent); Capel, St Thomas of Canterbury (Kent); Chalgrove, St Mary (Oxfordshire); Fairstead, St Mary (Essex); Flamstead, St Leonard (Hertfordshire); Ford, St Andrew (West Sussex); Great Hockham, Holy Trinity (Norfolk); Great Tew, St Michael (Oxfordshire); Gussage St Andrew, St Andrew (Dorset); Hardham, St Botolph (West Sussex); Ickleton, St Mary (Cambridgeshire); Little Easton, St Mary (Essex); Little Tey, St James the Less (Essex); Madley, Nativity of the Virgin (Herefordshire); North Cove, St Botolph (Suffolk); North Stoke, St Mary (Oxfordshire); Pickering, St Peter and St Paul (Yorkshire); West Chiltington, St Mary (West Sussex).

The Suicide of Judas

Breamore, St Mary (Hampshire); Gussage St Andrew, St Andrew (Dorset); Slapton, St Botolph (Northamptonshire).

Christ before Pilate

Belchamp Walter, St Mary (Essex); Chalgrove, St Mary (Oxfordshire); Fairstead, St Mary (Essex); Great Tew, St Michael (Oxfordshire); Little Easton, St Mary (Essex); North Stoke, St Mary (Oxfordshire); Pickering, St Peter and St Paul (Yorkshire).

The Flagellation

Amberley, St Michael (West Sussex); Bradwell, Bradwell Abbey, St Mary's Chapel (Buckinghamshire); Brook, St Mary (Kent); Chalgrove, St Mary (Oxfordshire); Easby, St Agatha (Yorkshire); Great Tew, St Michael (Oxfordshire); Hardham, St Botolph (West Sussex); Ickleton, St Mary (Cambridgeshire); Lakenheath, St Mary (Suffolk); Little Tey, St James the Less (Essex); Little Witchingham, St Faith (Norfolk); Madley, Nativity of the Virgin (Herefordshire); Martley, St Peter (Worcestershire); North Cove, St Botolph (Suffolk); North Stoke, St Mary (Oxfordshire); Peakirk, St Pega (Cambridgeshire); Pickering, St Peter and St Paul (Yorkshire); Pyrford, St Nicholas (Surrey); Shadingfield, St John Baptist (Suffolk); South Newington, St Peter ad Vincula (Oxfordshire); West Chiltington, St Mary (West Sussex); West Somerton, St Mary (Norfolk); White Notley, St Etheldreda (Essex).

Christ Crowned with Thorns/The Mocking

Crowned with Thorns: *Fairstead, St Mary (Essex); Flamstead, St Leonard (Hertfordshire); Halling, St John the Baptist (Kent); Crostwight, All Saints (Norfolk); Great Tew, St Michael (Oxfordshire).*

The Mocking: *Chalgrove, St Mary (Oxfordshire); West Somerton St Mary (Norfolk); St Teilo (The National Museum Wales, Cathays Park, Cardiff).*

Christ Carrying the Cross

Amberley, St Michael (West Sussex); Blyth, St Mary and St Martin (Nottinghamshire); Brook, St Mary (Kent); Chalgrove, St Mary (Oxfordshire); Croughton, All Saints (Northamptonshire); Fairstead, St Mary (Essex); Great Tew, St Michael (Oxfordshire); Gussage St Andrew, St Andrew (Dorset); Ickleton, St Mary (Cambridgeshire); Lakenheath, St Mary (Suffolk); Little Easton, St Mary (Essex); North Cove, St Botolph (Suffolk); Pickering, St Peter and St Paul (Yorkshire); South Newington, St Peter ad Vincula (Oxfordshire); West Chiltington, St Mary (West Sussex)

The Crucifixion

Amberley, St Michael (West Sussex); Ashby St Ledgers, St Mary & St Leodegarius (Northamptonshire); Burton Dassett, All Saints (Warwickshire); Chalgrove, St Mary (Oxfordshire); Crostwight, All Saints (Norfolk); Duxford, St John (Cambridgeshire); Faversham, St Mary of Charity (Kent); Flamstead, St Leonard (Hertfordshire); Great Tew, St Michael (Oxfordshire); Gussage St Andrew, St Andrew (Dorset); Little Easton, St Mary (Essex); Little Tey, St James the Less (Essex); Madley, Nativity of the Virgin (Herefordshire); Martley, St Peter (Worcestershire); North Cove, St Botolph (Suffolk); Peakirk, St Pega (Cambridgeshire); Pickering, St Peter and St Paul (Yorkshire); Pinvin, St Nicholas (Worcestershire); South Newington, St Peter ad Vincula (Oxfordshire); West Chiltington, St Mary (West Sussex).

The Deposition

Chalgrove, St Mary (Oxfordshire); Croughton, All Saints (Northamptonshire); Duxford, St John (Cambridgeshire); Easby, St Agatha (Yorkshire); Great Tew, St Michael (Oxfordshire); Gussage St Andrew, St Andrew (Dorset); Hertford, Bengeo, St Leonard (Hertfordshire); Little Easton, St Mary (Essex); Little Witchingham, St Faith (Norfolk); North Stoke, St Mary (Oxfordshire); Peakirk, St Pega (Cambridgeshire); Pickering, St Peter and St Paul (Yorkshire); Winchester Cathedral (Hampshire).

Joseph of Aramithea asking Pilate for Christ's body

Brook, St Mary (Kent); Duxford, St John (Cambridgeshire).

The Entombment

Ashby St Ledgers, St Mary & St Leodegarius (Northamptonshire); Brook, St Mary (Kent); Chalgrove, St Mary (Oxfordshire); Easby, St Agatha (Yorkshire); Flamstead, St Leonard (Hertfordshire); Great Tew, St Michael (Oxfordshire); Hardham, St Botolph (West Sussex); Little Easton, St Mary (Essex); Little Tey, St James the Less (Essex); Little Witchingham, St Faith (Norfolk); Peakirk, St

Pega (Cambridgeshire); Pickering, St Peter and St Paul (Yorkshire); Winchester Cathedral (Hampshire).

The Harrowing of Hell

Ashmansworth, St James (Hampshire); Brent Eleigh, St Mary (Suffolk); Chaldon, St Peter & St Paul (Surrey); Chalgrove, St Mary (Oxfordshire); Great Tew, St Michael (Oxfordshire); Little Tey, St James the Less (Essex); Little Witchingham, St Faith (Norfolk); Madley, Nativity of the Virgin, (Herefordshire); North Cove, St Botolph (Suffolk); Pickering, St Peter and St Paul (Yorkshire); Witley, All Saints (Surrey).

The Three Marys at the Sepulchre

Ashby St Ledgers, St Mary & St Leodegarius (Northamptonshire); Brook, St Mary (Kent); Duxford, St John (Cambridgeshire); Easby, St Agatha (Yorkshire); Faversham, St Mary of Charity (Kent); Hardham, St Botolph (West Sussex); Kempley, St Mary (Gloucestershire); Little Tey, St James the Less (Essex); Witley, All Saints (Surrey).

The Angel at the Tomb

Lakenheath, St Mary (Suffolk); West Chiltington, St Mary (West Sussex).

The Resurrection

Amberley, St Michael (West Sussex); Ashby St Ledgers, St Mary & St Leodegarius (Northamptonshire); Belchamp Walter, St Mary (Essex); Blyth, St Mary and St Martin (Nottinghamshire); Chalfont St Giles, St Giles (Buckinghamshire); Chalgrove, St Mary (Oxfordshire); Clayton, St John the Baptist (East Sussex); East Bergolt, St Mary (Suffolk); Exeter Cathedral (Devon); Fairstead, St Mary (Essex); Flamstead, St Leonard (Hertfordshire); Gloucester, St Mary le Crypt (Gloucestershire); Great Burstead, St Mary Magdalene (Essex); Great Tew, St Michael (Oxfordshire); Little Witchingham, St Faith (Norfolk); Madley, Nativity of the Virgin (Herefordshire); North Cove, St Botolph (Suffolk); Peakirk, St Pega (Cambridgeshire); Pickering, St Peter and St Paul (Yorkshire); Pinvin, St Nicholas (Worcestershire); Sarratt, Holy Cross (Hertfordshire); Seething, St Margaret and St Remigius (Norfolk); South Newington, St Peter ad Vincula (Oxfordshire); West Chiltington, St Mary (West Sussex); West Somerton, St Mary (Norfolk); Witley, All Saints (Surrey).

Noli me Tangere

Bradwell-juxta-Coggeshall, Holy Trinity (Essex); Bristol, Lord Mayor's Chapel (previously St Mark's Hospital) (Bristol); Capel, St Thomas of Canterbury (Kent); Great Tew, St Michael (Oxfordshire); Little Tey, St James the Less (Essex); Little Witchingham, St Faith (Norfolk); Peakirk, St Pega (Cambridgeshire); Purton, St Mary (Wiltshire); Risby, St Giles (Suffolk); Sundon, St Mary (Bedfordshire); West Harnham, St George (Wiltshire); Winchester Cathedral (Hampshire).

The Incredulity of St Thomas

Bradwell-juxta-Coggeshall, Holy Trinity (Essex); Great Burstead, St Mary Magdalene (Essex); Little Witchingham, St Faith (Norfolk); Rotherfield, St Denys

(East Sussex); St Albans Abbey (Hertfordshire); Westminster Abbey (London); Yaxley, St Peter (Cambridgeshire).

The Ascension of Christ

Chalgrove, St Mary (Oxfordshire); Holcot, St Mary and All Saints (Northamptonshire); Little Witchingham, St Faith (Norfolk); North Cove, St Boltoph (Suffolk); Pickworth, St Andrew (Lincolnshire); Pinvin, St Nicholas (Worcestershire); Sarratt, Holy Cross (Hertfordshire); Seething St Margaret and St Remigius (Norfolk); St Michael's on Wyre, St Michael (Lancashire)

Pentecost

Ashmansworth, St James (Hampshire); Holcot, St Mary and All Saints (Northamptonshire)

DEVOTIONAL IMAGES

Christ in Majesty:

Amberley, St Michael (West Sussex); Canterbury Cathedral (Kent); Canterbury, Eastbridge Hospital (Kent); Clayton, St John the Baptist (East Sussex); Copford, St Michael & All Angels (Essex); Kempley, St Mary (Gloucestershire); Little Witchingham, St Faith (Norfolk); Radnage, St Mary (Buckinghamshire); Salisbury Cathedral (Wiltshire); St Albans Abbey (Hertfordshire);

Agnes Dei (the Lamb of God)

Hardham, St Boltolph (West Sussex).

Trinity

Boughton Aluph, All Saints (Kent); Bradwell-juxta-Coggeshall, Holy Trinity (Essex); Bristol, Lord Mayor's Chapel (previously St Mark's Hospital) (Bristol); Framlingham, St Michael (Suffolk); Great Hockham, Holy Trinity (Norfolk); Hornton, St John Baptist (Oxfordshire); Houghton-on-the-Hill, St Mary (Norfolk); Lichfield Cathedral (Staffordshire); Tewkesbury Abbey (Gloucestershire); Worcester, The Commandery (Worcestershire); Wymington, St Lawrence (Bedfordshire).

The Crucified Christ

Bapchild, St Lawrence (Kent); Barnby, St John Baptist (Suffolk); Bradwell, Bradwell Abbey, St Mary's Chapel (Buckinghamshire); Brent Eleigh, St Mary (Suffolk); Brinsop, St George (Herefordshire); Broughton, St Mary (Oxfordshire); Chalfont St Giles, St Giles (Buckinghamshire) Chester, St Mary (Cheshire); Combe, St Laurence (Oxfordshire); Coventry, St Anne's Charterhouse (Warwickshire); Dorchester Abbey (Oxfordshire); Durham Cathedral (County Durham) East Bedfont, St Mary the Virgin (Greater London); Ely, Prior Crauden's Chapel (Cambridgeshire); Forde Abbey (Dorset); Godshill (Isle of Wight); Goxhill, All Saints (Lincolnshire); Horsham St Faith, St Faith's Priory (Norfolk); Laycock Abbey, Nunnery buildings (Wiltshire); Lichfield Cathedral (Staffordshire); Little Missenden, St John Baptist (Buckinghamshire); St Albans Abbey (Hertfordshire);

Sutton Bingham, All Saints (Somerset); Tong, St Bartholomew (Shropshire); Turvey, All Saints (Bedfordshire); Ulcombe, All Saints (Kent); Wimborne Minister (Dorset); Wisborough Green, St Peter ad Vincula (West Sussex).

Man of Sorrows
Bristol, Lord Mayor's Chapel (previously St Mark's Hospital) (Bristol); Glatton, St Nicolas (Cambridgeshire); Lydiard Tregoze, St Mary (Wiltshire).

Resurrected Christ
Ashton, St John the Baptist (Devon); Huntingfield, St Mary (Suffolk); Newington-next-Sittingbourne, St Mary (Kent); Northmoor, St Denis (Oxfordshire); Exeter Cathedral (Devon);Long Melford. Holy Trinity (Suffolk).

Rood Schemes
Ashampstead, St Clement (Berkshire); Ashby St Ledgers, St Mary & St Leodegarius (Northamptonshire); Attleborough, St Mary (Norfolk); Breamore, St Mary (Hampshire); Burton Dassett, All Saints (Warwickshire); Cawston, St Agnes (Norfolk); Compton, St Nicholas (Surrey); East Shefford, St Thomas (Berkshire); Fairford, St Mary (Gloucestershire); Glapthorn, St Leonard (Northamptonshire); Great Hockham, Holy Trinity (Norfolk); Hook Norton, St Peter (Oxfordshire); Kingston, All Saints & St Andrew (Cambridgeshire); Llantwit Major, St Illtud (Wales: Vale of Glamorgan); Lydiard Tregoze, St Mary (Wiltshire); Raunds, St Peter (Northamptonshire); Stratford upon Avon, Guild Chapel (Warwickshire).

THE VIRGIN MARY

The Virgin and Child
Belchamp Walter, St Mary (Essex); Bledington, St Leonard (Gloucestershire); Chichester, Bishop's Palace (West Sussex); Great Canfield, St Mary (Essex); Little Wenham, All Saints (Suffolk); Norwich Cathedral (Norfolk); Shelfanger, All Saints (Norfolk); Shorthampton, All Saints (Oxfordshire); South Newington, St Peter ad Vincula (Oxfordshire); St Albans Abbey (Hertfordshire); Stoke Dry, St Andrew (Rutland); Stone (near Dartford), St Mary the Virgin (Kent); Toddington, St George (Bedfordshire); Wickhamford, St John Baptist (Worcestershire).

Pieta
Ashby St Ledgers, St Mary & St Leodegarius (Northamptonshire); Hornton, St John Baptist (Oxfordshire); Thame, St Mary (Oxfordshire).

Early Life of the Virgin
Brook, St Mary (Kent); Croughton, All Saints (Northamptonshire).

Death of the Virgin
Brook, St Mary (Kent); Chalgrove, St Mary (Oxfordshire); Pickering, St Peter and St Paul (Yorkshire); Purton, St Mary (Wiltshire); Sutton Bingham, All Saints (Somerset).

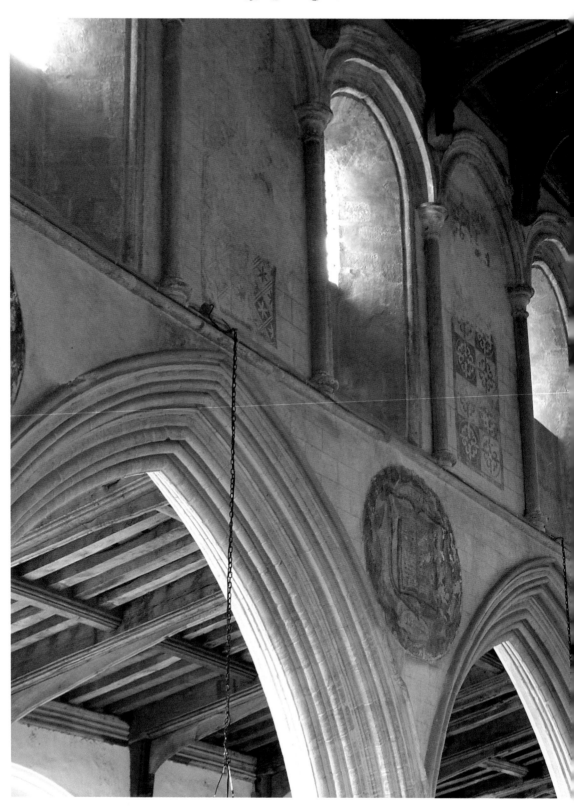

Figure 246
Fictive wall hangings between the
south clerestory windows, c. 1250.
Eighteenth century paintings below:
St Mary, West Walton.

Funeral of the Virgin

Chalgrove, St Mary (Oxfordshire); Cold Overton, St John Baptist (Leicestershire); Pickering, St Peter and St Paul (Yorkshire).

Coronation of The Virgin

Arundel, St Nicholas Priory (West Sussex); Black Bourton, St Mary (Oxfordshire); Brook, St Mary (Kent); Chalgrove, St Mary (Oxfordshire); Clifton Campville, St Andrew (Staffordshire); Great Burstead, St Mary Magdalene (Essex); Seething, St Margaret and St Remigius (Norfolk); St Albans Abbey (Hertfordshire); Tewkesbury Abbey (Gloucesterershire); Wootton Wawen, St Peter (Warwickshire).

Miracles of the Virgin

Chalfont St Giles, St Giles (Buckinghamshire); Chester Castle, Agricola Tower (Cheshire); Eton, Eton College Chapel (Buckinghamshire); Ripon Cathedral (Yorkshire); Risby, St Giles (Suffolk); Rochester Cathedral (Kent); Winchester Cathedral (Hampshire).

THE SAINTS AND LEGENDS

Angels

God was served by nine choirs, or orders of angels: the seraphim, cherubim, thrones, dominations, virtues, powers, principalities, archangels and angels. Individual angels, primarily **St Gabriel** and **St Michael,** appear in wall paintings of the Annunciation and Last Judgement/Weighing of Souls scenes respectively. All nine orders of angels can be seen at:

Exeter Cathedral (Devon); Lichfield Cathedral (Staffordshire).

The Apostles

Twelve of Christ's disciples became Apostles: Peter, Andrew, James the Great, John, Phillip, Bartholomew, Thomas, Matthew, James the Less, Thaddaeus, Simon and Judas Iscariot. After his Betrayal and Suicide, Judas was replaced by Matthias. Paul and Barnabas have also been referred to as Apostles. The Twelve appear as a group in some Christ in Majesty paintings adoring Christ and sitting alongside or below him in Doom paintings. Sts Peter and Paul are often paired. Individual Apostles can be recognised by their attributes.

The attributes are: **St Peter**: keys; **St Andrew**: saltire cross; **St James the Great (Major)**: scallop shell and pilgrim's staff; **St John the Evangelist**: chalice with dragon emerging; **St Phillip**: loaves or basket of bread; **St Bartholomew**: knife; **St Thomas**: spear; **St Matthew**: angel/scimitar; **St James the Less (Minor)**: Fuller's club; **St Thaddeus/St Jude**: a boat or halberd (a combination of a spear and an axe mounted on a staff); **St Simon**: fish (oar or saw); **St Matthias**: axe or scimitar; **St Paul**: sword; **St Barnabas**: roses on a shield or spandrel.

As a Group:

Ashampstead, St Clement (Berkshire); Chalgrave, All Saints (Bedfordshire); Combe, St Laurence (Oxfordshire); Hailes, church (Gloucestershire); Hereford Cathedral (Herefordshire); Kempley, St Mary (Gloucestershire); Little

Witchingham, St Faith (Norfolk); Stowell, St Leonard (Gloucestershire); Wellow, St Julian (Somerset).

Bishops

Without inscriptions or some other recognisable feature, it is impossible to identify images of bishop saints with any accuracy. Some may indeed be St Thomas Becket, as is often claimed (q.v.) but other known examples, such as St Cuthbert, St Richard of Chichester and St Edmund of Abingdon, counsel caution. Paintings of bishops venerated holy individuals and martyred saints. They also affirmed the authority and virtues of the church itself.

Evangelist Symbols

The symbols of the Four Evangelists, the authors of The New Testament Gospels, are St Matthew (Man/Angel); St Mark (Lion); St Luke: (Bull); St John (Eagle).

Little Witchingham, St Faith (Norfolk); St David's Cathedral (Wales: Pembrokeshire

INDIVIDUAL SAINTS & LEGENDS

St Agnes

A Roman child martyr who was killed after refusing marriage to a pagan claiming that she was betrothed to Christ. Her attribute is a ring.

Cawston, St Agnes (Norfolk); Eton College Chapel, (Buckinghamshire); Farnborough, St Peter (Hampshire); Little Kimble, All Saints (Buckinghamshire).

St Anne

The Mother of the Virgin Mary. Although St Anne appears briefly in some Holy Infancy cycles as conceiving her daughter with a kiss at the Golden Gate, she is more commonly shown as an older woman teaching her daughter to read *The Education of the Virgin.* This image could have multiple purposes: honouring St Anne; promoting learning; preparing the Virgin Mary for the Annunciation. The earliest surviving painting of this subject survives on the north wall at Croughton, Northants.

Bradford-on-Avon, Holy Trinity (Wiltshire); Bradwell, Bradwell Abbey, St Mary's Chapel (Buckinghamshire); Chalfont St Giles, St Giles (Buckinghamshire); Corby Glen, St John Evangelist (Lincolnshire); Coventry, St Anne's Charterhouse (Warwickshire); Croughton, All Saints (Northamptonshire); Haddon, Haddon Hall Chapel (Derbyshire); Shorthampton, All Saints (Oxfordshire); Slapton, St Botolph (Northamptonshire); Soberton, St Peter and St Paul (Hampshire); Wootton Wawen, St Peter (Warwickshire); Worcester Commandry (Worcestshire).

St Andrew

One of the original Apostles. Patron saint of Scotland. St Andrew was martyred on an X-shaped, or Saltire, Cross, which is also his attribute.

Brisley, St Bartholomew (Norfolk); Durham Cathedral (Co. Durham); Ickleton, St Mary (Cambridgeshire); Laycock Abbey, Nunnery buildings (Wiltshire);

Newington-next-Sittingbourne, St Mary (Kent); Norwich Cathedral (Norfolk); Stoke Dry, St Andrew (Rutland).

St Anthony Abbot (sometimes called 'of Egypt'), d. AD 356

Hermit and healer, regarded as the Father of Western monasticism. Traditionally shown with a pig.

Barton, St Peter (Cambridgeshire); Kempley, St Mary (Gloucestershire); Molesworth, St Peter (Cambridgeshire); Potter Heigham, St Nicholas (Norfolk).

St Apollonia, d. AD 249

Female martyr saint. Patron saint against toothache.

Eton College Chapel (Buckinghamshire).

St Barbara

A Virgin saint imprisoned by her pagan father in a tower to discourage suitors and killed by him when she refused to renounce Christ. Her attribute is a tower.

Eton College Chapel (Buckinghamshire); Hessett, St Ethelbert (Suffolk).

St Bartholomew

One of the original Apostles. His attribute is the knife with which he was flayed during his Martyrdom.

Chalgrave, All Saints (Bedfordshire); Chalgrove, St Mary (Oxfordshire); Selling, St Mary (Kent); Tidmarsh, St Laurence (Berkshire).

St Cecilia

Roman Virgin martyr.

Eton College Chapel (Buckinghamshire).

St Christopher

According to 'The Golden Legend' St Christopher (or Christbearer) was a pagan giant who vowed to serve the strongest master on earth. His first choice was a local king, but when he saw his ruler make the sign of the cross to ward off the devil, Christopher (or Reprobus as he was then known), decided to switch his allegiance to this seemingly even more powerful figure. But once again, he was to be disappointed. While riding with Satan in the desert, Christopher saw his new master panic as they passed a wayside cross exclaiming that 'a certain man named Christ was once nailed to a cross and, since that time, at the sign of the cross I take fright and flee!'

Now seeking the man more powerful than the devil himself, Christopher eventually met a hermit who converted him to Christianity and suggested that if carried travellers across a dangerous river, the 'Christ' he sought might appear. Many days later he heard a child asking for his services. Taking the boy on his shoulders Christopher strode into the water. But little by little the waves rose higher and the child became ever heavier until Christopher feared that they might both be drowned. Only by summoning all of his strength, did he manage to scramble ashore on the other side of the bank. As he put the child down Christopher complained that he had 'weighed so heavy upon

me that it was if the weight of the whole world had been upon my shoulders.' 'Wonder not', the child replied, 'For not only hast thou borne the whole world upon thy shoulders but Him that created the world'.

Some paintings show the saint's staff miraculously sprouting leaves as he reaches the shore as well as a number of other incidental details, including the hermit holding a lamp, a mermaid, fishermen and different types of fish, including dolphins. A few continue the story of St Christopher after his encounter with Christ when he was imprisoned, tortured and martyred for his Christian faith. The best examples of these Life/Martyrdom paintings survive at Hemblington (Norfolk) and Shorewell (Isle of Wight). Both schemes show the conversion of his pagan persecutor, King Dagarus, after he had ordered that the saint be shot with arrows, was then hit in the eye when a shaft miraculously changed direction, and had his sight restored by St Christopher's blood.

The earliest recorded image of the saint was painted in the chapel of St Peter-ad-Vincula in the Tower of London around 1240 and the earliest still surviving is at Little Hamden (Buckinghamshire).

Despite its length, the following is not a complete list of every surviving painting. It does not include a number of severely damaged examples. Those marked with an asterisk (*) include scenes of his Life/Martyrdom.

Albury, St Peter & St Paul (Surrey); Aldermaston, St Mary (Berkshire); Alpheton, St Peter and St Paul (Suffolk); Ampney St Mary, St Mary (Gloucestershire); Ashampstead, St Clement (Berkshire); Ashby St Ledgers, St Mary & St Leodegarius (Northamptonshire); Attleborough, St Mary (Norfolk); Banningham, St Botolph (Norfolk); Barnby, St John Baptist (Suffolk); Bartlow, St Mary (Cambridgeshire); Battle, St Mary (East Sussex); Baunton, St Mary Magdalene (Gloucestershire); Belton, All Saints (Norfolk); Black Bourton, St Mary (Oxfordshire); Bledlow, Holy Trinity (Buckinghamshire); Bloxham, St Mary (Oxfordshire); Bolnhurst, St Dunstan (Bedfordshire); Borden, St Peter and St Paul (Kent); Bradfield Combust, All Saints (Suffolk); Bramley, St James (Hampshire); Breage, St Breaca (Cornwall); Brisley, St Bartholomew (Norfolk); Brook, St Mary (Kent); Burnham Overy, St Clement (Norfolk); Burwell, St Mary (Cambridgeshire); Chippenham, St Margaret (Cambridgeshire); Cirencester, St John the Baptist (Gloucestershire); Cockthorpe, All Saints (Norfolk); Coombes, Church (West Sussex); Corby Glen, St John Evangelist (Lincolnshire); Cottered, St John Baptist (Hertfordshire); Cranborne, St Mary & St Bartholomew (Dorset); Creeting St Peter, St Peter (Suffolk); Crostwick, St Peter (Norfolk); Crostwight, All Saints (Norfolk); Ditcheat, St Mary Magdalene (Somerset); Dorchester Abbey (Oxfordshire); East Wellow, St Margaret (Hampshire); Edingthorpe, All Saints (Norfolk); Edstaston, St Mary (Shropshire); Fairford, St Mary (Gloucestershire); Fairstead, St Mary (Essex); Flamstead, St Leonard (Hertfordshire); Freefolk, St Nicolas (Hampshire); Fring, All Saints (Norfolk); Fritton, St Catherine (near Long Stratton) (Norfolk); Fritton, St Edmund (near Great Yarmouth) (Norfolk); Glapthorn, St Leonard (Northamptonshire); Great Ellingham, St James (Norfolk)*; Grundisburgh, St Mary (Suffolk); Haddiscoe, St Mary (Norfolk); Haddon, Haddon Hall Chapel (Derbyshire); Hailes, Church (Gloucestershire); Hales, St Margaret (Norfolk);*

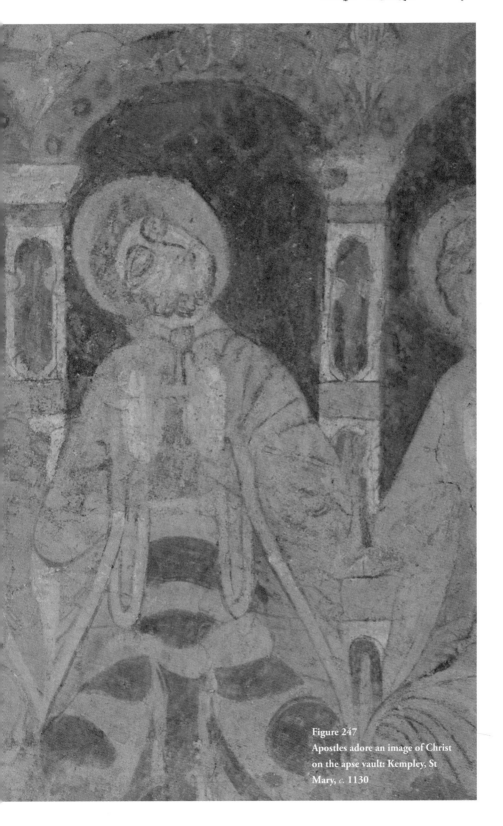

Figure 247
Apostles adore an image of Christ
on the apse vault: Kempley, St
Mary, *c.* 1130

Hardley, St Margaret (Norfolk); Hardwick, St Margaret (Norfolk); Hayes, St Mary the Virgin (Greater London); Hemblington, All Saints (Norfolk); Hessett, St Ethelbert (Suffolk); Horley, St Etheldreda (Oxfordshire); Houghton Conquest, All Saints (Bedfordshire); Hoxne, St Peter and St Paul (Suffolk); Impington, St Andrew (Cambridgeshire); Kempley, St Mary (Gloucestershire); Kingston, All Saints and St Andrew (Cambridgeshire); Kirtlington, St Mary (Oxfordshire); LLanynys, St Saeran (Wales: Denbighshire); Lambourne, St Mary and All Saints (Essex); Langley, St Michael (Norfolk)*; Laycock Abbey, Nunnery buildings (Wiltshire); Layer Marney, St Mary the Virgin (Essex); Lingwood, St Peter (Norfolk); Little Baddow, St Mary the Virgin (Essex); Little Hampden, Church (Buckinghamshire); Little Kimble, All Saints (Buckinghamshire); Little Missenden, St John Baptist (Buckinghamshire); Little Tey, St James the Less (Essex); Llantwit Major, St Illtud (Wales: Vale of Glamorgan); Martlesham, St Mary (Suffolk); Milton Regis, Holy Trinity (Kent); Mobberley, St Wilfrid (Cheshire); Molesworth, St Peter (Cambridgeshire); Moulton St Mary, St Mary (Norfolk); Naughton, St Mary (Suffolk); Newington-next-Sittingbourne, St Mary (Kent); Newnham, St Vincent (Hertfordshire); North Stoke, St Mary (Oxfordshire); Oaksey, All Saints (Wiltshire); Orton Longville, Holy Trinity (Cambridgeshire); Padbury, St Mary (Buckinghamshire); Paston, St Margaret (Norfolk); Peakirk, St Pega (Cambridgeshire); Pickering, St Peter and St Paul (Yorkshire); Pickworth, St Andrew (Lincolnshire); Piddington, St Nicholas (Oxfordshire); Potter Heigham, St Nicholas (Norfolk); Poughill, St Olaf (Cornwall); Raunds, St Peter (Northamptonshire); Ribchester, St Wilfred (Lancashire); Ridge, St Margaret (Hertfordshire); Rochester Cathedral (Kent); Ruislip, St Martin (Greater London); Scottow, All Saints (Norfolk); Seething, St Margaret and St Remigius (Norfolk); Shelton, St Mary (Bedfordshire); Shorwell, St Peter (Isle of Wight)*; Slapton, St Botolph (Northamptonshire); South Burlingham, St Edmund (Norfolk); South Pickenham, All Saints (Norfolk); St Albans Abbey (Hertfordshire); St Keverne, St Keverne (Cornwall)*; Stoke Dry, St Andrew (Rutland); Stowlangtoft, St George (Suffolk); Stradishall, St Margaret (Suffolk); Swannington, St Margaret (Norfolk); Tarrant Crawford, St Mary (Dorset); The Lee, Old Church (Buckinghamshire); Thorpe Mandeville, St John Baptist (Northamptonshire); Thurlton, All Saints (Norfolk); Thurton, St Ethelbert (Norfolk); Troston, St Mary (Suffolk); Trotton, St George (West Sussex); Tufton, St Mary (Hampshire); Warlingham, All Saints (Surrey); Wedmore, St Mary Magdalene (Somerset); West Chiltington, St Mary (West Sussex); West Somerton, St Mary (Norfolk); Westhall, St Andrew (Suffolk); Westminster Abbey (London); Whitcombe, Church (Dorset); Wickhampton, St Andrew (Norfolk); Widford, St Oswald (Oxfordshire); Wilby, All Saints (Norfolk); Wilby, St Mary (Suffolk); Willingham, St Mary and All Saints (Cambridgeshire); Winchester, St John the Baptist (Hampshire); Winslow, St Laurence (Buckinghamshire); Wood Eaton, Holy Rood (Oxfordshire); Wyken, St James (Warwickshire); Yelden, St Mary (Bedfordshire).*

St Clare (1194–1253)

Italian saint. Founder of the Minoresses or 'Poor Clares' order of nuns.

Follower of St Francis of Assisi.
Little Kimble, All Saints (Buckinghamshire).

St Clement, d. AD 100

The third Pope after St Peter. Venerated as a martyr. According to *The Golden Legend* he was lashed to an anchor and thrown into the sea. His attribute is an anchor.
South Leigh, St James (Oxfordshire).

St Cornelius, d. AD 253

Pope martyred during the Roman persecutions.
Alton, St Laurence (Hampshire).

St Cuthbert (AD 634–87)

A monk and Bishop of Lindisfarne, Northumbria. Northern England's most popular saint.
Durham Cathedral (County Durham); Pittington, St Lawrence (County Durham.

St Dorothy, d. *c.* AD 303

Female Martyr. Best known for sending fruit and flowers from the garden of heaven to one of her accusers.
Eton College Chapel (Buckinghamshire).

St Dunstan (AD 909 – 88)

An Anglo-Saxon bishop saint. Credited with reviving English monasticism in the tenth century. Archbishop of Canterbury AD 959–988 and author of the present coronation ritual. His attribute is the pair of tongs he used to seize the nose of a devil.
Barton, St Peter (Cambridgeshire).

St Edmund of Abingdon (1175–1240)

Archbishop of Canterbury 1233–40.
Fritton, St Catherine (near Long Stratton) (Norfolk).

St Edmund, King and Martyr (AD 841–869)

St Edmund was a Christian Anglo-Saxon King of East Anglia martyred by Danish invaders in AD 869 after refusing to serve his pagan conquerors. According to a near contemporary account of his life, he was tied to a tree after his capture and shot with arrows until he 'bristled like a hedgehog or thistle', before being decapitated and his head thrown into some bushes. Hours later when his followers went searching for his remains they heard his head calling them from a bramble thicket where it had been miraculously protected from scavengers by a wolf. The dead king's remains were subsequently interred at a great abbey that bore his name – Bury St Edmunds in Suffolk.

Edmund's shrine attracted pilgrims. His cult was promoted by the abbey. Around half of the wall paintings showing his image are in East Anglia, where he had a strong local appeal. He was a particular favourite of the Crown as a royal saint and appeared as one England's national saints in the

famous fourteenth-century 'Wilton Dyptch', a painting commissioned by Richard II and now displayed in the National Gallery, London. His attribute is one or more arrows. Most paintings of the saint are single scenes. Cycles of his Martyrdom life are denoted with an asterisk.

Belchamp Walter, St Mary (Essex); Bishopbourne, St Mary (Kent); Boxford, St Mary (Suffolk); Charlwood, St Nicholas (Surrey); Cliffe-at-Hoo, St Helen (Kent); East Wellow, St Margaret (Hampshire); Ely Cathedral (Cambridgeshire)*; Fritton, St Catherine (near Long Stratton) (Norfolk); Fritton, St Edmund (near Great Yarmouth) (Norfolk); Lakenheath, St Mary (Suffolk); Padbury, St Mary (Buckinghamshire); Pickering, St Peter and St Paul (Yorkshire); Sanderstead, All Saints (Surrey); Stanford Dingley, St Denys (Berkshire); Stoke Dry, St Andrew (Rutland); Thornham Parva, St Mary (Suffolk) *; Troston, St Mary (Suffolk).*

St Edward the Confessor (1003–1066)

King of England 1042–1066 and royal saint who also appeared in the 'Wilton Dyptch' mentioned above. Founded Westminster Abbey, where his body still lies. Among the stories told about his religious piety was that he gave his ring to a beggar, later revealed to be St John the Evangelist.

Ampney Crucis, Holy Rood (Gloucestershire); Faversham, St Mary of Charity (Kent).

St Eligius or Eloi

Bishop of Noyon in France, AD 558–660. Patron saint of smiths, farriers and precious metal workers. People also sought his help with their horses. Among the miracles credited to him was the removal of a leg from an unruly horse, shoeing it and then reattaching the leg with the sign of the cross and without any injury to the animal.

Broughton, St Lawrence (Buckinghamshire); Shorthampton, All Saints (Oxfordshire); Slapton, St Boltolph (Northamptonshire).

St Elizabeth

Mother of St John the Baptist.

Eton College Chapel (Buckinghamshire).

St Erasmus or Elmo

A Syrian bishop martyred during the persecutions of the Roman emperor Diocletian. Later accounts said his intestines were wound out of his body by a ship's windlass, his attribute in art.

Chippenham, St Margaret (Cambridgeshire); Axmouth, St Michael, (Devon); Tattersett, All Saints (Norfolk); Worcester, The Commandery (Worcestershire).

St Etheldreda

An Anglo-Saxon saint. She was the daughter of King Anna of the Angles and founded a monastery at Ely around AD 672. The present Cathedral stands on the site.

Eton College Chapel (Buckinghamshire); Willingham, St Mary & All Saints (Cambridgeshire); Worcester, The Commandery (Worcestershire).

St Eugenia

Roman martyr said to have disguised herself as a man to enter an Abbey.
Farnborough, St Peter (Hampshire).

St Eustace

A Roman commander who saw a stag with the holy cross between its antlers and converted to Christ. After numerous travailles he was martyred under the Emperor Hadrian.

Canterbury Cathedral (Kent).

St Faith

French Virgin martyr, sometimes also known as St Foi or Foy. Said to have been martyred at Agen (France) during the persecutions of the Emperor Diocletian. Patron saint of prisoners.
Horsham St Faith, St Faith's Priory (Norfolk); Westminster Abbey (London).

St Francis (1181–1226)

Italian saint who received the Stigmata – the five scars of Christ – on his own body in 1224. Founder of the order of Francisian friars. Can also be shown preaching to birds.
Receiving the Stigmata: *Doddington, Beheading of John the Baptist (Kent); Slapton, St Botolph (Northamptonshire).*
Preaching to Birds: *Little Kimble, All Saints (Buckinghamshire); Wissington/ Wiston, St Mary (Suffolk).*

St George

According to *The Golden Legend*, St George rescued the daughter of the King of Silene (in modern-day Libya) after she had been offered as a human sacrifice to a dragon which terrorized the city. Having converted the kingdom to Christianity by his bravery, the saint was eventually tortured (on a wheel fitted with swords, immersed in a cauldron of molten lead) and martyred for his faith by the Persian emperor, Dacian. Later legends claimed that St George appeared in a vision to the crusaders at the battle of Antioch in 1098. In the fourteenth century he was usually shown as a Christian knight wearing white armour or a surcoat adorned with a red cross. In the fifteenth century the image evolved and he was shown riding a white horse and slaying the dragon. At Astbury (Cheshire) he is shown as the Virgin's champion. St George was adopted as England's national patron saint in the fourteenth century by Edward III. The Order of the Garter's chapel at Windsor was dedicated to him. The earliest wall painting to depict the saint is at Hardham (West Sussex). During the fifteenth century he was often painted on a large scale, both comparable to, and paired with, images of St Christopher. As with other paintings of the same period, a number bustle with incidental details, such as human bones at the entrance to the dragon's lair, as at Dartford (Kent), and the Princess's parents watching St George from the walls of their city (Nether Wallop, Hants). The only surviving cycle of the Saint's life is at Hardham, St Boltoph (West Sussex).
Ampney St Mary, St Mary (Gloucestershire); Astbury, St Mary (Cheshire);

Figure 248
The martyrdom of St Sebastian:
Weare Gifford, Holy Trinity.

Banningham, St Botolph (Norfolk); Bartlow, St Mary (Cambridgeshire); Barton, St Peter (Cambridgeshire); Baulking, St Nicholas (Berkshire); Bedale, St Gregory (Yorkshire); Bradfield Combust, All Saints (Suffolk); Broughton, St Lawrence (Buckinghamshire); Calstock, St Andrew (Cornwall); Dartford, Holy Trinity (Kent); Earl Stonham, St Mary (Suffolk); East Wellow, St Margaret (Hampshire); Farleigh Hungerford Castle (Somerset); Fritton, St Catherine (near Long Stratton) (Norfolk); Hardham, St Botolph (West Sussex); Hartley Wintney, St Mary (Hampshire); Heath Chapel (Shropshire); Hornton, St John Baptist (Oxfordshire); Kirtlington, St Mary (Oxfordshire); Little Kimble, All Saints (Buckinghamshire); Llangattock Lingoed, St Cadoc (Wales: Monmouthshire); Llanmaes, St Cattwg (Wales: Vale of Glamorgan); Mobberley, St Wilfrid (Cheshire); Nether Wallop, St Andrew (Hampshire); Norwich, St Gregory (Norfolk); Padbury, St Mary (Buckinghamshire); Pickering, St Peter and St Paul (Yorkshire); Raunds, St Peter; (Northamptonshire); Slapton, St Botolph (Northamptonshire); St Just in Penwith, St Just (Cornwall); The Lee, Old Church (Buckinghamshire); Troston, St Mary (Suffolk); Willingham, St Mary and All Saints (Cambridgeshire); Wissington/Wiston, St Mary (Suffolk).

St Godwall (Gudwal)
Sixth-century Celtic abbot said to have commanded the sea not to flood his monastery.
Worcester, The Commandery (Worcestershire).

St Gregory the Great (AD 540–604)
Seventh-century Pope known as St Gregory the Great. In AD 596 he sent the Christian missionary, St Augustine, to England.
The Mass of St Gregory: *Slapton, St Boltolph (Northamptonshire);*

As one of the Four Doctors of the Church: *Norwich, St Gregory (Norfolk).*

St Helena, d. AD 330
The mother of the Emperor Constantine. Claimed to have discovered remnants of the True Cross on which Christ was crucified.
Ampney Crucis, Holy Rood (Gloucestershire); Broughton, St Lawrence (Buckinghamshire); Chalgrove, St Mary (Oxfordshire).

St James the Great (or Major)
One of the original Apostles. Patron saint of Spain and pilgrims. His attributes include a scallop shell, a pilgrim's staff to help him walk and 'fend off the wolf and the dog', a small scrip or pouch for his rations and a soft cap, known as a palmer's hat. The epithet 'Great' or 'Major' was used to distinguish him from the younger apostle of the same name, known as James the Less.
Ampney Crucis, Holy Rood (Gloucestershire); Belton, All Saints (Norfolk); Bradwell-juxta-Coggeshall (Essex); Chalgrave, All Saints (Bedfordshire); Hales, St Margaret (Norfolk); Ickleton, St Mary (Cambridgeshire); Little Kimble, All Saints (Buckinghamshire); South Newington, St Peter ad Vincula (Oxfordshire); St Albans Abbey (Hertfordshire); Stoke Orchard, St James the Great (Gloucestershire); Wisborough Green, St Peter ad Vincula (West Sussex); Yelden, St Mary (Bedfordshire).

St John the Baptist

John was the son of Mary's cousin, Elizabeth, and thus related to Jesus. Some Romanesque paintings tell the story of his birth: how an angel appeared to his father (The Annunciation to Zacharias) and how the saint was named: possibly that at Capel, St Thomas of Canterbury (Kent), for the former; certainly that at Canterbury Cathedral, St Gabriel's chapel, for the latter. As a man, St John lived in the wilderness and wore a coat of camel's skin. In some paintings the head of the camel is shown dangling by his legs, as at Ewelme, St Mary (Oxfordshire). Jesus was baptised by John, symbolising the beginning of his public ministry as the Son of God. Baptism subsequently became the essential first step for entering the Christian church.

When King Herod Antipas took his brother's wife, Herodias, as his lover, John rebuked him for breaking God's commandments. Although imprisoned by the King, the guilty pair wanted greater revenge. When Herodias's daughter won the King's pleasure after dancing at a feast he promised to give her anything she wanted as a reward. Herodias persuaded Salome to ask for John's head. The saint was then beheaded (The Decollation of St John), and his head served to her on a platter.

St John was the last prophet and the first saint.

Barton, St Peter (Cambridgeshire); Battle, St Mary (East Sussex); Black Bourton, St Mary (Oxfordshire); Canterbury Cathedral (Kent); Cerne Abbas, St Mary (Dorset); Chalfont St Giles, St Giles (Buckinghamshire); Chalgrove, St Mary (Oxfordshire); Cold Overton, St John Baptist (Leicestershire); Ewelme, St Mary (Oxfordshire); Fritton, St Edmund (near Great Yarmouth) (Norfolk); Godalming, St Peter & St Paul (Surrey); Heacham, St Mary (Norfolk); Heydon, St Peter and St Paul (Norfolk); Idsworth, St Hubert (Hampshire); Kingston Lisle, St John Baptist (Berkshire); North Stoke, St Mary (Oxfordshire); Old Weston, St Swithin (Cambridgeshire); Pickering, St Peter and St Paul (Yorkshire); Seething, St Margaret and St Remigius (Norfolk); Weston Longville, All Saints (Norfolk).

St John the Evangelist

The Apostle that Jesus loved more than any other. He is usually shown with his head resting on Jesus in paintings of the Last Supper. He was the author of one of the four Gospels. His evangelist symbol is the eagle which brought him a pen when he was exiled on the Isle of Patmos by the emperor Domitian and where he also wrote the Book of Revelation, prophesying the Final Judgement of mankind. Some paintings allude to his miraculous escape when he made the sign of the cross over a cup which had been poisoned by high priest of Diana at Ephesus and caused a Satan-like dragon to fly out. At Durham cathedral he is shown surviving immersion in a cauldron of boiling oil during the persecutions of the Emperor Domitian.

Durham Cathedral (Co. Durham); Holcot, St Mary and All Saints (Northamptonshire); Weston Longville, All Saints (Norfolk); Selling, St Mary (Kent).

St Juliana

Roman martyr beheaded after terrible tortures.

Eton College Chapel (Buckinghamshire).

St Katherine of Alexandria

St Katherine was one of the most popular female saints. According to *The Golden Legend*, she was a Christian virgin who defied the pagan emperor Maxentius when he ordered her to offer sacrifices to his Gods. Thereafter she trounced fifty of his best philosophers when they tried to persuade her of the errors of her ways. Having lost the argument they promptly converted to Christianity whereupon the emperor had them executed. The Saint then survived several terrible tortures (including being strapped to a spiked wheel miraculously destroyed by angels) before being beheaded for her beliefs. After her death she was buried on Mount Sinai in a monastery which still bears her name.

Paintings of her life and martyrdom survive, separately and in cycles. The longest cycles are at Sporle (Norfolk) and Great Burstead (Essex). Her attributes are the wheel of her tortures, the sword of her execution and the book which symbolises her superior knowledge over the pagan philosophers. At Soberton (Hampshire), she is shown trampling the wicked emperor below her feet. She is often paired with paintings of St Margaret. Cycles of her martyrdom are denoted with an asterisk.

Bardwell, St Peter & St Paul (Suffolk); Black Bourton, St Mary (Oxfordshire); Burton Latimer, St Mary (Northamptonshire)*; Cardiff, St Fagans, National History Museum (4 miles west of Cardiff city centre) (Wales: Vale of Glamorgan); Cassington, St Peter (Oxfordshire); Castor, St Kyneburgha (Cambridgeshire)*; Circencester, St John the Baptist (Gloucestershire); Cold Overton, St John Baptist (Leicestershire); Combe, St Laurence (Oxfordshire); Great Burstead, St Mary Magdalene (Essex)*; Great Chalfield, All Saints (Wiltshire)*; Hailes, Church (Gloucestershire); Hardley, St Margaret (Norfolk); Little Kimble, All Saints (Buckinghamshire); Little Missenden, St John Baptist (Buckinghamshire)*; Little Wenham, All Saints (Suffolk); Maidstone, All Saints (Kent); Nassington, St Mary and All Saints (Northamptonshire); North Stoke, St Mary (Oxfordshire); Norwich Cathedral (Norfolk); Old Weston, St Swithin (Cambridgeshire); Pickering, St Peter and St Paul (Yorkshire); Raunds, St Peter (Northamptonshire)*; Soberton, St Peter & St Paul (Hampshire); Sporle, St Mary (Norfolk)*; Wooton Wawen (Warwickshire)*.*

St Laurence/Lawrence, d. AD 259

A Deacon of Rome, martyred on a roasting gridiron after enraging the Prefect of the city by reacting to a demand that he hand over the riches of the church by presenting him with the poor whom it served. His attribute is a gridiron.

Abbots Langley, St Lawrence (Hertfordshire); Bishopsbourne, St Mary (Kent); Catfield, All Saints (Norfolk); Frindsbury, All Saints (Kent); Ickleton, St Mary (Cambridgeshire); Little Kimble, All Saints (Buckinghamshire); Milton Regis, Holy Trinity (Kent); North Stoke, St Mary (Oxfordshire); Ruislip, St Martin (Greater London); Ruscombe, St James (Berkshire).

St Margaret of Antioch

According to *The Golden Legend*, St Margaret was a Christian virgin who rejected the advances of the pagan prefect, Olibrius, and refused to worship his gods.

Terrible tortures then ensued. She was hung from her hair, immersed in boiling hot and freezing cold water, burned and scourged. While imprisoned she was allegedly swallowed by the devil in the guise of a dragon but escaped unscathed after making the sign of the cross. Another devil in human form then sought to deceive her but she threw him to the ground and put her foot on his neck. After further tortures and ordeals she was beheaded whereupon her executioner also dropped down dead. Individual representations of the Saint usually show her triumphing over a dragon while holding a cross-headed staff.

St Margaret was the patron saint of childbirth. During the Reformation prayers invoking her help were specifically banned. She is often paired with paintings of St Katherine. Cycles of her martyrdom are denoted by an asterisk. Single scenes of her tortures, as at Ashby St Ledgers (Northamptonshire), Stoke Dry (Rutland) and Little Kimble (Buckinghamshire) may have been part of now lost cycles.

Ashby St Ledgers, St Mary & St Leodegarius (Northamptonshire); Battle, St Mary (East Sussex); Binsted, St Mary (West Sussex); Byford, St John Baptist (Herefordshire); Cassington, St Peter (Oxfordshire); Charlwood, St Nicholas (Surrey)*; Claverley, All Saints (Shropshire)*; Cliffe-at-Hoo, St Helen (Kent)*; Cold Overton, St John Baptist (Leicestershire); Combe, St Laurence (Oxfordshire); Duxford, St John (Cambridgeshire)*; East Wellow, St Margaret (Hampshire)*; Eton College Chapel (Buckinghamshire); Hailes, Church (Gloucestershire); Hartley Wintney, St Mary (Hampshire); Heydon, St Peter and St Paul (Norfolk); Kempley, St Mary (Gloucestershire); Kidlington, St Mary (Oxfordshire); Little Kimble, All Saints (Buckinghamshire); Little Wenham, All Saints (Suffolk); Newington-next-Sittingbourne, St Mary (Kent); Norwich Cathedral (Norfolk); Old Weston, St Swithin (Cambridgeshire); Oxenton, St John Baptist (Gloucestershire); Rochester Cathedral (Kent); Soberton, St Peter & St Paul (Hampshire); South Newington, St Peter ad Vincula (Oxfordshire); Stoke Dry, St Andrew (Rutland); Stowell, St Leonard (Gloucestershire) (?); Sutton Bingham, All Saints (Somerset); Tarrant Crawford, St Mary (Dorset)*; Wendens Ambo, St Mary (Essex)*; Whitchurch, St John the Evangelist (Buckinghamshire); Wissington/Wiston, St Mary (Suffolk)*.*

St Martha

Sister of Lazarus and Mary of Bethany. One of the Three Marys at the Tomb.

Eton College Chapel (Buckinghamshire).

St Martin of Tours, d. AD 397

A Hungarian-born Roman knight who gave half of his cloak to a beggar after which he had a vision of Christ. He resigned from the army saying,

'I am Christ's soldier. I am not allowed to fight.' He was made Bishop of Tours in AD 370 and played a significant role in the conversion of France to Christianity. He was an active missionary and is regarded as the 'Father' of monasticism in France.
Wareham, St Martin (Dorset); Chalgrave, All Saints (Bedfordshire); Nassington, St Mary and All Saints (Northamptonshire).

St Mary of Egypt
Fifth-century penitent prostitute who lived in the wilderness.
Eton College Chapel (Buckinghamshire).

St Mary Magdalene
Usually portrayed with long hair and holding a jar of ointment. She appears in several post-Resurrection scenes, in particular as one of the Three Marys at the Sepulchre and when she met Christ shortly after his Resurrection and was told not to touch him – *Noli me Tangere.*
Chalgrove, St Mary (Oxfordshire); Eton College Chapel, (Buckinghamshire); Ewelme, St Mary (Oxfordshire); Farnborough, St Peter (Hampshire); Glatton, St Nicolas (Cambridgeshire); Little Wenham, All Saints (Suffolk); Llantwit Major, St Illtud (Wales: Vale of Glamorgan).

St Morwenna
Cornish saint and patron saint of Morwenstow who was said to have carried a stone on her head from which a well sprang when she put it down.
Stratford-upon-Avon, Guild Chapel (Warwickshire).

St Nicholas
Fourth-century Bishop of Myra whose remains were re-interred at Bari in Italy in 1087. St Nicholas was one of the most popular pan-European saints. Many miracles were attributed to him. Known as the patron saint of children, he was said to have given three bags of gold to save three girls from prostitution and to have revived three murdered boys pickled in a brine tub during a famine. One of his best-known stories was the Miracle of the Cup, painted on the north wall at Haddon Hall Chapel around 1427. It tells the story of a wealthy man who promised to give a gold cup to the saint's tomb if he were given a son. The son was duly born and the man had the cup made. But when it was finished he kept it for himself and ordered a copy to be made for the saint. On the way to the tomb he asked his son to fetch him some water in the first cup. But the boy fell into the sea (or a river) and was presumed drowned. Although grief-stricken the father continued his journey to the tomb, but when he offered the second cup to the altar, an unseen hand threw it back and knocked him to the ground. His dead son then appeared holding the first cup and told how St Nicholas had saved him and kept him safe and well whereupon the grateful father gave both cups to the saint. Cycles of his Miracles are denoted with an asterisk.
Aldermaston, St Mary (Berkshire); Ashmansworth, St James (Hampshire); Bishopbourne, St Mary (Kent); Charlwood, St Nicholas (Surrey); Colwinston,*

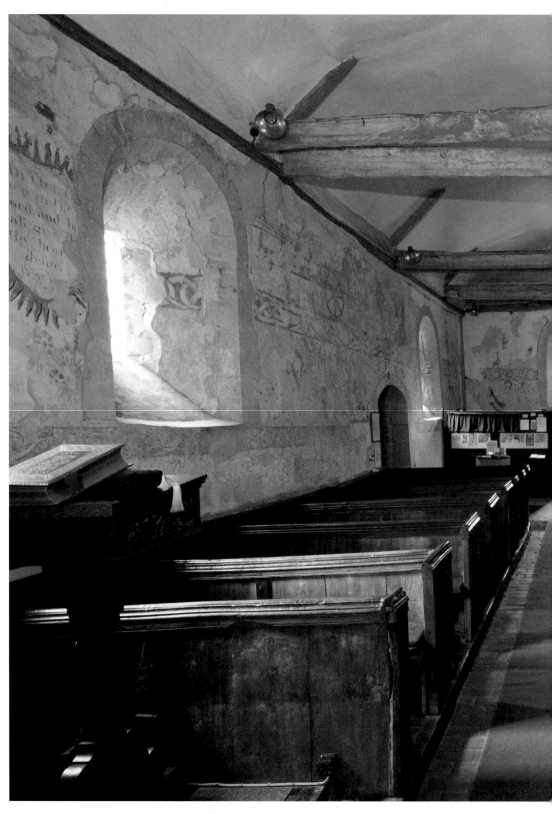

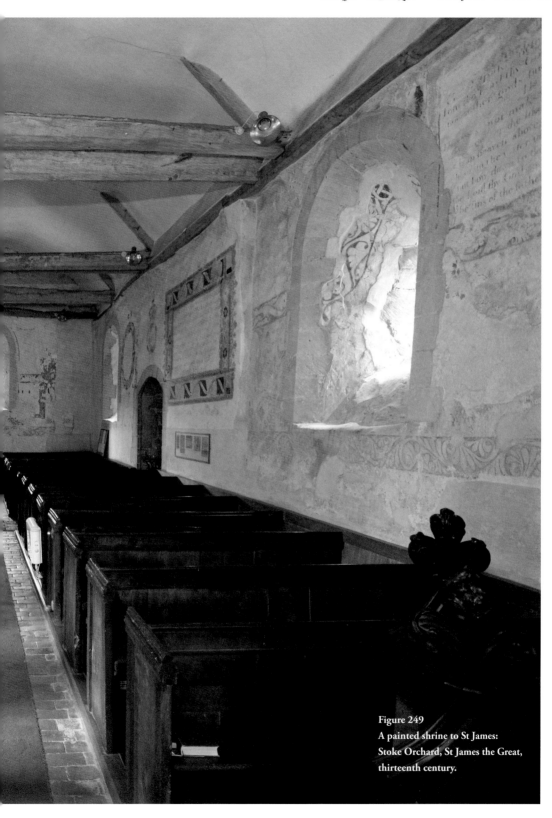

Figure 249
A painted shrine to St James:
Stoke Orchard, St James the Great,
thirteenth century.

St Michael (Vale of Glamorgan); Haddon, Haddon Hall Chapel (Derbyshire);*
Inworth, All Saints (Essex); Little Horwood, St Nicholas (Buckinghamshire);*
Nether Wallop, St Andrew (Hampshire); Norwich Cathedral (Norfolk);
Padworth, St John Baptist (Berkshire); Potter Heigham, St Nicholas (Norfolk);
Romsey Abbey (Hampshire); Wissington/Wiston, St Mary (Suffolk).*

St Paul

St Paul was the Apostle to the gentiles, spreading Christianity to Europe.
Born in Tarsus, his first name was Saul. Although he took part in the stoning
of **St Stephen,** he subsequently converted to Christianity after a vision on
the road to Damascus and took the name of Paul. Charged with preaching
against Jewish law, he used his Roman citizenship to appeal to Caesar. On his
way to Rome he was shipwrecked in Malta where he survived a snake-bite,
as depicted at St Anselm's Chapel, Canterbury Cathedral. Later he refuted
Simon Magus, a sorcerer who tried to buy the powers of the church (simony),
as shown at Milton Regis, Holy Trinity (Kent). St Paul was martyred under
the emperor Nero. Usually shown with a bald head and a long beard, his
emblems are the sword (of his execution) and the Book of Law (Clayton,
East Sussex).

Ampney Crucis, Holy Rood (Gloucestershire); Black Bourton, St Mary
(Oxfordshire); Canterbury Cathedral (Kent); Chalgrave, All Saints
(Bedfordshire); Chalgrove, St Mary (Oxfordshire); Checkendon, St Peter and
St Paul (Oxfordshire); Clayton, St John the Baptist (East Sussex); Coombes,
Church (West Sussex); Durham Cathedral (Co. Durham); Hereford Cathedral
(Herefordshire); Hook Norton, St Peter (Oxfordshire); Idsworth, St Hubert
(Hampshire); Kingston Lisle, St John Baptist (Berkshire); Little Hampden,
Church (Buckinghamshire); Marston Magna, St Mary (Somerset); Milton Regis,
Holy Trinity (Kent); Newington-next-Sittingbourne, St Mary (Kent); Norwich
Cathedral (Norfolk); Ruscombe, St James (Berkshire); Selling, St Mary (Kent).

St Peter

A fisherman who became the leader of the Apostles. Also known as Simon
Peter, he was the brother of St Andrew. Told by Christ that he was 'the rock'
on whom the church would be built. Martyred under Nero and crucified
upside down, as shown at Chacombe, (Northants). St Peter is regarded as the
first Pope. His attribute are the Keys to Heaven. He appears in many Last
Judgement schemes and groupings of the Apostles.

Black Bourton, St Mary (Oxfordshire); Chacombe, St Peter and St Paul
(Northamptonshire); Chalgrave, All Saints (Bedfordshire); Chalgrove, St Mary
(Oxfordshire); Checkendon, St Peter and St Paul (Oxfordshire); Clayton, St John
the Baptist (East Sussex); Coombes, Church (West Sussex); possibly Doddington,
Beheading of John the Baptist (Kent); Durham Cathedral (County Durham);
possibly Fritton, St Edmund (near Great Yarmouth) (Norfolk); Hook Norton, St
Peter (Oxfordshire); Ickleton, St Mary (Cambridgeshire); Idsworth, St Hubert
(Hampshire); Kempley, St Mary (Gloucestershire); Kingston Lisle, St John
Baptist (Berkshire); Little Hampden, Church (Buckinghamshire); Newington-
next-Sittingbourne, St Mary (Kent); Norwich Cathedral (Norfolk); Plumpton,

St Michael (East Sussex); Radnage, St Mary (Buckinghamshire); Ruscombe, St James (Berkshire); Selling, St Mary (Kent); Worcester Cathedral (Worcestershire); Worcester, The Commandery (Worcestershire).

St Richard of Chichester (1197–1253)
Bishop of Chichester 1245–53. Author of the famous prayer 'May I know thee more clearly, love thee more dearly, and follow thee more nearly'.
Black Bourton, St Mary (Oxfordshire); Norwich Cathedral (Norfolk).

St Roche or Rock
A fourteenth-century pilgrim and healer. Stricken with plague at Piacenza he was apparently cured, succoured by a dog. Often portrayed with an angel pointing to his plague spot. At Pinvin (Worcestershire) his image was painted over an earlier six-scene scheme of the Life of Christ.
Pinvin, St Nicholas (Worcestershire) Worcester, The Commandery (Worcestershire).

St Sebastian
A roman knight martyred under the emperor Diocletian and, like St Edmund, executed by archers. He was thought to provide protection against plague.
Possibly Weare Gifford, Holy Trinity (Devon)

St Sidwell of Exeter
A pious maiden murdered by haymakers at the instigation of her stepmother.
Eton College Chapel (Buckinghamshire)

St Sitha
See: St Zita

St Spiridon (or Spiridion)
A fourth-century Bishop of Trimethus in Cyprus said to have had miraculous powers. Fragmentary remains of a six-scene cycle can be seen at Upchurch (Kent), showing the miracle where the saint turned a serpent into gold which he lent to a farmer to buy seed and then changed it back into the serpent after the money had been returned.
Upchurch, St Mary (Kent).

St Stephen
A Christian deacon. The first martyr of the church. Stoned to death in Jerusalem around AD 35.
Black Bourton, St Mary (Oxfordshire); Catfield, All Saints (Norfolk); North Stoke, St Mary (Oxfordshire); Ruscombe, St James (Berkshire).

St Swithin or Swithun, d. AD 862
Anglo-Saxon Bishop of Winchester. Legends associated with the saint include the claim that the weather on his feast day – 15 July – will continue for the next forty days. Assorted miracles include his restoration of a widow's broken eggs.
Corhampton, Church (Hampshire).

St Thomas Becket (1118–1170)

St Thomas Becket was the greatest martyr of the English medieval church. He was murdered at the high altar of Canterbury Cathedral on 29 December 1170 by four knights loyal to Henry II. As news of his murder spread across Europe, the church moved quickly. Miracles were attributed to his blood and in 1193 he was canonized and Henry forced to undertake public penance. For the next four hundred years the saint's shrine at Canterbury was one of the greatest pilgrim destinations of Western Christendom. Paintings of the saint survive in his archiepiscopal vestments, occasionally inscribed 'Thomas', or in his act of Martyrdom. Apart from the saint and his assailants, the latter scene often includes a depiction of Edward Grim, a monk who tried to protect the Archbishop. Remains of a unique three-scene scheme of Becket's martyrdom death survive at Stow (Lincolnshire), where he was shown eating a last supper before his death. After Henry VIII declared himself Supreme Head of the English Church in 1534, Becket was denounced as a rebel and a traitor, his shrine smashed and wall paintings of the saint defiled and obliterated.

Paintings of St Thomas usually show him either as a bishop administering a blessing or being attacked during his Martyrdom. Paintings of his Martyrdom are denoted with an asterisk.

Abbots Langley, St Lawrence (Hertfordshire); Ashmansworth, St James (Hampshire); Black Bourton, St Mary (Oxfordshire)*; Bramley, St James (Hampshire)*; Breage, St Breaca (Cornwall); Brookland, St Augustine (Kent)*; East Wellow, St Margaret (Hampshire)*; Hadleigh, St James the Less (Essex); Hauxton, St Edmund (Cambridgeshire); Kempley, St Mary (Gloucestershire)*; Little Horwood, St Nicholas (Buckinghamshire)*; Lydiard Tregoze, St Mary (Wiltshire)*; Maidstone, All Saints (Kent); Marston Magna, St Mary (Somerset)*; Newton, St John Baptist (Wales: Bridgend)*; North Stoke, St Mary (Oxfordshire)*; Pickering, St Peter and St Paul (Yorkshire)*; Preston, St Peter (East Sussex)*; South Burlingham, St Edmund (Norfolk)*; South Cadbury, St Thomas Becket (Somerset); South Newington, St Peter ad Vincula (Oxfordshire)*; St Albans Abbey (Hertfordshire); Stone (near Dartford), St Mary the Virgin (Kent)*; Stow-in-Lindsey, St Mary (Lincolnshire); Stratford upon Avon, Guild Chapel (Warwickshire)*; Winslow, St Laurence (Buckinghamshire)*; Worcester Cathedral (Worcestershire).*

St Thomas de Canteloupe/Cantilupe (or Hereford) (1218–82)

Formidable Bishop of Hereford who clashed with the Archbishop of Canterbury, John Pecham (Peckham). After miracles were reported at his tomb he was canonized while still excommunicated by Pecham.

Barton, St Peter (Cambridgeshire).

True Cross, Legend/Invention of

According to accounts in *The Golden Legend* when Adam lay dying he asked his son, Seth, to go to the Archangel Gabriel and beg for life-saving oil from the Tree of Life in the Garden of Eden. But the Archangel refused and after

Adam's death, Seth planted a branch from the tree over his father's grave which, in time, also grew into a magnificent tree.

The tree was still flourishing during the reign of King Solomon when the King ordered it to be cut down and used to build a temple. But no matter how often his builders tried to use it, the timber was always too long or too short. Eventually it was thrown across a pond as a bridge and when the Queen of Sheba visited Solomon she had a vision on the bridge and told her host that one day a man would be hung from it whose death would spell the end to the Jewish kingdom.

Afraid of what was meant, Solomon ordered the timber to be buried where it remained for fourteen generations until it was found and used to make the cross of the crucifixion. After Christ's death the cross was buried and a Roman temple built over the site.

Following the emperor Constantine's conversion to Christianity, his mother St Helena destroyed the Temple and discovered the True Cross. Relics were displayed in Constantinople and Jerusalem. In AD 614 the Persian king, Khosru II (Chosroe) stole the latter relic when he captured the city but it was recovered when the Byzantine emperor, Heraclius, defeated Chosroes in AD 628. Many churches claimed to own fragments of the True Cross, including St Mary's, Warwick, and St George's Chapel, Windsor.

A cycle of paintings depicting the Legend was discovered during the 1804 restoration of the Guild Chapel (of the Holy Cross) in Stratford-upon-Avon, Warwickshire.

St Uncumber or Wilefortis
Virgin martyr who grew a beard to avoid marriage to a heathen king and who was crucified upside down.
Possibly: *Burton, Church (West Sussex).*

St Ursula
German Virgin martyr, allegedly killed with 11,000 others.
Eton College Chapel (Buckinghamshire).

St Walstan
Norfolk saint popular with farmers as he is said to have worked with farm labourers. He was often shown with a scythe or farm animals.
Cavenham, St Andrew (Suffolk).

St Winifred
Seventh-century Welsh saint who was beheaded and restored to life. Her relics were enshrined in the Benedictine Abbey church at Shrewsbury in 1138. Pilgrimages followed.
Eton College Chapel (Buckinghamshire).

St Zita (Sitha or Zitha), d. 1278
A pious Italian domestic servant acclaimed as patron saint of maidservants after her death at Lucca in 1278. Her attribute is a bunch of household keys

and a purse.

Horley, St Etheldreda (Oxfordshire); Shorthampton, All Saints (Oxfordshire); St Albans Abbey (Hertfordshire)

There are a number of useful books about saints and their attributes, including: *The Oxford Dictionary of Saints* and *Hall's Dictionary of Subjects and Symbols in Art.* Modern translations of *The Golden Legend* and a Middle English version of the *South English Legendary* are available. Studies of the lives of individual saints can also provide useful information.

DEATH AND THE AFTERLIFE

The Doom

Pre-1200 – Hardham, St Boltolph (West Sussex); Chaldon, St Peter and St Paul (Surrey); Houghton-on-the-Hill (Norfolk); Stowell, St Leonard (Gloucestershire); Witley, All Saints (Surrey).

Thereafter: Ashampstead, St Clement (Berkshire); Ashmansworth, St James (Hampshire); Bacton, St Mary (Suffolk); Battle, St Mary (East Sussex); Beckley, St Mary (Oxfordshire); Berkeley, St Mary (Gloucestershire); Bloxham, St Mary (Oxfordshire); Blyth, St Mary and St Martin (Nottinghamshire); Bradfield, St Giles (Norfolk); Bradwell-juxta-Coggeshall, Holy Trinity (Essex); Broughton, All Saints (Cambridgeshire); Broughton, St Lawrence (Buckinghamshire); Cassington, St Peter (Oxfordshire); Chelsworth, All Saints (Suffolk); Chesterton St Andrew (Cambridgeshire); Colchester, St Martin (Essex); Combe, St Laurence (Oxfordshire); Corby Glen, St John Evangelist (Lincolnshire); Coventry, Holy Trinity (Warwickshire); Croughton, All Saints (Northamptonshire); Denham, St Mary (Buckinghamshire); Earl Stonham, St Mary (Suffolk); East Bedfont, St Mary the Virgin (Greater London); East Harling, St Peter and St Paul (Norfolk); Flamstead, St Leonard (Hertfordshire); Ford, St Andrew (West Sussex); Great Bowden, St Peter and St Paul (Leicestershire); Great Harrowden, All Saints (Northamptonshire); Great Shelford, St Mary (Cambridgeshire); Harbledown, St Nicholas (Kent); Hastings, All Saints (East Sussex); Hornton, St John the Baptist (Oxfordshire); Houghton Conquest, All Saints (Bedfordshire); Hoxne, St Peter and St Paul (Suffolk); Ickleton, St Mary (Cambridgeshire); Ilketshall St Andrew, St Andrew (Suffolk); Kelmscott. St George (Oxfordshire); Kempley, St Mary (Gloucestershire); Lathbury, All Saints (Buckinghamshire); Little Kimble, All Saints (Buckinghamshire); Little Missenden, St John Baptist (Buckinghamshire); Lutterworth, St Mary (Leicestershire); Lyddington, St Andrew (Rutland); Marston Moretaine, St Mary the Virgin (Bedfordshire); Marton, St James and St Paul (Cheshire); Nassington, St Mary & All Saints (Northamptonshire); Newington-next-Sittingbourne, St Mary (Kent); North Cove, St Botolph (Suffolk); North Leigh, St Mary (Oxfordshire); North Stoke, St Mary (Oxfordshire); Oddington, St Nicholas (Gloucestershire); Patcham, All Saints (East Sussex); Pickworth, St Andrew (Lincolnshire); Portsmouth Cathedral (Hampshire); Rotherfield, St Denys (East Sussex); Salisbury, St Thomas (Wiltshire); Shorthampton, All

Saints (Oxfordshire); South Leigh, St James (Oxfordshire); South Newington, St Peter ad Vincula (Oxfordshire); Stanningfield, St Nicholas (Suffolk); Stoke-by-Clare, St John the Baptist (Suffolk); Stratford upon Avon, Guild Chapel (Warwickshire); Sundon, St Mary (Bedfordshire); Waltham Abbey, Abbey Church (Essex); West Somerton, St Mary (Norfolk); Willingham, St Mary & All Saints (Cambridgeshire); Winslow, St Laurence (Buckinghamshire); Wissington/Wiston, St Mary (Suffolk); Woodham Ferrers, St Mary the Virgin (Essex); Wymington, St Lawrence (Bedfordshire); Yaxley, St Mary (Suffolk); Yaxley, St Peter (Cambridgeshire).

The Weighing of Souls

Bartlow, St Mary (Cambridgeshire); Barton, St Peter (Cambridgeshire); Beckley, St Mary (Oxfordshire); Bishopbourne, St Mary (Kent); Bradwell, Bradwell Abbey, St Mary's Chapel (Buckinghamshire); Broughton, St Lawrence (Buckinghamshire); Burton Latimer, St Mary (Northamptonshire); Byford, St John Baptist (Herefordshire); Catherington, All Saints (Hampshire); Clayton, St John the Baptist (East Sussex); Corby Glen, St John Evangelist (Lincolnshire); Cowlinge, St Margaret (Suffolk); Croughton, All Saints (Northamptonshire); Great Burstead, St Mary Magdalene (Essex); Great Tew, St Michael (Oxfordshire), Hailes, Church (Gloucestershire); Hessett, St Ethelbert (Suffolk); Holcot, St Mary and All Saints (Northamptonshire); Imber, St Giles (Wiltshire); Kempley, St Mary (Gloucestershire); Lathbury, All Saints (Buckinghamshire); Lenham, St Mary (Kent); Little Hampden, Church (Buckinghamshire); Llangybi, (sometimes written Llangibby) St Cybi (Wales: Monmouthshire); Lydiard Tregoze, St Mary (Wiltshire); Nassington, St Mary & All Saints (Northamptonshire); Newton, St John Baptist (Wales: Bridgend); Paston, St Margaret (Norfolk); Pickworth, St Andrew (Lincolnshire); Preston, St Peter (East Sussex); Purton, St Mary (Wiltshire); Rotherfield, St Denys (East Sussex); Ruislip, St Martin (Greater London); Shelton, St Mary (Bedfordshire); Slapton, St Botolph (Northamptonshire); South Leigh, St James (Oxfordshire); South Newington, St Peter ad Vincula (Oxfordshire); Stanion, St Peter (Northamptonshire); Stowell, St Leonard (Gloucestershire); Swalcliffe, St Peter and St Paul (Oxfordshire); The Lee, Old Church (Buckinghamshire); Toddington, St George (Bedfordshire); Winterbourne, St Michael (Gloucestershire); Worcester, The Commandery (Worcestershire).

The Three Living and The Three Dead

Alton, St Peter (Staffordshire); Barrington, All Saints, (Cambridgeshire); Belchamp Walter, St Mary (Essex); Belton, All Saints (Norfolk); Charlwood, St Nicholas (Surrey); Cranborne, St Mary and St Bartholomew (Dorset); Edworth, St George (Bedfordshire); Flamstead, St Leonard (Hertfordshire); Great Burstead, St Mary Magdalene (Essex); Great Livermere, St Peter (Suffolk); Haddiscoe, St Mary (Norfolk); Haddon, Haddon Hall Chapel (Derbyshire); Heydon, St Peter and St Paul (Norfolk); Hurstbourne Tarrant, St Peter (Hampshire); Kentford, St Mary (Suffolk); Little Tey, St James the Less (Essex); Lutterworth, St Mary (Leicestershire); North Stoke, St Mary (Oxfordshire); Packwood,

St Giles (Warwickshire); Paston, St Margaret (Norfolk); Peakirk, St Pega (Cambridgeshire); Pickworth, St Andrew (Lincolnshire); Raunds, St Peter (Northamptonshire); Seething, St Margaret and St Remigius (Norfolk); Slapton, St Botolph (Northamptonshire); Tarrant Crawford, St Mary (Dorset); Wensley, Holy Trinity (Yorkshire); Wickhampton, St Andrew (Norfolk); Widford, St Oswald (Oxfordshire); Winterbourne, St Michael (Gloucestershire).

PIETIES: GOOD VERSUS EVIL

The Seven Deadly Sins

Alveley, St Mary (Shropshire); Arundel, St Nicholas Priory (West Sussex); Branscombe, St Winifred (Devon); Corby Glen, St John Evangelist (Lincolnshire); Cranborne, St Mary & St Bartholomew (Dorset); Crostwight, All Saints (Norfolk); Dalham, St Mary (Suffolk); Hardwick, St Mary (Cambridgeshire); Hartley Wintney, St Mary (Hampshire); Hessett, St Ethelbert (Suffolk); Hook Norton, St Peter (Oxfordshire); Hoxne, St Peter and St Paul (Suffolk);Imber, St Giles (Wiltshire); Kingston, All Saints and St Andrew (Cambridgeshire); Little Hampden, Church (Buckinghamshire); Little Horwood, St Nicholas (Buckinghamshire); Llangar, Church (Wales: Denbighshire); Oddington, St Nicholas (Gloucestershire); Padbury, St Mary (Buckinghamshire); Poundstock, St Winwaloe (Cornwall); Raunds, St Peter (Northamptonshire); Ruislip, St Martin (Greater London); South Leigh, St James (Oxfordshire); Wooton Wawen, St Peter (Warwickshire); Trotton, St George (West Sussex).

The Seven Works of Mercy
Arundel, St Nicholas Priory (West Sussex); Barnby, St John Baptist (Suffolk); Baulking, St Nicholas (Berkshire); Catfield, All Saints (Norfolk); Dalham, St Mary (Suffolk); Edingthorpe, All Saints (Norfolk); Hardwick, St Mary (Cambridgeshire); Hoxne, St Peter and St Paul (Suffolk); Kingston, All Saints and St Andrew (Cambridgeshire); Lathbury, All Saints (Buckinghamshire); Linkinhorne, St Mellor (Cornwall); Little Horwood, St Nicholas (Buckinghamshire); Moulton St Mary, St Mary (Norfolk); Oddington, St Nicholas (Gloucestershire); Pickering, St Peter and St Paul (Yorkshire); Potter Heigham, St Nicholas (Norfolk); Ringshall, St Katherine (Suffolk); Ruabon, St Mary (Wales: Denbighshire); Ruislip, St Martin (Greater London); Toddington, St George (Bedfordshire); Trotton, St George (West Sussex); Wickhampton, St Andrew (Norfolk).

The Seven Virtues
Cranborne, St Mary and St Bartholomew (Dorset).

The Sunday Christ
Ampney St Mary, St Mary (Gloucestershire); Breage, St Breaca (Cornwall); Duxford, St John (Cambridgeshire); Hessett, St Ethelbert (Suffolk); Llangybi, (sometimes written Llangibby) St Cybi (Wales: Monmouthshire); Michaelchurch Escley, St Michael (Herefordshire); Nether Wallop, St Andrew (Hampshire);

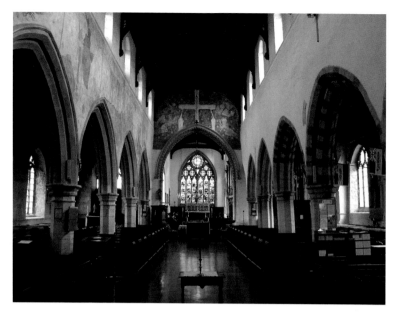

Figure 251
The painted nave: Raunds, St
Peter, fifteenth century.

Oaksey, All Saints (Wiltshire); Poundstock, St Winwaloe (Cornwall); Purton, St Mary (Wiltshire); St Just in Penwith, St Just (Cornwall); West Chiltington, St Mary (West Sussex).

The Warning to Blasphemers
Broughton, St Lawrence (Buckinghamshire); Corby Glen, St John Evangelist (Lincolnshire).

The Warning to Janglers
Brook, St Mary (Kent); Colton, St Andrew (Norfolk); Crostwight, All Saints (Norfolk); Eaton, St Andrew (near Norwich) (Norfolk); Grundisburgh, St Mary (Suffolk); Little Melton, St Mary and All Saints (Norfolk); Lower Halstow, St Margaret (Kent); Melbourne, St Michael and St Mary (Derbyshire); Naughton, St Mary (Suffolk); Peakirk, St Pega (Cambridgeshire); Seething, St Margaret and St Remigius (Norfolk); Slapton, St Botolph (Northamptonshire); Wissington/ Wiston, St Mary (Suffolk).

CHRISTIAN SYMBOLS & ALLEGORIES

Wheel of Fortune
Catfield, All Saints (Norfolk); Ilketshall St Andrew, St Andrew (Suffolk); Rochester Cathedral (Kent)

Wheel of Life
Kempley, St Mary (Gloucestershire); Leominster Priory (Herefordshire).

Signs of the Zodiac
Copford, St Michael and All Angels (Essex).

Select Bibliography

T his is a list of books about wall paintings. It does not include studies of medieval architecture and religious life which often mention wall paintings. Nor does it include local histories, churchwarden accounts and studies of the Reformation which proved useful during the writing of this book. That said, Eamon Duffy's *The Stripping of the Altars* (1992); Richard Marks's *Image and Devotion in Late Medieval England* (2004) and 'The Pevsner Architectural Guides' series have been invaluable.

BOOKS ABOUT WALL PAINTINGS

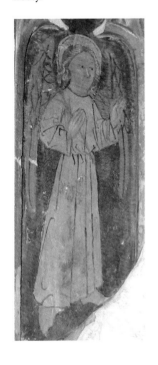

Angel: Buckland, St Michael, fifteenth century. Possibly from a reredos, formerly at Hailes Abbey.

Babington, C., T. Manning and S. Stewart (1999) *Our Painted Past: Wall Paintings of English Heritage*, London.

Bell, C. (1947) *Twelfth Century Paintings at Hardham & Clayton*, Lewes.

Binski, P. (1986) *The Painted Chamber at Westminster*, Society of Antiquaries Occasional Paper n.s. 9, London.

Binski, P. (1991) *Painters, Medieval Craftsmen*, London.

Bird, W.H. (1927) *Ancient Mural Paintings in the Churches of Gloucestershire*, Gloucester.

Borenius T. and E. W. Tristram (1927) *English Medieval Painting*, Paris.

Burnham P. (ed.) (1986) *Conservation of Wall Paintings – the International Scene*, London.

Caiger-Smith, A. (1963) *English Medieval Mural Paintings*, Oxford.

Cather, S. (1991) *The Conservation of Wall Paintings, Proceedings of a Symposium organized by the Courtauld Institute of Art and the Getty Conservation Institute, London, July 13–16, 1987.* [Editor's note: None of the contributions specifically discuss English or Welsh paintings]

Cather, S., D. Park and P. Williamson (eds) (1990) *Early Medieval Wall Painting and Painted Sculpture in England*, BAR British Series, 216.

Davidson, C. (1988) *The Guild Chapel Wall Paintings at Stratford-upon-Avon*, New York.

Fawcitt, A. (1990) *The Wallpaintings of Willingham*, Willingham.

Gowing R. and A. Heritage (eds) (2000) *Conserving the Painted Past:*

Developing Approaches to Wall Painting Conservation (post-prints of an English Heritage Conference, 1999), London.

Heath-Whyte, R.W. (2003) *An Illustrated Guide to the Medieval Wall Paintings in the Church of Saint Mary the Virgin at Chalgrove in the County of Oxfordshire*, Chalgrove.

Howard, H. (2003) *Pigments of English Medieval Wall Painting*, London.

James, M. R. (1907) *The Frescoes in the Chapel at Eton College. Facsimilies of the Drawings by R. H. Essex, with Explanatory Notes*, London

Kendon, F. (1923) *Mural Paintings in English Churches during the Middle Ages*, London.

Keyser, C. E. (1883) *A List of Buildings in Great Britain and Ireland having Mural and other Painted Decorations, of Dates Prior to the Latter Part of the Sixteenth Century*, London.

Meates, G. W. (1987) *The Roman Villa at Lullingstone, Kent. II. The Wall Paintings and Finds,* Monograph Series of the Kent Archaeological Society, Vol. III, Maidstone.

Mora, P., L. Mora and P. Philippot (1984) *Conservation of Wall Paintings*, London.

Reeve, M. M. (2008) *The Thirteenth-Century Wall Paintings of Salisbury Cathedral: Art, Liturgy, and Reform*, Woodbridge.

Reiss, A. (2000) *The Sunday Christ: Sabbatarianism in English Medieval Wall Painting*, BAR British series 292.

Rickert, M. (1954) *Painting in Britain: The Middle Ages*, London.

Roberts E. (1993) *The Wall Paintings of Saint Albans Abbey*, St Albans.

Rouse, E. Clive (1968 with later revisions and reprints) *Discovering Medieval Wall Paintings*, Princes Risborough.

Rouse, E. Clive (1987 with reprints) *Longthorpe Tower*, English Heritage Handbook, London.

Tristram, E. W. (1944) *English Medieval Wall Painting: The Twelfth Century*, London.

Tristram, E. W. (1950) *English Medieval Wall Painting: The Thirteenth Century*, two volumes, London.

Tristram, E.W. (1954) *English Medieval Wall Painting: The Fourteenth Century*, London.

Victoria and Albert Museum (1932) *A Picture Book of English Medieval Wall Paintings*, London.

Wall, J. Charles (n.d. 1914?) *Medieval Wall Paintings*, London.

Waite, H. C. (1929) *St. Christopher in English Medieval Wallpainting*, London.

And for an affectionate, fictional account of the restoration of a wall painting:

Carr, J. L. (1980) *A Month in the Country*.

A Selection of Studies about Irish and Continental Wall Paintings (English language only)

Ainaud, J. (1962) *Spanish Frescoes of the Romanesque Period*, London.

Anthony, E. W. (1951) *Romanesque Frescoes*, Princetown.

Bolvig, A. (2003) 'Danish Medieval Wall Painting', in P. Lindley (ed.) *Making Medieval Art*, Donnington: 140–151.

Bolvig, A. (2003) ' Reformation of What? Whose and Which Reformation is exposed in Danish wall-paintings', in D. Gaimster and R. Gilchrist (ed.) *The Archaeology of Reformation 1480 – 1580*, Leeds: 84 – 93.

Borelius, A. (1956) *Romanesque Mural Paintings in Östergötland*, Stockholm. Text in English and Swedish.

Borenius, T. (1932) 'The Gothic Wall Paintings of the Rhineland', *Burlington Magazine*, **61**, No. 356: 218–224.

Borsook, E. (1980) *The Mural Painters of Tuscany*, Oxford.

Caie, Graham D. (1998) 'Drama on the Wall: Medieval Drama Illustrated by Danish Church Wall Paintings', in S. Higgins and F. Paino (eds), *European Medieval Drama 1*, Camerino: 21–31.

Dale, Thomas E.A. (1997) *Relics, Prayer, and Politics in Medieval Venetia: Romanesque Painting in the Crypt of Aquileia Cathedral*, Princetown.

Dale, T. (ed.) with J. Mitchell (2004) *Sacred Space and Institutional Identity in Romanesque Mural Painting*, Aldershot.

Demus, O. (1970) *Romanesque Mural Painting*, London.

Dvorakova, V. and J. Krasa, A. Merhautova and K. Stejskal (1964*) Gothic Mural Painting in Bohemia and Moravia 1300–78*, Oxford.

Hublow, K. (1979) *The Working of Christ in Man: Thousand Year Old Frescoes in the Church of St George on the Island of Reichenau*, Edinburgh.

Inguenard, V. (2004) 'Notes on some Burgundian Painted Wall Decorations' in *Art from the Court of Burgundy 1364–1419*, Cleveland Museum of Art: 290–294.

Kupfer, M. (1993) *Romanesque Wall Painting in Central France*, New Haven and London.

Jensen, J. M. (2003) 'The Wall-Paintings of Sulsted Church, Denmark: Between the Middle Ages and the Reformation?', in D. Gaimster and R. Gilchrist, *The Archaeology of Reformation 1480–1580*, Leeds: 94–107.

Lavin, M. A. (1990*) The Place of Narrative; Mural Decoration in Italian Churches, 431–1600,* Chicago.

Manning, C. (2005) *A New Survey of Clare Island, Volume Four, The Abbey*, Dublin.

Michel, P-H. (1949) *Romanesque Wall Paintings in France*, Paris.

Mitchell, J. (1990) 'Early Medieval Wall Paintings Excavated in Germany, Italy and England: a Preliminary Survey', in Cather, S., D. Park and P. Williamson (eds) *Early Medieval Wall Painting and Painted Sculpture in England*, BAR Series 216, 123–133.

Morton, K. (2006) 'Aspects of Image and Meaning in Irish Medieval Wall Paintings', in R. Moss, C. O' Clabaigh and S. Ryan (eds) *Art and Devotion in Late Medieval Ireland*, Dublin: 51–71.

Oakshott, W. (1972) *Sigena: Romanesque Paintings in Spain and the Artists of the Winchester Bible*, London.

Pacht, O. (1961) 'A Cycle of English Frescoes in Spain', *The Burlington Magazine*, **103**, No. 698: 166–175.

Stratford, N. (1993) 'The wall-paintings of the Petit-Quevilly', in J. Stratford (ed) *Medieval Art, Architecture and Archaeology at Rouen: British Archaeological Association Conference Transactions for the year 1986*, **12**: 51–59.

Walker, R. (2000) 'The Wall Paintings in the Panteon de los Reyes at Leon: A Cycle of Intercession', *The Art Bulletin*, **82**: 200–225.

There are also a large number of books about individual Italian mural artists and particular paintings. In addition, some Danish language books about medieval wall paintings include many useful illustrations.

CHAPTERS AND ARTICLES ABOUT WALL PAINTINGS IN GREAT BRITAIN

This is a list of some of the published guides, chapters and articles about wall paintings that I found useful in writing this book. Inclusion does not necessarily imply endorsement of the opinions expressed. With a few exceptions, most church guides are excluded. Unpublished conservation reports are also omitted.

Allardyce, F. A. (1985) 'The Painting of the Legend of St. Eustace in Canterbury', *Archaeologia Cantiana*, **101**: 115–130.

Andre, J. L. (1888) 'Mural and Other Paintings in Churches', *Archaeological Journal*, **45**: 400–422.

Andre, J. L. (1899) 'Battle Church', *Sussex Archaeological Collections*, **42**: 214–236.

Andre, J. L (1892) 'Mural Paintings in Sussex Churches', *Sussex Archaeological Collections*, **38**: 1–20.

Andre, J. L., C. E. Keyser and P. M. Johnson (1900) 'Mural Paintings in Sussex Churches', *Sussex Archaeological Collections*, **43**: 220–248.

Armfield, H. T. (1873) 'Note on the Choir vault paintings', *Proceedings of the Society of Antiquaries*, second series, **6**: 477–479.

Armfield, H. T. (1878) 'The ancient roof paintings in Salisbury Cathedral', *Wiltshire Archaeological and Natural History Magazine*, **17**: 129–135

Ashby, J. (1979) 'Medieval Doom Paintings in Oxfordshire Churches', *The Oxford Art Journal*, **3**: 54–58.

Bagshaw, S., R. Bryant and M. Hare (2006) 'The Discovery of an Anglo-Saxon Painted Figure at St Mary's Church, Deerhurst, Gloucestershire', *The Antiquaries Journal*, **86**: 66–109.

Baigent, F. J. (1851) 'Communication of Discoveries of Medieval Paintings, etc', *Archaeological Journal*, **6**: 76–80.

Baigent, F. J. (1854) 'On the Church of St. John, Winchester, and the paintings discovered on the north wall', *Archaeological Journal*, **9**: 1–14.

Baigent, F. J. (1855) 'On the Martyrdom of St Thomas of Canterbury, and other paintings discovered in St. John's Church, Winchester', *Archaeological Journal*, **10**; 53 – 87.

Baker, A. M. (1998) 'Adam and Eve and the Lord God, the Adam and Eve cycle of wall paintings in the church of Hardham, Sussex', *Archaeological Journal*, **155**: 207–225.

Baker, A. M. (1970) 'The Wall Paintings in the Church of St John the Baptist Clayton', *Sussex Archaeological Collections,* **108**: 58–81.

Baker, A. M. (1946) 'Lewes Priory and the Early Group of Wall Paintings in Sussex', *Walpole Society*, **31**, 1942–43: 1–44.

Baker, E. (1962) 'Wall Paintings in the Church of St Mary the Virgin, Cerne Abbas', *Proceedings of the Dorset Natural History and Archaeological Society*, **84**: 109–110.

Baker, E. (1969) 'A Medieval Painting in Llanynys Church', *Archaeologia Cambrensis*, **118**: 135–137.

Baker, E. (1969) 'The Adoration of the Magi at Shelfhanger Church, Norfolk', *Norfolk Archaeology*, **34**: 90–91.

Baker, E. (1972) 'East Shefford Church, Berkshire, and its Wall Paintings', *Transactions of the Ancient Monuments Society*, **19**: 37–45.

Baker, R. (1986) 'Conservation of English Medieval Wallpaintings over the last Century', in P. Burman, *Conservation of Wall Paintings*, London: 28–31.

Ballantyne, A. (1990) 'Conservation of the Anglo-Saxon wall painting at Nether Wallop', in S. Cather, and D. Park and P. Williamson (eds) *Early Medieval Wall Painting and Painted Sculpture in England*, BAR British Series 216: 105–109.

Barber, Edward (1909) 'The S. Oswald's Reredos; and the Frescoes in Chester Cathedral', *Journal of the Architectural, Archaeological and Historic Society of Chester and North Wales*, **15**: 119–132.

Barber, Edward (1911) 'The Painting in the South Aisle of the Church of St Mary-on-the-Hill, Chester', *Journal of the Architectural, Archaeological and Historic Society of Chester and North Wales*, **17**: 126–129.

Bardswell, M. (1925) 'Some Recent Discoveries at Paston', *Norfolk Archaeology*, **22**, Part II: 190–193.

Bardswell, M. (1926) 'Wall paintings recently uncovered at Seething and Caistor by Norwich', *Norfolk Archaeology*, **22**, Part III; 338–340

Barker, P. and C. Romain (2001) 'The Painted Decoration of the Late 12th and 13th Centuries', *Worcester Cathedral: A Short History*, Herefordshire: 43–48.

Beal, W. M. (1852) 'Description of certain mural paintings lately discovered in his church', *Norfolk Archaeology*, **3**: 62–70.

Benton, G. Montagu (1926) 'Wall-Paintings in Essex Churches I: Wall-paintings formerly in the Churches of Felsted and Great Chishall', *Transactions of the Essex Archaeological Society*, **17**: 28–36.

Benton, G. Montagu (1928) 'Wall Paintings in Essex Churches II: Wall paintings in, or formerly in, East Hanningfield Church', *Transactions of the Essex Archaeology Society*, **18** (new series): 105–118.

Benton, G. Montagu (1933) 'Wall paintings in Essex, III; Wall Paintings in Walter Belchamp Church', *Transactions of the Essex Archaeological Society*, **20**, New series: 86–94. (Note: this church is now described as Belchamp Walter).

Parts 4 and 8 of Benton's study of Wall Paintings in Essex describe post-Reformation paintings. Other articles from the same series are listed under: Tristram and Benton (Parts 5, 6 & 7); and Rouse and Benton (Part 9).

Biddle, M. 'A late ninth-century wall painting from the site of New Minster', *Antiquaries Journal*, **47**: 277–279.

Biddle, M. and B. Kjølbye-Biddle (1990) 'The Dating of the New Minster Wall Painting', in S. Cather, and D. Park and P. Williamson (eds) *Early Medieval Wall Painting and Painted Sculpture in England*, BAR Series 216 : 45 – 62

Binnell, P. B. G. (1965) 'Thirteenth-Century Vault Paintings in Lincoln Cathedral', *Antiquaries Journal*, **45**: 265–266.

Binski, P. and D. Park (1986) 'A Ducciesque episode at Ely: the mural decorations of Prior Crauden's Chapel', in W. M. Ormrod (ed.) *England in the Fourteenth Century* (Proceedings of the 1985 Harlaxton Symposium), Woodbridge: 28–41.

Binski, P. (1992) 'The murals in the nave of St. Albans Abbey', in D. Abulafia *Church and City 1000–1500: Essays in honour of Christopher Brooke*, Cambridge: 249–278.

Binski, P. (1995) 'A Feast for the Eyes: Devotion, Display and the Altar', in *Westminster Abbey and the Plantagenets: kingship and the representation of power, 1200–1400*, New Haven and London: 141–174.

Binski, P. (1999) 'The English Parish Church and its Art in the Later Middle Ages: a Review of the Problem', in *Studies in Iconography*, **20**, especially pages: 15–17.

Boileau, J. P. (1864) 'Notes on some Mural Paintings lately discovered in Eaton Church', *Norfolk Archaeology*, **6**: 161–70.

Bolingbroke, N. (1881) 'Mural Painting of St. Christopher at St. Etheldred's church, Norwich', *Norfolk Archaeology*, **9**: 343–45.

Borenius, T. (1932) St Thomas Becket in Art, London: especially pages 97–102, but also elsewhere. Wall paintings are also discussed in two preceding articles by the same author: 'The Iconography of St Thomas of Canterbury', *Archaeologia* (1929), **79**, 29–54; and 'Addenda to the Iconography of St Thomas of Canterbury', *Archaeologia*,(1931), **81**: 19–32.

Borenius, T. (1932), 'A Destroyed Cycle of Wall-Paintings in a Church in Wiltshire', *Antiquaries Journal* **12**: 393–406. [Winterbourne Dauntsey]

Borenius, T (1943) 'The Cycle of Images in the Palaces and Castles of Henry III', *Journal of the Warburg and Courtauld Institutes*, **6**: 40 – 50.

Bott, A. (1996) 'Wall Paintings in Godalming Church', *Surrey Archaeological*

*Collection*s, **83**: 21–35.

Brindley, H. H. (1924) 'Notes on the Mural Paintings of St Christopher in English Churches', *The Antiquaries Journal*, **4,** No 3, July 1924: 227–241.

Brindley, H. H. (1929) 'St Christopher', in C. Hussey (ed.) *A Supplement to Bloomfield's Norfolk*, London: 299–314, plus Table.

Brown, S. (1999) 'Paintings, Tiles and Textiles', *Sumptuous and Richly Adorn'd: The Decoration of Salisbury Cathedral,* London: 161–168.

Bruton, E. G. (1864–71) 'The Recent Discovery of Wall-painting on the Apse of Checkendon Church', *Oxfordshire Architectural and History Society Proceedings*, New Series, **2**: 75–78.

Bull, H. (1873) 'Church of All Saints, Lathbury', *Records of Buckinghamshire*, **4**: 36–42.

Bulwer, J. (1852) 'Notice of a Mural Painting discovered in the South Transept of Cawston Church', *Norfolk Archaeology*, **3**: 37–39.

Burges, W. (1860) 'On mural paintings in Chalgrove church, Oxfordshire', *Archaeologia*, **38**: 431–438.

Burges, W. (1864) 'Mural Paintings in Charlwood Church, Surrey, with remarks on the more ordinary Polychromy of the thirteenth century', *Archaeological Journal*, **21**: 209–215.

Campion, C. H. (1864) 'Mural Paintings in Westmeston Church', *Sussex Archaeological Collections*, **16**: 1–19.

Campion, C. H. (1865) 'Mural paintings, Keymer Church', *Sussex Archaeological Collections*, **17**: 249–50.

Campion, C. H. (1867) 'Mural Paintings in Plumpton Church', *Sussex Archaeological Collections*, **20**: 198–202.

Caroe, W. (1912) 'Wall Paintings in the Infirmary Chapel, Canterbury Cathedral', *Archaeologia*, **63**: 51–56.

Carus, C. (1999) 'Wall painting discovery in Norwich', *Church Archaeology*, **3**: 34–36.

Cather, S. and D. Park (1998) 'Wall Paintings', in W. J. Rodwell, *Holy Trinity Church, Bradwell-juxta-Coggeshall: a survey of the fabric and appraisal of the Norman brickwork, Essex Archaeology and History,* **29**: 105–109.

Cather, S., D. Park, and R. Pender, (2000) 'Henry III's Wall Paintings at Chester Castle', in A. Thacker (ed.) *Medieval Archaeology, Art and Architecture at Chester* (British Archaeological Association Conference Transactions 22): 170–189.

Caviness, M. (1974) 'A Lost Cycle of Canterbury Paintings of 1220', *The Antiquaries Journal,* **54**: 66–74.

Chazelle, C. M. (1990) 'Pictures, books, and the illiterate: Pope Gregory I's letters to Serenus of Marseilles', *Word & Image*, **6**: 138–153.

Cheales, H. J. (1885) 'On the Mural Paintings in All Saints Church, Friskney, Lincolnshire', *Archaeologia*, **48**: 270–280; *Archaeologia*, **50** (1887): 281–286; *Archaeologia*, **3** (second series) (1893): 427–432; *Archaeologia*, **59** (second Series) (1905): 371–374.

Cherry, J. and N. Stratford (1995) 'Edward III and St Stephen's Chapel', in *Westminster Kings and the Medieval Palace of Westminster*, London: 28–49.

Chittock, J. (1992) 'The Medieval Wall Paintings of St Mary and All Saints, Willingham', *Proceedings of the Cambridge Antiquarian Society*, **81**: 71–80.

Courtauld Institute of Art, Conservation of Wall Paintings Department, (1994) *St Botolph's Church, Hardham, West Sussex: The Wall Paintings*, Pulborough.

Courtauld Institute of Art, Conservation of Wall Paintings Department (revised ed. 2001), *St Mary's Church, Thornham Parva, Suffolk: A guide to the wall paintings*, Thornham Parva.

Croft-Murray, E. (1956) 'Lambert Bernard: An English Early Renaissance Painter', *The Archaeological Journal*, **112**: 108–125.

Curteis, T. (1998) 'The uncovering and conservation of the medieval wall paintings at St James the Less, Little Tey', *Essex Archaeology and History*, **29**: 136–144.

Curteis, T. (2006) *The conservation of the wall paintings in Ilketshall St Andrew Parish Church*, Cambridge.

Dashwood, G. H. (1852) 'On Mural Paintings lately detected in the Church of Stow Bardolph', *Norfolk Archaeology*, **3**: 134 – 39.

Deighton, A. (1993) 'The Literary Context of the Wall Painting at Idsworth, Hampshire', *Antiquaries Journal*, **73**: 69–75. See also: Edwards, J. 1983.

Dewick, E. S. (1908) 'Consecration Crosses and the ritual connected with them', *Archaeological Journal*, **65**: 1–34.

Dodwell, C. R. (1982) *Anglo-Saxon Art: a new perspective*, Manchester: Chapter IV: 84–94.

Druce, G. (1910) 'Some minor features of the Chaldon painting', *Surrey Archaeological Collections*, **23**: 1–30.

Duggan, L. G. (1989) 'Was Art Really the "Book of the Illiterate"?' *Word & Image*, **5**: 227–251.

Dunlap, A. P. (1852) 'Paintings on the walls of Bardwell Church', *Proceedings of the Suffolk Institute of Archaeology*, **2**, Part 2: 41–50.

Dyke, W. M. (1846) 'Decorations in Distemper in Stanton Harcourt Church, Oxfordshire', *Archaeological Journal*, **2**: 365–368.

Edwards, I. (1993) ' Medieval Wall Paintings in Clwyd Churches', *Denbighshire Historical Society Transactions,* **42**: 11–25.

Edwards, J. (1981) 'The Morality of the Three Living and Three Dead: Medieval Wall Paintings at St Mary's Church, Raunds', *Northamptonshire Archaeology*, **16**: 148–152. (The church is dedicated to St Peter.)

Edwards, J. (1981) 'A Medieval Wall-painting at Hailes', *Transactions of the Bristol and Gloucestershire Archaeological Society*, **99**: 167–169.

Edwards, J. (1982) 'The Milcombe Chapel Martyr', *Cake and Cockhorse*, (Journal of the Banbury History Society) **7**, Spring 1982: 222–231.

Edwards, J. (1982) 'A Newly-deciphered Wall-painting of St Martin at Widford', *Oxoniensia*, **47**: 127–132.

Edwards, J. (1983) 'A "Fifteenth-century" Wall-painting at South Leigh', *Oxoniensia*, **48**: 131–142.

Edwards, J. (1983) 'The Wall-painting at Idsworth, Hampshire, reconsidered', *Antiquaries Journal*, **63**: 79–94. See also: Deighton (1993)

Edwards, J. (1984) 'Widford Wall-Paintings; more new decipherments', *Oxoniensia*, **49**: 133–139.

Edwards, J. (1984) 'The Wall-Paintings in St Lawrence's church, Broughton', *Records of Buckinghamshire*, **26**: 44–55.

Edwards, J. (1984) 'The Martyrdom Wall-Paintings at St Leonard's Church, Stowell', *Transactions of the Bristol and Gloucestershire Archaeological Society*, **102**: 133–140.

Edwards, J. (1985) 'The Wall-Painting of the Unknown Saint at St Mary's Church, Padbury', *Records of Buckinghamshire*, **27**: 101–106.

Edwards, J. (1985) 'The Kelmscott Wall-paintings', *Oxoniensia*, **50**: 239–245.

Edwards, J. (1985) 'Trotton's 'Abbreviated' Doom', *Sussex Archaeological Collections*, **123**: 115–125.

Edwards, J. (1986) 'Hexagonal Heavenly Cities at Clayton and Plumpton', *Sussex Archaeological Collections*, **124**: 263–265.

Edwards, J. (1986) 'The Mural and the Morality Play: a suggested source for a wall painting at Oddington', *Transactions of the Bristol and Gloucestershire Archaeological Society*, **104**: 187–200.

Edwards, J. (1986) 'Some Wall-Paintings at St Peter's Church, Martley', *Transactions of the Worcestershire Archaeological Society*, 3rd series, **10**: 59–69.

Edwards, J. (1988) 'The Medieval Wall-Paintings formerly at St Andrew's Church, Headington, Oxford', *Archaeological Journal*, **145**: 263–271.

Edwards, J. (1988) 'A Wall-Painting at St Mary's Church, Lydiard Tregoze, Re-Considered', *Wiltshire Archaeological and Natural History Magazine*, **82**: 92–98.

Edwards, J. (1989) 'English Medieval Wall-Paintings: The Monica Bardswell Papers', *Archaeological Journal*, **143**: 368–369.

Edwards, J. (1989) 'English Medieval Wall-Paintings: Some Nineteenth Century Hazards', *Archaeological Journal*, **146**: 465–475.

Edwards, J. (1990) 'Some Lost Medieval Wall-Paintings', *Oxoniensia*, **55**: 81–98.

Edwards, J. (1990) 'New Light on Christ of the Trades and other Medieval Wall-Paintings at Purton', *Wiltshire Archaeological and Natural History Magazine*, **83**: 105–117.

Edwards, J. (1991) 'The Other Wall-Paintings at South Newington', *Oxoniensia*, **56**: 103–109.

Edwards, J. (1992) 'The Cult of 'St' Thomas of Lancaster and its Iconography', *Yorkshire Archaeology Journal*, **64**: 103–122.

Edwards, J. (1992) 'Comments on: "New Light on Christ of the Trades and Other Medieval Wall-paintings at St Mary's, Purton"', *Wiltshire Archaeological and National History Magazine*, **85**: 153.

Edwards, J. (1993) 'Some Murals in North-East Oxfordshire', *Oxoniensia*, **58**: 241–251.

Edwards, J. (1994) 'The Interpretation of English Medieval Wall-Paintings: A Retrospective', *Archaeological Journal*, **151**: 420–424.

Edwards, J. (1994) 'Turkdean Church Wall-Paintings, a Cautionary Tale', *Transactions of the Bristol and Gloucestershire Archaeological Society*, **112**: 105–110.

Enys, J. D. (1902) 'Mural Paintings in Cornish Churches', *Journal of the Royal Institution of Cornwall*, **15**: 136–60.

Fairholt, F. W. (1848) 'On Mural Paintings recently discovered at Shorwell, Isle of Wight, and Great Waltham', *Archaeological Journal*, **3**: 85–93.

Fawcett, R. (2002) 'Painted Decoration', *Scottish Medieval Churches, Architecture & Furnishings*, Stroud: 321–326.

Fletcher, J. and C. Upton (1983) 'Destruction, Repair and Removal: An Oxford College Chapel during the Reformation', *Oxoniensia*, **48**: 119–130.

Flynn, K. (1979) 'Romanesque Wall-Paintings in the Cathedral Church of Christ Church, Canterbury', *Archaeologia Cantiana*, **95**: 185–195.

Flynn, K. F. N. (1980) 'The Mural Paintings in the Church of Saints Peter and Paul, Chaldon, Surrey', *Surrey Archaeological Collections*, **72**: 127–156.

Forster, T. (1885) 'Distemper Paintings in Fingringhoe Church, Essex', *The Antiquary*, **12**: 122–24.

Fowler, J. T. (1895?) 'Mural Paintings in Pittington Church', *Transactions of the Architectural and Archaeological Society of Durham and Northumberland*, 1st Series, **4**: 1–5.

Fuller, R. F. (1932) 'Mural Paintings in Great Chalfield Church', *Wiltshire Archaeological and Natural History Magazine*, **45**: 503–504.

Gärtner W. and T. Organ (1989) 'Monitoring and Conservation of the Romanesque Wall Painting of St Anselm's Chapel, Canterbury Cathedral', *The Conservator*, **13:** 7–14.

Gem, R. and P. Tudor-Craig (1981) 'A "Winchester School" wall painting at Nether Wallop, Hampshire', in *Anglo-Saxon England*, **9**: 115–136.

Gem, R. (1990) 'Documentary references to Anglo-Saxon painted architecture', in S. Cather, D. Park and P. Williamson (eds) *Early Medieval Wall Painting and Painted Sculpture in England*, BAR British Series 216: 1–15.

Gilbert, C. E. (1974) 'Last Suppers and their Refectories', in C. Trinkhaus and H. Oberman (eds) *The Pursuit of Holiness in Late Medieval and Renaissance Religion and Queries*, Leiden: 371–407.

Giles, K. (2001) 'Marking Time? A 15th-century liturgical calendar in the wall paintings of Pickering Parish Church', *Church Archaeology*, **4**: 42–51.

Gill, M. (1995) 'The saint with a scythe: a previously unidentified wall painting in the church of St Andrew, Cavenham', *Proceedings of the Suffolk Institute of Archaeology*, **37**: 245–254.

Gill, M. (1995) '"Now help, Saynt George, Oure Ladye Knyght ... to

strengthe our Kyng and England right." Rare scenes of Saint George in a wall painting at Astbury, Cheshire', *Lancashire and Cheshire Antiquarian Society*, **91**: 91–102.

Gill, M., T. Manning, D. Park and S. Stewart (1996) 'The gatehouse wall paintings: stylistic analysis', in *Berry Pomeroy Castle, Proceedings of the Devon Archaeological Society* **54**: [1996], 317–323.

Gill, M. (1996) 'Kenelm cunbearn ... haudes bereafed: a reconstructed cycle of wall paintings from St Kenelm's Chapel, Romsley', *Journal of the British Archaeological Association*, **149**: 23–36.

Gill, M. (1998) 'The Lost Wall Paintings of Halesowen', *Worcestershire Archaeological Society*, third series, **16**: 133–141.

Gill, M. and H. Howard (1997) 'Glimpses of Glory; paintings from St Mark's Hospital, Bristol', in L. Keen (ed.) *Almost the Richest City: Bristol in the Middle Ages* (British Archaeological Association Conference Transactions 19), London: 97–106.

Gill, M. (1998) 'Sacred and Secular: The Chantry Paintings of Sir Thomas de Bradeston at Winterbourne', in E. Bailey (ed.) *Small is Cosmic: Millennial Issues in Parochial Perspective*, Winterbourne: 30–35.

Gill, M. (2000) 'The role of images in monastic education: the evidence from wall painting in late medieval England', in G. Ferzoco and C. Muessig (eds) *Medieval Monastic Education*, London and New York: 117–135.

Gill, M. and R. K. Morris (2001) 'A wall painting of the Apocalypse in Coventry rediscovered', *Burlington Magazine*, **143**, No. 1181: 467–473.

Gill, M. (2002) 'Preaching and images in late medieval England', in C. Muessig (ed.) *Preacher, Sermon and Audience in the Middle Ages*, Leiden, Boston, Köln: 155–180.

Gill, M. (2002) 'Female piety and impiety: selected images of women and their reception in wall paintings in England after 1300', in S. J. E. Riches and S. Salih (eds) *'Gender and Holiness': Men, Women and Saints in Late Medieval Europe*, London and New York: 101–120.

Gill, M. (2003) 'The Wall Paintings in Eton College Chapel: the Making of a Late Medieval Marian Cycle', in P. Lindley (ed.) *Making Medieval Art*, Donnington: 173–201.

Glasscoe, M. (1987) 'Late Medieval Paintings in Ashton Church, Devon', *Journal of the British Archaeological Society*, **140**: 182–190.

Goddard, E. H. (1937) 'Wall Paintings in Oaksey Church', *Wiltshire Archaeological and Natural History Magazine*, **47**: 632–636.

Goodhall, J. (2001) 'The Chapel of St John the Baptist', in *God's House at Ewelme*, London: 159–179.

Green, M. (2004) 'The Penn Doom', *Records of Buckinghamshire*, **44**: 31–49.

Harcourt, L. V. (1851) 'The Mural Paintings Recently Discovered in Stedham Church', *Sussex Archaeological Collections*, **4**: 1–18.

Harris, H.A. (1927) 'Medieval Mural Paintings in Suffolk', and 'A List of Suffolk Churches associated with Wall Paintings', *Proceedings of the Suffolk Institute of Archaeology and Natural History*, **19**, Part 3: 286–303; 304–312.

Heslop, T. (2001) 'Worcester Cathedral Chapterhouse and the Harmony of the Testaments', in P. Binski and W. Noel (eds) *New Offerings, Ancient Treasures: Studies in Medieval Art for George Henderson*, Stroud: 280–311.

Hollaender, A. (1944) 'The Doom-Painting of St. Thomas of Canterbury, Salisbury', *Wiltshire Archaeology and Natural History Magazine*, **50**: 351–370.

Holmes, C. (1923) 'The Wall Paintings in Eton College Chapel', *Burlington Magazine*, **43**, No. 248: 229–236.

Horlbeck, F. R. (1960) 'The Vault Paintings of Salisbury Cathedral', *Archaeological Journal*, **67**: 116–130.

Howard, H. (1990) '"Blue" in the Lewes Group', in S. Cather, D. Park and P. Williamson (eds.) *Early Medieval Wall Painting and Painted Sculpture in England*, BAR British Series 216: 195–199.

Howard, H. (1993) 'Wall Painting. The Chapel of Our Lady Undercroft, Canterbury Cathedral', *Technologia Artis* **3**: 31–34.

Howard, Helen C. (1995) 'Techniques of the Romanesque and Gothic Wall Paintings in the Holy Sepulchre Chapel, Winchester Cathedral', in Wallert, A. Hermens, E. and Peck, M. (eds) *Historical Painting Techniques, Materials and Studio Practice*, Leiden: 91–104.

Howe, E. (2001) 'Divine Kingship and Dynastic Display: The Altar Murals of St Stephen's Chapel, Westminster', *Antiquaries Journal*, **81**: 259–303.

Howe, E. (2006) 'Painting and patronage at Westminster Abbey: the murals in the south transept and St Faith's Chapel', *Burlington Magazine*, **148**, No. 1234: 4–14.

Hudson Turner, T. (1851) 'Extracts from Records Illustrative of Domestic Architecture in the Thirteenth Century,' in *Some Accounts of Domestic Architecture in England*, London: 181–263.

Hulbert, A. C. (1991) 'The Sylke Chantry', *Friends of Exeter Cathedral Sixty-first Annual Report (to 31 March 1991)*: 12–17.

Hulbert, A. C. (1994) 'Rediscovering the Angels: Current Conservation Work on the Wall Painting of the Assumption of the Virgin', *Friends of Exeter Cathedral Sixty-fourth Annual Report (to 31 March 1994)*: 23–28.

Husenbeth, F. C. (1852) 'Mural Paintings at Drayton', *Norfolk Archaeology*, **3**: 24 – 28.

Husenbeth, F. C. (1859) 'On some mural paintings discovered in Limpenhoe Church, Norfolk', *Norfolk Archaeology*, **5**: 221–225.

Husenbeth, F. C. (1864) 'Mural Paintings in Norwich Cathedral', *Norfolk Archaeology*, **6**: 271–276.

James, M. R. (1895) 'On the Wall Paintings in Willingham Church', *Proceedings of the Cambridge Antiquarian Society*, **9**: 96–101.

James, M. R. (1896) 'On the paintings formerly in the Choir at Peterborough', *Cambridge Antiquarian Society Proceedings*, **38**: 178–194.

James, M. R. and E. W. Tristram (1928) 'Medieval Wall-Paintings at Christ Church, Oxford', *Walpole Society*, **16**: 1–6.

James, M. R. and E.W. Tristram (1928–29) 'The wall paintings in Eton

College Chapel and in the Lady Chapel of Winchester Cathedral', *Walpole Society*, **17**: 1–43.

James, M. R. (1929) 'The mural paintings in Wickhampton Church', in C. Hussey (ed.) *A Supplement to Bloomfield's Norfolk*, London: 129–142.

James, M. R. (1929) 'The wall paintings in Brooke Church', in C. Hussey (ed.) *A Supplement to Bloomfield's Norfolk*, London: 14–25.

James, M. R. (1932) 'The Iconography of Bucks', *Records of Buckinghamshire*, (1927–33) **12**: 281–298.

Johnston. P. M. (1900) 'Ford and its Church', *Sussex Archaeological Collections*, **43**: esp. 142–151

Johnston, P. M. (1901) Mural Paintings in Sussex Churches', *Sussex Archaeological Collections*, **44**: 204–206.

Johnston, P. M. (1901) 'Stoke d'Abernon Church: some recent discoveries', *Surrey Archaeological Collections*, **26**: esp. 121–125.

Johnston, P. M. (1901) 'Hardham Church, and its early paintings', *Archaeological Journal*, **58**, second series, **VIII**: 62–92.

Johnston, P. M. (1901) 'Hardham Church, and its Early Paintings', *Sussex Archaeological Collections*, **44**: 73–115.

Johnston, P. M. (1903) 'Claverly Church and its Wall Paintings', *Archaeological Journal*, **60**: 51–71.

Johnston, P. M. (1905) 'Shorthampton Chapel and its Wall Paintings', *Archaeological Journal*, **62**: 157–171.

Johnston, P. M. (1906) 'An Ancient Painting at Aldingbourne Church', *Sussex Archaeological Collections*, **49**: 157–58.

Johnston, P. M. (1916) 'Discovery of Wall Paintings at Hardham Priory', *Sussex Archaeological Collections*, **58**: 1–5.

Johnston, P. M. (1918) 'An Early Window and Wall Paintings in Witley Church', *Surrey Archaeological Collections*, **33**: 28–44.

Johnston, P. M. (1927) 'Charlwood Church and its Wall Paintings', *Surrey Archaeological Collections*, **37, Part I**: 64–70.

Jones, D. J. (1983) 'The Cult of St. Richard of Chichester in the Middle-Ages', *Sussex Archaeological Collections,* **121**: 79–86.

Kahn, D. (1984) 'The structural evidence for the dating of the St Gabriel Chapel wall-paintings at Christ Church Cathedral, Canterbury', *Burlington Magazine*, **126**, No. 973: 224–229.

Keyser, C. E. (1877) 'The mural paintings at Kempley Church, Gloucestershire', *Archaeological Journal*, **34**: 270–278.

Keyser, C. E. (1878) 'The Mural and Decorative Paintings which are now existing, or which have been in existence during the present century, at Canterbury Cathedral', *Archaeological Journal*, **35**: 275–288.

Keyser, C. E. (1881) 'Mural painting of the Doom at Patcham Church, Sussex', *Archaeological Journal*, **38**: 80–95. See also: Waller, J. G. (1881).

Keyser, C. E. (1891) 'On Mural Paintings and Other Coloured Decorations at Chippenham Church, Cambridgeshire', *Cambridge Antiquarian Communications*, **6**: 321–329.

Keyser, C. E. (1892) 'A recently discovered panel painting of the Doom',

[Wenhaston - RR] *Archaeological Journal*, **49**: 399–401.

Keyser, C. E. (1894) 'On a panel painting of the Doom discovered in 1892, in Wenhaston Church, Suffolk', *Archaeologia*, **54**: 119–130.

Keyser, C. E. (1896) 'On recently discovered mural paintings at Willingham Church, Cambridge, and elsewhere in the south of England', *Archaeological Journal*, **53**: 160–191.

Keyser, C. E. (1896) 'Description of the Mural paintings at the Churches of Clayton and Rotherfield', *Sussex Archaeological Collections*, **40**: 211–221.

Keyser, C. E. (1897) 'On some mural paintings recently discovered in the churches of Little Horwood and Padbury, Buckinghamshire', *Records of Buckinghamshire*, **7**: 215–230.

Keyser, C. E. (1901) 'Recently discovered mural paintings in our English churches', *Archaeological Journal*, **58**: 47–61.

King, E. J. (1984) 'Medieval Wall-Paintings in Northamptonshire', *Northamptonshire Past and Present*, **7**.2: 69–78.

Lethaby, W. R. (1916) 'Master Walter of Colchester, "The Incomparable Painter", c. 1180–1248, and the Master of the Chichester Roundel', *Burlington Magazine*, **29**, No. 161: 189–196.

L'Estrange, J. (1872) 'Mural Paintings at West Somerton Church', *Norfolk Archaeology*, **7**: 256 – 259.

Lightfoot, G. H. (1895) 'Mural Paintings in St Peter's Church, Pickering', *Yorkshire Archaeological Journal*, **13**: 353–370.

Lindley, E. S. (1953) 'Church murals at Linkinhorne', *Journal of the Royal Institution of Cornwall*, New Series 2, Part I: 112–115.

Lindley, Phillip (1986) 'The imagery of the Octagon at Ely', *British Archaeological Association Journal*, **139**: 75–99.

Lloyd, R. R. (1882) 'The Wall Paintings in St Alban's Abbey', *Archaeological Journal*, **39**: 64–70.

Long, E. T. (1929) 'Ancient Mural Paintings in Dorset Churches', *Proceedings of the Dorset Natural History and Archaeological Society*, June–Dec 1928, **50**: 97–108.

Long, E. T. (1930) 'Some Recently Discovered Wall Paintings', *Burlington Magazine*, **56**, No. 326: 225–232.

Long, E. T. (1934) 'Some Wall Paintings in Oxfordshire', *Burlington Magazine*, **65**, No. 377: 80–83.

Long, E. T (1936) 'Wall Paintings at Turvey and Wymington', *Burlington Magazine,* **68**, No. 395: 96–101.

Long, E. T. (1937) 'The Wall Paintings in Shorthampton Church,' *Oxfordshire Archaeological Society Report*, **83**: 8–11.

Long. E. T. (1937) 'Mural paintings in Eynsham Church', *Oxonensia*, **2**: 204–205.

Long, E. T. (1937) 'The Stanningfield Doom', *Burlington Magazine,* **70**, No. 408: 128–129.

Long, E. T. (1940) 'Recently Discovered Wall-Paintings in England, Part 1', *Burlington Magazine*, **76**, No. 445: 124–128.

Long, E.T. (1940) 'Recently Discovered Wall-Paintings in England, Part II',

Burlington Magazine, **76**, No. 446: 156–162.

Long, E. T. (1941) 'Wall Paintings at Durham and Easby', *Burlington Magazine*, 79, No. 464: 166 – 69.

Long, E. T. (1941–1942) 'Mural Paintings in Berkshire Churches, Part I', *Berkshire Archaeological Journal*, **45**, Part 2, (1941): 94–105; Part II, (1942), **46**, Part I: 28–31; Part III, **47**, Part 2, (1942): 74–77.

Long, E. T. (1972) 'Medieval Wall Paintings in Oxfordshire Churches', *Oxoniensia*, **37**: 86–107.

Lowndes, C. (1870) 'Mural Paintings in Whaddon Church', *Records of Buckinghamshire*, **2**: 270–273.

Martindale, A. (1995) 'The Wall-Paintings in the Chapel of Eton College', in C. Barron and N. Saul (eds) *England and the Low Countries in the late Middle Ages,* Stroud: 133–152.

Micklethwaite. J. C. (1881) 'A description of the paintings in the church at Kempley, near Ross', *Archaeologia*, **46**: 187–194.

Middleton. J. H. (1883) 'On a wall-painting discovered at Westminster Abbey in 1882', *Archaeologia*, **47**: 471–472.

Milner-Gulland, R. R. (1985) 'The problem of the early Sussex frescoes', *Southern History*, **7**: 25–54.

Milner-Gulland, R. R. (1990) 'Clayton Church and the Anglo-Saxon Heritage', in Cather, S. and D.Park and P. Williamson (eds) *Early Medieval Wall Painting and Painted Sculpture in England*, BAR Series 216: 205–219. See also: Park, D. (1990) in the same volume.

Minns, G. W. W. (1864) 'Notice of Mural Paintings at Witton', *Norfolk Archaeology,* **6**: 42–49.

Montague, Jeremy (1988) 'The Restored Chapter House Wall Paintings in Westminster Abbey', *Early Music*, **16**: 238–249. (This article focuses on the musical instruments shown in the paintings)

Morant, A.W. (1859) 'Mural Painting discovered at Burlingham St Edmund, Norfolk', *Norfolk Archaeology*, **5**: 185–187.

Morris, J. (1891) 'On a wall painting in St Anselm's Chapel in Canterbury Cathedral Church', *Archaeologia*, **52**: 389–392.

Moore, E. (1938) 'Wall Paintings recently discovered in Worcestershire', *Archaeologia*, **38**: 281–289.

Nilgenm, U. (1980) 'Thomas Becket as a Patron of the Arts', *Art History*, **3**, No. 4: 357–374.

Noppen, J. G. (1932) 'The Westminster Apocalypse and its Sources': *Burlington Magazine*, **61**, No. 355: 146-159.

Norton, C. (1996) 'The Medieval Paintings in the Chapter House', *Friends of York Minster Annual Report*, **67**: 34–51.

Pacht, O. (1961) 'A Cycle of English Frescoes in Spain', *The Burlington Magazine*, **103,** No. 698: 166–175.

Page, William (1902) 'The St Albans School of Painting, Mural and Miniature; Part 1, Mural Painting', *Archaeologia*, **58**: 275–92. See also: Binski, P. (1992).

Park, D. (1983) 'The Romanesque Wall Paintings of All Saints' Church, Witley, Surrey', *Surrey Archaeological Collections*, **74**: 157–167.

Park, D. (1983) 'The Wall Paintings of the Holy Sepulchre Chapel', in *Medieval Art and Architecture at Winchester Cathedral* (British Archaeological Association Conference Transactions **6**, 1980), London: 38–62.

Park, D. (1984) 'The "Lewes Group" of wall paintings in Sussex', in R. Allen Brown (ed.) *Anglo Norman Studies 6* (Proceedings of the Battle Conference 1983), Woodbridge: 200–235.

Park, D. (1984) 'Medieval Paintings in Rochester Cathedral', *Friends of Rochester Cathedral, Annual Report 1984*: 9–11.

Park, D. (1986) 'The Creation: Marginalia and Ornament in the Refectory Paintings of Bushmead Priory', *Bedfordshire Archaeology*, **17**: 72–76; plates, 99–106.

Park, D. (1986) 'Cistercian wall painting and panel painting', in C. Norton and D. Park (eds) *Cistercian art and architecture in the British Isles*, Cambridge: 181–210.

Park, D. (1986) 'The Medieval Painted Decoration of Lincoln Cathedral', in T. A. Heslop and V. Sekules (eds) *Medieval Art and Architecture at Lincoln Cathedral*, (British Archaeological Association Conference, 8, 1982): 75–82.

Park, D. (1987) 'Wall Painting', in J. Alexander and P. Binski (eds) *Age of Chivalry: Art in Plantagenet England 1200–1400*, London: 125–130.

Park, D. (1987) 'Form and Content', in C. Norton, D. Park and P. Binski, *Dominican Painting in East Anglia: the Thornham Parva Retable and The Musee de Cluny Frontal*, Woodbridge: 33–56.

Park, D. (1987) 'Romanesque Wall Paintings at Ickleton', in *Romanesque and Gothic: Essays for George Zarnecki., Vol. I*, Woodbridge: 159–169.

Park, D. (1990) 'Anglo-Saxon or Anglo-Norman? Wall paintings at Wareham and other Sites in Southern England', in S. Cather, D. Park and P. Williamson (eds.) *Early Medieval Wall Painting and Painted Sculpture in England*, BAR British Series 216: 225–247.

Park, D. (1993) 'The Interior Decoration of the Cathedral', in D. Pocock (ed.) *Durham Cathedral: A Celebration*, Durham: 57–115.

Park, D. and P. Welford (1993) 'The Medieval Polychromy of Winchester Cathedral', in J. Crook (ed.) *Winchester Cathedral 1093–1993*, Chichester: 123–138.

Park, D. (1994) 'Simony and Society: Herbert Losinga, St. Wulfstan of Worcester and Wall-Paintings in Norwich Cathedral', in D. Buckton and T. A. Heslop (eds) *Studies in Medieval Art and Architecture presented to Peter Lasko*, Stroud: 157–170.

Park, D. (1994) 'Recently conserved wall-paintings in the south transept', *Winchester Cathedral Record*, **63**: 27–32.

Park, D. (1995) 'The Medieval Polychromy of Worcester Cathedral', in P. Barker and C. Guy *Archaeology at Worcester Cathedral*: Report of the fifth

Annual Symposium March 1995: 6–12.

Park, D. and H. Howard (1996) 'The Medieval Polychromy', in I. Atherton (ed.) *Norwich Cathedral, Church, City and Diocese 1096–1996*, London: 378–409.

Park, D. and S. Heywood (1997) 'Romanesque wall paintings discovered in Norfolk', *Minerva*, **8:2**: 8–9.

Park, D. (1998) 'Late twelfth-century polychromy from Glasgow Cathedral', in R. Fawcett (ed.) *Medieval Art and Architecture in the Diocese of Glasgow:* (British Archaeological Association Conference Transactions, 23), London: 35–41.

Park, D. (2000) 'In Glorious Colour', *Past Masters, Present Delights: the Churches Conservation Trust Review and Report*, London: 20–25.

Park, D. (2001) 'The Duxford Master: a Thirteenth-Century Painter in East Anglia', in P. Binski and W. Noel (eds.) *New Offerings, Ancient Treasures: Studies in Medieval Art for George Henderson*, Stroud: 312–324.

Park, D. and R. Pender (2002) 'Henry III's Wall Paintings of the Zodiac in the lower ward of Windsor Castle', in L. Keen and E. Scarff (eds) *Windsor: Medieval Archaeology, Art and Architecture of the Thames Valley,*(British Archaeological Association Conference Proceeding 25), Leeds: 125–131.

Park, D. (2003) 'English Medieval Wall Painting in an International Context', in R. Gowing and A. Heritage (eds) *Conserving the Painted Past: Developing Approaches to Wall Painting Conservation.* (post-prints of an English Heritage Conference, 1999), London: 1–8.

Park, D. (2003) 'The Polychromy of English Medieval Sculpture', in S. Boldrick, D. Park and P. Williamson *Wonder: Painted sculpture from Medieval England*, Leeds: 30–54.

Park, D. and S. Cather (2004) 'Late Medieval Paintings at Carlisle', in M. McCarthy and D. Weston *Carlisle and Cumbria: Roman and Medieval Architecture and Archaeology,* Leeds: 214–231.

Park, D. and S. Stewart (2006) 'The Painted Decoration of Ewenny Priory and the Development of Romanesque Altar Imagery', in John R. Kenyon and Diana M. Williams (eds) *Cardiff: Architecture and Archaeology in the Medieval Diocese of Llandaff* (British Archaeological Association Conference Transactions, 29), Leeds: 42–59, with plates.

Parkinson, A. J. (2005) 'Llangar Church: The Wall Paintings', in W. N. Yates *Rug Chapel, Llangar Church, Gwydir Uschaf Chapel, Derwen Churchyard Cross*, CADW: 35–37.

Perry, D. (1994) 'The Restoration of the Wheel of Fortune', *Friends of Rochester Cathedral Annual Report, 1993-94*: 3–4.

Phipson, R. M. 'Notes on Starston Church, and a Mural Painting lately discovered there', *Norfolk Archaeology*, **7**: 300–302.

Plummer, P. (1986) 'The Wallpaintings in Eton College Chapel', in P. Burman (ed.) *Conservation of Wall Paintings*, London: 36–40.

Powell, K. (1994) 'The Chapel Paintings', *Bradwell Abbey History No. 5*, Milton Keynes.

Praetorius, C. J. (1913) 'On a wall-painting recently at Hardham Priory, Sussex,' *Archaeologia*, **64**: 453–54. pl. 63.

Puddephat, W. (1960) 'The Mural Paintings of the Dance of Death in the Guild Chapel of Stratford-upon-Avon', *Birmingham Archaeological Society Transactions and Proceedings*, **76**: 29–35.

Purcell, D. (1973) 'The Priory of Horsham St Faith and its Wall Paintings', *Norfolk Archaeology* **35**: 469–473.

Reeve, M. M. and O. Horsfall Turner (2005) ' Mapping Space, Mapping Time: The Thirteenth-Century Vault Paintings at Salisbury Cathedral', *Antiquaries Journal*, **85**: 57–102.

Rickerby, S. (1988) 'Conservation of Medieval Wall Paintings in Rochester Cathedral', *Friends of Rochester Cathedral Annual Report,* 1988: 9–12.

Rickerby, S. (1990) 'Kempley: A Technical Examination of the Romanesque Wall Paintings', in S. Cather, D. Park and P. Williamson (eds) *Early Medieval Wall Painting and Painted Sculpture in England*, BAR British Series 216: 249–260.

Rickerby, S. and D. Park (1991) 'A Romanesque "Visitatio sepulchri" at Kempley', *The Burlington Magazine*, **133**, No. 1054: 27–31.

Rigold, S. E. and E. C. Rouse (1973) 'Piccotts End: A Probable Medieval Guest House and its Wall Paintings', *Hertfordshire Archaeology* **3**: 78–89.

Roberts, E. (1968) 'The St William of York Mural in St Albans Abbey and Opus Anglicanum', *Burlington Magazine*, **110**, No. 782: 236–241.

Robertson Scott, W. A. (1880) 'The Crypt of Canterbury Cathedral Part I, St Gabriel's Chapel,' *Archaeologia Cantiana*, **13**: 48–80.

Robertson, Scott, Canon (1889) 'St Anselm's Chapel, Canterbury Cathedral', *Archaeologia Cantiana*, **18**: 169–173.

Rodwell, W. G. Hauff, S. Mieth (1990) ' The Wall Paintings', in W. Rodwell, *The Fishermen's Chapel, Saint Brelade, Jersey*, Stroud: 21–50. Also, U. Fuhrer and G. Hauff, 'Conservation and Restoration', 102–118, and plates 1–35, in the same volume.

Rosewell, R. (2006) 'How many for the pot?' *Journal of the Antique Metalware Society*, **13**: 36–37.

Rouse, E. C. (1929) 'Mural Painting in Chalfont St Giles Church', *Records of Buckinghamshire*, **12**, No. 3: 108–118.

Rouse, E. C. (1935) 'Mural Paintings at Dorney & Aston Clinton: Little Missenden Addenda', *Records of Buckinghamshire*, **12**, Part II, 1933: 399–404.

Rouse, E. C. (1935) 'Two Buckinghamshire Paintings of the Doom', *Records of Buckinghamshire*, **13,** Part II: 138–142.

Rouse, E. C. (1936) 'Wall Paintings in the Church of All Saints, Chalgrove, Beds', *Archaeological Journal*, **92** (1935): 81–97.

Rouse, E. C. (1936) 'Wall Paintings in Carlby and Goxhill Churches', *Lincolnshire Architectural and Archaeological Society*, **I**: 127–136.

Rouse, E. C. (1937) 'Wall paintings in Southease Church', *Sussex Archaeological Collections*, **78**: 3–12.

Rouse, E. C. (1943) 'Wall Paintings in the Church of St John the Evangelist,

Corby, Lincolnshire', *The Archaeological Journal* **100**: 150–176.

Rouse, E. C. (1948) 'Wall Painting in Radnage Church, Bucks', *Records of Buckinghamshire*, **15,** Part II: 134–138.

Rouse, E. C. (1950) 'Wall-Paintings in St Andrew's Church, Pickworth, Lincolnshire', *Journal of the British Archaeological Association*, **13**: 24–33.

Rouse, E. C. (1954) 'Wall Paintings in the Church of St Pega, Peakirk', *Archaeological Journal*, **110**: 135–149.

Rouse, E. C. (1955) 'Wall paintings in Risby Church', *Proceedings of the Suffolk Institute of Archaeology*, **26**: 27–34. See also: Park, D. (2001) 'The Duxford Master: a Thirteenth-Century Painter in East Anglia,' as above.

Rouse, E. C. and A. Baker (1955) 'The Wall-paintings at Longthorpe Tower near Peterborough, Northamptonshire', *Archaeologia*, **96**: 1–57.

Rouse, E. C. and Benton, G. Montagu (1955) 'Wall Paintings in Essex Churches Part IX: A Wall-painting recently discovered in Lambourne Church', and 'Essex Wall-paintings of St. Christopher', *Transactions of the Essex Archaeology Society*, **25**, Part I, New Series: 101–107.

Rouse, E. C. (1956) 'Wall Paintings in St Michael's Church, Plumpton', *Sussex Notes and Queries*, **14**: 187–189.

Rouse, E. C. (1959) 'A Wall-Painting of St Christopher in St Mary's Church, Wyken, Coventry', *Birmingham Archaeological Society Transactions and Proceedings*, **75**: 36–42.

Rouse, E. C. (1962) 'The Penn Doom', *Records of Buckinghamshire*, **17,** Part II: 95–104.

Rouse, E. C. (1966) 'Wall Paintings in St Mary's Church, Padbury', *Records of Buckinghamshire,* **18**: 24–33.

Rouse, E. C. and A. Baker (1967) 'Wall paintings in Stoke Orchard Church', *Archaeological Journal*, **123**: 79–119.

Rouse, E. C. (1973) 'Bradwell Abbey and the Chapel of St Mary', *Milton Keynes Journal of Archaeology and History*, **2**: 34–38.

Rouse, E. C. and K. Varty (1976) 'Medieval paintings of Reynard the Fox in Gloucester Cathedral and some other related examples', *Archaeological Journal*, **133**: 104–117.

Rouse, E. C. and A. Baker (1979) 'The early wall paintings in Coombes Church, Sussex and their Iconography', *Archaeological Journal*, **136**: 218–228.

Rouse, E. C. (1979) 'Wall Paintings in St Mary's Church, Battle', *Sussex Archaeological Collections*, **117**: 151–159.

Rouse, E. C. (1982) 'Doom Painting', in G. Odell (ed.) *The Church of St Mary the Virgin, Marston Moreteyn,* Bedford: 13–14.

Rushforth, G. Mc (1914) 'The Wheel of the Ten Ages of Life in Leominster Church', *Proceedings of the Society of Antiquaries*: 47–60.

Rushforth, G. Mc. (1929) 'Seven Sacraments Compositions in English Medieval Art', *The Antiquaries Journal*, **9,** 2: 93–94; Plate IX. (illustrating Kirton-in-Lindsey, Lincs).

Salmon, J. (1936) 'St. Christopher in English Medieval Art and Life', *Journal of the British Archaeological Association*, **41**: 76–115.

Salzman, L. F. (1952) 'Plaster, Whitewash, Paint', in *Buildings in England down to 1540*, Oxford: 155–154.

Slatter, J. (1870) 'On the frescos in Swanbourne church', *Records of Buckinghamshire*, **3**: 136–40.

Sodden, I. (1994) 'The Propaganda of Monastic Benefaction: Statement and Implication in the Art of St Anne's Charterhouse, Coventry', in M. Locock (ed.) *Meaningful Architecture: Social Interpretations of Buildings*, Aldershot: 147–166.

Spooner, J. (2002) 'A Fragment of Medieval Painting Discovered next to St Bartholomew, Smithfield', *Antiquaries Journal*, **82**: 339–343.

Sutton, A. F. (1982) 'Christian Colborne, Painter of Germany and London, died 1486', *British Archaeological Association Journal*, **135**: 55–61.

Taylor, E. S. (1859) 'Notices, Historical and Topographical of the Parish of Stokesby, Norfolk, with some account of the mural paintings discovered in the Parish Church', *Norfolk Archaeology*, **5**: 287–296.

Tristram, E. W. (1917) 'Piers Plowman in English wall painting', *Burlington Magazine*, **31**, October: 135–140.

Tristram, E. W. and M. R. James (1927) 'Wall Paintings in Croughton Church, Northamptonshire', *Archaeologia*, **76**: 179–204.

Tristram, E. W. (1927) 'Hoxne and Kentford Wall-Paintings', *Apollo*, **5**: 33–35.

Tristram, E. W. (1933) 'The Wall Paintings at South Newington', *Burlington Magazine*, **62**, No. 360: 114–129.

Tristram, E. W. and G. Montagu Burton (1937) 'Wall paintings in Essex Churches Part V: Copford Church and its Wall-paintings', *Transactions of the Essex Archaeological Society*, **21**: 1–24.

Tristram, E. W. and G. Montagu Benton (1940) 'Wall paintings in Essex churches VII: Wall-paintings in Fairstead Church', *Transactions of the Essex Archaeological Society*, **13**: 211–220.

Tristram, E. W. and G. Montagu Benton (1940) 'Wall-Paintings in Essex Churches VI: Wall-paintings in the churches of Little Easton, Hadleigh and Wendens Ambo', *Transactions of the Essex Archaeological Society*, **30**: 1–27.

Tudor-Craig, P. (1959) 'The Painted Chamber at Westminster', *Archaeological Journal*, **114**: 92–105.

Tudor-Craig, P. (1990) 'Nether Wallop Reconsidered', in S. Cather, D. Park and P. Williamson (eds) *Early Medieval Wall Painting and Painted Sculpture in England*, BAR British Series 216: 89–104.

Tudor-Craig, P. (1992) 'Painting in Medieval England: the Wall-to-Wall Message', in N. Saul (ed.) *Age of Chivalry: Art and Society in Late Medieval England*, London: 106–119.

Turner, B. (1985) 'The Patronage of John of Northampton', *Journal of the British Archaeological Association*, **138**: 89–100.

Turner, D. (1847) 'Mural Paintings in Catfield Church', *Norfolk Archaeology*, **I**: 133–139.

Turner, D. (1849) 'Drawings by Mrs Gunn of mural paintings in Crostwight Church, communicated by Dawson Turner, esq, vice president', *Norfolk Archaeology*, **2**: 352–362.

Walford, S. (2004) *Holy Trinity Church Coventry: The Medieval Doom Painting*.

Waller, J. (1871) 'On a painting discovered in Chaldon Church', *Surrey Archaeological Collections*, **5**: 275–306.

Waller, J. G. (1847) 'On recent discoveries of Mural Paintings in Churches, particularly those in Battel, Sussex', *Archaeological Journal*, **2**: 141–155. (The current spelling is Battle – RR)

Waller, J. G. (1873) 'On Recent Discoveries of Wall Paintings at Chaldon, Surrey; Wisborough Green, Sussex; and South Leigh, Oxfordshire', *Archaeological Journal*, **30**: 35–58.

Waller, J. G. (1874) 'On a painting of St Christopher in Newdigate Church, Surrey', *Surrey Archaeological Collections*, **6**: 57–63; and in the same volume, 'Notes on the Figures of St Christopher', 293–300.

Waller, J. G. (1877) 'On the Wall Paintings Discovered in the Churches of Raunds and Slapton, Northamptonshire', *Archaeological Journal*, **34**: 219–241.

Waller, J. G. (1880) 'Notes on the Chaldon Painting', *Surrey Archaeological Collections*, **7**: 295–299.

Waller. J. G. (1881) 'Note on the painting of the Doom at Patcham', *Archaeological Journal*, **38**: 96–97. See also: Keyser, C. E. (1881).

Waller, J. G. (1885) 'On the Series of Wall Paintings in the Church of St Mary, Guildford', *Archaeologia*, **49**: 199–212.

Way, A. (1864) 'Les trios Vifs et les trios Morts:' Mural Painting in Charlwood Church, Surrey', *Archaeological Journal*, **21**: 216–19.

Whale, K. (1999) 'The Wenhaston Doom; a biography of a sixteenth-century panel painting', *Proceedings of the Suffolk Institute of Archaeology and History*, **39**, Part 3: 299–316.

Whittingham, A. B. (1985) 'The Erpington Retable or Reredos in Norwich Cathedral', *Norfolk Archaeology*, **39**: 202–206.

Williams, E. Carlton (1956) 'Mural Paintings of St Catherine in England', *Journal of the British Archaeological Association*, **19**: 20–33.

Williams, E. Carlton (1942) 'Mural paintings of the Three Living and the Three Dead in England', *Journal of the British Archaeological Association*, third series, **7**: 31–40.

Williams, E. Carlton (1949) 'Mural Paintings of Saint George in England', *Journal of the British Archaeological Association*, **12**: 19–36.

Williamson, M. (2000) 'Pictura et scriptura: the Eton Choirbook in its Iconographical Context', *Early Music,* **28**: 359–378.

Wilson, Canon (1909–14) 'On Some Twelfth Century Paintings on the Vaulted Roof of the Chapter House of Worcester Cathedral', *Worcester Cathedral Notes and Monographs,* Worcester: 1–17.

Winter, C. J. W. (1872) 'Discovery of a Mural Painting in the Church at

Sporle', *Norfolk Archaeology*, **7**: 303–308.

Woodforde, C. (1950) 'The "Blasphemy" window at Heydon', *The Norwich School of Glass-Painting in the Fifteenth Century*, Oxford.

Woodruff, C. H. (1902) 'Thirteenth Century Wall-Painting at Upchurch', *Archaeologia Cantiana*, **25**: 88–96.

Wormald, F. (1945) 'A Wall-Painting at Idsworth and a Liturgical Graffito', *Antiquaries Journal*, **25**: 43–47.

Wright, G. R. (1884) 'Recently Discovered Fresco at Patcham Church, Sussex', *Archaeological Journal*, **40**, 182–84.

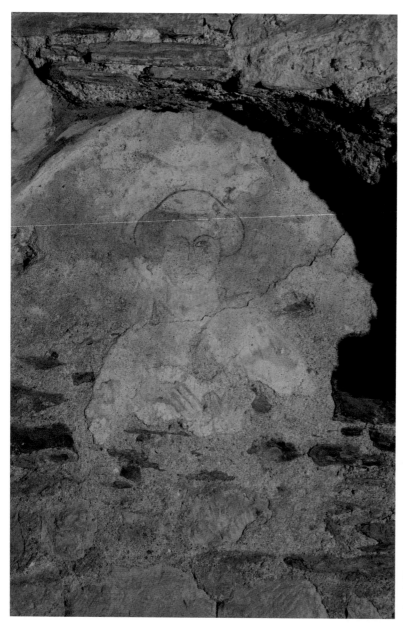

Figure 252

The ghost of a cleric: Dittisham, St George, thirteenth century.

Picture Credits

All photographs are reproduced with the permission of the copyright holders and the courtesy and kindness of others listed below. All numbers refer to **figure numbers** rather than page numbers unless marked otherwise

The Author: Opp Preface; 3; 4; 6; 9; 10; 11; 12; 13; 14; 17; 18; 19; 21; 22; 23; 24; 28; 29; 30; 31; 32; 33; 34; 36; 37; 38; 39; 41; 43; 44; 46; 47; 48; 50; 51; 52; 53; 54; 55; 56; 57; 59; 60; 61; 62; 64; 65; 66; 67; 70; 72; 73; 74; 75; 76; 77; 79; 80; 82; 83; 85; 86; 87; 90; 94; 96; 97; 98; 99; 100; 101; 102; 103; 104; 105; 106; 107; 108; 111; 112; 113; 118; 119; 121; 122; 123; 124; 127; 128; 129; 131; 132; 133; 134; 135; 136; 137; 139; 141; 142; 145; 146; 147; 148; 150; 151; 153; 154; 155; 156; 158; 159; 160; 161; 163; 164; 165; 166; 167; 168; 169; 170; 171; 172; 173; 174; 176; 177; 178; 179; 181; 182; 184; 186; 187; 188; 189; 192; 193; 196; 197; 199; 200; 201; 202; 203; 204; 205; 207; 208; 209; 210; 211; 216; 217; 218; 219; 220; 221; 223; 224; 225; 226; 227; 232; 233; 234; 237; 238; 239; 240; 242; 243; 246; 247; 250; 251.

Mrs Mollie Beaulach: 143.
The Trustees of the British Museum: 5.
Richard Bryant: 7.
The Bishop of Chichester: 21; 204.
The Dean and Chapter of Canterbury Cathedral: 13; 161.
Dover College: 191.
Phillip Draper: 117.
Durham Cathedral: 15.
English Heritage: 205.
The Dean and Chapter of Exeter Cathedral: 172; 192; 219; 220.
Boydell and Brewer Ltd ©Mr Eric North: Cover image; 35 & details; 157 & details; detail inset page 1.

Kunstmuseum Basel: Kupferstichkabinett: 222.

The Chapter of Lichfield Cathedral: 76; 189.

Lord and Lady Edward Manners, Haddon Hall: 86; 156.

Milton Keynes Council: 73; 217.

c b newham: 1; 2; 8; 16; 20; 25; 26; 40; 42; 45; 49; 63; 68; 69; 71; 78; 81; 84; 88; 89; 92; 95; 109; 110; 115; 116; 126; 138; 140; 144; 149; 162; 175; 180; 183; 185; 190; 194; 195; 198; 206; 212; 213; 214; 215; 228; 229; 230; 231; 235; 241; 244; 245; 248; 249; 252.

The Chapter of Norwich Cathedral: 132; 154; 202; 250.

The Perry Lithgow Partnership: 130.

The Chapter of Rochester Cathedral: 112; 151.

The Chapter of St Albans Abbey: 66; 188; 216.

The Chapter of St David's Cathedral: 211.

St Fagans: National History Museum, National Museum of Wales: 58.

The Society of Antiquaries of London: 114; 120.

The Vicar and Churchwardens of Tewkesbury Abbey: 77; 207.

Westminster Abbey: 27; 125.

The Dean and Chapter of Winchester Cathedral: Opp. Preface; 19; 20; 22; 160; 227.

The Dean and Chapter of Worcester Cathedral: 39.

Alan Wright: 91; 93; 152.

Index